GOLF'S FINEST PAR THREES

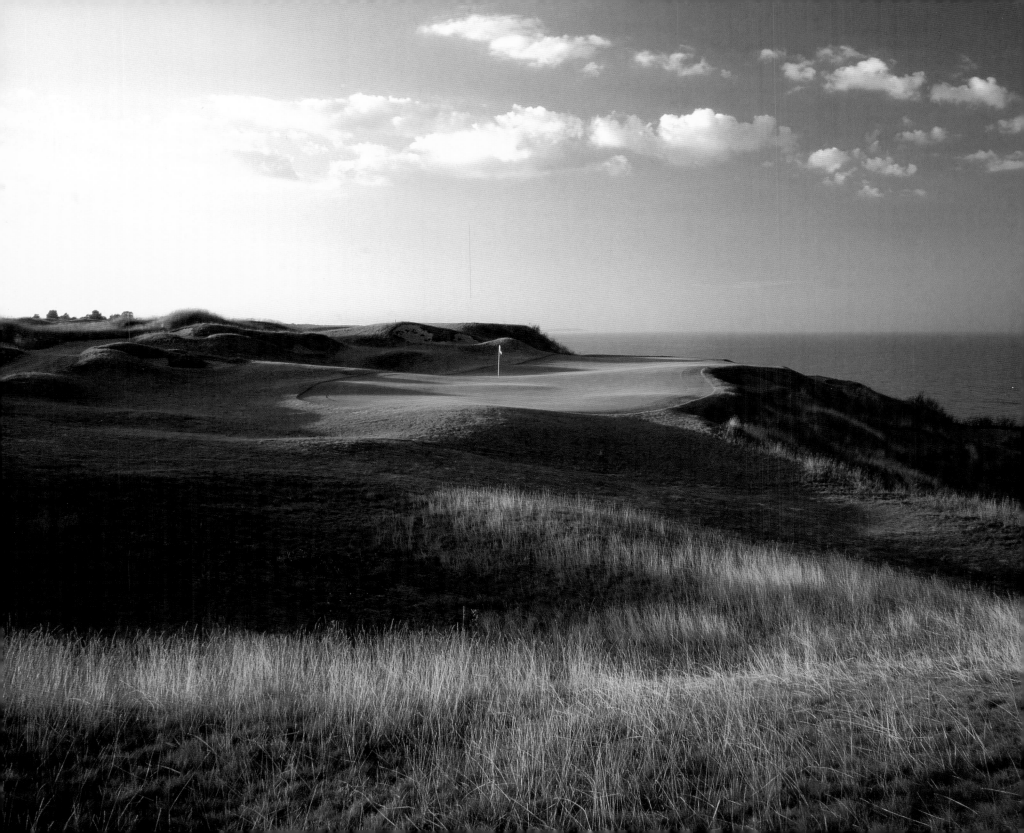

GOLF'S FINEST PAR THREES

The Art & Science of the One-Shot Hole

TONY ROBERTS & MICHAEL BARTLETT

ECW Press

Published by ECW Press
2120 Queen Street East, Suite 200, Toronto, Ontario, Canada M4E 1E2
416.694.3348 / info@ecwpress.com

LIBRARY AND ARCHIVES CANADA CATALOGUING IN PUBLICATION

Bartlett, Michael
Golf's finest par threes : the art and science of
the one-shot hole / Michael Bartlett and Tony Roberts.

ISBN 978-1-55022-957-8
ALSO ISSUED AS: 978-1-55490-957-5 (PDF)

1. Golf courses. 2. Golf course architects.
I. Roberts, Tony II. Title.

GV975.B36 2011 796.352'068 C2010-906698-7

Developing editor: Jennifer Knoch
Cover and Text Design, Typesetting: Tania Craan
Production: Troy Cunningham
Printing: Wai Man Book Binding 1 2 3 4 5

ECW PRESS
ecwpress.com

PRINTED AND BOUND IN CHINA

Table of Contents

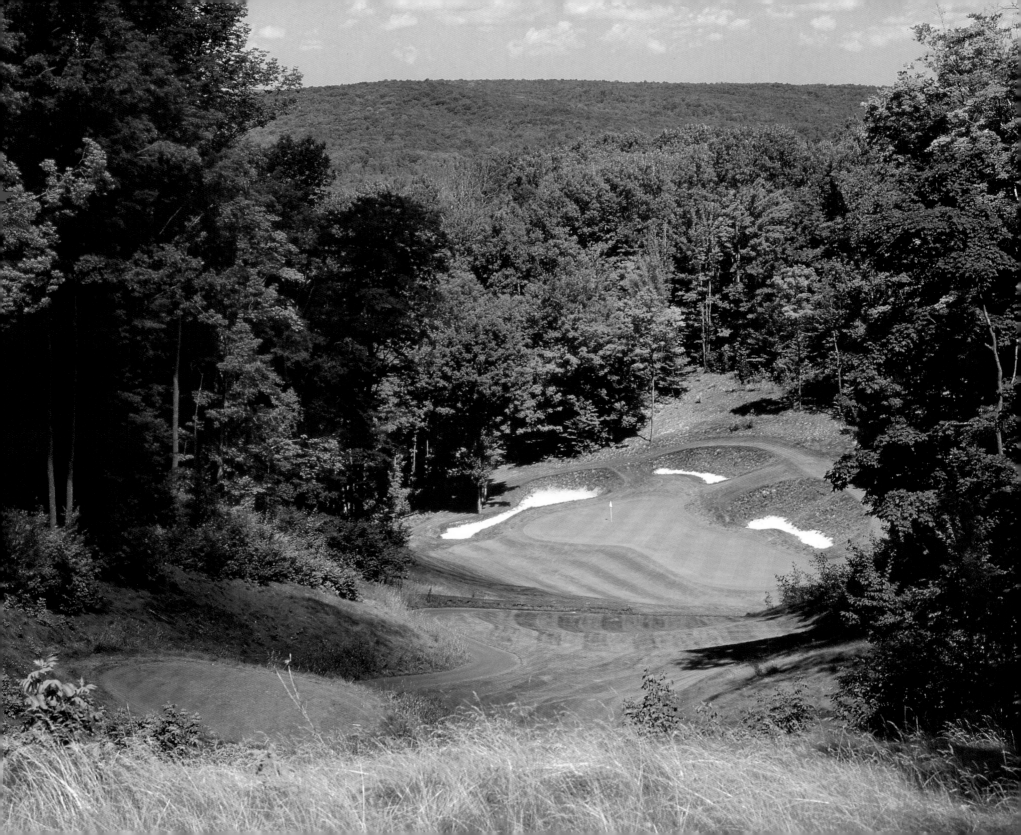

To Leslie for her love and support in life and photography.

To Jim McCann — a plus-three in the mind game.

When we began this endeavor some three years ago with the question, "Has anyone ever written a book about the great par-three holes?" we had no idea how much work would go into selecting and researching the core 100 (along with others) presented here. For sure, we have measurably enhanced our personal understanding of golf course architecture and the one-shot hole in particular.

Some of our material derives from the books in our bibliography. Among those listings, we need to pay special thanks to those who have devoted years to studying and writing specifically about the great architects and golf courses of the world. These include: Ron Whitten, Geoff Shackelford, Forrest Richardson, Bradley Klein, Bill Davis and the editors at *Golf Digest*, George Peper and the editors at *Golf* magazine, Mark Rowlinson, Malcolm Campbell, David Barrett, Paul Daley and Tom Ramsey.

We took inspiration from the work of great golf writers, among them Bernard Darwin, Peter Dobereiner, Dan Jenkins, Henry Longhurst, Charles Price, Pat Ward-Thomas and Herbert Warren Wind.

We could not have completed the presentation of our "Finest Holes" without the generous contributions of our many friends who specialize and excel in photographing golf courses worldwide. We applaud their artistic excellence and dedication to making golf photography about the love of the game. A special thanks to our longtime friend Brian Morgan for his encouragement, recommendations and images. Evan Schiller and Pat Drickey contributed their photographs with enthusiasm for the project, as did Paul Handley and Jim Krajicek. Russell Kirk, Joann Dost, Geoff Shackelford and Ken May went the extra mile to find needed images. We also want to mention Bob Schank, a talented amateur photographer,

who discovered the joy of shooting at dawn at Medinah No. 3. All of our contributing photographers are listed in the back of the book along with their websites where you will find a cornucopia of the very best in golf photography.

Our gratitude goes to expert readers Al Barkow, Joe Passov, Forrest Richardson, Lorne Rubenstein and Matt Vorda, who gave valuable time to review the entire manuscript. Their corrections, observations and suggestions made this a much better book.

Among golf course architects who took time to respond to our questions about par threes, we would like to cite Bill Coore, Pete and Alice Dye, Tom Fazio, David McLay Kidd, Jay Morrish, Dick Nugent, Gary Panks, Kyle Phillips, Forrest Richardson and Tom Weiskopf.

Architect Tom Doak deserves special recognition for providing help on multiple fronts — with his unique *Confidential Guide to Golf Courses*, photos of some of the holes and a careful reading of the original text.

Our early research began at the United States Golf Association library where Nancy Stulack and David Fay provided access to a treasure-trove of golf course literature.

Those who bring a book idea to publishers are of course key to the project. When Farley Chase called from Scott Waxman Literary Agency, we knew we had an idea worth doing. And Farley made sure we shaped our proposal just so, thus exerting an early and important influence on the final product. We thank him for his editing skills and encouragement along the way.

To all those at ECW Press — Jack David, Jennifer Knoch, Tania Craan, Erin Creasey and Simon Ware — our gratitude for taking the concept and making it into something we can share with golfers everywhere.

Our sincere thanks to Pete and Alice Dye for generously contributing a foreword. Their words and work speak for themselves.

Finally, we want to thank Leslie Roberts, whose steadfast goodwill and culinary talents kept the authors on an even keel; Jim and Karen McCann, whose hospitality sustained our early research; and Charlie Bartlett, who always knew a good par three when he saw one.

During our fifty years designing courses we have always tried to wed the best of old and new. Our first experiences playing St. Andrews Old Course and many classic venues in Scotland, Ireland and England grounded us in a style of design that favors nature's unpredictability. We fell in love with the eccentricities that dominate early layouts like Prestwick, Nairn, Cruden Bay, Royal Dornoch and Royal County Down, and the work of Old Tom Morris, James Braid, Harry S. Colt and Donald Ross. Some of the par threes we saw and studied remain favorites — the fifteenth at Cruden Bay, North Berwick's original Redan, the Postage Stamp and the Eden at St. Andrews.

Although we have built some outstanding par fours and fives, the world knows us for our par threes — the ocean holes at Teeth of the Dog and Kiawah Island, number seventeen at TPC Sawgrass and PGA West, the lakeside threes at Whistling Straits and the seventeenth at Harbour Town. We delight in the one-shot holes for many reasons. For example, the tee shot on a par three is in our control. This lets us select yardages and angles that produce different challenges. We also make sure every golfer can select a club that will allow him or her a chance to reach the green. Because the threes are spatially condensed, we treat them like a beautiful painting that will leave a lasting image in the mind of each golfer.

When Michael Bartlett and Tony Roberts approached us about writing a foreword for their book, we found the idea of devoting a volume to the art and science of the one-shot hole intriguing. After reading it, we can safely say they have succeeded in producing a memorable combination of informative writing and striking photography. We were particularly impressed with the section on blind holes, the book's

homage to those old-fashioned creations. It put us in mind of what Tommy Armour said to critics of blind holes: "A hole is only blind once for a golfer with a good memory." The variety of categories showcases the wonderful diversity that defines golf's playing field. We are pleased to see that the holes chosen are a roll call of the best architects and great courses, our own among them.

So, we encourage you to settle in and enjoy a reading tour through some of the world's great par-three holes. We are glad to be part of it.

— Pete and Alice Dye

"The merit of any hole is not judged by its length but rather by its interest and variety.
It isn't how far but how good!" — A. W. TILLINGHAST, GOLDEN AGE COURSE ARCHITECT

Alcatraz . . . Biarritz . . . Cleopatra . . . Dell . . . Eden . . . Himalayas . . . Postage Stamp . . . Redan. Ask someone to identify these names and they might respond: prison, city in France, Egyptian queen, secluded glen, paradise, mountain, mail fee, fortification. And they would be right. But for golfers, the correct answer is that each belongs on a list of the game's best-known par-three holes. All owe their fame to a natural setting and the imaginative genius of gifted course designers who believed that less can really be more.

At last count the United States Golf Association library contains 25,000 books, including 1,200 under the heading "Golf Courses." Search as one may, there is no volume devoted solely to the par-three hole. This was a curious omission that we decided to rectify. Our goal: Canvass the world for some of the finest, most interesting, dramatic, beautiful, historic, delightful and confounding one-shot holes and assemble them in a collection that showcases their particular virtues and role in golf history.

Why else a book on par-three holes? Looked at imaginatively, a par three is "the whole-in-one." Most par threes let a golfer see the entire challenge — tee to green — and, with skill and luck, complete the hole in a single shot — the ace.

In a distance-obsessed era, the threes remind us that controlled shotmaking is fundamental to the game, and, on many short holes, finesse is all. Augusta National Golf Club #12, Cypress Point Club #15 and Royal Troon Golf Club #8 exemplify this dimension.

Maybe too it's about respect. Golf's short holes are sometimes overshadowed by the tougher handicap holes that comprise the finishing stretches on a course. But look deeper, and gradually the list of threes

1

that regularly produce high scores grows. They aren't pushovers, for sure. And golf history highlights many a par-three seventeenth — the Tournament Players Club at Sawgrass, Pebble Beach Golf Links and Pinehurst Country Club No. 2 Course, for example — that has determined victory or defeat in major competitions.

In his "Thirteen Principles" of golf course design, Dr. Alister MacKenzie, creator of Augusta National and Cypress Point, stated firmly that there should be "at least four one-shot holes" on every course. In his case, he also laid out two in a row (the fifteenth and sixteenth at Cypress Point), or made the eighteenth a three (Pasatiempo Golf Club). As we shall document, course architects know the importance of well-made, strategically placed one-shotters and use them to enhance the quality of a course.

We very much subscribe to the thought of Japanese architect Shunsuke Kato who said, "The importance of the par-three hole is that it truly represents the designer's policy as to the character of the golf course. It is a wrong idea that a par-three hole is easy to make because it is just a short yardage. The [good] designer puts his heart into making a par-three hole special among others." The top courses are distinguished by a strong complement of par threes, each good to great. In many cases, one of the threes becomes the signature hole.

To set the stage for our collection, a Prologue presents the origin of three famous one-shot holes. This is followed by a brief essay, titled "Evolution," which highlights the thoughts of leading designers about the par three and provides some historical context on its development.

Course ratings and rankings seldom produce complete agreement. Our choices are based on many years of playing, walking and photographing courses worldwide. Buttressing our own judgment are the critical observations and writings of golf course historians and architects, leading golf writers from many eras and local experts who shared their takes on individual holes.

For those who need to discriminate, we offer two tiers — "Gold" and "Silver," and, for fun, we've created an "Ultimate 18-Hole Par-Three Course." Further, we think the arrangement of the top holes around a dominant geographical feature or distinguishing design element is a more interesting way to look at them. In the end, our selection of 100 from the 130,000 or so par threes in the world can only be illustrative of their overall excellence.

We hope you'll get to play some, or if you have already, to relive your experiences through our words and pictures.

— *Tony Roberts and Michael Bartlett*

CREATION

A TRINITY OF THREES

"Imagination is more important than knowledge." — ALBERT EINSTEIN

St. Andrews, Scotland, Summer, Sometime in the late sixteenth century

The band of players made its way along a peninsula in the Kingdom of Fife, home to the town of St. Andrews, an important seat of culture with its castle, cathedral and eponymous university. Contoured by the Firth of Tay to the north and the Firth of Forth to the south, Fife resembled an arrowhead aimed at the heart of the North Sea beset by capricious winds, alternately stinging and soft. The area trod by the group had all the characteristics of true linksland — the irregular footprints of sun and sea that nurtured ragged marram grass, prickly gorse, springy turf, punctuated by colorful heather and butterwort; and stretches of sand sculpted into dunes, mounds and hollows that became sheltering refuge for animals and punishing prisons for errant golf shots.

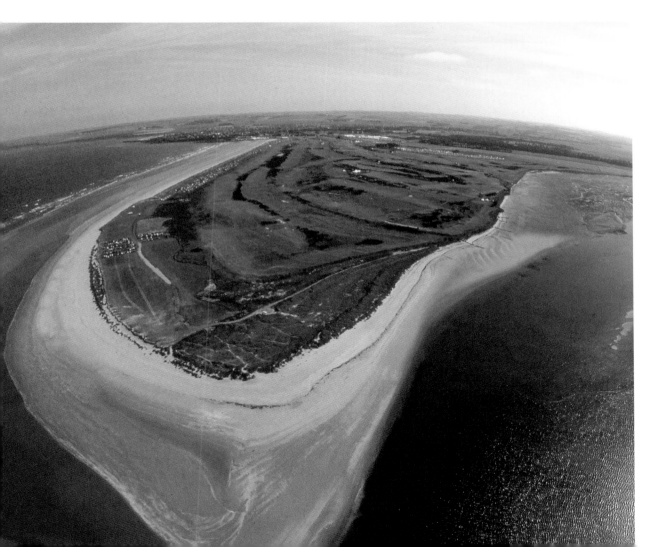

The home of golf, St. Andrews, built on true linksland shaped by wind and water.

Locals and visitors still enjoy the informal setting that characterized rounds of golf played on the Old Course in the sixteenth and seventeenth centuries.

This seaside strip was alive with hundreds of people engaged in a hodgepodge of pursuits. While a decree of 1552 permitted the community to rear rabbits on the links and "play futbul, schuteing . . . with all other manner of pastimes," and ensured the proprietor was bound "not to plough up any part of said golf links in all time coming," the golfers still shared the space with grazing sheep, fishermen tending to nets, archers sharpening their aim, laundry hanging on bushes to dry, townspeople out for a stroll and anyone else who wandered into what was the first golf course in the world.

Well, some of it. At this imaginary point in golf history, St. Andrews had six recognizable holes that ran in a line out toward the Eden Estuary. The group of golfers was really a committee charged with adding

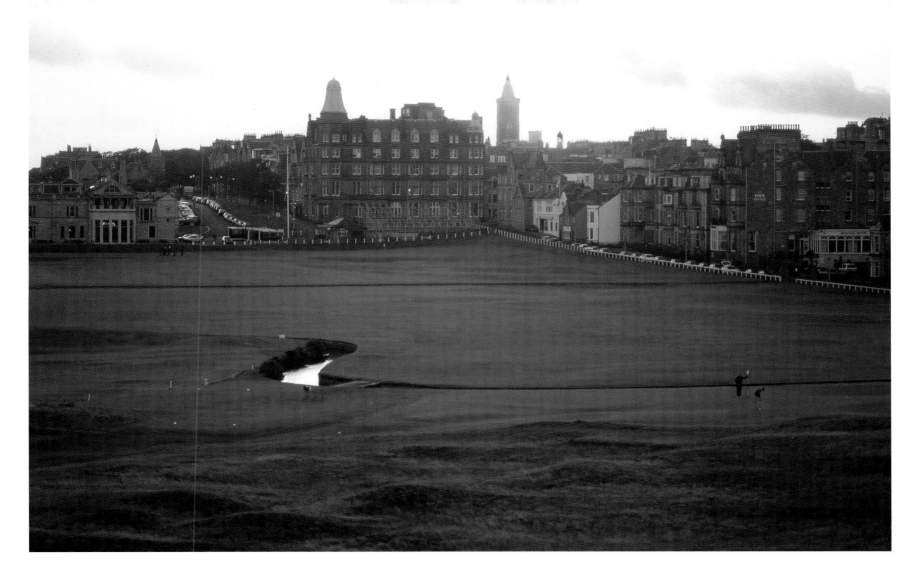

A rare singleton putting out in the early dawn on the Old Course's first hole, with the eighteenth green in the distance.

to this number and making sure players could turn back toward the first hole and complete a loop without their golf balls conking others on the head. As it turned out, they fulfilled this mandate and added a groundbreaking innovation.

St. Andrews' first hole demanded two well-placed shots to reach the putting area. The group's leader, Fergus, took his stance and swung. The ball rose, got caught in a breeze and fell to earth a paltry 100 yards out. Fergus muttered a quiet oath. The next tee shot landed short and right. Then Duncan, a lumbering giant, smashed his ball 180 yards, in great shape to reach the putting area in two.

Each player at the ready — no wasted time for a Scotsman — they quickly covered the six holes (as we

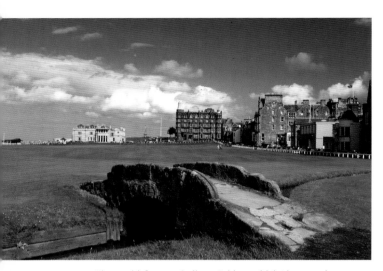

The world-famous Swilcan Bridge, which the game's greats have crossed on their way to winning the Open Championship.

OPPOSITE: Cypress Point's closing holes, numbers fourteen to eighteen, set on "the greatest meeting of land and water in the world."

know the Old Course today): Burn (a two-shotter 370 yards long), Dyke (playing at about 450 yards), Cartgate Out (just under 400 yards), Ginger Beer (the first long three-shot hole at 480 yards), Hole o' Cross Out (at 570 yards, a huge test marked by the cluster of bunkers set right in the landing area and called the "Beardies"), and Heathery (named for the bushes lying in front of the teeing area and playing something over 400 yards). Standing on the sixth green, they surveyed the area and saw they could fit in one more hole before reaching the estuary. This became St. Andrews' seventh and they called it "High-out."

Maybe it was the shafts of sunlight through the clouds but something made them pause, and then came an illumination.

Duncan noted all seven holes took two or three shots to reach the putting area and opined he was tired of having to knock the ball so far to finish. All chimed agreement and decided the next one would take only a single swing to get near the target. But how to decide the distance? Easy, have Fergus (the short hitter) play a tee ball and wherever it landed, there the putting surface would be. Miffed at being chosen for this task, he cracked it to a spot within reach of most players. Cheering this historic stroke, everyone agreed they had St. Andrews' first one-shot hole. In no-nonsense fashion they named it "Short" and cut the hole in back of some sand mounds to add an extra challenge. The group continued the loop back toward the first tee with a ninth and tenth hole, both medium length, and capped their work with another one-shot hole, number eleven.

Like its newborn sibling at eight, it played at 170 yards but was much tougher. This time the design team positioned the tee shot so it had to avoid three threatening sand hollows. The first was to the right, large and shaped like a cockleshell, so they named it "Shell." The second, guarding the left side, was a deep crater of sand, and they called this "Hill." The third was an exclamation point, a tiny pot bunker front and center that became known as "Strath." Over centuries innumerable balls would be swallowed by this menacing trio. In a final touch, they extended the seventh hole's putting surface onto a tricky sloped area not far from the Eden, and this became the eleventh green. They named the hole "High-in," although eventually it became better known as the "Eden." Their task done, the proud architects hurried off to tell the town and celebrate with another important contribution to the world — Scotch whisky.

If they had been able to see the future, they would have relished how great players — Robertson, Morris, Park, and others — met the challenges posed by numbers eight and eleven. Of St. Andrews' two short holes, it was the Eden that grew in stature, touching the careers of Jones, Sarazen, Nicklaus and Woods, and earning accolades as a truly great three. And because the Old Course became a revered template, architects throughout history also sought to create superior one-shot holes.

The Coast of Northern California, 1926

On a March morning winds whipped the water into plumes that painted the shoreline of California's Monterey Peninsula. A young American woman and a distinguished looking gentleman stared out over a

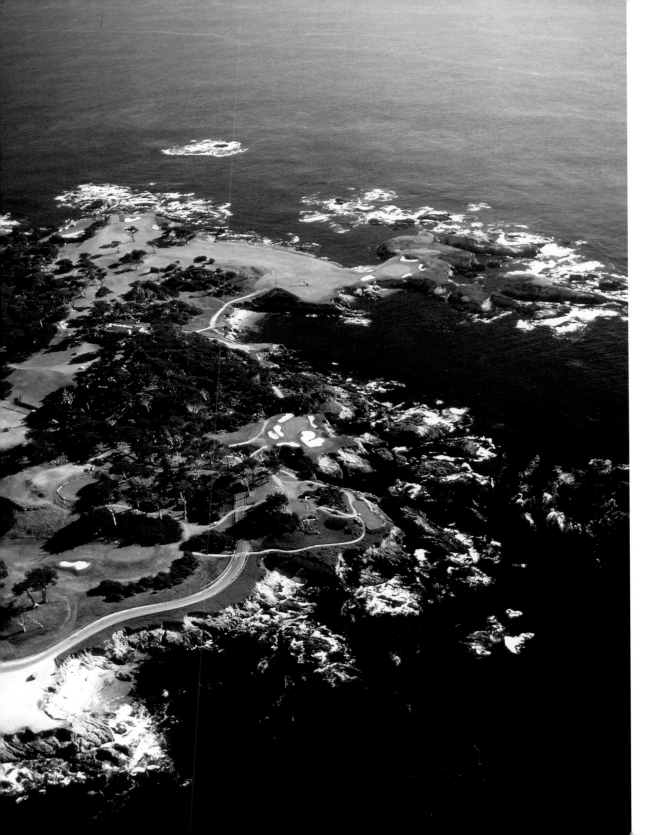

cove at a small spit of land jutting into the Pacific Ocean. Behind them lay fifteen holes of routing for a golf course situated on what was described as "the greatest meeting of land and water in the world."

The project at hand was the Cypress Point Club, intended as an exclusive golf club located on one of the rarest properties on earth. The woman, Marion Hollins, was the scion of a wealthy Long Island family. When her father lost his fortune in a bank failure, Hollins headed to California and landed a job working for Samuel F. B. Morse, the man behind the Del Monte Properties Company. In 1919 Morse opened the Pebble Beach Golf Links and the Lodge at Pebble Beach. These were an instant success and sparked a rush by the wealthy to populate the gorgeous littoral area 100 miles south of San Francisco.

Part of Hollins' job was scouting for other potential golf course developments. She found 150 acres just north of Pebble Beach. The Spanish called it "*La Punta de Cipreses*," or Cypress Point. When Morse hesitated about investing in such wild terrain, Hollins raised the necessary funds, acquired the property and commissioned architect Seth Raynor to design the course.

In addition to her entrepreneurial talents, Hollins was one of the era's premier athletes. Born to ride, she achieved recognition as a world-class polo player, the only woman to compete regularly with men. The Scottish pro Willie Dunn tutored her in golf, and by 1921, at age 29, she won the U.S. Women's Amateur Championship. Strongbodied with a powerful swing, she could whale the ball 250 yards. The press dubbed her the female Bobby Jones.

Raynor had roughed out plans for the Cypress

Point course when he died prematurely at age fifty-one. Fate then sent Hollins the man who would complete the task. After early success in the United Kingdom established his reputation as a golf course architect, Dr. Alister MacKenzie, a former surgeon in the British Army, embarked on a world tour that took him to Australia, where he completed Royal Melbourne Golf Club's esteemed West Course, among others. California was next on his itinerary, and there mutual friends introduced him to Hollins, who hired him immediately.

Cypress Point begins by weaving inland through wooded hillsides. Walking from the fourteenth green, the golfer crosses Seventeen-Mile Drive and comes suddenly onto the dramatic ocean's edge defined by rocks, the swell of the waves and the sounds of sea life. The plan called for number fifteen to be a par three, slightly downhill over water, playing at about 140 yards and requiring anything from a wedge to an eight iron. And so it became.

On to sixteen. As Hollins and MacKenzie stood looking at the rocky outcropping some 200 yards from the teeing ground, they had different visions about what to build. Originally, MacKenzie had wanted to push the tee box back 100 yards to make it a strong short four. A two-shot hole would follow the rules of course balance (no consecutive threes) and, besides, asking golfers to reach a green where winds might force a carry in excess of 225 yards was not to his liking. One of MacKenzie's cardinal rules was that golf should be fun for everyone.

As the wind and spray slapped their faces, Hollins argued strenuously for a one-shot hole. Defiantly, she threw down three balls, teed one up and, using a brassie, launched a shot over the cove

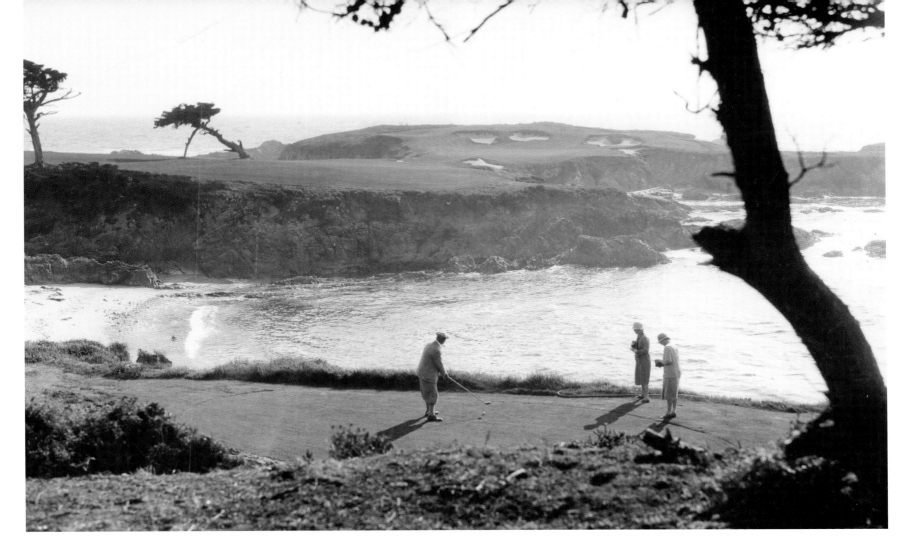

Architect Alister MacKenzie prepares to drive on Cypress Point's challenging sixteenth, observed by his wife, Hilda, and a friend readying to record the moment with a camera.

OPPOSITE: The 168-yard par-three seventh at Cypress Point is surrounded by majestic Monterey Pines that dominate the early holes.

and onto the green site. She followed with two more. Confronted with this performance, MacKenzie agreed to the heroic carry that would forever tantalize players of all stripes. He did win his argument that a fairway should be built left so that, for the conservative, an iron off the tee and a deft chip would yield a safe four or possibly a one-putt three. No less than Ben Hogan often used this strategy. Later, MacKenzie was to write an account of the design of Cypress Point and the creation of the sixteenth, graciously acknowledging Hollins' role: "I must say that, except for minor details in construction, I was in no way responsible for the hole. It was largely due to the vision of Miss Marion Hollins."

In the end, the big-hitting amateur champion and the artistic course genius teamed up to create a superb par three; one many vote best in the world. It has not changed much since Cypress Point opened

in 1928 and still sets the standard for the ultimate test of length, accuracy, nerve, strategy and luck in the pursuit of a 3 on one's scorecard.

Coincidentally, the collaboration between Hollins and MacKenzie led indirectly to the creation of two more of the world's great short holes. Bobby Jones had come to California in 1929 to compete in the U.S. Amateur. Losing in the first round, he extended his visit to play Cypress Point, judging it "almost perfect." He also met MacKenzie, found a kindred soul in design philosophy, and shared his plan to build a course in Georgia. In 1930 they began work on the Augusta National Golf Club layout. Augusta's two back-nine par threes would someday become as famous as Cypress's sixteenth.

TPC Sawgrass number seventeen under construction, as the tantalizing island green takes shape.

Ponte Vedra Beach, Florida, 1980

The man touring pros later dubbed Darth Vader was knee-deep in rattlesnakes and marshland wondering what it would take to finish a course unlike any made to this point. British golf writer Peter Dobereiner summarized the commission this way: "Deane Beman said, 'Behold this tract of jungle swamp. Pray, turn it into the world's first golf stadium.' Pete Dye glanced over the uncompromising acres of marsh and said, 'Certainly, bring me a bulldozer and two quarts of Mountain Lion Sweat.'"

Dye never intended the course nor its par-three seventeenth to be as tough as they turned out. On the other hand, a round of golf with him invariably elicited a favorite aphorism, "Golf's not a fair game." Of affable mien with a no-nonsense Midwestern attitude, Dye was a gifted player. He won the Ohio State High School Championship, had good showings at five U.S. Amateurs and at the 1957 U.S. Open finished ahead of Arnold Palmer and Jack Nicklaus.

In 1963 Dye qualified for the British Amateur. With the eminent Richard Tufts of Pinehurst fame as a mentor, he and wife Alice O'Neal Dye, also a top amateur, made a whirlwind tour of Scotland's

courses. The Dyes filled notebooks with observations, snapped pictures and absorbed every aspect of this utterly natural form of the game — pot bunkers, wild grasses, crazy bounces, maddening greens tilted at unreal angles and sweeping sand dunes. From this time on, his work incorporated oddly shaped fairways and waste bunkers that mimed old world courses. He added punishing fairway and green contours that made some people say he was one of golf's Four Horsemen.

When he agreed to help Beman, commissioner of the PGA Tour, build a course worthy of hosting the Tournament Players Championship (inaugurated in 1974), Dye didn't know his excruciating layout would lead to outright revolt by the Tour pros. After the first Players Championship at TPC Sawgrass in 1982, even "Gentle" Ben Crenshaw was inflamed, exclaiming, "This is *Star Wars* golf. The place was designed by Darth Vader!" Seventeen epitomized the penal nature of the course; it was not only a dramatic creation that teased player and spectator, but also a brilliant Vaderesque lightsaber that hung perilously in competitors' minds for sixteen holes.

Dye had long been known as a hands-on designer; in fact, he and Alice moved into a motel near the site to keep an eye on construction, and it was Alice who became the catalyst for seventeen's final version. Pete found the best sand for use on the fairways in the area where he had planned the seventeenth, originally a mild-mannered 150-yard carry to a green protected by water on one side. However, as more and more sand was hauled away, voilà, there sat an island green sans water.

Here a bit of design evolution kicked in. In 1948 the Dyes had played the nearby Ponte Vedra Club course designed in 1928 by Herbert Strong. It included one hole set out in water; in this case, the green was surrounded with sand bunkers and lots of grassed berm allowing for bailout positions. Looking at the emerging island on seventeen, Alice Dye had an an "a-ha" moment. She and Pete hurried to Beman, told him their idea and he gave hearty approval.

When finished, the hole had an apple-shaped green 26 paces long and 30 wide. At the bottom of the apple, Dye placed a single pot bunker right, leaving a narrow stem leading to land. Looked at one way, it was difficult for any golfer, including a pro, to find fault with a 137-yard shot from a perfect lie to a 3,900–square-foot green. But when it's all water tee to green and the green surface runs almost to the edge of the island, the chances for ruin increase dramatically.

Greg Norman summed up the challenge when he called it, "under pressure the hardest 142-yard [sic] par three in the world." Statistics bear Norman out. At the first TPC, the overall scoring average was 3.79; it has fallen since, but the hole's reputation has risen steadily. It now ranks as one of the most dangerous one-shot holes ever and regularly validates writer Bernard Darwin's opinion that "Golf at its best is a perpetual adventure . . . it ought to be a risky business."

The stories behind the making of three famous holes can only be exemplary of thousands around the world. In each case, the common thread was an inspired, pivotal moment that led to a singular golf hole.

Pete and Alice Dye have always been a hands-on design team, wielding dozers and rakes to shape holes.

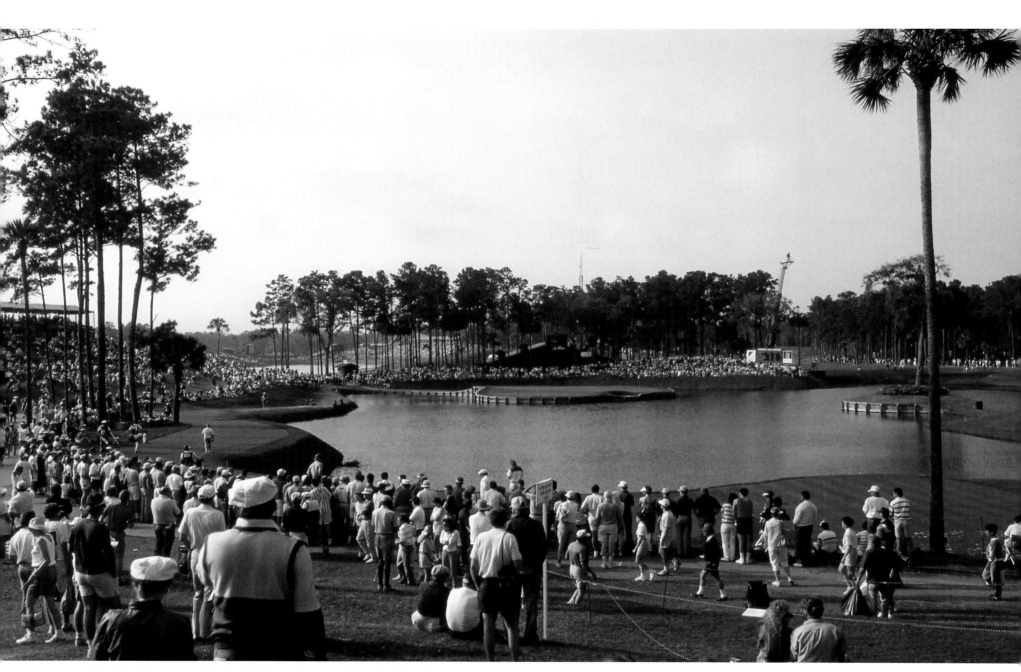

The TPC at Sawgrass was the first stadium golf course, designed with ample
mounds and bleacher sites to give spectators an up-close vantage point.

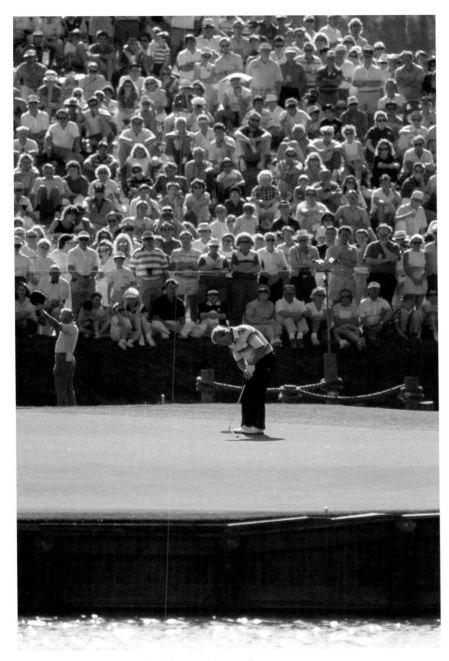

At St. Andrews' eighth and eleventh, it was the invention of the oldest one-shot holes we can still play. It's possible the first golf holes were short, since one can imagine early players picking a target they could hit in one stroke. In time, they extended the game so that two- and three-shot holes dominated. At some point, as in the eleventh at St. Andrews, the focus became more on how many challenges could be built into a short distance; like subatomic physics, designers discovered new worlds in a smaller sphere.

Every architect hopes for a site so naturally perfect that the course is already "there." Alister MacKenzie did move trees and earth on the first fourteen holes at Cypress Point, but at the ocean holes there was little alteration to what nature had been sculpting for centuries. The genius of the sixteenth comes from not changing anything and settling on the one shot across the cove. As much as it would have made a fascinating short four, the sixteenth was preordained to be the world's most dramatic par-three hole.

The island-hole seventeenth at Sawgrass was, as Pete Dye well knew, not an original concept. There had been island greens for at least eighty years before he shaped his version. So why is it so famous? Maybe it's something as simple as being telegenic. After all, Dye and Beman were building a stadium course with a premium on viewing a hole in the round. The real draw is the either/or quality of the tee shot. To complete Sawgrass seventeen you must get on the green and putt out or keep plunking balls in the water, no matter how many tries it takes. It is golf's version of the Flying Wallendas meet Evel Knievel.

Aristotle said the way to understand the big picture is to examine "the involution of the universal in the particular." The par-three golf hole is best understood by observing the principles and execution of golf course architects. What they build defines the genre. Having done this we may also get a practical benefit — playing them a bit better. And surely we will appreciate their variety and jewel-like beauty.

Golf's greatest, Jack William Nicklaus, putting on the seventeenth green during the Players Championship.

The par-three fourth hole at Five Farms East Course (Baltimore Country Club); architect A. W. Tillinghast employed a raised green and an advance bunker to heighten the challenge.

EVOLUTION

FROM SHORT TO SPECTACULAR

"Tam arte quam marte." (As much as by skill as by strength.) — MOTTO OF THE ROYAL TROON GOLF CLUB

In their writings golf course architects and course historians refer to it as the one-shotter, wee three, pitch-and-putt, three par, dainty and whimsically, "tiny tim," to use A. W. Tillinghast's sobriquet. All are talking about a hole, generally 100 to 250 yards, that offers average players and world-class pros the same opportunity — a chance to complete the entire golf challenge in a single stroke by hitting it from a tee into the cup.

In our prologue we imagined what might have happened at the creation of golf's two oldest extant par threes, numbers eight ("Short") and eleven ("Eden") at St. Andrews' Old Course. The inspiration of these visionary golf architects stemmed from the desire for a golf hole that required a single shot to reach the putting area, the need to route a course in a certain direction, and the practicalities of fitting holes into a given space. Once the one-shot hole was fixed as an essential part of a round of golf, it was left to designers to explore its many possibilities.

We leave it to course historians and scholars to write a definitive study of the one-shot hole. In this brief space we'll present what leading course architects have to say, in their own words, about golf's par three as it evolved from the naturalistically brilliant holes at St. Andrews to the technically engineered, highly imaginative creations of the twentieth and twenty-first centuries.

We'll focus on the influence of Old Tom Morris and Charles Blair Macdonald on the short hole, the number of one-shot holes on an 18-hole course and their sequence, the length of the one-shot hole, the teeing ground and the distinctive nature of the par-three tee shot, green size and green complexes, defenses used to

protect the short hole, why so many par threes are signature golf holes and what this reveals and classical and contemporary champions of the short hole.

Old Tom Morris and Charles Blair Macdonald

The first golf clubs were founded by ardent amateur enthusiasts who laid out a few holes on which to play. By the middle of the nineteenth century course design moved into the hands of a new class — the professional golfer. The earliest pros, led by Allan Robertson and his protégé Old Tom Morris, competed for prize money, made clubs and balls, gave instruction and in time took the lead in course design. With their trained player's eye and ability to hit the maximum shot, they could quickly and effectively route a course that offered real challenges.

The 197-yard tenth at Royal County Down by Old Tom Morris; an elevated tee shot must avoid four deep bunkers right and left.

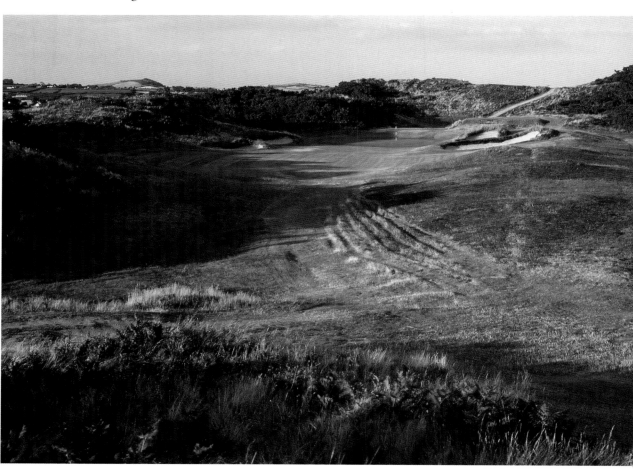

OPPOSITE: H. S. Colt's Valley Course at Royal Portrush with its fields of marram seagrass and tumbling dunes.

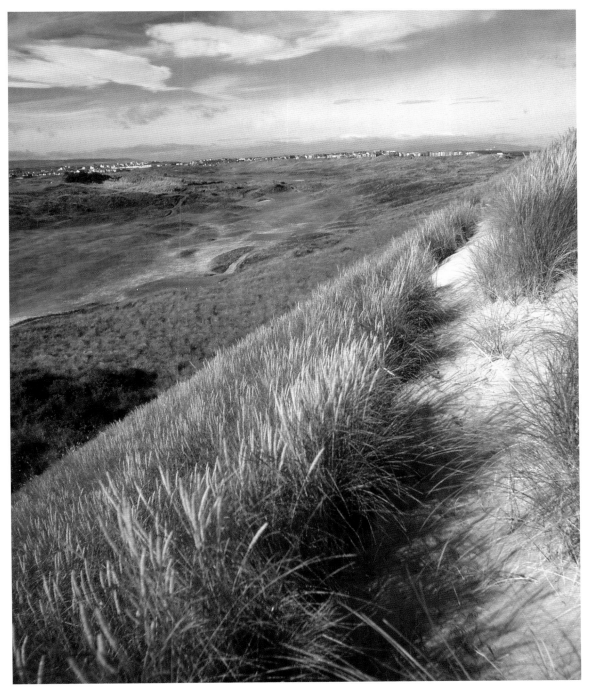

Old Tom Morris was the first of the great player-designers, with at least sixty courses to his credit; he created the original plans for Prestwick, Carnoustie, Muirfield, Royal County Down, Lahinch and the Jubilee Course at St. Andrews. Most of his sites were linksland or areas near railroad lines, and the routing took him through, around and over towering sandhills and dense hollows of vegetation, with the occasional meandering burn (a brook or stream). A typical commission was usually done quickly (he devoted a mere two days to Royal County Down) and without the earth-moving equipment that became standard in the twentieth century. Thus, natural features dominated the look and playing strategy.

Old Tom's contribution to the list of notable one-shot holes was his use of a trendy and at the time acceptable challenge — the blind shot. Can't knock a dune down? Then play *over* it to an unseen target. Morris's blind threes — the Dell at Lahinch, the Himalayas at Prestwick and Cruden Bay's fifteenth (each profiled in our "Finest 100") — still exist. They inspire love and hate, but everyone wants to play them. Ask the dean of American architects, Pete Dye, and he'll tell you Cruden Bay, because of its quirkiness, is one of the great courses.

As the game boomed during the latter part of the nineteenth century, a corps of designers emerged, dominated by British pros. Win the Open Championship and you could add "Course Design" to your portfolio and lay down rules on how to build a golf course. During the same period, amateurs got into golf architecture. Pre-eminent among these was the American Charles Blair Macdonald, father of "inspired imitations." About

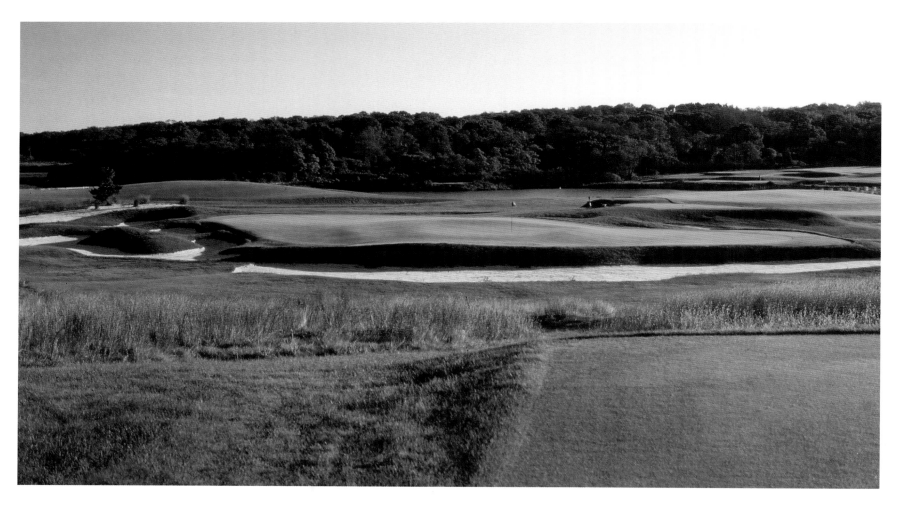

C. B. Macdonald's sixth hole at the National Golf Links; known as "Short," it became a model for dozens of short-yardage tests emphasizing finesse over strength.

Macdonald, Herbert Warren Wind wrote, "Far more than any architect, Macdonald stands as the connecting link between the old and the new. On one hand, no one had a greater reverence for the British courses, and on the other hand, no one in his time was more forward-looking. . . ."

Macdonald studied the classic holes of Britain and Europe assiduously in order to use them as touchstones for his American courses; his master showcase is the National Golf Links of America on Long Island. Four foreign models in particular influenced the evolution of the par three — the Redan, the Biarritz, the Eden and the Short. The Redan and Biarritz are covered in detail elsewhere in this book. The Redan template is used on a variety of holes (threes, fours and fives), while the Biarritz is a more limited form, usually reserved for long one-shotters. The Eden, short for the Eden Estuary, is the name given to St. Andrews'

An illustration reveals the dogleg shape of Cruden Bay's fifteenth hole with its blind tee shot.

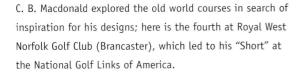

C. B. Macdonald explored the old world courses in search of inspiration for his designs; here is the fourth at Royal West Norfolk Golf Club (Brancaster), which led to his "Short" at the National Golf Links of America.

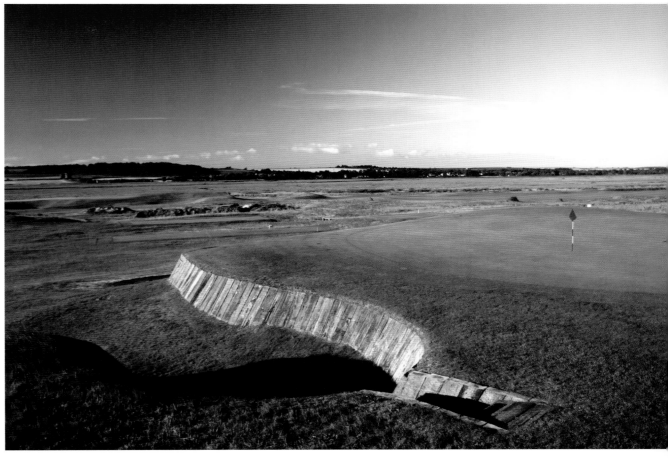

eleventh hole. It features the use of penal greenside bunkers, depressions in back that force difficult recoveries, a dramatic back-to-front slope that makes putting and chipping difficult, a nearby body of water and, of course, exposure to shifting winds — all classic design defenses.

The Short at the National Golf Links was Macdonald's tribute not to St. Andrews' Short (the eighth), but the 129-yard fourth at Royal West Norfolk Golf Club (Brancaster). George Bahto, author of the definitive biography on Macdonald, *Evangelist of Golf: Charles Blair Macdonald*, is our best source here. Bahto explains, "He favored this particular version (Brancaster #4) over the eighth at St. Andrews because the tee box was higher and afforded a clearer view of the green. He surrounded his versions of the genre with a sea of sand — elevating the green to make the target more dramatic and intimidating. A horseshoe feature with the open end facing the tee and a rounded dish depression in the green were mainstays of the design."

Two examples covered in our "Finest 100" are the sixth at the National Golf Links and the tenth at Chicago Golf Club, also a Macdonald creation. Evangelist that he was, Macdonald's message was to make sure every course has one par three measuring less than 150 yards.

How Many One-Shot Holes Should There Be and Where Should They Fall?

St. Andrews' Old Course has only two par threes. In 1851 Old Tom Morris placed three at Prestwick, a 12-hole layout; this suggests there was still no standardized quota for one-shot holes on a course, many of which contained only nine, ten or twelve holes. With the advent of the British Open Championship in 1860, it was decreed that two 18-hole rounds would constitute the event. During the last years of the nineteenth century, eighteen holes progressively became the standard number for a course. About this

Nick Faldo putting out on the eighteenth green at St. Andrews to claim the last of his three British Open championships.

time too, a design convention began to prescribe that the eighteen holes should be divided up, somewhat arbitrarily, between eight par fours, four par fives and four par threes. Notably, it wasn't until 1911 that the term "par" was formally defined by the United States Golf Association.

In 1913, writing in *Golfing*, Alister MacKenzie codified the practice with his "Thirteen General Principles," stating firmly every course should have "at least four one-shot holes." Some one-upped him with five, as at Harry S. Colt's Sunningdale New Course. Contemporary architect Tom Doak created five at his acclaimed 2001 Pacific Dunes layout. In 1928 Herbert Fowler did two courses at Berkshire Golf Club at Ascot and may have been the first designer to make six threes in eighteen holes. This number has been equaled more recently by Tom Weiskopf on the Canyon Course at Forest Highlands Golf Club in Flagstaff, Arizona, and Ben Crenshaw and Bill Coore at the 20-hole Lost Farm layout in Australia.

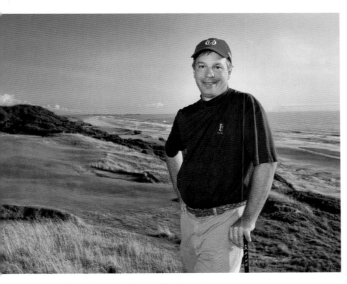

Tom Doak at his Pacific Dunes layout.

RIGHT: The Lost Farm course done by Ben Crenshaw and Bill Coore. Both teams of architects are known for their minimalist approach to design that challenges golfers to discern what is pure nature and what is their invention. They lavish special attention on each of their one-shot holes.

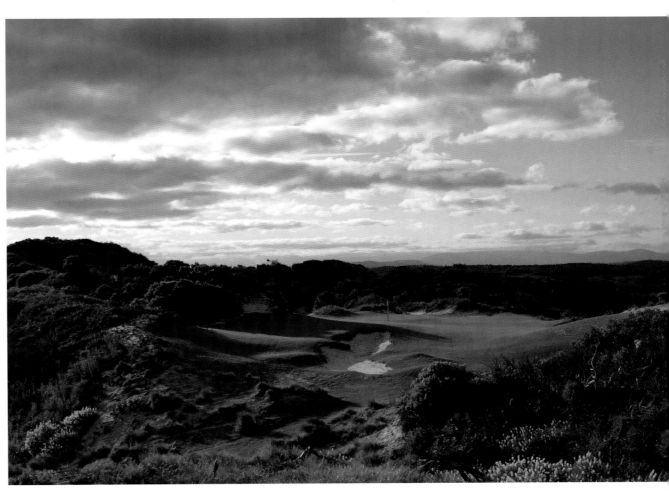

Another consideration was where to slot par threes in an 18-hole sequence. The accepted wisdom was short holes don't begin a round; they were thought to play more slowly (some recent time studies disprove this), so convention demanded an easy four or five to get golfers on their way. Six-time British Open champion Harry Vardon weighed in here: "When the power of selection is left to the designer, I incline to the belief that Nos. 3 and 7 are the best for these dainties. I like a short hole to come early in a round, as at No. 3, because then a golfer who has made a bad start is given a chance of recovering before he is hopelessly out of the hunt. He has a better chance of making a recovery (or thinks he has, which is much the same thing) at a short hole than at a long one."

Vardon corroborates what became an almost universal rule — the first short hole on most courses is the third, fourth or fifth. Canadian eminence Stanley Thompson concurs: "The first short hole should be either the fourth or fifth to get players away and avoid congestion early in the round . . . the short holes and the long holes should be fairly equally distributed." He went even further in 1949 when he created a chart with his "Ideal Sequence" of short holes, yardage included: "#5-145, #8-220, #12-170 and #17-245."

Voicing the contrarian approach, Colt, author with partner Charles Alison of *Some Essays on Golf Course Architecture*, says, "The sequence of the holes does not matter, and what we have to look for are four or five good short holes." British golf writer and architect Donald Steel supports the no-rules school.

Rye Golf Club's well-protected par-three seventh green, one of the course's five one-shotters from designer Harry S. Colt.

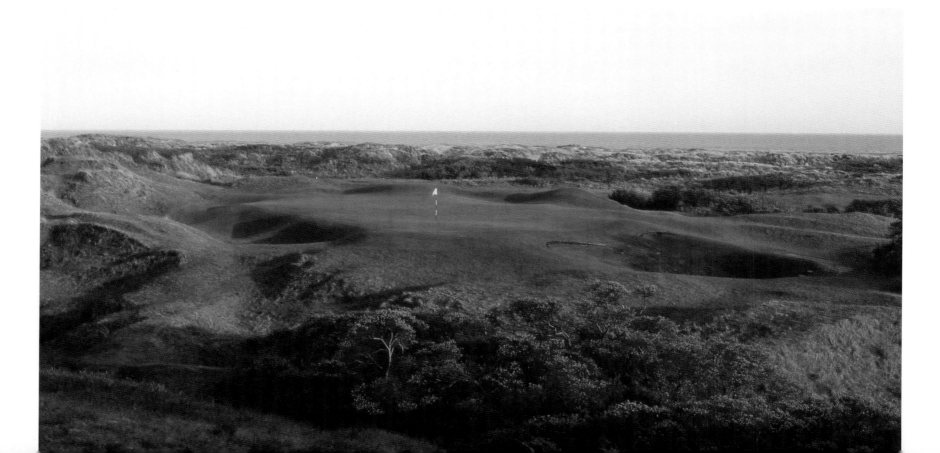

He argues, "The make-up of a layout is no benchmark (of quality) either. The modern belief in a par 72 made up of two threes and two fives a side is absurd. There is a lot to be said for five par threes. Golfers enjoy good short holes; they don't take so long to play and today's best players probably drop more shots on them than the fours and fives."

Progressively, architects have adopted a more flexible approach about the number and sequencing of threes, fours and fives, producing some wonderful layouts. After all, at Cypress Point MacKenzie liberated everyone to do consecutive (numbers fifteen and sixteen) short holes. A MacKenzie admirer, Doak did the same at Pacific Dunes with consecutive threes at numbers ten and eleven— with two tees at ten no less.

A few architects start their routing plan with the threes. Stanley Thompson, who considered par threes to be the vital links of a golf course, stated, "First choose the sites for the par threes." Tom Simpson also favored this method. In *The Practical Greenkeeper*, published in 1920, he writes, "It is a mistake to plan the

The lone oceanside par three at Pacific Dunes, the 148-yard eleventh is rigorously defended with mounds and bunkers.

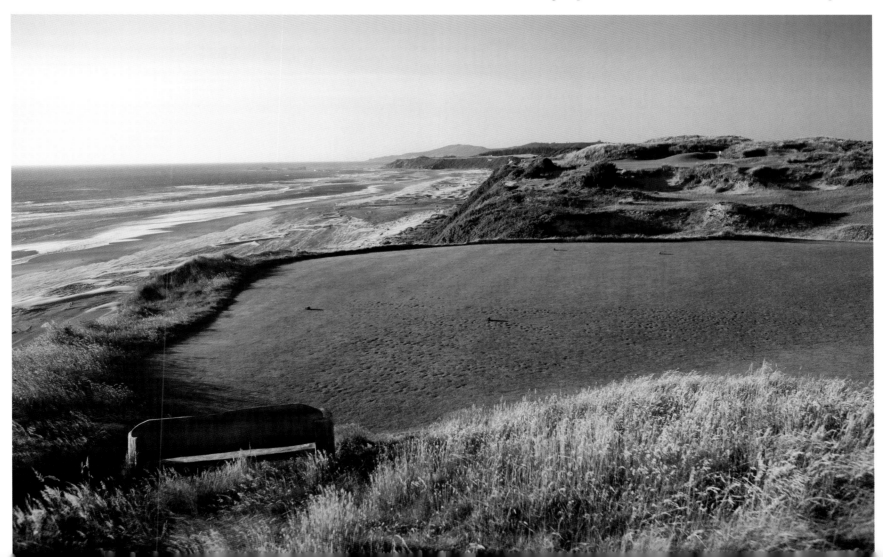

Perched on the edge of the Carrabassett River, Sugarloaf Golf Club's drop-shot eleventh was labeled one of the course's "sparkling holes" by designer Robert Trent Jones, Jr.

course until you have selected the best site for the one-shot holes. It may not be possible to work in all the best sites, but they should at least be explored."

One of today's top practitioners, David McLay Kidd, speaks for the majority: "I think it depends on the site. Sometimes there are par three opportunities screaming at you from the first visit. At the Castle Course at St. Andrews, the eastern end of the site had a crescent-shaped bay higher on one side and 170 yards across. This obvious par three drove the entire layout of the course." Kyle Phillips, Kingsbarns' creator,

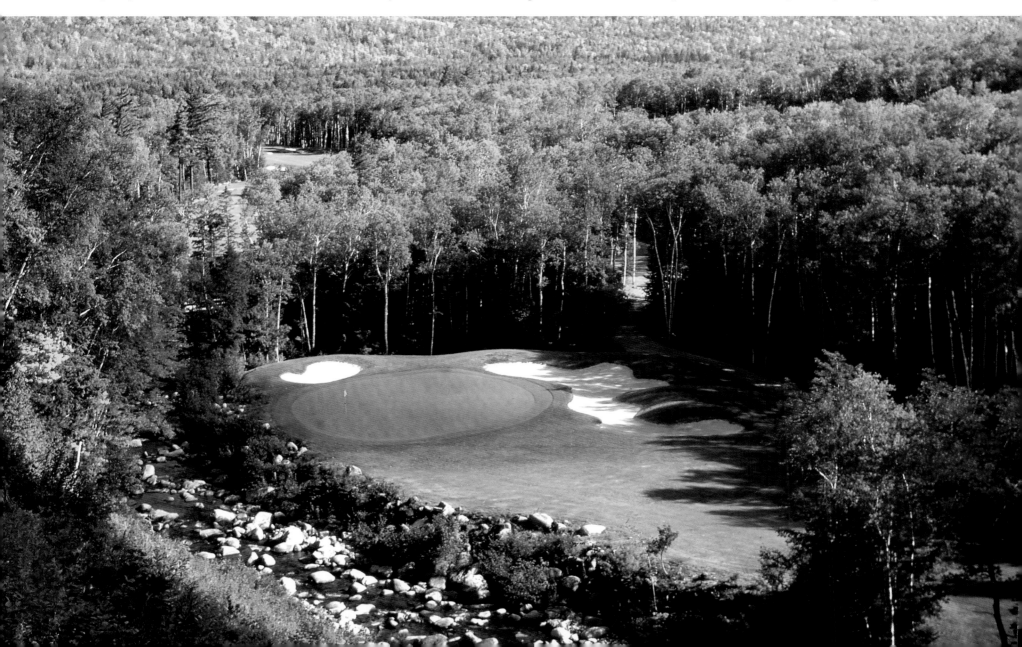

who worked on Sugarloaf Golf Club with Robert Trent Jones, Jr., says the drop-shot eleventh (the signature hole) triggered the routing of the back nine. And Doak's Pacific Dunes found its beginning in the corner of land where he ended up placing the fifth, tenth and eleventh holes — all par threes.

Is the Par Three Simply a Link?

A common routing question is "Should a designer use a par three to get from one point to another?" Rarely do designers use a three as a throwaway hole just to advance the routing. Yet, primarily because it is short and more flexible, they employ it pragmatically as a link between land features. Some applications include avoiding a long walk to the next tee or having to cross a green or fairway, finding a new angle for playing the wind, getting up or down to a different level, and creating a bridge to another piece of property.

Two examples illustrate this last function. After laying out the front nine at Bel-Air Country Club, designers George C. Thomas, Jr., and Billy Bell came to a ravine that prevented them from reaching the land they wanted for the back nine. How to get there? Their answer was to build the famous "Swinging Bridge" 200-yard tenth hole. (They whimsically struck their drives with a putter to prove anyone could get across.) Similarly, at Toronto's National Golf Club, George and Tom Fazio completed nine and reached an impasse. George saw acreage next door and said that would make a great back nine stretch — eleven through fifteen. The site was on a level far below the existing first nine. To get there they built the challenging and memorable par-three tenth with its precipitous drop from tee to green.

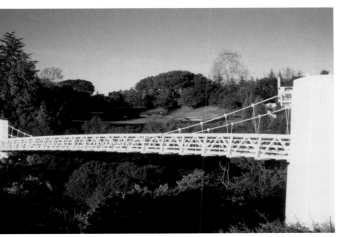

Bel-Air's distinctive Swinging Bridge, linking tee and green at the club's tenth hole.

RIGHT: A ravine must be carried to reach green.

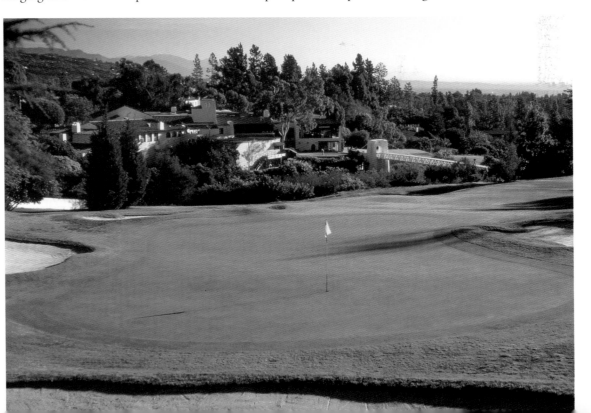

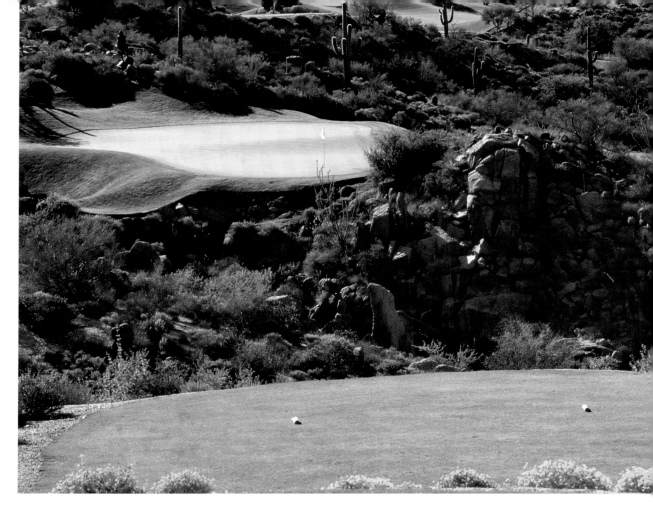

No ordinary par three, the eighteenth at Desert Mountain's Geronimo Course is a rare one-shot closer by Jack Nicklaus.

In practice, designers balance the dictates of the land and their own concepts. Thus you find courses that open with a par three, notable among them Royal Lytham & St. Annes, which is part of the British Open rota. And quite a few courses close with a one-shotter. On making the eighteenth a three, Jack Nicklaus says, "I think it's okay to do a three for an eighteenth, as I did on the Geronimo course at the Golf Club at Desert Mountain. What matters is great atmosphere and if it's a real challenge right in front of the clubhouse, why not? It surely couldn't be an ordinary par three."

Adding Variety in Placement and Length

Nothing is more boring than a course with four threes playing at the same distance in the same direction. So how do architects add variety to their par threes? The mathematical approach is represented by

ABOVE LEFT: Tom Weiskopf always includes one drop-shot par three in his routing mix; RIGHT: Tom Fazio loves to frame his one-shotters for strategic and aesthetic reasons.

Thompson with his charts and Thomas who balanced his holes in proportioned increments of 145, 165, 190 and 220 yards. On the other side, Tom Weiskopf uses a flexible but disciplined approach to vary his short holes. He explains, "They all go in different directions; one is slightly uphill where you can see the green, one level and one drop down (anywhere from 10 to 30 feet); and I like to place the longest and shortest on the same nine."

Tom Fazio asks, "How will par threes be oriented as to the four directions, and how will these shorter holes compare with the longer ones in taking advantage of the prevailing winds and the angles of the sun? A 'short' par three into a stiff prevailing wind can play two or three clubs longer." Fazio loves to frame holes and wields this aesthetic approach to further distinguish his threes.

In the debate about the proper distance for one-shot holes, John Low, runner-up in the 1901 British Amateur and author of *Concerning Golf,* spoke for the less-is-more school: "The short hole should not be long. This seems a simple remark to make, but it is not an unnecessary one, for many short holes are spoilt because of their length . . . I think that the true short hole ought to exact from the player a tee shot which answers to a perfect long approach. The short hole, if it requires a full drive, differs in no way, as far as the tee shot is concerned, from the longer holes, and does not supply that variety which constitutes its 'raison d'être.'"

The famed "Triumvirate" of British golf — Vardon, J. H. Taylor and James Braid — formulated rules

for short holes. In his 1902 book *Taylor on Golf*, Taylor leaned toward keeping short holes short, noting, "For the one-stroke hole 140–150 yards would be best even though a strong driver might get his ball 180 to 200 yards from the tee." Braid concurred that "one of the short holes should demand a good full drive."

Vardon argued both ways: "I call a good short hole one that can be reached by good play at any time with an iron club, because it fails to be a short hole when it is necessary to take wood upon the tee in order to get to the green." However, contradicting his earlier statement about length, he added that if there is a fourth short hole (he thought three enough) it should be about 200 yards, afford a sporting chance and make the player "nerve himself to a superior effort; an occasional strain of this kind is advantageous in the long run . . . on such occasions he would experience more pleasure and satisfaction from this particular tee shot than from any other of the whole round."

Macdonald accented short-game skills, explaining, "Fine short holes and drive-and-pitch holes are

Most designers include one extra-length par-three hole; this is James Braid's eleventh at St. Enodoc Golf Club in Cornwall.

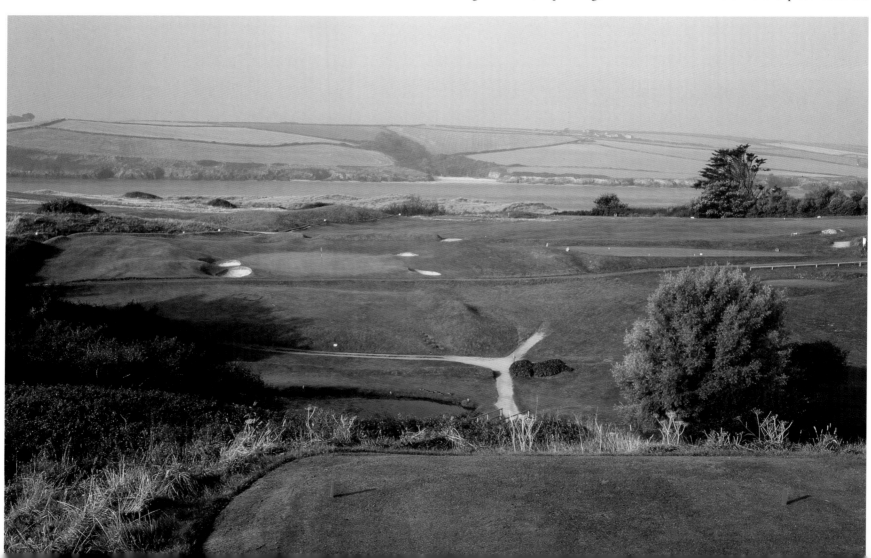

nearly always most interesting to play, for skill is a greater factor here than mere physical power. I am also against the 210- or 220-yard type of short hole, except on rare occasions. This type of hole is rarely interesting. For short holes I like the range of distances from 130 to 180 yards, calling for a mashie iron or spoon — depending on the wind — and not a full shot with a driver or brassie." Nicklaus echoes Macdonald's preference for citing specific club distances as a gauge: "For the most part a par three should be reachable by golfers with a long iron (no fairway woods)." Today's hybrids might be the club of choice on longer par threes.

Putting a finer point on the length of par threes, golf writer Charles Price, with his typical wit and wisdom, speculated, "Worse still, try to explain that par for a hole is determined primarily by its length. That's why the 106-yard seventh at Pebble Beach (a downhill hole) is only a par three. Then why is the (uphill) 225-yard fifth at Pine Valley also a par three?"

When it comes to length, par threes run the gamut from the diminutive 106-yard seventh at Pebble Beach to the extra-long 288-yard eighth hole at Oakmont CC (below).

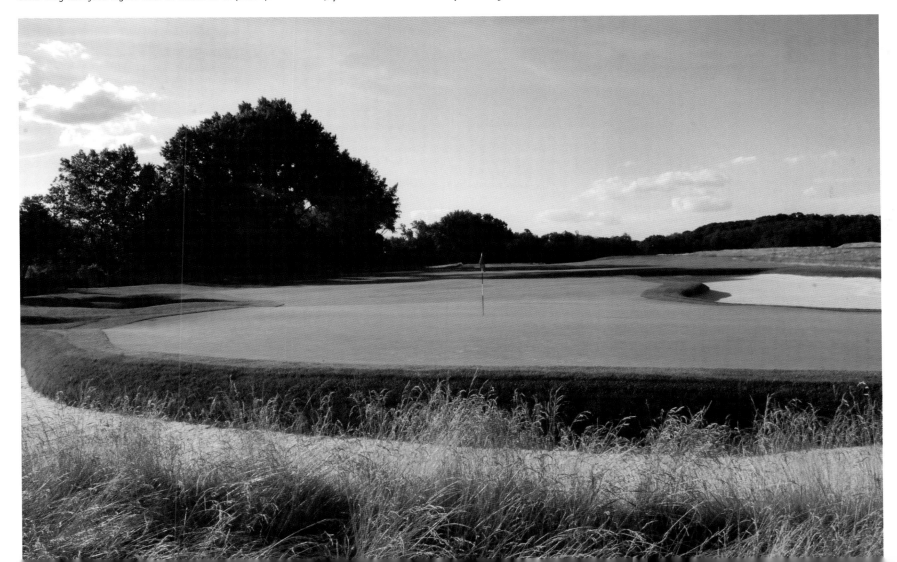

So what's the point of a very long three? Bobby Jones felt there should always be one on a course; its purpose was to challenge pros and better players. As examples, he cited numbers eight and sixteen at Oakmont. Course expert Joe Passov updates Jones's intention when he notes that "once brutish threes like Doral's 246-yard thirteenth are now good pro holes because they have to hit a long iron or hybrid." The USGA took this approach to the max with par threes when it stretched Oakmont's eighth to 288-yards (and for one round to 300 yards) at the 2007 U.S. Open.

It's the short shot though, here defined as anything under 150 yards, that gets designers most enthused. "You have to encourage precision," Nicklaus says. "A short par three can cause all kinds of havoc. Most of the trouble lies in the contradictions going on in the mind of the golfer . . . It's only a nine iron, should be a piece of cake." British golf writer Henry Longhurst recommends "an intriguingly tricky little job of 120 yards to a suitably small green." Universally, designers love to put a wedge in the pros' hands because it often produces a bit of uncertainty, leading to some big scores on shorter holes.

The final pieces of the par-three puzzle are the basic features of every hole — tee, green and all the defenses (hazards like sand and water) standing in the way of a par.

What Makes the Par-Three Tee Shot Special?

The teeing ground at a short hole is similar to that of par fours and fives in providing the player a perfect lie. Unlike the longer holes, and to the delight of average players, it provides a controlled, high-percentage approach to the target. Designers see this as a reason to dictate what kind of tee shot will most successfully get a par, whether this means flying the ball directly to the green or finding alternate routes. On the short holes, they ask more of the first shot.

Designer and course historian Forrest Richardson points out that "the par 3 represents a unique condition. It is the only place in golf where we put golfers within a set area of ground intending them to have to hit a green." Robert Hunter, who worked on Cypress Point with MacKenzie, specifies further, "As the ball can be placed on the tee, and as the distance is accurately known, the shots required at these holes should be more exact than shots of the same length made from the fairway." Weiskopf agrees, saying short holes should demand a lot: "The designer lets the golfer create lie and angle on the teeing ground, giving him a chance at what pros do, or strive for — absolute precision. Each par three has a perfect club and perfect shot built into it."

There is a second aspect to a par-three tee. From it a golfer can, blind shots exempted, see the entire hole and all its challenges. Robert Trent Jones, Sr., used the phrase "full painting" to describe this characteristic: "Every golfer, on a well-conceived par three, can see every aspect of the hole from the tee; the aesthetic balance and juxtaposition of the visual elements, the beauty of the setting, the hazards in play which will affect his shot and the strategy involved in attacking the various pin positions. If the architect

In his "full painting" prescription, Robert Trent Jones, Sr., formulated a succinct guideline for making a great par-three hole.

Great design ideas and techniques bridge generations. The finely sketched fourth hole at New Zealand's Titirangi Golf Club by Alister MacKenzie is echoed in MacKenzie admirer Tom Weiskopf's fourth green complex at Seven Canyons Golf Club in Sedona.

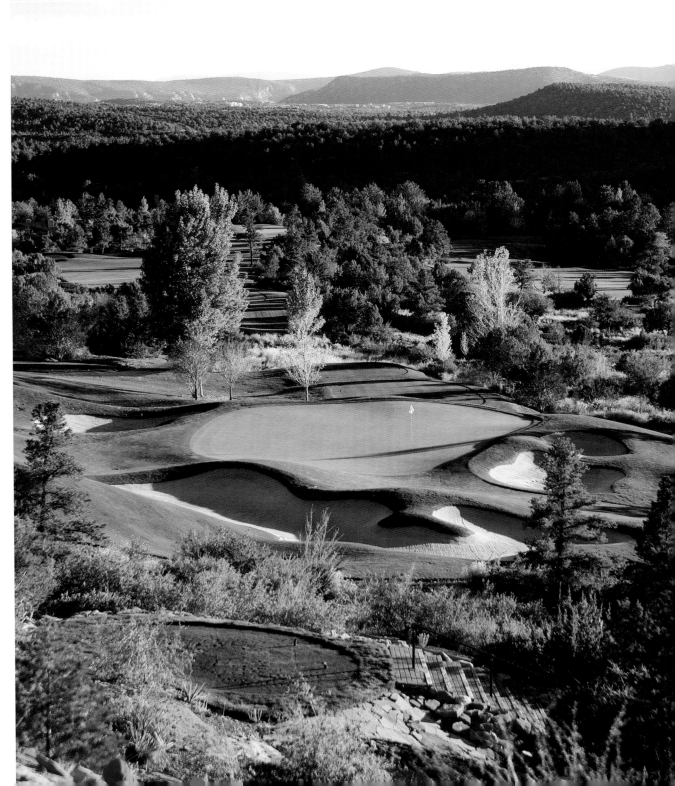

has done his job well, it is this characteristic, i.e., enabling the golfer to take in the entire tableau at a glance, that makes a well-designed par three special among the other holes." It's easy to see why so many par threes end up as the signature hole used to market an entire course. It's not a new idea. Even the great MacKenzie was known to use a single, beautifully realized par three as a sales tool to sell memberships in a club.

Another observation on the par-three tee: The use of the multiple tee has changed the configuration of all golf holes. This is most pronounced at the short holes, which often have four to six tee positions that create different angles and challenges. This way every golfer has a shot at the green.

Defenses on the Tee

Since the player has a perfect lie and is making a direct approach to the green without having to hit two or three shots (or more) to get there, it figures the architect will defend the target vigorously. What are some of the ways he does this?

First, elevation changes are a common technique. Writing in the late nineteenth century, British Open champion Willie Park, Jr., favored a bit of an uphill bias on short holes. Working in the 1930s at Prairie Dunes Country Club, Perry Maxwell had all four short holes going uphill, sometimes as much as fifteen feet. The old-time blind holes are uphill and downhill shots.

The majority of threes do play level or downhill. During the 1920s and 1930s the downhill, or drop shot, became more popular. A. W. Tillinghast, who worked during this Golden Age, loved finding ravines and drop-offs to create demanding drop-shot threes. Taken to new heights in mountain and cliffside settings, the distance has reached 100 to 150 feet. The long drop shot is one of golf's hardest: the golfer must accurately calculate distance plus vertical drop to land the ball on the green; or, as is often the result, come up short. Another reason designers like drop-shot holes is their aesthetic value. They offer many of the most spectacular vistas in the game.

Second, designers put an intimidating hazard right in front of the tee. The most dangerous is water. Favored are a pond or coastal cove, which can stretch all the way from tee box to the edge of the green. The distance to be cleared can be a deft pitch of 130 to 150 yards (doable for most, but not always easy when confronting a closely guarded target), or a longer shot of 175 to 200 yards to reach land. The most difficult form of this challenge is the shot to an island green set in water or surrounded by sand. The first well-known par three of this type was designed by Herbert Strong in 1928 at Ponte Vedra Inn & Golf Club. Strong's version was fair, with plenty of bailout room around the green. Fifty years later the form evolved to its ultimate expression when Pete Dye created the give-no-quarter island target at TPC Sawgrass seventeen. Variations in design and difficulty abound.

Third, designers defend with sand. Courses like Jupiter Hills, Sand Hills and Pine Valley carpet the tee-to-green area with various forms of sand hazards that cause difficult recoveries. Oakmont's eighth, in addition to its length of 288 yards, hems the left side of the hole with a 100-yard bunker named Sahara.

Or, look at Pete Dye's huge strip bunker guarding the seventeenth at Harbour Town. No longer used much, the cross-bunker, as wide as a fairway or green, was another effective stopper.

When it comes to defending a par-three green, smaller, well-placed bunkers rule. St. Andrews eleventh is the template, with three bunkers, each offering a different punishment. Citing the eleventh, Longhurst prescribes that "short hole bunkers should abound. They should be so numerous and so fearful in aspect that the player delivers his tee shot almost without hope of escape. These should be close to the hole, so that great daring is required if the shot is to be perfect."

If the architect wants to add another defensive dimension, he makes the golfer hit a longer tee shot, labeled the forced carry. Designers known for building really tough courses use it frequently on par-three

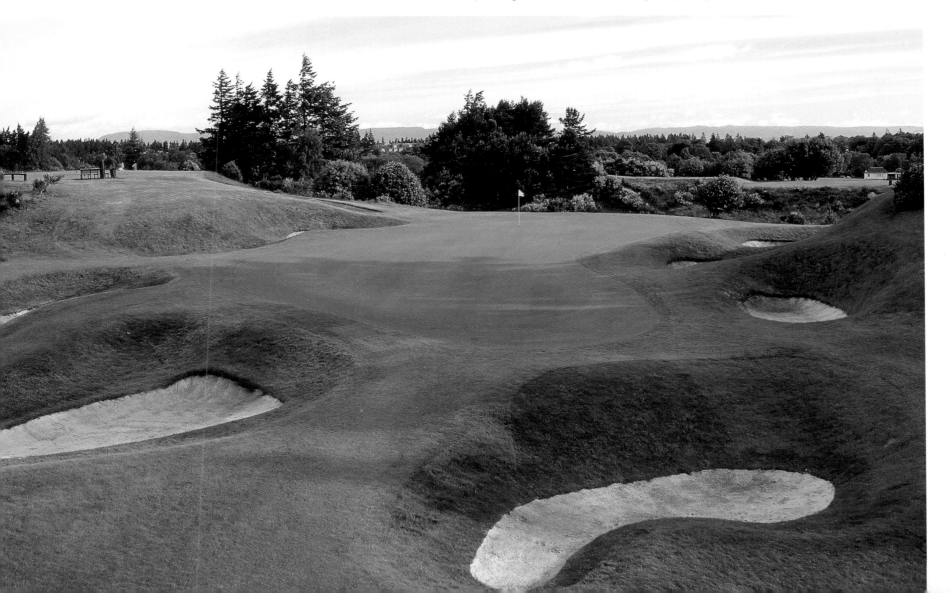

British Open champion and course designer James Braid's sixteenth hole at Gleneagles' Kings Course, with its *nine* bunkers, illustrates the principle that short holes should challenge the golfer with multiple defenses.

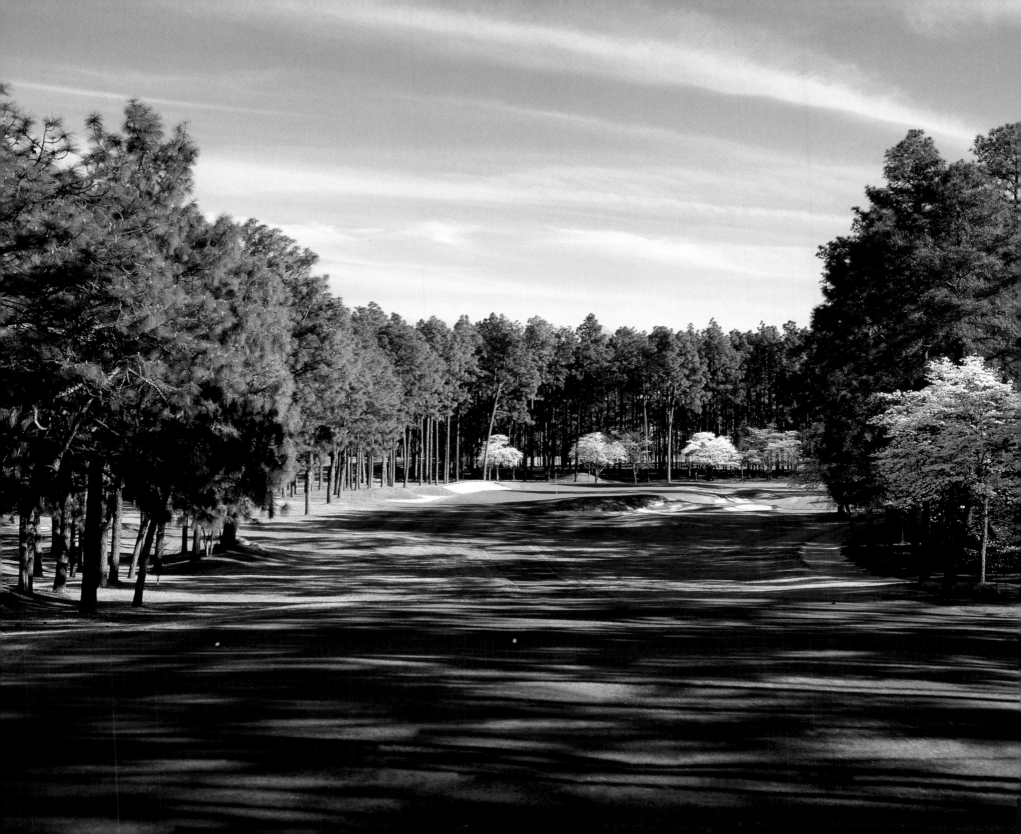

holes. Thomas, creator of the demanding Riviera Country Club, made sure there was at least one forced-carry par three on all of his courses. His famous fourth at Riviera, a par-three Redan, requires a 230 to 240 yard shot to the green.

Thinking Carefully on the Par-Three Tee

Generally, most designers are reasonable and offer alternate ways to reach a par-three green. But it is essential to take a moment and analyze the hole to find where they are directing you. Famed British golf writer Bernard Darwin said it well: "The architect meant them to play it one way and they were resolved to play it another . . . full spoon, full bang, almost impossible to stop . . . wilderness in back, etc. They failed to see he had carefully designed a little place of safety, short and rather to the right, and he meant people to play an iron shot to this plateau and thence a run-up to the green, with a more or less certain four and the hope of a three." MacKenzie was particularly solicitous about leaving an opening, but demanded a "perfectly steered running approach" to reach the green. The majority of threes have such bailout areas, but it is fascinating how few golfers avail themselves of these avenues to a good score.

This emphasizes why the short hole should make a golfer think even more carefully, especially about what club to use for the first shot. The par three, unlike the fours and fives, allows using every club in the bag — putter to driver — to reach the target. Players have even used a putter to reach the green at St. Andrews' eleventh and Pebble Beach's seventh. As designers vary the distances from 120 yards to 250-plus, the three becomes a continuing adventure in club selection. Macdonald crystallizes this challenge, noting, "On the tee at the short hole the player should have to look well at his bag of clubs and make his choice with care. . . . To my mind the best length for a short hole is one of those lengths which is not in the ordinary run of shots, something which is not quite a cleek shot, or, again, a distance just outside a full mashie. What is essential is that the tee shot should be one that makes the player think — a stroke, in short, which requires Deliberation, spelt with a big D."

Defending the Short-Hole Green

The architect's biggest defense is the green and the green complex. The first decision involves establishing how big the green should be in relation to the length of the hole. Standard practice usually prevails: The shorter the shot, the smaller and tougher the green, including all the bunkers mentioned above. Nicklaus explains, "On a long hole, we build an easier green complex and more options; with shorter holes, we make the golfer go right at the pin or 'play the hole as it is.' As the hole gets longer, you have to create more outs, more options and variety. If the hole is really long, you have to be really fair." Thomas formulated very specific dimensions for greens depending on length of shot: 125 x 100 feet for a full wood shot, 80 x 65 feet for 140 yards, 75 x 60 feet for 125 to 140 yards, and so on.

ABOVE: Bill Coore (left) and Ben Crenshaw bring classical touches to their select portfolio of course designs.

OPPOSITE: The seventeenth at Pinehurst Resort's No. 2 Course is framed with brilliant stands of southern pines and dogwoods.

In *Anatomy of a Golf Course*, architect Doak writes, "A small green site surrounded by trouble is best suited to a par three, since the length of the approach is controlled and the player is guaranteed a reasonable lie for his approach." He then quotes H. N. Wethered and Tom Simpson who add, "but reduce the dimension of the target and give it a slightly unusual or unexpected shape, and the chances are that the ball will not be laid within twice the distance from the pin."

A master of the complex green, Donald Ross followed the accepted practice of designing less undulating greens for the long par-three and par-four holes, and smaller targets for the par-five holes and the shorter threes and fours. On the other hand, if there is anyone who knew how to make a green repel a shot, it was Ross. He explains, "In the design of the shorter holes designated for irons and chip shots, the Pinehurst conditions offered a really exceptional opportunity . . . the rolling hollows and contours . . . this contouring around a green makes possible an infinite variety in the requirements for short shots that no other form of hazard can call for."

MacKenzie's green complexes show similar sophistication. As a profile of him explains, "In addition to the features he gave to the bunkers and the putting surfaces, MacKenzie did contour work around the greens as well, creating little mounds and moguls and hollows. The reasons for this were both to add interest to greenside play and to 'tie in' the edge of the green to the natural contours around it. Sometimes MacKenzie really made a statement. At Sitwell Park on a 140-yard par three he built a putting surface that fell off more than 10 feet from back to front in several distinct levels."

Asked to comment, as many have for this book, all course architects give the short hole its due but some have shown a special predilection for the "tiny tims."

The coiner of that nickname, A. W. Tillinghast, wrote, "A really good natural par three is a treasure of design and should not be passed up." In his gold-standard article on Tillinghast, Frank Hannigan noted, "On the other hand he was at his best as a designer of par threes. In fact, he made no bones about saying that the par threes were the keystones of his overall designs. Such a viewpoint helps to explain why the two most celebrated Tillinghast holes, the tenth on the West Course at Winged Foot and the fourth of the Lower Course at Baltusrol, are sure to appear on lists of outstanding American holes."

Design historian Geoff Shackelford documents Tillinghast's belief in the micro side of golf: "Tillinghast was also the proud innovator of the 'Lilliput Links,' for which he received a patent in 1916. The 'Lilliput' concept was a pitch-and-putt course designed for short game practice on sites not large enough for full-length courses."

In our estimation, two designers, one from the Golden Age and a contemporary who cherishes the style of that era, deserve special recognition when it comes to the par three.

Thomas, very much influenced by Tillinghast, seems to have possessed the most affection for par threes. He even took time to author a succinct essay titled, "The Theory and Architecture of the One-Shot Hole"

On the Pacifico Golf Course at Punta Mita in Mexico: Breaking molds, Jack Nicklaus offers golfers two options at the one-shot third hole; dubbed "3-B," this longer version plays to the world's only natural island green, named "Tail of the Whale."

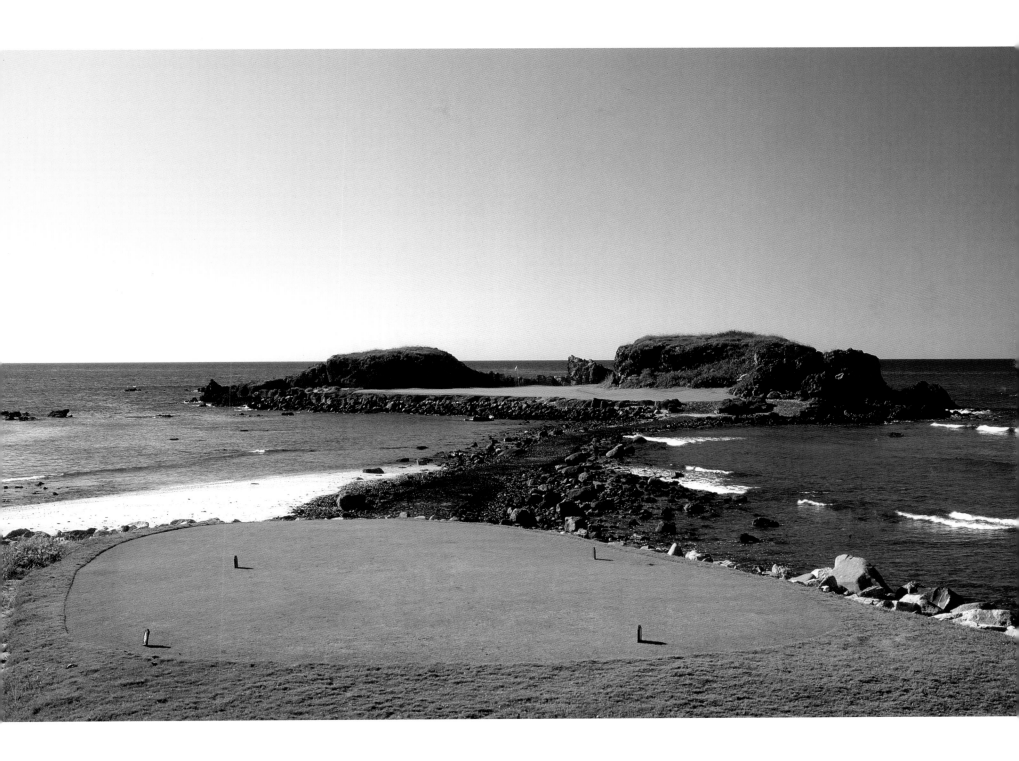

(*Game and Gossip Magazine*, January 1932). Its high points include these thoughts, which echo the ideas of other architects quoted above: "The pre-arranged position of the tee shot demands more exactness and interest in the initial effort on such a hole; existing hazards are utilized with less fear of complications, because of the ability to plan the start; five splendid one-shot greens are not too many. Imagine the distinction of portraying five nearly perfect three pars; one-shotters must give a radical change in length and class of shot to the holes preceding and following."

Thomas wanted to see more "two-way holes," like his original design for the par-three eleventh at Los Angeles Country Club's North Course. This played as a short and long three or as a short par four. He also pushed for more short-hole practice courses. If there is a patron saint for the short hole and short layouts, it's Thomas.

Masters champion Ben Crenshaw is one of the pre-eminent authorities on the history and traditions of golf. He brings this sensibility to the select course commissions he and partner Bill Coore accept and is admired, along with an emerging cadre of designers, for reaffirming classical elements in contemporary design. Like Thomas, Crenshaw is a devotee of the short hole in particular and author of "The Short Par 3," the name of a fittingly brief statement he penned. One line sums up why regular players love the wee holes: "This type of hole is a thrill for everyone, and usually elicits high drama for the tangible possibilities of scoring '2' — and anything upwards. Par threes of this type call for proper execution, nerve and bravery."

Whither the short hole in the twenty-first century? One trend is toward length. Contemporary thinking, abetted by equipment technology, is that for the par three to challenge the best players, it must play between 250 and 300 yards. Some of these holes are built with tournaments in mind; as an example, The Pete Dye Course at the French Lick Resort (2009) has a 301-yard tee at the sixteenth hole. Dye states clearly that "We've go to do something to challenge the pros. Their skill sets combined with equipment advances have changed the nature of shotmaking, and this definitely includes the par threes." Ironically, as mega-threes multiply, there is a move toward building more "drivable par fours," usually playing between 300 and 350 yards. In effect, the long three and short four are overlapping.

The par three is benefiting from a growing willingness by architects to break molds and pursue innovative course design; we need only look to Nicklaus's third at Punta Mita, with its "3-A" and "3-B" options for a great example. (See our list of "Outside the Box" holes in "Reflection.")

Summing up, the evolution of the one-shot hole mirrors the conundrums found in golf's many settings, ranging from the brusque beauty of St. Andrews' Eden and Pine Valley's tenth, through the sylvan calm of Augusta National's back nine threes to the majestic ocean carry at Cypress's sixteenth. On each tee, the architects offer us the opportunity to meld vision and ability with a single swing and either achieve perfection — or, barring that, at least a birdie or par.

"These holes possess an extraordinary shot value set off by impressive hazards and stern green contouring which makes the effective target even smaller; and, the length of these holes, God forbid, should be in everyone's range!"

— BEN CRENSHAW, "THE SHORT PAR 3"

We would like to say that all the holes chosen for our collection were within everyone's range. Most are and by using the right tees you give yourself good odds of getting home in one or setting up a chip-and-one-putt par. But regardless of skill level, anyone can delight in these holes' dramatic profiles and design challenges.

Rather than attempt the standard rating and ranking, it seemed to us more interesting and enlightening to arrange our "Finest 100" in groups that illustrate a dominant feature, either geographic or design-inspired. We begin with links holes, since linksland was the ground for the two oldest extant par threes — numbers eight and eleven at St. Andrews' Old Course. We conclude with some of the short and short-short threes, which demonstrate consistently that wee holes yield more to skill than strength. In between we showcase exceptional threes in categories such as Coastal, Inland, Drop Shot, Island and Peninsula, Sand and Dune, Rock and Chasm, Blind, Pond, Redan and Biarritz — proof that the auld game's threes share a wide array of dominant characteristics.

Our criteria for inclusion in the "Finest 100" are numerous: shot value, dramatic setting, integration into the landscape, balanced challenges for low and high handicappers, superior execution of a particular design concept, the work of distinguished architects (who sometimes identify their "personal best" par three), imaginative flair, the hole's role in golf history, consensus among golf writers and course experts, reputation (a course's signature hole), and of course, making you want to play it again, and again.

In the main, our finest holes include many of these characteristics, especially those that comprise our "Ultimate 18-Hole Par-Three Course."

Located on California's Monterey Bay, the fourth at Spanish Bay is a connoisseur's delight — an elegant par three presenting a large undulating green set among high dunes and Monterey Pines.

A note on these profiles: Our primary purpose is to combine history, commentary from designers and experts, anecdotes, statistics and playing features into a balanced profile complemented by a photograph. As to the essential facts, we list all designers who influenced the course or hole, indicate when courses were opened (and re-opened if they were radically re-designed), and list the distance range (from the back tee to the front tee, sourced from the club scorecard).

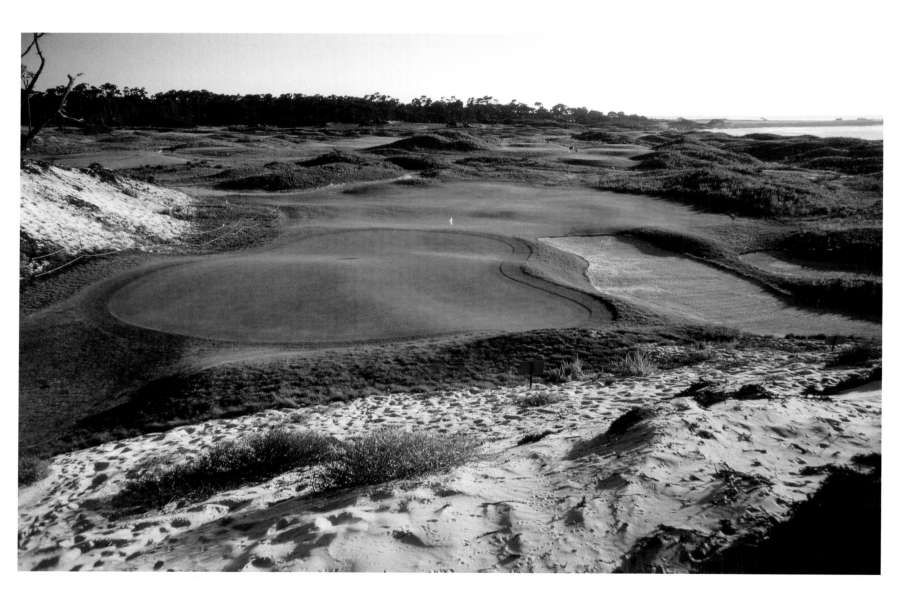

LINKS HOLES

One of golf's most misused terms is "links." For some, it's slang for any golf course; it is also confused with "seaside" or "coastal" courses. In fact, there are more than 240 links courses in the entire world and three-quarters of those are in Scotland, England and Ireland.

The true definition says they are laid out on land left when the sea receded, leaving vegetation such as marram grass and gorse. Other distinguishing marks include sandy soil that drains easily, uneven terrain, the presence of sandy depressions, bunkers and small streams (called burns) — all common strategic hazards on links. In our book, all links courses have the sea nearby, eliminating what are termed "inland links."

Linksland is not good for cultivation, but it did offer a field of play for the game of golf evolving in the sixteenth and seventeenth centuries along the coastlines of Scotland, Ireland and England. There was, and is, only so much real links property to go around. Here and there contemporary developers have discovered untouched links ground at places like Bandon Dunes Golf Resort in Oregon, Barnbougle Dunes in Tasmania, Kingsbarns near St. Andrews and Doonbeg Golf Club on the coast of Ireland.

Links golf plays fast and firm, has an uneven quality about its bounces, and can be changed dramatically by the nearby seaside winds. It is rough and natural golf and still considered the original form of the game. Following are some great links and their finest par threes, starting with one of the oldest extant one-shot holes.

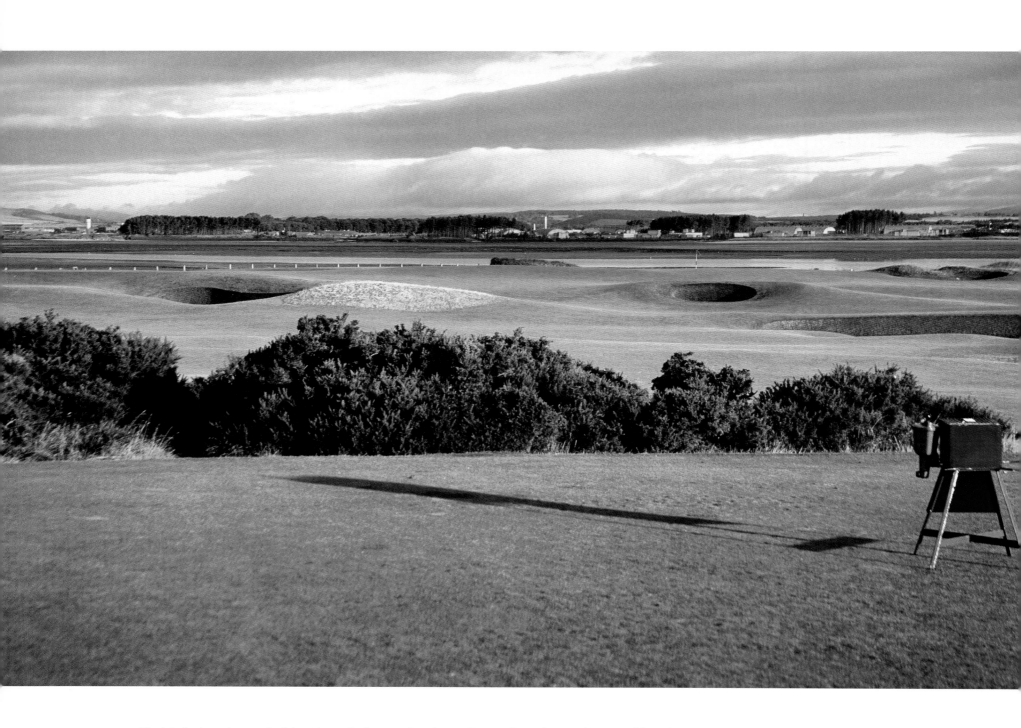

"I think the eleventh (the short hole coming in at St. Andrews) may be considered one of the ideal holes of the world."

—— ALISTER MACKENZIE

Old Course at St. Andrews

Length: 174–150 yards

Designers: Unknown/Allan Robertson and Old Tom Morris

Opened: Unknown

Location: St. Andrews, Fife, Scotland

The modern par three is often a meticulous affair, manicured and tame. It wasn't always so as evidenced by St. Andrews' eleventh, which is set on a sand ridge abutting the Eden estuary of the North Sea. Centuries of howling winds have etched its crest and forced grazing sheep to burrow into slight indentations that have become infamous bunkers.

The eleventh (named "High (in)," but better known as "Eden") and the eighth are the two oldest extant one-shot holes. They are also the only one-shotters on the world's first course. Does that mean the Scots who laid it out were biased against what would become today's par three? If so, they compensated with quality.

Eleven has been called "the most deadly short hole in the world." It is definitely a candidate for the Penal School of Design Hall of Fame. For example, Gene Sarazen took three shots to get out of the Hill bunker, losing the 1933 Open by two strokes; Bobby Jones infamously picked up and left the course finishing with a six; Frenchman Arnaud Massy also made six, costing him the 1910 championship. Canadian golf writer Lorne Rubenstein humorously suggested renaming the eleventh to read, "If I Put the Ball in Strath Bunker One More Time I'll Give Up This %*&%@ Game." Echoing this, England's Bernard Darwin (grandson of Charles Darwin) said, "This may sound pusillanimous, but trouble once begun at this hole may never come to an end till the card is torn into a thousand fragments."

As one observer accurately points out, "This is the most clearly defined target on the course, yet also the most clearly and powerfully defended." Advice abounds on how to play it. A summary would read: Be conservative and get ready to endure some pain.

Club selection runs from a Phil Mickelson eight iron to a wood club. Exposed as it is, St. Andrews always has some wind, and this must be reckoned accurately. Beware of the false fronts that make distance appear shorter. You must land your ball just so. Too much means going over and into the grassy depression, which is a bad place to be; too little means being in the area short of the green that is carefully contoured to gather shots into the Hill or Strath bunkers. The larger Shell bunker lies short and right to complete the defense.

Ah, the Strath. This is the centerpiece hazard, deep, some eight feet, and sitting like a bull's-eye front and center of the green. Designer Robert Trent Jones, Jr., aptly called it a "sod-revetted hell." It multiplies recovery shots; hitting back to the fairway is often the smart play.

The green slopes from back to front and measures about 70 to 80 feet deep. It harbors more surface complexities than you might expect; for example, sidehill putts require a big borrow. Ideally, you want to land under the hole, but this can be difficult because the pin is frequently cut near the Strath.

There is one last way to play the hole, disdained by many: run the ball up through an opening to the green with a chipping iron or putter. Only the adventurous try this.

We'll let MacKenzie have the final word on the eleventh: "Under certain conditions it is extremely difficult for even the best player that ever breathed, especially if he is attempting to get a two, but at the same time the inferior player may get a four if he plays his game exceptionally well."

Old Course at Ballybunion Golf Club

Length: 214–165 yards

Designers: James McKenna/Tom Simpson and Molly Gourlay

Opened: 1893/1927

Location: County Kerry, Munster, Ireland

"A man would think the game of golf began here. There appears to be no man-made influence. It looks like a course as it was laid out in the tenth century." — TOM WATSON, FIVE-TIME BRITISH OPEN CHAMPION

When Tom Watson first played Ballybunion in 1981, his fulsome praise for the course buttressed that of the eminent Herbert Warren Wind, who, in 1971 wrote unequivocally, "Very simply, Ballybunion revealed itself to be nothing less than the finest seaside course I have ever seen." Many also insist that if you took the best eighteen holes from both Ballybunion courses, Old and New (Cashen), it would be the finest links circuit ever.

Thus, choosing from among Ballybunion Old's five par threes — numbers three, eight, twelve, fourteen and fifteen — can prove difficult. Even Watson has a hard time picking a favorite: "The short eighth is one of the most unsung par threes in golf . . . downhill to a narrow sloping green . . . if one misses the green a very tough par. While many pick the fifteenth for its beauty and length, my choice would be the twelfth. One tough uphill shot: if you're short, you'll roll down the hill; go right and you are thirty feet below the green. It's the most challenging hole on the course."

Ballybunion Old's twelfth is the quintessential hit-and-hope hole. With an uphill rise of about ten feet, it requires a carry of 170 to 200 yards. If the prevailing wind (from the left off the ocean) is up, it can knock your shot offline as you try to go between large sandhills to an ample plateau surrounded by severe drop-offs that make recovery extremely difficult.

As Watson emphasizes, you must get there or you will slide off the green down the slope. If a great three is judged by how well you gauge the length of your tee shot, Ballybunion Old's number twelve ranks very high.

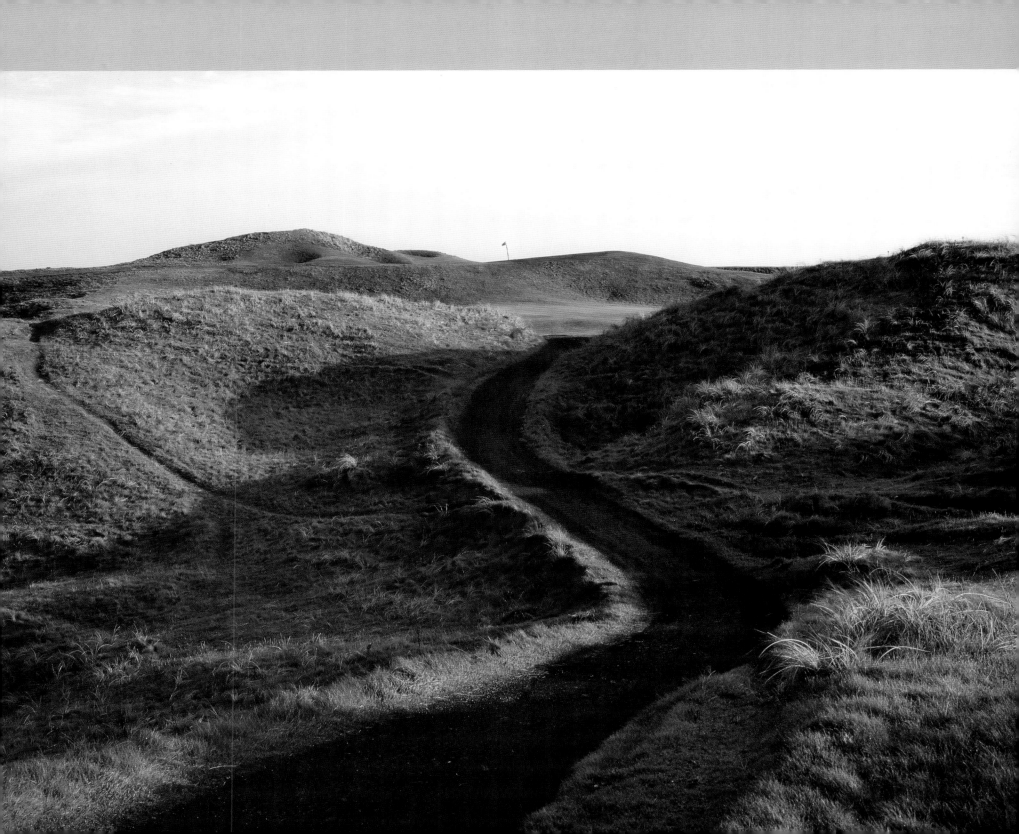

#10

Pacific Dunes Course at Bandon Dunes Golf Resort

Length: 206–129 yards

Designer: Tom Doak

Opened: 2001

Location: Bandon, Oregon, USA

"What fascinates many who come to Pacific Dunes is Doak's utmost concern for clarity and detail . . . the sheer connection between nature and golf is surreal."
— *World Atlas of Golf*

Having seen Pacific Dunes for the first time and finished reading all the rave reviews, one is put in mind of the actor who said, "It only took me twenty-five years to become an overnight success." Since its debut in 2001, Pacific Dunes has gotten almost unanimous praise (all deserved), moved to the top of course rating charts and even fetches comparisons to Pine Valley. Two factors explain Pacific Dunes' precocity. The site is a unique melding of Old Course linksland with the dramatic headlands of the Oregon Coast. Tom Doak brought years of analyzing the world's courses along with apprenticing under Pete Dye to this masterful creation.

A traditionalist and unabashed fan of the Classical School (Alister MacKenzie in particular), Doak has some of the contrarian about him. His homage to MacKenzie is his placement of consecutive par threes at ten and eleven, à la Cypress Point's

fifteen and sixteen. And in another non-formulaic twist he built a total of five par-three holes, with four of them on the back nine. Choosing among them is difficult. Eleven is a lovely short hole at 148 yards, and seventeen is Doak's take on the Redan.

Our choice is the tenth as one of the most intelligent par-three designs we've seen. However, your experience here depends on how you play the ninth, and this turns on which of its two greens (upper and lower) the club has chosen for the day (a sign on the tee indicates which one you play).

Ten from the upper tee, about 30 to 40 feet above green level, offers a more dramatic view of the postcard elements that give the course its name — the Pacific Ocean and dunes. Our preference is the lower tee. Here, you are hitting from approximately green level and the tee box is enveloped in dune grass and soft mounds. Sizing up the target

means pinpointing where fairway and the small kidney-shaped green meet, and taking note of the thick rough and mounding covered with scrub and marram grass.

The biggest challenge, as it is on all eighteen holes, is gauging the wind, which vacillates from zephyrs to stormy blasts. Prevailing currents are off the ocean, which at ten means head on. If you can't fly the ball all the way, just land it short and chip on for a one-putt par or commendable bogey. Be warned though that the rear portion of the green runs away back right.

All in all, Pacific Dunes' tenth, like the course itself, weds traditional design elements with a perfectly natural setting, allowing you a rare chance to experience golf as it was originally played.

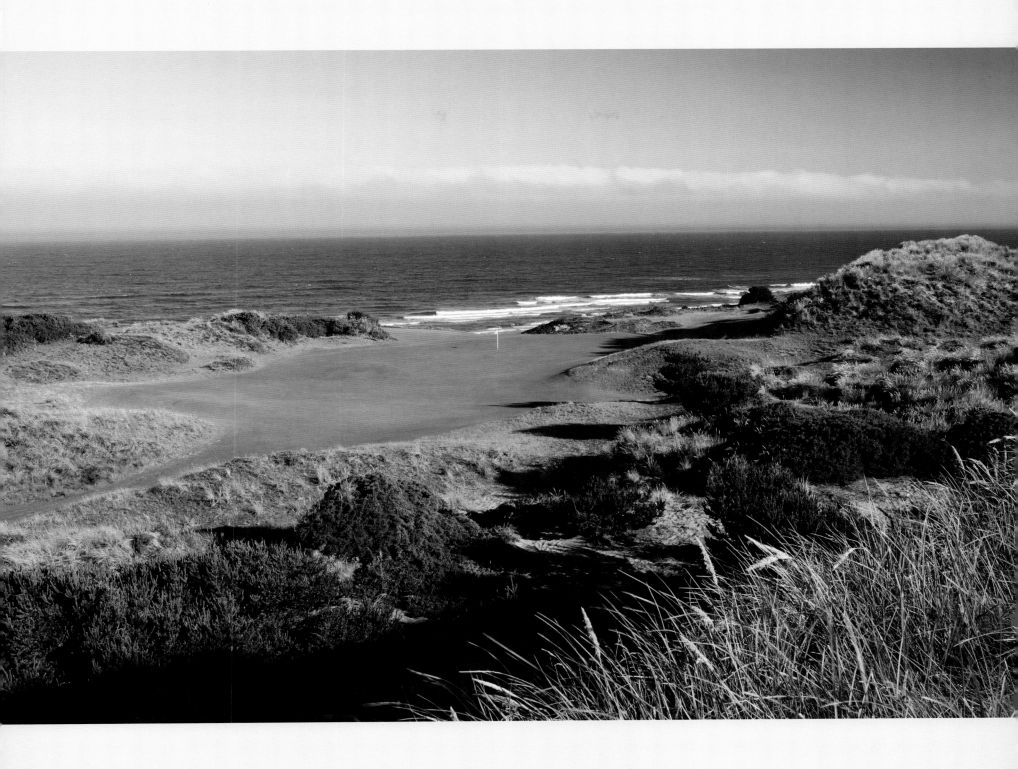

"If you are plugged, you can send out for drinks and a sandwich — you may well be in there the rest of the day."

—— CLUB MEMBER ON THE FRONT LEFT BUNKER AT MUIRFIELD'S THIRTEENTH HOLE

#13

Muirfield

Length: 191–133 yards

Designers: Old Tom Morris/Harry S. Colt and Tom Simpson

Opened: 1744 (Club)/1891 and 1928 (Course)

Location: Gullane, East Lothian, Scotland

While lying not far from the Firth of Forth, Muirfield doesn't exactly mimic the dramatic sweep of dunesland and rugged contours that characterize many seaside courses. Hemmed in on three sides by its famous Greywalls and laid out in two loops that make wind direction a constantly changing adventure, it is generally described as fair. Add that there are no trees, water or huge carries, and one wonders what makes it tough.

Muirfield's primary defenses are its undulating greens that would make a template for the wildest roller-coaster rides, and its, count them, more than 160 bunkers, described by a British golf writer as "subtle, devious, menacing and often quite penal." Architect Tom Doak defines them accurately: "Muirfield's bunkering, penal though it may be in its extractions for errant play, is essentially strategic in concept." This is especially true on Muirfield's

fine threes, and number thirteen is exemplary for what it demands in green play and bunker recovery.

Having played number twelve going south, you now reverse course and are hitting into a prevailing wind that quarters from the left. Your shot is uphill, almost 15 feet. If you want to try your bump-and-run skills you can actually hit a low shot into the green. When the pin is back, you will definitely have to fly the ball, but you are excused from worrying about the five bunkers that are clustered around the front, two left and three right. As advertised, they are deep, built with steep turf walls, and totally unpredictable when it comes to what kind of stance and lie you face. For the 2002 British Open, thirteen was lengthened some 30 yards to make it a harder target and assure the bunkers would be in play. Thus strengthened, it proved the toughest of the par threes.

The green is narrow and long (45 feet wide by 120 feet long), which translates into a two-club difference front to back. It slopes sharply from back to front. The story is told that on his way to winning the 1929 British Open, Walter Hagen played into the bunkers, "preferring an uphill shot from the sand rather than a long slippery downhill putt."

Arriving at the green you will discover the subtle contours architects Harry S. Colt and Tom Simpson engineered when they redid the hole in 1928. Barring some miracle second shot, making a conventional par requires your tee ball to: 1) get close enough to the pin for two-putts and 2) stay below the hole to avoid the dreaded slick, downhill putt. Of course, if you do find a bunker, lunch is always available.

Royal Birkdale Golf Club

Length: 183–145 yards

Designers: George Low/Fred Hawtree and J. H. Taylor/Martin Hawtree

Opened: 1897/1931

Location: Southport, Merseyside, England

"The ground is so thick with gorse, whin, bracken and broom that a team of Englishmen weed whackers would have trouble recovering a missing ball. This is truly rough rough."

— AUTHOR LORNE RUBENSTEIN
ON BIRKDALE'S TWELFTH

Championship courses are known for their formidable finishing stretches usually running from the fifteenth to the eighteenth hole. Royal Birkdale may have the longest in the world because "the treacherous road for home" begins with the 498-yard par-four thirteenth, followed by five equally demanding tests. The delightful prelude to this run is the twelfth hole that Tom Watson called his favorite par three in golf.

Royal Birkdale owes its character to the original designer, George Low, who routed the course in and around high sandhills covered with buckthorn and willow scrub. However, it was in preparation for the 1965 Open that the current twelfth was built — a new hole by Martin Hawtree and nestled in dunes closer to the ocean.

When one arrives at twelve, which runs parallel to the beach, it seems almost aloof in its solitary setting framed by a moonscape of linksland. Reaching the tee, there is a purity of isolation as though this round of golf is yours and yours alone.

How do you play the hole? It would not be classified as tough, but like all links courses, one must be straight. The dunes define your target — a narrow raised green nestled among penal tussocks. Four pot bunkers, two on a slope falling away and two tight to the front, await balls that miss the putting surface. Your shot is from a raised tee over a hollow and the carry is at least 170 yards to the front edge. The entire setup makes the green look smaller and the shot harder. When winds blow, nearby waves resemble "white horses kicking and rearing their heads in the Irish Sea," as they did at the gale-struck 1961 Open Championship where Arnold Palmer's stirring victory renewed the stature of the tournament among Grand Slam events.

To ensure the course ranks in Great Britain's top 10, the Royal Birkdale membership has seen to its proper evolution. In 1931 J. H. Taylor, winner of five Opens, was hired to do a redesign. And in 1991 with the help of Martin Hawtree the club had all the greens dug and re-laid, so, you can hit with bold confidence knowing twelve's green will take a well-struck shot. It's a hole one might enjoy three or four times running, as if you were playing on your own private course.

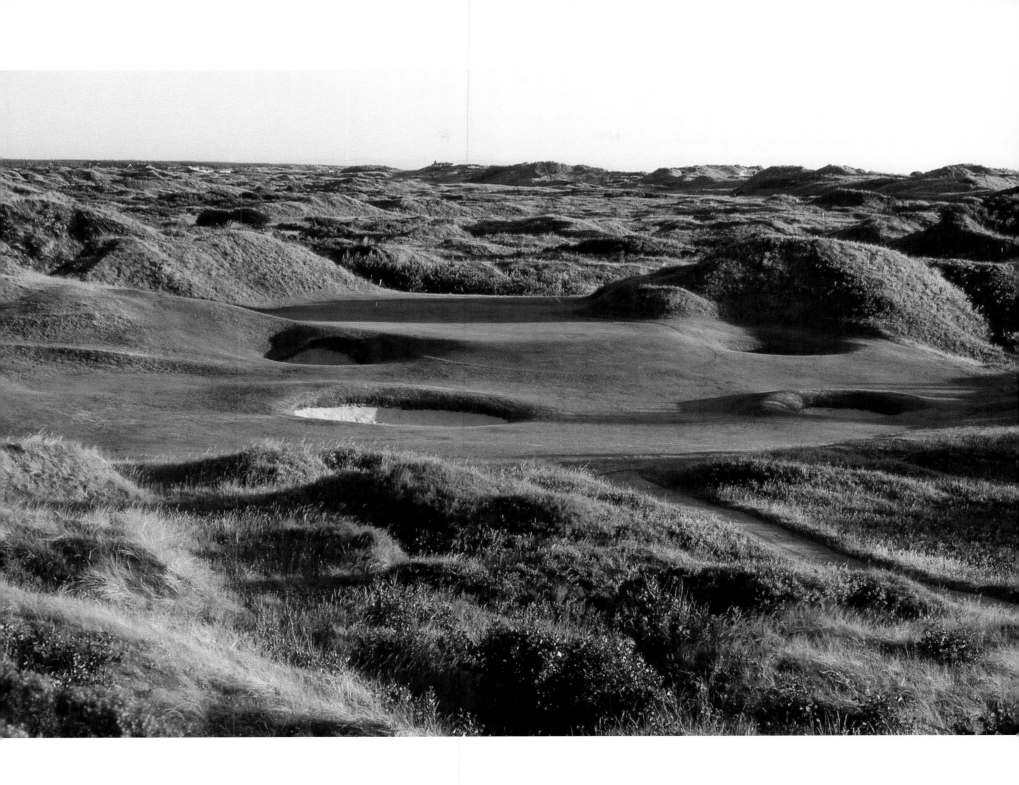

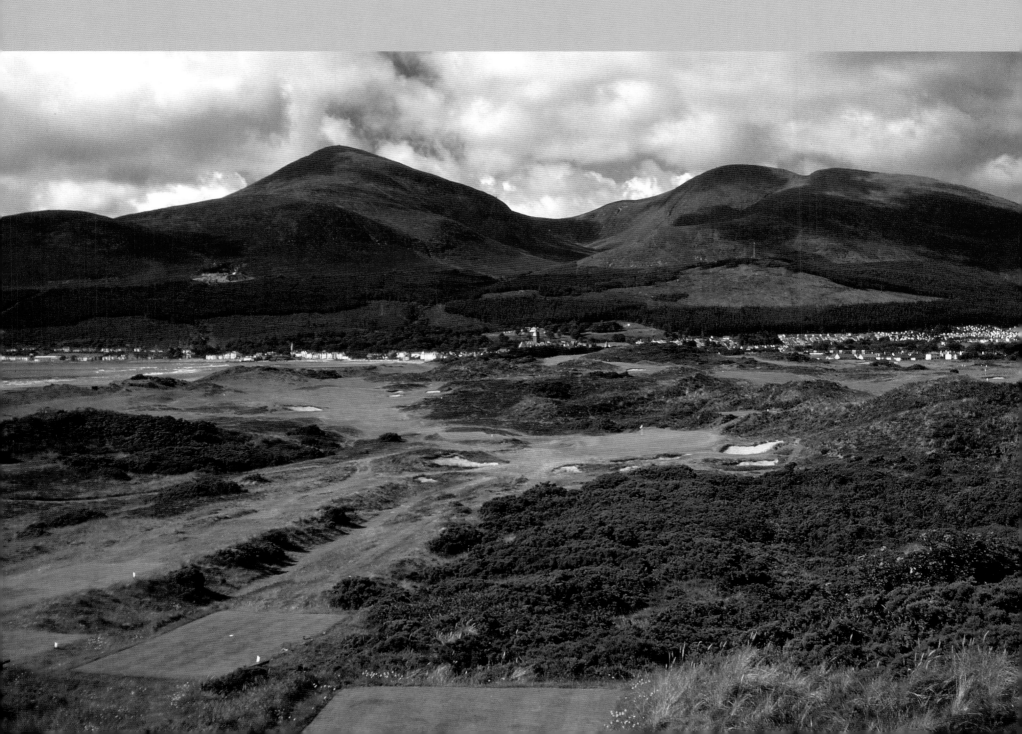

"The kind of golf people play in their ecstatic dreams." — BERNARD DARWIN ON THE LINKS AT ROYAL COUNTY DOWN

#4

Championship Links at Royal County Down Golf Club

Length: 212–159 yards

Designers: Old Tom Morris/George Combe/Harry S. Colt

Opened: 1889

Location: Newcastle, County Down, Northern Ireland

In 1889 some parsimonious Irish members hired Old Tom Morris to lay out eighteen holes at their new club. In return for four meager pounds, he worked two frugal Scottish days and bequeathed Ireland one of its greatest courses — Royal County Down. Morris did have help. As author Peter Dobereiner points out, "This strip of dune land was 90 percent along on the road to being a golf course long before the game was invented." What makes County Down special is its combination of brutal toughness and natural splendor.

The fourth hole has both. Ever in search of perfection, the club hired designer Harry S. Colt in 1926 to work on what have become Royal County Down's signature holes — four and nine. Colt, master of the one-shotter, elevated the fourth to a solid "10" in the par-three pantheon.

Siting the back tee against a hillside, he gave golfers a glorious vista. In the distance the Mountains of Mourne descend from their highest peak, Slieve Donard, to Dundrum Bay and the Irish Sea. The spire of the Slieve Donard Hotel punctuates the dazzling blue skies and in springtime an ocher and indigo carpet of gorse rolls down the right side of the hole toward an emerald green that lies 15 feet below, awaiting your tee shot.

Measurements show a carry of 194 yards to the front. The five bunkers sprinkled in the fairway await the under-hit shot. Let your tee ball get away to the right and three more bunkers hemming the green will reach up and grab it. On a good day, a solid straight shot will get home. However, Royal County Down's winds can become so fierce they'll make it hard to focus on the target. On such a day, laying up might be the smart strategy.

Adding to these hazards, Colt's ingenious green complex is the hole's defining feature and the key to its superiority. Colt raised the putting surface to create a sharp five-foot fall-off running left and back into a swale. It is easy to bound off the surface, which is longer than it is wide, into this tricky area, or land in clumps of rough that complete the complex.

Royal County Down has a number of blind tee shots. At the fourth, don't let the view blind you to the task at hand.

Championship Course at Royal Dornoch Golf Club

Length: 161–135 yards

Designers: Old Tom Morris/J. H. Taylor and John Sutherland

Opened: 1886–1889

Location: Dornoch, Sutherland County, Scotland

6

"The four par threes . . . are all relatively short but miss those treacherously raised targets and you need the touch of a bomb disposal expert to give yourself a chance at par."

— VISITOR TO ROYAL DORNOCH GOLF CLUB

Trivia question: Among golf's great courses, which sits the farthest north and ranks as the third oldest club in the world? Answer: Royal Dornoch Golf Club, which shares a latitude with the Bering Sea and has records to prove the game was played there in 1616. The club is a long way from Scotland's principal cities, Edinburgh and Glasgow. So why trek to a tiny town perched at Embo Bay on the Dornoch Firth?

Dornoch's most famous native son Donald Ross offers these reasons for making the journey: "No American golfer should omit to come here, where he will find the best golf, a royal welcome and no rabble." You'll also experience the finest links never to host the British Open, and in summer you can play all day. Tom Watson once did fifty-four holes

in twenty-four hours and exclaimed, "It was the most fun I've had playing golf in my whole life."

From a design perspective you'll encounter first-hand the inspiration for those elevated and crowned "Donald Ross" greens that lie open in front only to send your ball running off on all sides. Such upturned-saucer surfaces deflect any but the most accurate tee shots. Most are elevated and all have intricate contours.

Number six is a perfect example of these features — a classic shelf green on a natural plateau tucked into a hillside that in spring is ablaze with the gorse blossoms that inspire its name, "Whinny Brae."

Take a moment to scan the long and skinny putting surface, so well defended. On the left, pay careful attention to the gorse and three bunkers. You

may be able to feather a shot out of the sand but not the gorse. The right is guarded by, in order, a large bunker forward of the green and a sharp slope, also called "an abyss," of some twenty-five feet from which a par is unlikely. Golf writer Lorne Rubenstein, a member at Royal Dornoch, explains this mistake: "You cannot miss right or the ball bounds away and the shot back to the green requires a carry over a steep slope, or drilling the ball into the hill and hoping for the right bounce."

Playing at only 165 yards, number six calls for a mid-iron into a prevailing cross wind. The design challenges you to stick your tee shot or suffer penalties. Once on, two putts is doable with the happy prospect of recording three on one of golf's seminal one-shot holes.

Ailsa Course at Turnberry

Length: 206–162 yards

Designers: Willie Fernie/Philip Mackenzie Ross

Opened: 1901/1951

Location: Turnberry, Ayrshire, Scotland

"Ye banks and braes o' bonnie Doon

　How can ye bloom sae fresh and fair!

How can ye chant, ye little birds

　And I sae weary fu' o' care!

Thou'll break my heart, thou warbling bird,

　That wantons thro' the flowering thorn."

—— ROBERT BURNS, AYRSHIRE POET,

"THE BANKS O' DOON"

Turnberry, 1977: The Duel in the Sun. Nicklaus the King and Watson the Prince going mano a mano in the final round of the British Open. Nicklaus is one up after sixty-eight holes. On the tee, they ready themselves to hit to Turnberry's fifteenth green 206 yards away. Nicklaus chooses a three iron and drops the ball inside thirty feet. Watson pulls his shot left. What to do? Rap it with a putter, of course.

Here is author Jim Finegan's wonderful summary of what followed: "Rap it he did — off the hardpan, over the apron, tight to the putting surface and true to the unattended flagstick some 60 feet distant, a straight-on contact with the pole, then gone, down, an astonishing 2 where he had been in danger of taking 4. " Watson faced going two down for the match. Instead, he pulled even on fifteen and went on to win by one shot — 65 to Nicklaus's 66.

Some holes, while very good in their own right, are made especially memorable by historic events.

Thanks to superb play by champions Nicklaus and Watson, Turnberry's fifteenth fits this description. Nicknamed "Ca' Canny," and labeled a "classic short hole," it isn't really short at more than 200 yards. The hole plays parallel to the sea, so the wind off the sea is at right angles. The locals like to characterize its direction as whimsical. Either way, average players will need a longer club to reach the green.

Assuming your shot goes the distance, it must navigate a Scylla and Charybdis defense. On the left side, two bunkers are ready to trap balls steered away from the opposite hazard — a huge bank right that runs down into dense vegetation and, like the mythical whirlpool, consumes errant shots. Having reached the green that cants steeply from left to right and back to front, you will need your best putting touch to get down in three. Ca' Canny — "Take care" — indeed.

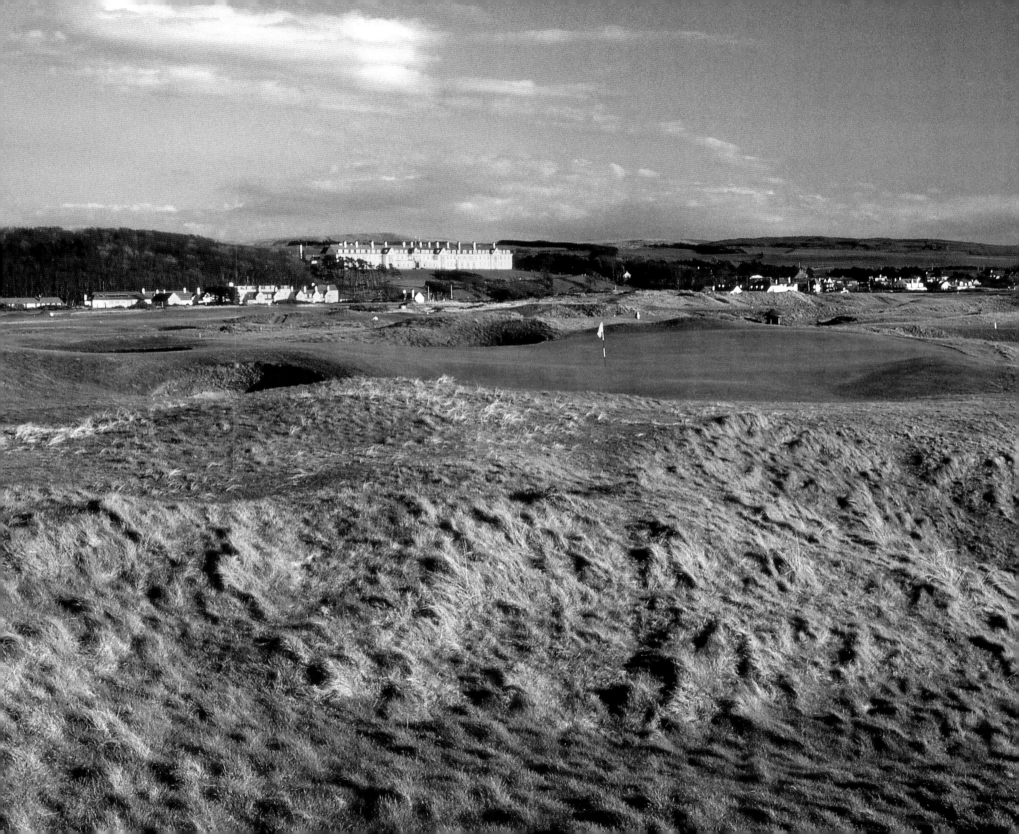

Bandon Dunes Course at Bandon Dunes Golf Resort

Length: 163–102 yards

Designer: David McLay Kidd

Opened: 1999

Location: Bandon, Oregon, USA

A classic example of David McLay Kidd's thoughtful creations, this delightful mid-length one-shotter harkens back to James Braid's Gleneagles Hotel Golf Club where Kidd roamed the fairways as a child. For lovers of the ground game, the green is approachable from the left side with a tall bank directing shots to the middle. The right, however, is protected by the course's deepest bunker, which regularly foils attempts to make three and often extracts four shots. Add in the ocean backdrop and prevailing winds to complete a true links experience. Bandon Dunes was Kidd's first major architectural effort and a brilliant one.

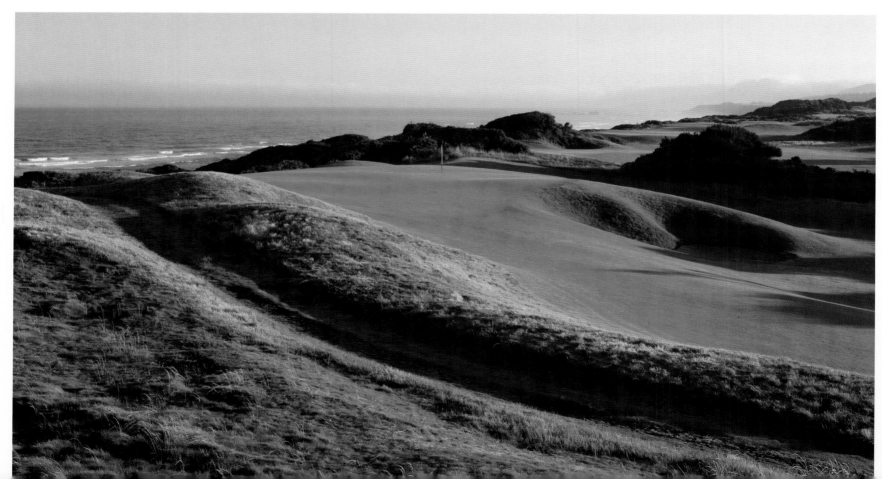

Barnbougle Dunes Golf Club

#7

Length: 112–85 yards

Designers: Tom Doak and Mike Clayton

Opened: 2004

Location: Bridport, Tasmania, Australia

There are Tasmanian Devils (carnivorous marsupials), and then there's Tom's Little Devil (the seventh at Barnbougle Dunes). Be wary of both when you travel Down Under to play this links course already evoking comparisons with the Old Course and Royal Troon, home to another great "wee hole," the Postage Stamp. Here, Doak set the back tee at 112 yards and fashioned a small, exposed green defended left by a bunker so cavernous it hides players trying to hit recovery shots. The prevailing wind is in your face, and when it's up you may be hitting as much as a mid-iron in order to reach the target. Going downwind, holding your ball on the slippery green surface is tough. Listed as one of Australia's shortest holes, it's devilish all the way.

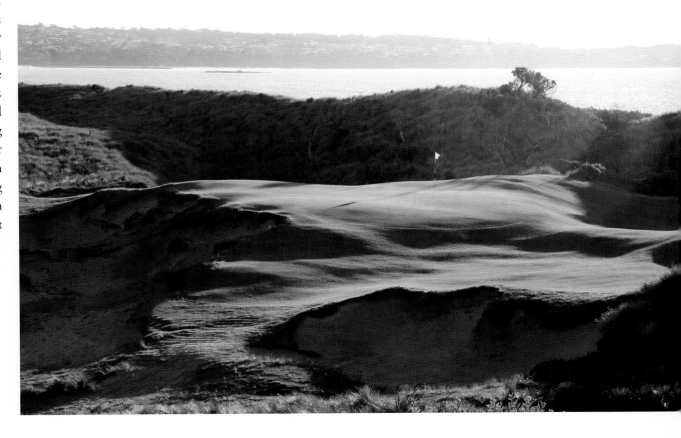

Championship Links at Portmarnock Golf Club

Length: 189–176 yards

Designers: W. C. Pickeman/Mungo Park

Opened: 1896

Location: Portmarnock, County Dublin, Ireland

The fearsome winds blowing in from the Irish Sea and the spare riveting beauty of this peninsular spit make the 189-yard fifteenth at Portmarnock dramatic and one of golf's great challenges. There are accounts of golfers hitting out over the nearby beach in an attempt to let the wind carry the ball back to the target. The 100-foot-long mesa-like green is protected by a dune and also sports three closely manicured bunkers that guard the approach. Its surface is replete with rolls and cants that make two-putting a minor miracle. It can be conquered: At the 1960 Canada Cup, Arnold Palmer hit a three iron through stiff winds to within three feet of the pin. Because this hole comes at a critical point in the round, many competitive events, and friendly wagers, have been won and lost here.

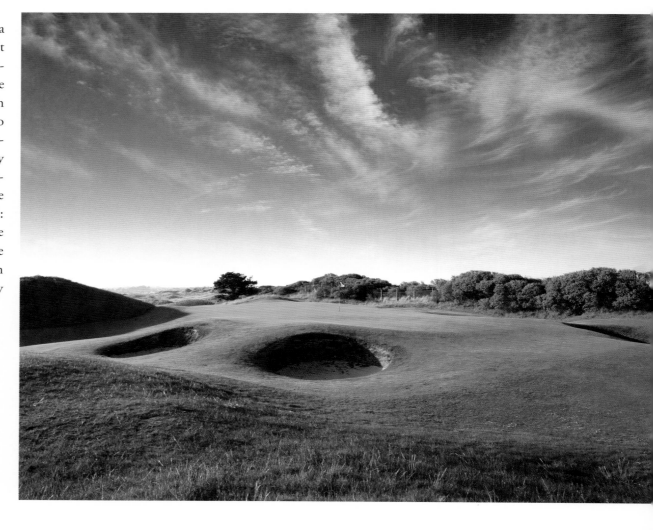

Waterville Golf Links

#17

Length: 194–120 yards

Designers: Eddie Hackett/Tom Fazio

Opened: 1973

Location: Waterville, County Kerry, Ireland

Waves of marram grass sweep from tee to green on the seaside seventeenth at Waterville Golf Links, making it one of original owner Jack Mulcahy's favorites. The sounds of nearby surf on Ballinskelligs Bay and ever-present westerlies crossing the hole make club selection problematic, especially from the elevated tee known as Mulcahy's Peak. If the pin is set behind the large, deep bunker fronting the left approach, the forced carry is a good 190 yards. In recent years designer Tom Fazio was brought in to make some changes to Waterville but wisely chose to leave the seventeenth untouched.

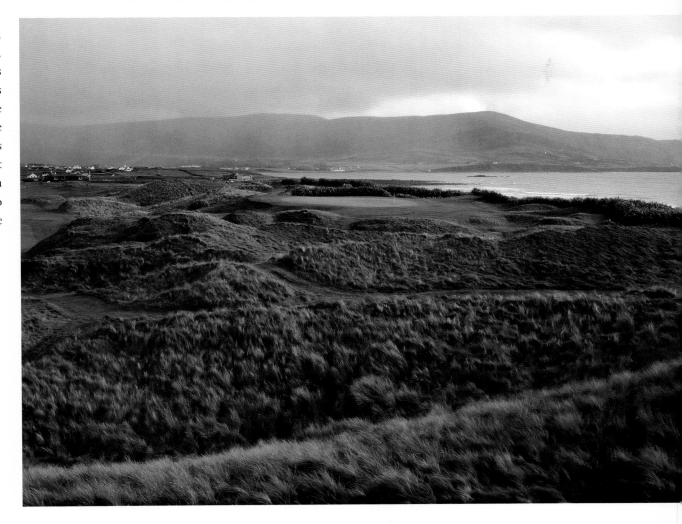

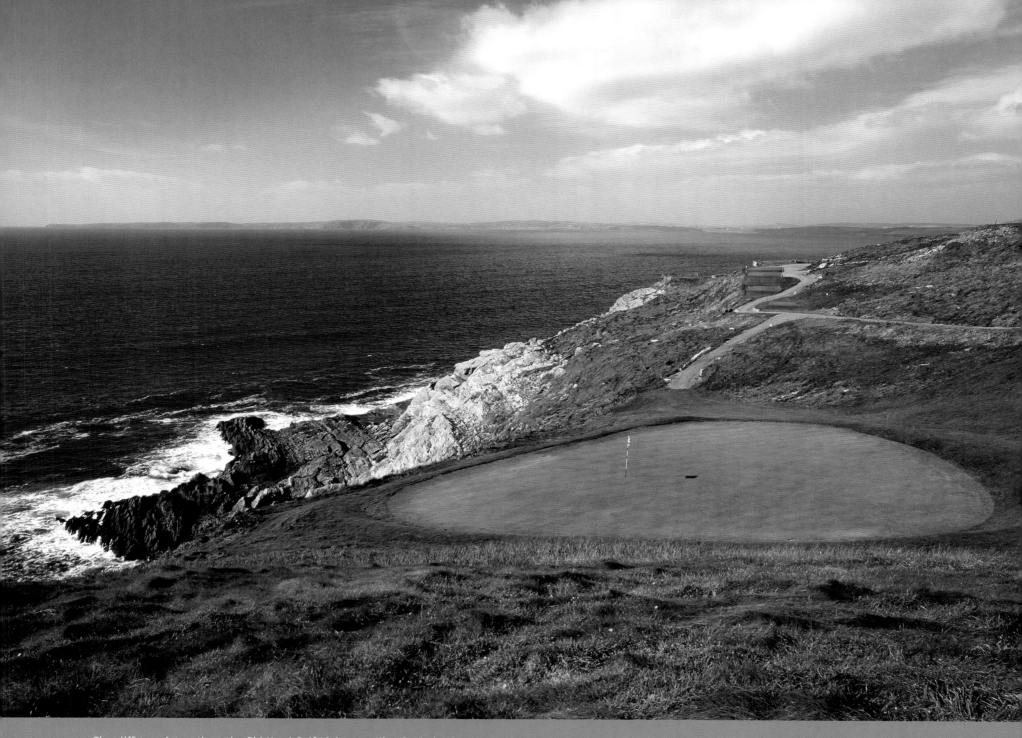

The cliff-top sixteenth at the Old Head Golf Links near Kinsale, Ireland.
Ferocious Atlantic winds and coastal surf are quotidian challenges on this
famous headlands course. A recent restoration produced an elevated green.

COASTAL HOLES

The rules of golf define only two hazards — sand and water. Even the deepest bunker offers hope of recovery. Ninety-seven percent of the time water hazards become, as the telecasters say, "a watery grave." Thus, we can comprehend the fear and tense swings water inspires in most golfers. Seaside holes add the noise factor, as crashing surf pounds shore and rocks, impinging on our concentration. All in all, water is both an aesthetic and dangerous design feature.

Architects lucky enough to be given a site near an ocean, sea or large lake have no excuse if they don't create some memorable holes. Proximity to a sizable body of water means the presence of waves, rocks, beaches, cliffs, coves, vistas and marine sounds. In their own right these locales are sought-after destinations for travelers and subjects for photographers; they add beauty to the golf challenge and offer dramatic shot-making possibilities. Often, holes on water become a course's "signature" image.

In our selection, three holes are situated on the Monterey Peninsula, judged one of the ten most beautiful locales in the world. Tropical venues like the Caribbean and Hawaii provided designers Pete Dye and Robert Trent Jones, Sr., with coves and rocky shorelines that outline heroic and dangerous carries. Some holes hang on cliffs while others sit low and next to the water.

Many are part of a famous group, like the nine seaside holes at Pebble Beach or the ten adjoining the ocean at Kiawah Island. At Whistling Straits on Lake Michigan, each of the four par threes sits on water. Others are the only water hole on the course, as with Mauna Kea's third. All share the difficulties wrought by winds that on occasion can become ferocious. Here are fourteen that lead lists of great one-shotters over or near water.

Teeth of the Dog Course at Casa de Campo

Length: 229–90 yards

Designer: Pete Dye

Opened: 1971

Location: La Romana, Dominican Republic

"I'm not going to leave this !@#%&* course until I hit one of those !@#%&* par threes with my first shot."

— CASA DE CAMPO GUEST ON PLAYING THE TEETH OF THE DOG COURSE

Christopher Columbus's discovery of the New World occurred when, having sailed across the Atlantic Ocean, he landed on the shores of the Dominican Republic. Pete Dye's discovery of the D.R. site for the Teeth of the Dog course was a bit more modest. "I borrowed an old metal boat with a Johnson outboard motor and puttered along the coastline," he recalls. "From there I tried to envision how we could fit as many holes as possible along the top of the rocky bluff."

Dye found room for seven holes. Three are par threes, each a great subject for photographers, with number five generally winning the prize for "signature hole." Numbers five, eleven and sixteen all have their virtues and advocates. Five is a shorter version of seven, with water on the left and regular tee carries of 157 and 176 yards from the tee. Sixteen has water on the right with regular carries of 155 and 180 yards. Eleven lies inland and features an island green surrounded completely by sand.

Our pick though is number seven, which also plays over water. About this unnerving proximity, golf photographer Brian Morgan quipped, "Pebble Beach has seven holes along the sea, but only Casa de Campo has seven holes *in* the sea." While the course sits on the lee side of the island, strong winds can blow, setting up a left-to-right shot over the water into the green. The generous green makes a reasonable target, but is ringed by bunkers and sand. One subtle touch: a stand of tall trees hems in the tee a bit and psychologically nudges the player to hit left toward the rocks and sea. Typical of Dye courses, multiple tees temper the difficulty; at seven they range from 90 yards to a heroic 229 yards from the tips.

The rocks guarding the edge of number seven are what remains of the coral landscape that dominated the shoreline. Hand crushed by local laborers, the coral was tediously transformed into fairways and greens. The jagged edges resembled teeth, hence the name "dientes de perro," or Teeth of the Dog. At Casa de Campo all the holes can bite, especially the one-shotters. Hit all of them in regulation and you should make Pete buy you a drink.

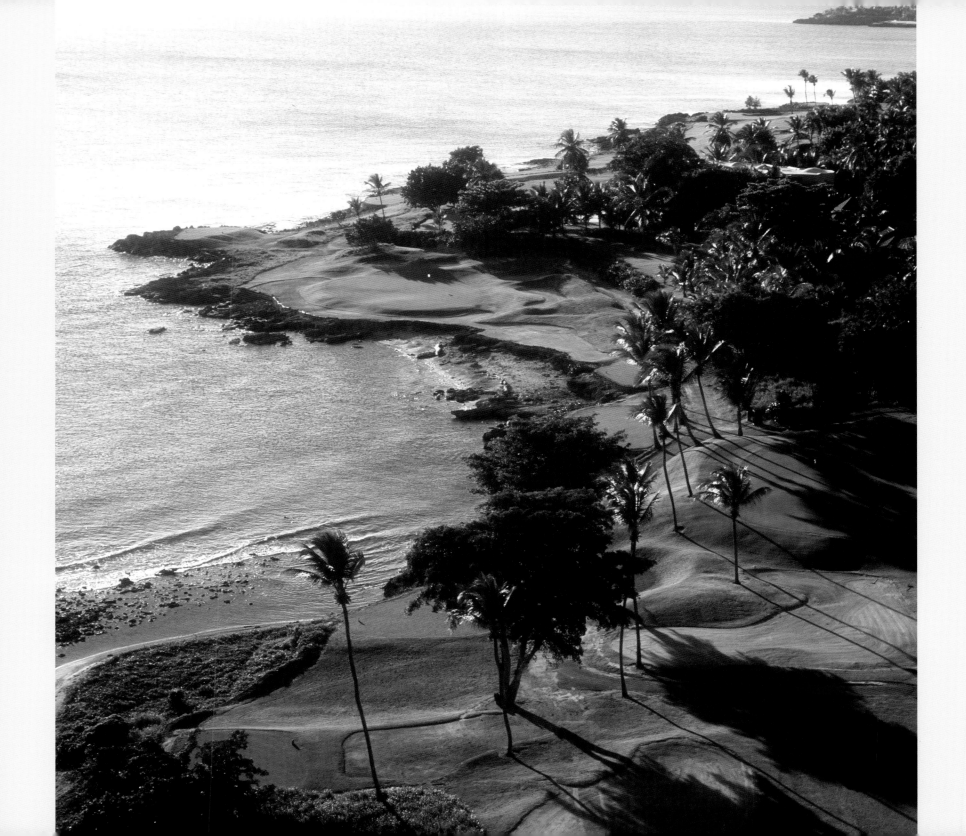

Cypress Point Club

Length: 231–208 Yards

Designers: Alister MacKenzie and Robert Hunter

Opened: 1928

Location: Pebble Beach, California, USA

Some call Cypress Point golf's Sistine Chapel, but from the sixteenth tee one thinks more of Sisyphus. While the scene rivals Michelangelo's ceiling, the shot execution suggests a golfer could spend an eternity trying to get the ball on the distant green. If you can't comfortably carry a tee shot 230 yards on a calm day, don't even think about getting home in one stroke; and if the winds are in your face, make that 250. It's okay to be a wimp at the sixteenth. If you've got a good score going, hit an easy iron to the fairway about 140 yards out to the left and carefully chip on for two putts and a solid 4.

On the other hand, like a lottery ticket, you've got to give it a try or you'll never be able to say you really played the hole the way Marion Hollins — founder of the Cypress Point Club and self-appointed design assistant to Alister MacKenzie — wanted it to be played. For the record, during the test runs she knocked three tee shots in a row onto the green site with room to spare and set the standard thousands have tried, and failed, to equal. Ask comedian Groucho Marx, who dunked five consecutive tee shots, threw his clubs in the ocean and vowed to quit the game for good.

Where to begin? One writer notes the hole contains all three major schools of design — strategic, heroic and penal — in one. Here is how MacKenzie suggested tackling the hole: "There are three alternative routes, namely, the direct route over 200 yards of ocean to the green, an intermediate route over about 100 yards of ocean, and a still shorter route to the left. A well played shot to the lone Cypress tree with a nicely calculated slice gets the help of the slope and runs very near the green, enabling the player to run up a slight swale and still have a good chance of a three. I doubted if this hole would be considered ideal, because I feared that, compared with the other Cypress Point holes, there was not a sufficiently easy route for the weaker player. My mind was set at rest a few months ago."

The golfer stepping on to the tee might not share MacKenzie's sanguine outlook. A panoply of hazards defends the hole — a carry over water, rocks from tee to green, a variety of winds, five bunkers ringing the green, ice plant. Did we miss anything? Even the player who opts for MacKenzie's conservative routes on the left side has to worry. The fairway does slope toward the green, but it's not

hard to hit through it and wind up in the water. Reaching the dance floor in regulation demands the aforementioned "heroic carry," or what MacKenzie came to call the "Lindbergh Thrill." For billiard enthusiasts, there is a well-calibrated bank shot off the top of one of the rocks and onto the green, a feat accomplished more than once, however accidental. When it comes to the green, MacKenzie played by accepted design rules. It is medium-size, circular and shaped to receive a long tee shot or short approach — fair in every way. The green site, by the way, is the actual "point" for which the club is named.

The hole can be conquered: there have been six holes in one. Member Bing Crosby made one of these. It was Crosby who introduced the world to Cypress Point when he included it in his trio of venues for the Bing Crosby National Pro-Am. The sight of the pros going at the sixteenth, sometimes with disastrous results, became a high point of the tournament. From a scoring perspective, MacKenzie originally wanted it to be a tough short four. Golf writer Charles Price called it a "par three-and-a-half," and anybody who has managed a par knows it feels like a birdie.

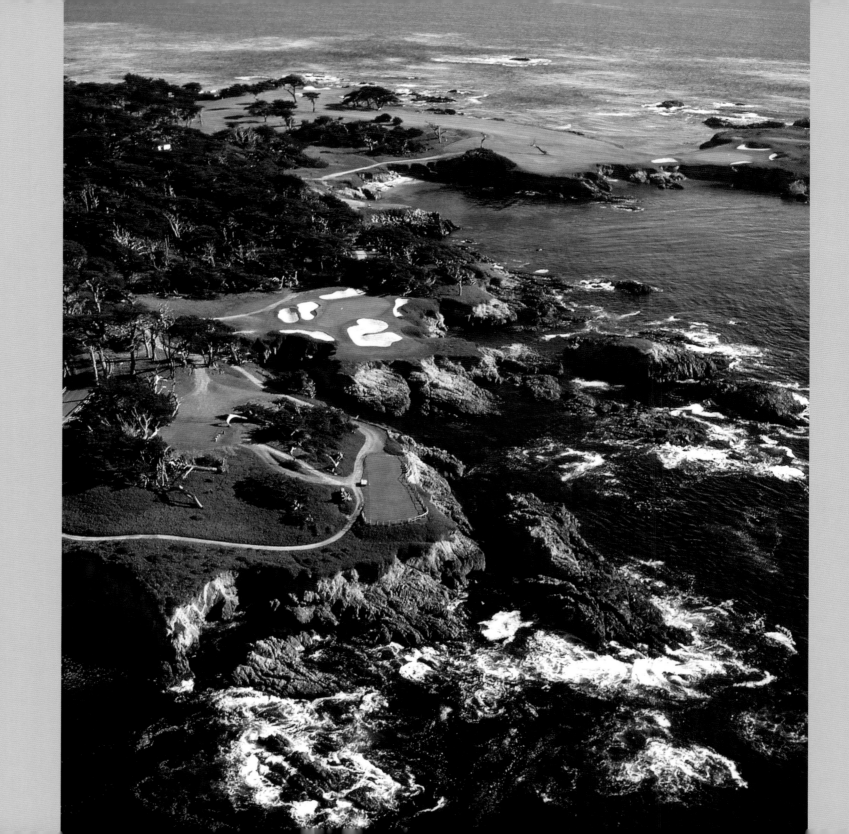

#15

Cypress Point Club

Length: 143–119 yards

Designers: Alister MacKenzie and Robert Hunter

Opened: 1928

Location: Pebble Beach, California, USA

"The hole owes its reputation almost entirely to the beauty of the green and its surroundings."

— ALISTER MACKENZIE, *The Spirit of St. Andrews*

Always a bridesmaid, number fifteen presents a dramatic entry to a seaside threesome of Cypress Point's most famous holes. The heroic sixteenth and strategic seventeenth complete the run that starts on the fifteenth tee, a platform set high above the crashing sea. Samuel F. B. Morse, pioneer developer on the Monterey Peninsula, said only a poet should write of Cypress Point. Thus, we won't launch into a lengthy description of this littoral gem except to say it inspires mystical, lyric and religious comparisons.

Fifteen is a hole not to be rushed. Before you hit, stop and enjoy it from a purely sensual perspective — light, color, smell, sound. You make your own catalogue: surreal tree shapes, emerald hues, roiling waters, tangy salt spray, a chorus of marine life and more. The hole sits in a rocky cove. The green shape evokes a tricorn hat and is not large. The square footage of the six deep white-sand bunkers easily dwarfs it. MacKenzie loved bunkers and few made them better. Notice the tufted edges that mime the original landscape. A grove of cypress trees wedges in from the left and the ocean guards the right.

The shot: On a clear day, it's a gentle pitch with an eight or nine iron. With the wind at Monterey Peninsula ferociousness, one might need a mid- to long iron. Ordinarily, the breeze will come from the right or behind, causing a knockdown effect. MacKenzie criticized the hole because it didn't have "a sufficient number of alternative shots to play it." One must be "right" or land in trouble. Certain pin placements will make a three elusive, while a solid tee shot does set up a birdie. This happened in 1956 during the famous match between amateurs Ken Venturi and Harvie Ward playing against Byron Nelson and Ben Hogan. Ward and Hogan hit tap-in tee shots, and Hogan conceded the putt and the hole was halved.

No matter what you score, you can add Cypress Point's fifteenth to your list of "jewel-box" threes fit for mounting in golf's fantasy version of the Louvre.

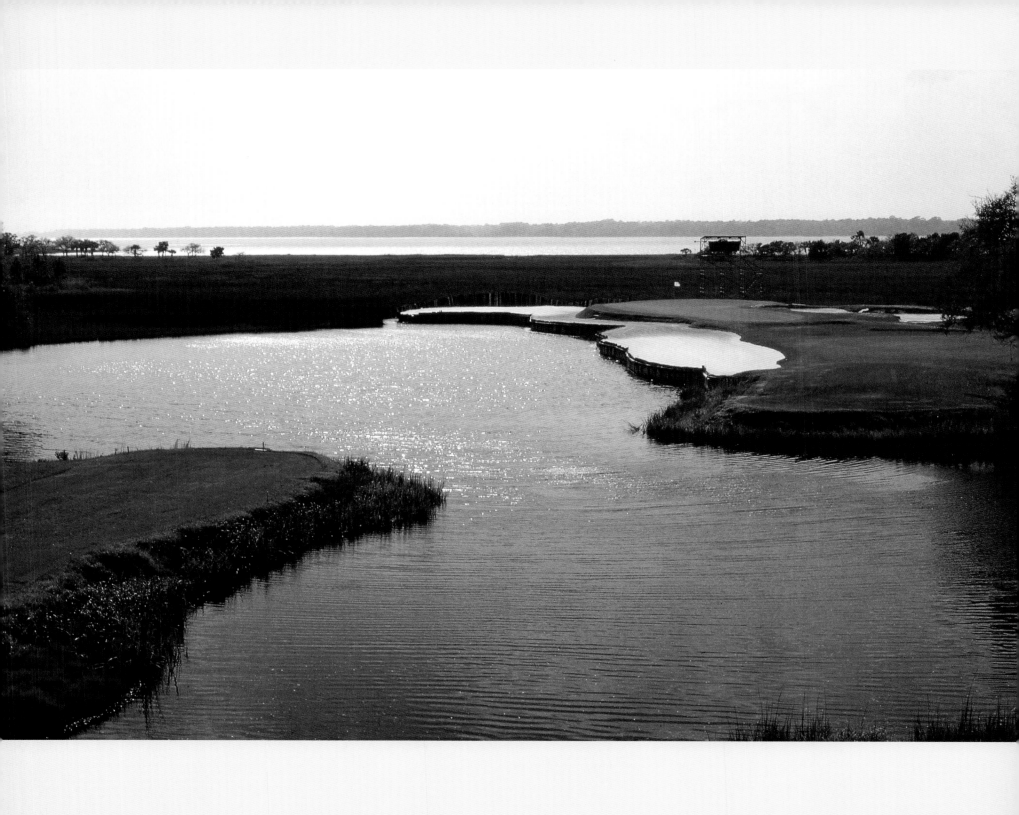

Harbour Town Golf Links

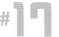

#17

Length: 185–130 yards

Designers: Pete Dye and Jack Nicklaus

Opened: 1969

Location: Hilton Head Island, South Carolina, USA

"The highest praise is reserved for Harbour Town's quartet of threes, each a watery terror from the white tees."

— BRIAN McCALLEN, *Golf Magazine's Top 100 Courses You Can Play*

What does one call a hole that allows for little margin of error but is truly fair? The seventeenth at Harbour Town, or any one of the other three outstanding one-shot challenges on this throwback design that fosters thoughtful strategy and pinpoint accuracy during a round of golf. Built forty years ago, little has changed except for some tweaks by Dye and the lengthening of the par-three fourth to 200 yards.

Maybe this traditional approach was inspired by the fact that the "Heritage Classic," as the original Tour stop was called, paid homage to the South Carolina Golf Club, America's oldest, founded in 1786. From the first hole to the celebrated finishing eighteenth, it begs you to put driver in the bag and use a shorter club to reach preferred landing areas so approaches get home in regulation. It's old-time shotmaking at its best.

At the seventeenth, Dye calls for resolve and accuracy if you want any hope of par. Your tee shot has to find a slightly angled and very long green (some 100 feet) shaped like a light bulb, narrow in front and widening at the back. Now, reckon the wind to decide the shape of your shot. If you favor right to left, then beware of the sizable bunker that pinches the right side of the green where it starts to widen.

Coming in from the left, your ball will hang for approximately 90 yards over a marshy lagoon that contours the back of the green. Between water and green, Dye has wrapped a swath of 100 yards of sand that starts out as a six-foot-deep strip bunker and ends in the shape of a basket and is contained by his signature timbers. The combination makes the green look even narrower. Landing in the front with the pin back will mean a very long two-putt.

Don't forget, if you are there later in the day, you'll be hitting toward a setting sun — a beautiful backdrop to a strait-is-the-gate homestretch hole.

Mauna Kea Resort Golf Course

Length: 210–140 yards

Designers: Robert Trent Jones, Sr./Rees Jones

Opened: 1964

Location: Kamuela, Kohala Coast, Hawaii, USA

Google Earth is the best tool to situate Mauna Kea's famous third hole. Zoom in on the Pacific Ocean, then Hawaii's Big Island, then the 230 acres of black lava rock that greeted Robert Trent Jones, Sr., when, in 1962, Laurance Rockefeller asked him to build a course on this geologically impossible landscape. Long known for his epic style, Jones was undeterred and thus began one of the most complicated engineering projects ever faced in golf course construction.

Seeing the holes was not the challenge, for as Jones said, "There were elevations for the tees, nice pockets for the greens, everything you could want for a great course." And this applied to number three in particular. Much like Alister MacKenzie when he came upon the promontory ideally suited for the sixteenth green at Cypress Point, Jones looked across an inlet and knew instantly he had the perfect site for a spectacular and terrifying one-shot hole. The problem was how to build a green on lava rock and where to locate tees so pro and duffer alike had proportionate challenges to carry the aquamarine waves.

With a Rockefeller-size budget in hand, Jones researched big machines that crushed rock, found one, modified it for his purposes, and began to blast and pulverize the lava into a sub-foundation for tees, fairways and greens. At number three, which is shaped like a comma, he put the green as far out as land permitted. This allowed him extra length for the one-shot carry and left a bailout area to the right.

The green angles away from your shot and slopes subtly; it is set back 35 feet from the shoreline so you can land short and still be safe. At 180 feet long, it offers a generous target. Consistent with the Jones style, seven bunkers ring the green. Filled originally with native coral crush, they now feature a lighter and whiter Canadian silica sand. Currently, the hole has six tees — ranging from an easy hit to a fearsome 261 yards from the tournament tees — each with its own angle.

Though that is the static profile of the hole, your score at three turns heavily on the capricious Pacific winds. As a travel guidebook says, "If the trades are blowing, 80 yards might as well be 1,000." More is more here, so take enough club. In true Polynesian fashion, the locals wish you *"pomaika i"* — good luck.

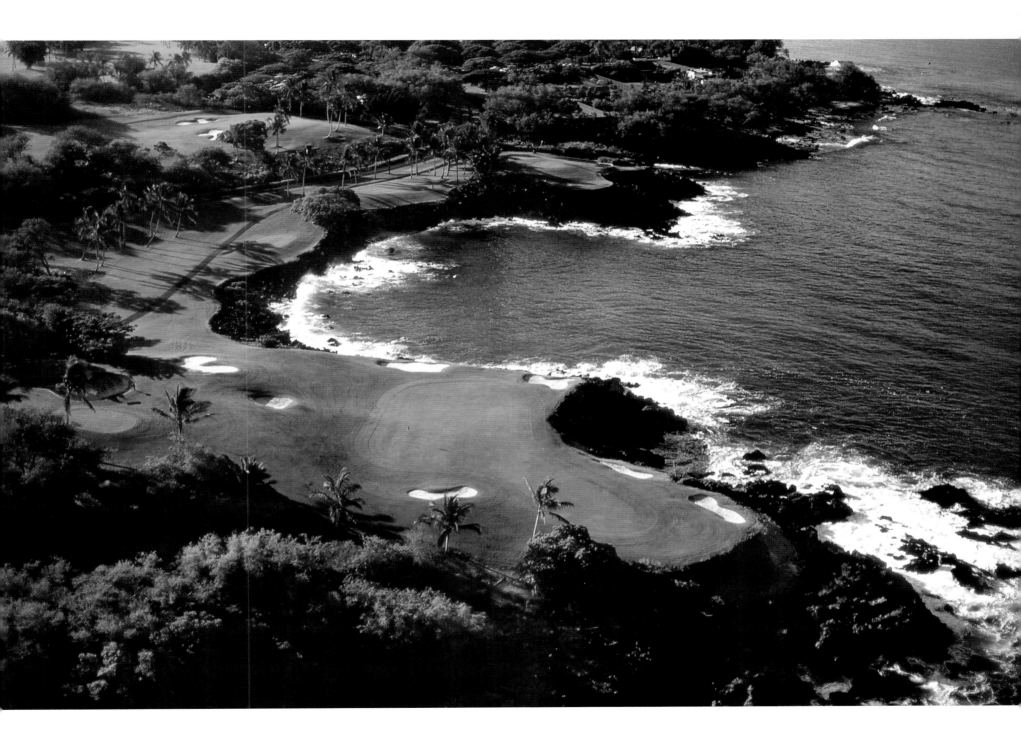

"I built the course to fit the land." — ROBERT TRENT JONES, SR.

South Course at Mauna Lani Resort

Length: 216–92 yards

Designers: Homer Flint and R. F. Cain/Robin Nelson and Rodney Wright

Opened: 1981

Location: Kohala Coast, Hawaii, USA

Number fifteen on Mauna Lani's South Course has its share of a'a lava, but there are plenty of other places for your tee shot to land — five white-sand bunkers, the crashing blue waters of a curving cove that arches toward the sea, fairway grass, your intended target (a large, squarish green 140 feet at its widest points) and, of course, the jagged black rock that edges the entire hole. Intimidating? Yes. Beautiful? Absolutely — one of the world's most photographed holes.

By the time you reach the fifteenth, you will have absorbed some of the spirit of place that pervades this top-drawer resort complex. Visionary founder and descendant of Hawaiian royalty Francis H. I'i Brown bought the property in 1932 with the primary purpose of protecting and preserving this ancient 'il,' or land section, known as Kalahuipua'a, a hallowed place where kings recreated and elders worshiped. Consequently, when you step onto the lava rock, you are on sacred ground.

From a playing perspective, you will be reminded of Mauna Kea's third with its demanding tee shot. The fact is that from the back tee you need carry only 160 yards to find earth and about 175 yards to reach the green. However, be wary of 100-foot bunkers that sit left of the green. There is fairway right and shorter hitters can aim for this with the prospect of a run-up shot for a four; the shorter tees make you carry directly over a bunker right. Those confident of making the green can use the distant framing bunker 240 yards away as a guide.

If you are going to make par here, you must put your ball within shouting distance of the pin or face a very long first putt and possible three-putt. The two-tiered green slopes left to right some four feet; happily, there are no tricky contours. As with all Hawaiian courses, the trade winds rule and can change the nature of a hole radically. If Pele is with you, your shots will find ground that is green and not lava black.

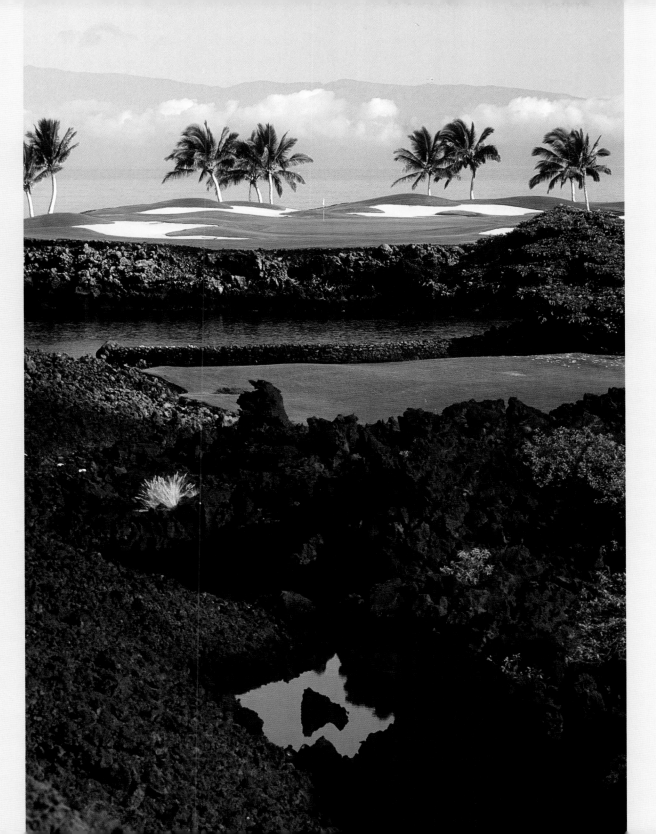

"Volcano goddess Pele reigns supreme on this course. If she favors you, balls hit into the lava will miraculously bounce back into the fairway. If not, kiss them goodbye." — MAUNA LANI COURSE GUIDE

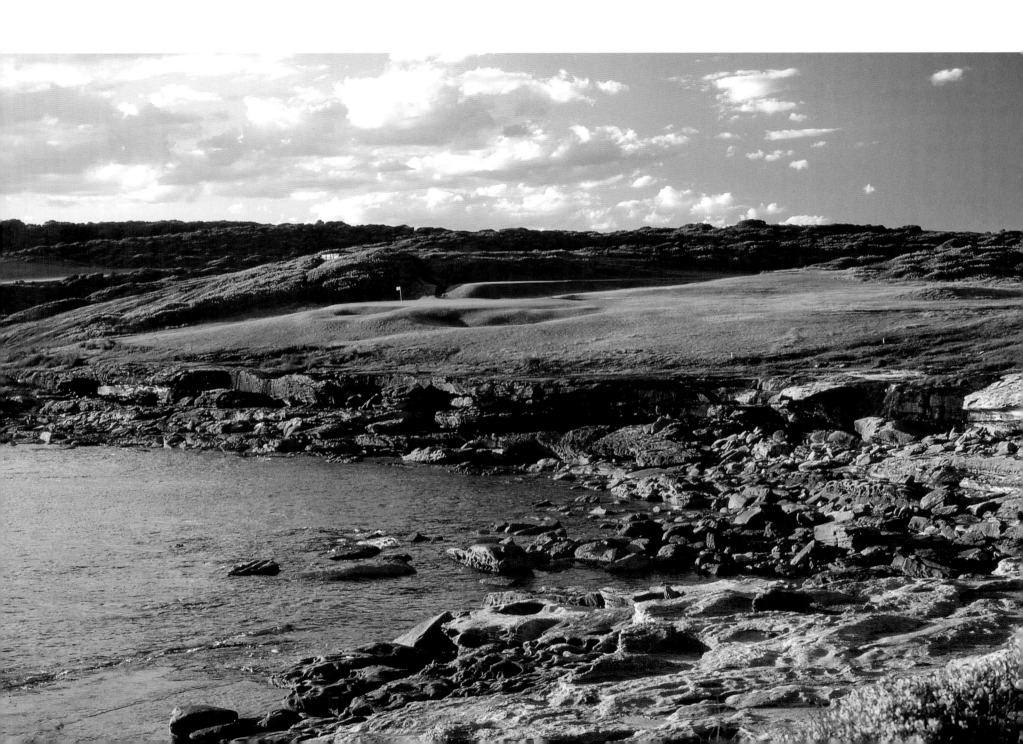

"From the point of view of scenery, challenge and danger, this par three has it all." — KEL NAGLE, BRITISH OPEN CHAMPION

New South Wales Golf Club

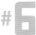

#6

Length: 187–132 yards

Designers: Alister MacKenzie/Eric Apperly

Opened: 1928

Location: Sydney, New South Wales, Australia

Eric Apperly is not a name that leaps to the top of golf architect lists, but if people are judged by one brilliant stroke, then he deserves applause. When Alister MacKenzie routed the New South Wales Golf Club course in 1926, he left a blank space between numbers five and seven. It was Apperly who gets credit for divining what MacKenzie might have done and artfully nesting the now famous number six on a cove to create the most-photographed hole in Australia. It didn't hurt that the MacKenzie-Apperly team was working with the rocky cliffs of Henry Head near Cape Banks, a coastline comprable to California's Monterey Peninsula, with arresting panoramas and rugged terrain exposed to winds and water. All of these converge at the sixth.

As one leaves the fifth hole, which runs down toward the ocean's edge, there is a choice waiting. The White tees offer a simpler challenge, a mid-iron uphill at about 165 yards, with the shot covering land all the way. The hole Apperly wants you to play is from the Blue tees, which rest on a reef accessible by a bridge.

At this spot, you are only a few feet above the water and exposed to the steady winds that dictate the kind of bold play even pros consider carefully. Australian pro and British Open champion Kel Nagle described the shot as full of "pure danger and a real nightmare if a howling westerly is blowing." The setup is truly brilliant. The circular green is medium-size and guarded by one bunker left and two right. The carry over water is about 160 yards. Water to your left makes you want to hit right. But the green moves from right to left and recovery from the right side and its bunkers is much more difficult. The true path is out over the water, and, using your best judgment on club selection and wind movement, you can bring the ball into the slope of the green.

So at New South Wales' sixth, when the wind blows off the sea, hanging it left is the right way to go. Believe it.

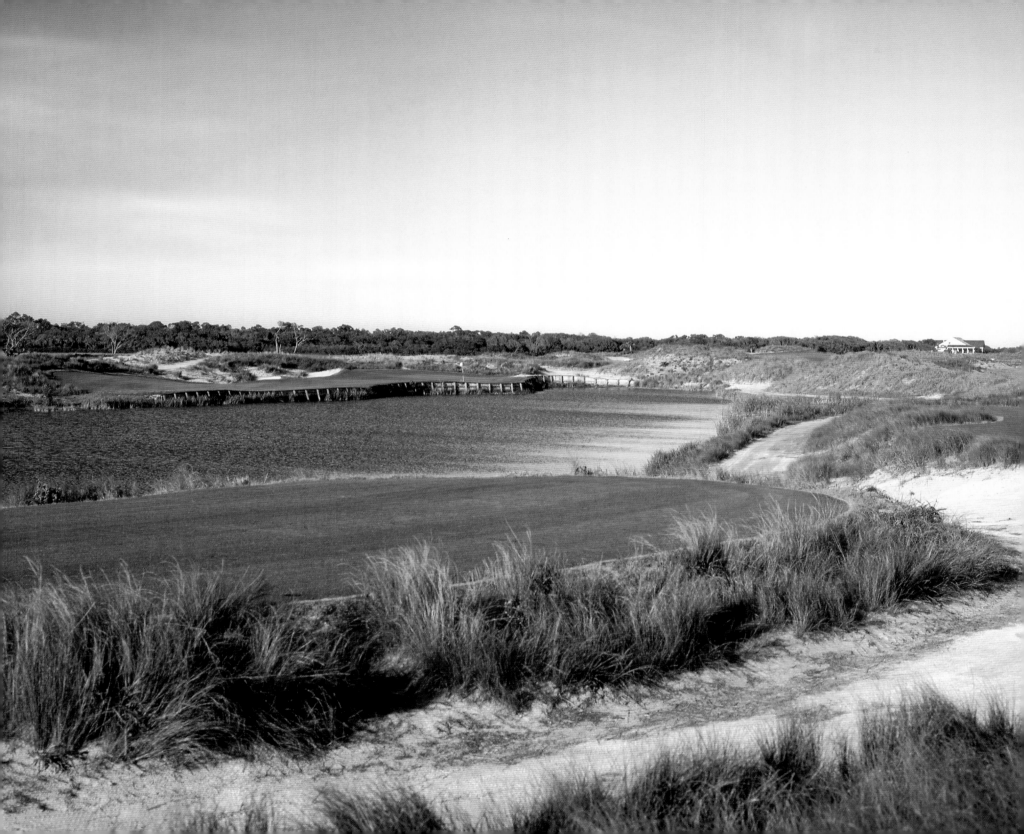

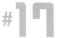

Ocean Course at Kiawah Island Golf Resort

Length: 221–122 yards

Designers: Pete and Alice Dye

Opened: 1991

Location: Kiawah Island, South Carolina, USA

If you wonder why Pete Dye has created so many great golf courses, look to his secret weapon — Alice O'Neal Dye, his wife and talented design partner. It's a matter of two heads being better than one, since while Pete takes the lead, Alice is always there to point out, suggest and challenge. The Ocean Course at Kiawah Island is a perfect example. It was Alice who suggested raising the entire course to a level just above the shoreline dunes. This not only gives the golfer unsurpassed views of the ocean, but also exposes an already testing layout to winds much in the way of Scottish linksland venues beloved by the Dyes, like the Old Course and Nairn. For the record, there are ten seaside holes, more than any course in America, and the other eight aren't far removed.

By the time you complete your round, even if you are a single-digit handicap, you will feel as if you've earned membership in the masochist's society of your choice. The slope from the back is a breathtaking 155. It doesn't matter what length you play since you are constantly confronting decisions about angles off the tee, worrying about landing in the ever-present marsh and acres of sand, or calcu-

lating the wind shifts which can make a four- to six-club difference.

Among the par threes, all over 190 yards from the back, the seventeenth is Pete's favorite and part of a finishing stretch that ranks with the finest in the world. Multiple tees set on both sides of a lake let golfers find their comfort zone. There is even an island tee attached to the walkway that gets you to the green. One concession the Dyes made at the Ocean Course was to build large greens. This one is 10,000 square feet and Pete characterizes it as "a double green with front and back landing areas." Both sections have catch bunkers waiting for the overly long shot. The final touch is a one-foot rise front to back.

Take comfort. During the famous 1991 Ryder Cup Matches, christened "The War by the Shore," pros were hitting long irons and woods into the teeth of a thirty-knot northwesterly at seventeen and not getting home. Among them were Colin Montgomerie and Mark Calcavecchia, who were playing head-to-head; both ended in seventeen's water hazard. The Yanks won 14 ½ to 13 ½, but the real winner was the Ocean Course.

"Pete always makes you dig down and find your best shots." — HALE IRWIN, THREE-TIME U.S. OPEN CHAMPION

Pebble Beach Golf Links

Length: 208–148 yards

Designers: Jack Neville and Douglas Grant/H. Chandler Egan

Opened: 1919

Location: Pebble Beach, California, USA

Stillwater Cove is bookended by Pebble Beach's most famous par threes — the diminutive number seven and the more demanding and strategically important seventeenth. Critics of seventeen might argue Neville and Grant used the latter to get across the road to the eighteenth tee. Logistically, this is correct, however, on closer inspection the hole proves its weight from design and competitive perspectives.

Historically, it has been the scene for tournament-changing strokes, bad and good. As the penultimate hole, it teams with the spectacular three-shot eighteenth to test the nerves of aspirant winners of the PGA Tour's AT&T Pebble Beach National Pro-Am and since 1972 five U.S. Opens. Among U.S. Open venues, seventeen ranks one-two in the "hardest par threes" ratings, with scoring averages of 3.46 in 1992, 3.44 in 2000 and 3.48 in 2010. At the 1964 Bing Crosby National Pro-Am, Arnold Palmer made nine; and in 1976 Jack Nicklaus got caught in a bunker and finished with a triple-bogey.

A helicopter ride over seventeen reveals two key design features. One is the distinctive hourglass shape that narrows to 20 feet at the ridge where the two halves join. At its widest points the green measures 40 feet and stretches to 40 yards front to back. A back pin placement can add a club-and-a-half to the length.

The other distinctive feature is the hole's positioning in relation to the prevailing winds off Stillwater Cove. When they are up, a shot to the back portion of the green will make average players pull out a three wood or driver. In the face of such a wind at the 1972 U.S. Open, Jack Nicklaus, a long-hitter in his prime, used a one iron; the shot clanged off the pin and stopped inside six inches for a birdie that ensured his victory. Ten years later, Tom Watson chipped in for a birdie on his way to the Open title.

The bunkering is severe to say the least. One huge piece of sand runs the length of the left side. Balancing it are five bunkers on the right side. And for good measure another guards the rear of the green. There is ample opportunity for a bunker-to-bunker situation. Threading these sand hazards with the wind up makes the tee shot one of the hardest at Pebble Beach. Add in competitive pressure, a U.S. Open title or friendly Nassau with a friend, and seventeen will be sure to test your mettle time and again.

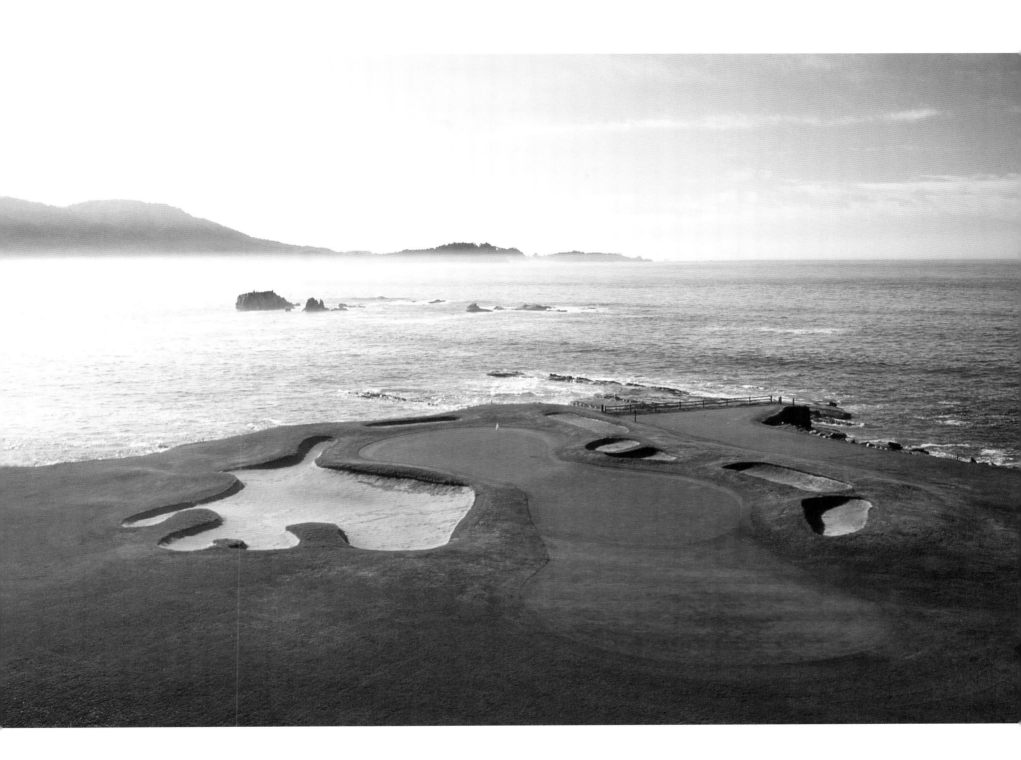

"Hell, no. I'm going to make it." — TOM WATSON, BEFORE HOLING OUT TO WIN THE 1982 U.S. OPEN

Straits Course at Whistling Straits

Length: 183–106 yards

Designer: Pete Dye

Opened: 1998

Location: Haven, Wisconsin, USA

"The gunners failed to hit any targets; surface-to-air missiles soon rendered such training unnecessary." — *The Sheboygan Times,* 1958

It's fitting that the property Herb Kohler purchased as the site for Whistling Straits was once a U.S. Army artillery range. There are moments when golfers wish they did have surface-to-air launch capability when confronted with designer Pete Dye's battery of threes, each one demanding superior skill at sticking a shot.

Like many of Dye's courses, choosing a #1 from the Whistling Straits quartet is tough. Number seventeen is dubbed the signature hole and at 223 yards from the tips lives up to its nickname, "Pinched Nerve." Number seven provides glorious photo ops. All four are set right on Lake Michigan. Three and seventeen have water left; seven and twelve, right. Which of course exposes them to the vagaries of Midwestern winds and weather. As a local pro says,

"Whistling Straits is a unique place in that the wind can blow one way in the morning, another in the afternoon and yet another in the evening." So don't count on consistency when reckoning your shots.

After playing the first two holes inland, you reach number three's tee box and get your first view of the curving shoreline of Lake Michigan, which lies about 25 feet below on your left. You might even say the name of the hole, "O' Man," as in "there is going to be a lot of water from here on!" You are now officially on the Straits.

The way Dye has set up the hole, you feel a bit off balance as you address your tee ball. He gives little quarter, with bunkers stippling the left side, the lake looming and more troubles on the right.

Your target is a very large, undulating green set at a forty-five-degree angle to the tee and running away from you right to left, Redan-like. From 180 yards, the back left corner appears to be surrounded by water on two sides. The difference between the front and back can equal a two- or three-club swing. While technically not a true Redan, it acts like one; specifically, it has a high right bank that feeds a ball to the lower back bowl portion. If the pin is back left, only the skilled will make a par. And if Whistling Straits' wind god, Aeolus, has his back up, who knows what will happen? O' Man is right.

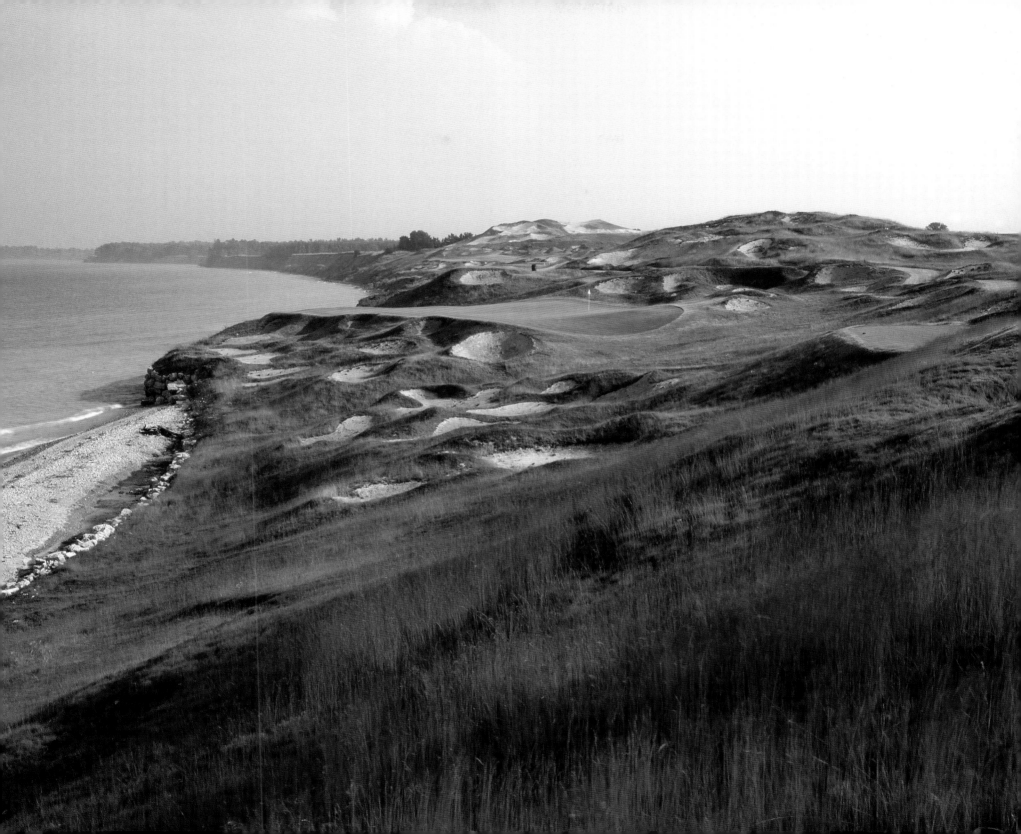

Ocean Course at Cabo del Sol Resort and Golf Club

Length: 178–102 yards

Designer: Jack Nicklaus

Opened: 1994

Location: Cabo San Lucas, Baja California Sur, Mexico

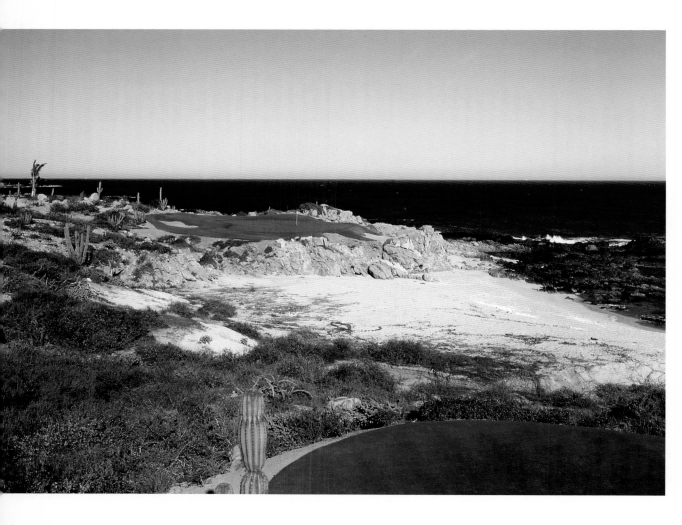

Baja California's Sea of Cortez, teeming with exotic marine life, provides a beautiful backdrop for this coastal design. The hole is not terribly long, but distance is not the point. The green sits naked on some strata rocks and, depending on wind, makes a difficult target. Making three from off the green is for up-and-down experts only. The pro tee just off the sixteenth green presents the ultimate challenge to this hole: a full carry of 170 yards over beach, sand and rocks. It's a ten on both the beauty and beast scale.

Kingsbarns Golf Links

#15

Length: 212–110 yards

Designers: Kyle Phillips and Mark Parsinen

Opened: 2000

Location: Kingsbarns, Fife, Scotland

In 1998 Kyle Phillips was offered the chance to lay out a course on a rocky coastal property just southeast of St. Andrews. After moving 300,000 cubic yards of dirt, he produced a true seaside links that looks as ancient as the Old Course. One of its dominant features is the way Phillips keeps the sea in view. Nowhere is this more dramatically achieved than at the fifteenth, his wonderful interpretation of a Cape-style hole with a green jutting into the North Sea that forces a tee shot over roiling waves into the brunt of the wind. Local advice includes: While the tee may be calm, winds on the trees to the left can be up, and, a line on the back left bunker gets one's ball flying over playable turf. The green is nearly 184 feet wide, which might make for a target more visually impressive than technically difficult; however, it remains a hefty distance for even the most skilled player.

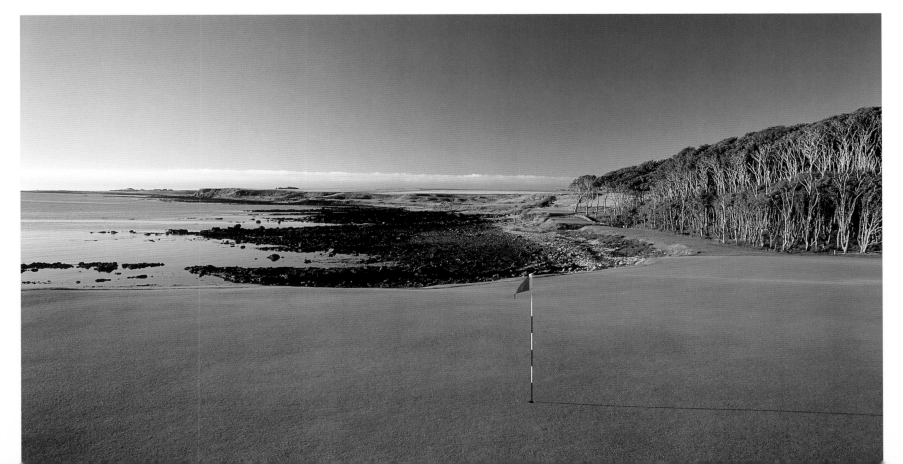

Port Royal Golf Course

Length: 235–105 yards

Designer: Robert Trent Jones, Sr.

Opened: 1970

Location: Southampton, Bermuda

This cliffside gem easily qualifies for inclusion in the "big shot" category. The tee setting is dramatic, with an acrophobia-inducing drop of 200 feet on the left. At the green, a series of bunkers guards the right side. If you land in one and don't get your sand shot just right, you may end up in the ocean. Four tee boxes offer variety in angle and difficulty. Jones created many holes that mandate a bold stroke and few demonstrate that as forcefully as Port Royal's sixth.

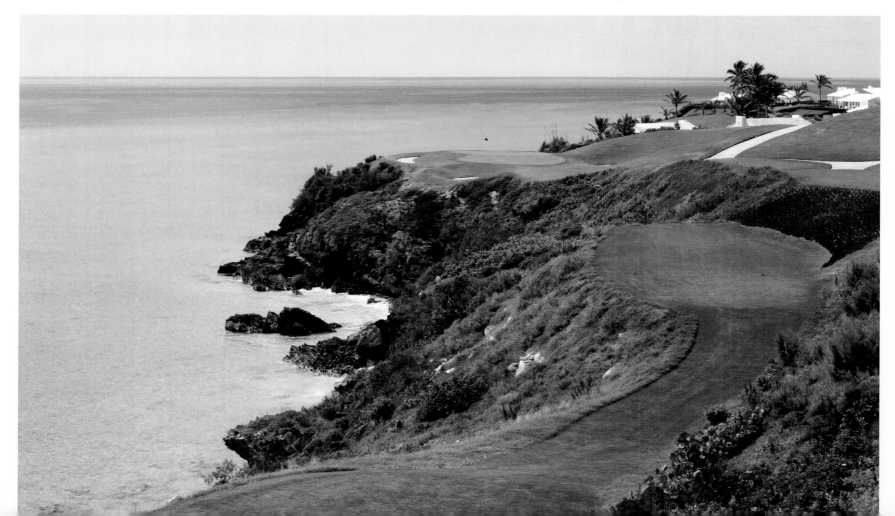

Located on the Discovery Coast in the resort state of Bahia, Terravista Golf Course is ranked #1 in Brazil. The first nine play through the lush Atlantic Rainforest. The incoming holes sit near "*falesias*," rock-ribbed cliffs that rise 130 feet above the Atlantic Ocean. One of these is the fourteenth, immediately consecrated as the postcard hole. Designer Blankenship recommends you take time for pictures, then pay close attention to the wind. How well you measure it will determine whether your ball makes it to a large three-tiered green. Birdie here yields only to what the Portuguese call "*tacada no Paraiso*" — a shot in heaven.

#**14**

Terravista Golf Course

Length: 216–107 yards

Designer: Dan Blankenship

Opened: 2004

Location: Trancoso, Bahia, Brazil

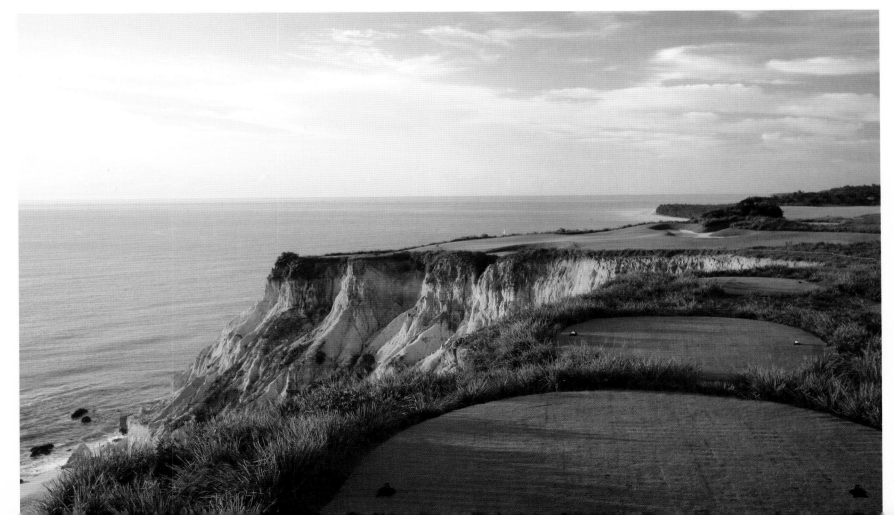

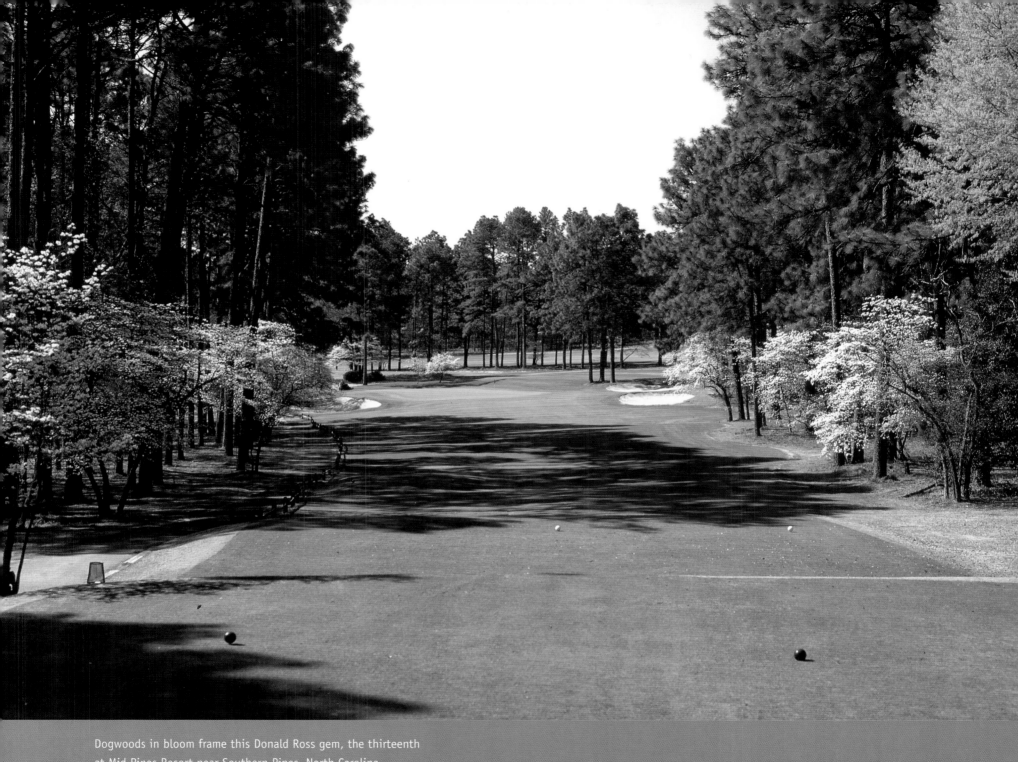
Dogwoods in bloom frame this Donald Ross gem, the thirteenth at Mid Pines Resort near Southern Pines, North Carolina.

INLAND HOLES

As golf grew in popularity at the end of the nineteenth century, course designers began using locations that were well away from the seaside and often near urban centers. We have grouped these under the simple heading of "Inland," which traditionally includes parkland and heathland settings. Heathland is marked by a large range of colorful plants, like heather or gorse, which make for penal golf hazards. Parkland terrain is distinguished by the presence of trees, streams, wetlands and ravines.

Generally speaking, inland courses lack extraordinary natural features like coastal surf and cliffs. This puts a premium on the architect's ability to engineer challenges that are often more subtle. They feature creative use of elevation on tees and greens (L.A. North), the aforementioned tree stands or sometimes a single well-placed tree (The Olympic Club), dramatic bunker complexes (Bethpage), and intimidating green contouring (Oakmont).

Augusta National Golf Club

Length: 155–145 yards

Designers: Alister MacKenzie and Bobby Jones

Opened: 1933

Location: Augusta, Georgia, USA

It is both beauty and beast. Called Golden Bell, it nestles in the middle of the three holes golf writer Herbert Warren Wind dubbed "Amen Corner" for their pivotal influence on the outcome of every Masters Tournament since its 1934 inception. While thirteen is classic risk-and-reward, eleven and twelve are exercises in caution where par really does equal perfect. Ask any Masters invitee — he'll gratefully take three at twelve every day.

Augusta National Golf Club is built on a sweeping hillside, dropping 130 feet from the white antebellum clubhouse to Rae's Creek, which fronts the twelfth. When he sketched the hole, Alister MacKenzie noted, "The tee is high ground from which the green and stream are very visible. There is a deep sandy slope covered with trees beyond the green. The bold player will go for the pin on the right while the less ambitious will steer for the larger landing space on the left side of the green." Acknowledging its ability to ruin a round, Jack Nicklaus's strategy has always been to "aim at the center of the green no matter where the pin is placed."

Statistics back up Nicklaus's caution: the twelfth ranks as the second hardest hole at Augusta. The worst consecutive scores in a tournament were 3-11-4-4 by Dow Finsterwald; in 1980 Tom Weiskopf recorded the highest single score: 13. On the positive side, Scott Verplank went 2-2-2-2 in 2003, and there have been three holes in one.

The twelfth is a model for Augusta National's never-ending pursuit of perfection. At one point it was decided, because of the extreme shade and resulting possibility of frost, that the twelfth green be equipped with its own underground heating and cooling system to ensure perfect putting conditions. While not as severe as other Augusta greens, it does have some back-to-front slope and still demands a precise touch, especially when you putt or chip from above the hole. On Masters Sunday the pin placement is right and a bit below center — protected by the bow-tie bunker that hugs the middle of the green.

Completing the defense are two side by side medium-size bunkers back right along with the signature golden bells, azaleas, pine needles and trees.

The big worry is coming up short on the manicured bank that slopes down to Rae's Creek. But the major hazard is the wind. Because the hole lies at the course's lowest point and the pine trees have grown to heights of 50 feet, erratic wind behavior is a constant. Players take more time tossing grass, checking treetops and changing clubs on the twelfth tee than any other hole.

The history of twelve is replete with every kind of fortune-changing story. At least a dozen Masters have been won or lost here. The most miraculous shot, since it defied the laws of physics, was Fred Couples' too-short approach that hung on the front bank long enough for him to make a deft chip and get down in three on his way to winning. Or, recall the two free drops Arnold Palmer received in 1958 and 1960, when he won, and his triple-bogey 6 in 1959 when he lost by two.

In the rhythm of Augusta's eighteen holes, twelve is the one-shot challenge that focuses the players to the max, demanding every bit of skill and nerve to play it well.

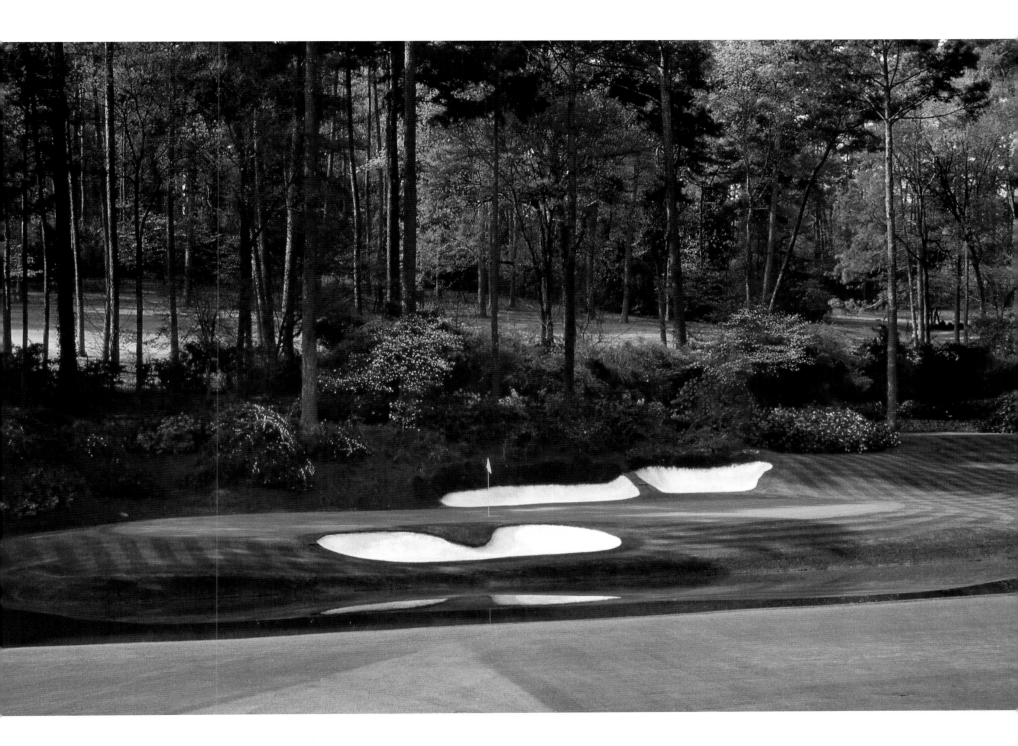

"The most dangerous par three in the world." — JACK NICKLAUS

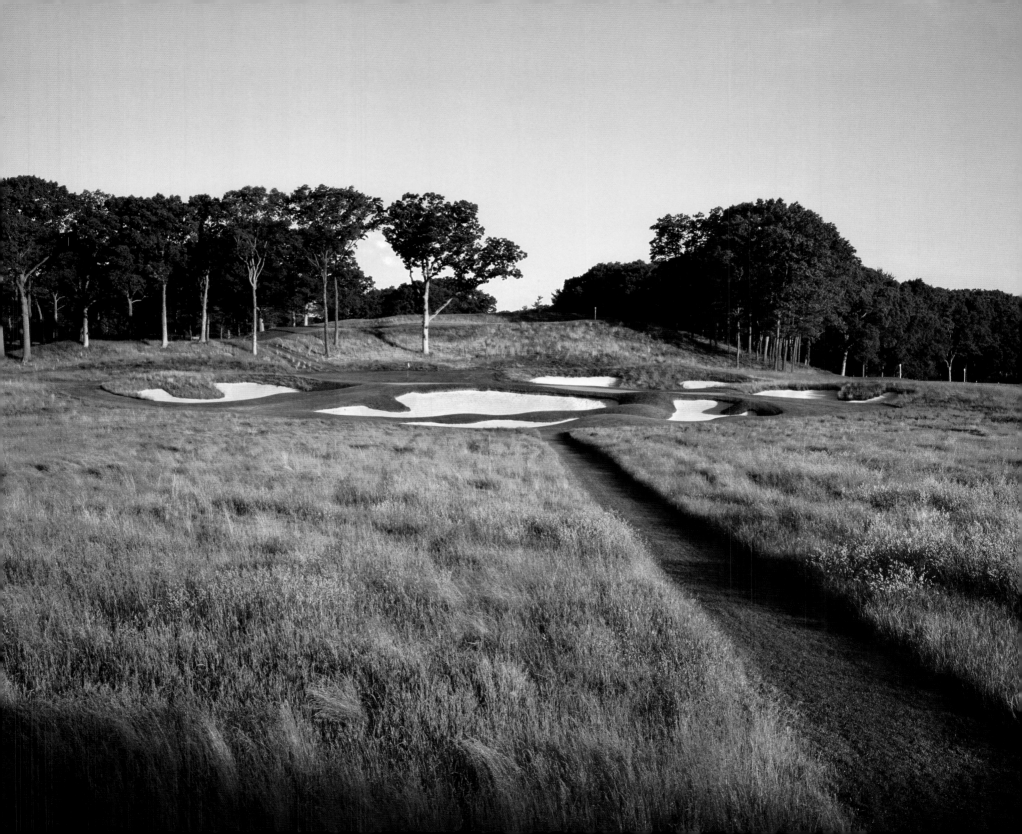

Black Course at Bethpage State Park

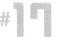

Length: 207–178 yards

Designers: A. W. Tillinghast/Rees Jones

Opened: 1936

Location: Farmingdale, New York, USA

"Tillinghast's work at Bethpage serves as a thesis on how to bunker a course."

— GOLFCLUBATLAS.COM

The Black Course at Bethpage State Park on Long Island is remarkable for many reasons: It has characteristics similar to Pine Valley; the holes and their features are "huge and enormous"; and even after two U.S. Opens, anyone willing to endure the extraordinary wait (five to seven hours) for a tee time can play at a fair price given its high ranking among America's best courses.

The USGA's Executive Director David Fay deserves primary credit for realizing this A. W. Tillinghast masterpiece had suffered from neglect and deserved not only restoration but a place in the U.S. Open rota. Working with Rees Jones, the USGA went back to Tillinghast's original drawings and completely restored this marvelous, rolling sand-ridge layout.

Of the five courses at Bethpage, the Black is described on a sign near the first tee as "an extremely difficult course which we recommend only for highly skilled golfers." Number seventeen fits this description and also illustrates the overall challenge Tillinghast wanted to achieve. Like most of Pine Valley's holes, the 210-yard tee shot demands a full carry to a slightly elevated green that slopes from left to right. Three huge bunkers in front guard almost every foot of the 140-foot long putting surface. Two more back right await shots that go long. It's also the shallowest green on the course.

There is a small tongue of grass between the bunkers to the left, and if you're short, and lucky, you may land here. During the 2009 U.S. Open Phil Mickelson and David Duval, playing together and tied for the lead after seventy holes, both hit their tee shots to this sliver of turf, with a solid chance to save par. Both failed and lost their chance at the title. Consequently, the seventeenth became a part of Open history.

Pros will hit four and five irons to reach the green. Average players will need metal wood or hybrids, especially if they want to reach the left upper tier. With its great size and spine in the middle, getting down in two putts can be difficult. At the Open the hole is ringed by spectators perched on mounds and bleachers, adding to the pressure. As one writer described the experience, "when encountered for the first time, (the seventeenth) strikes fear into the hearts of many."

Lake Course at The Olympic Club

Length: 223–187 yards

Designers: Wilfrid Reid/Willie Watson/Sam Whiting

Opened: 1924

Location: San Francisco, California, USA

"Except for the short holes there is no such thing as a straight line at the Lake Course." — OLYMPIC CLUB MEMBER

For a golf course located in San Francisco, a cluster of holes called "Earthquake Corner" is very appropriate. Unlike many layouts that wait until the second nine to challenge you, Olympic's Lake Course does it from the get-go. Quake Corner is a four-hole stretch — third to the sixth — and includes three of the most difficult holes on the course. Ranked as the eleventh toughest, number three is no slouch either.

After completing a 500-yard opener followed by a modest-length par four, golfers playing from the back at three can reach for a wood-length club. From the tips the hole plays to 247 yards (223 and 205 yards from the shorter markers). Depending on the time of year and time of day, you may be hitting through fog or sea mist that deadens the flight of your ball and makes the hole play longer. Also, the two large bunkers adjacent to the green can make you think the green is closer, so calculate accordingly.

The tee box presents a view of the Golden Gate Bridge and the Marin County headlands. Like most of Olympic's holes, it is hemmed with trees, some of the 30,000 on the course, but unless you duck hook or shank, they won't be a factor. Pay attention to the two trees left and right that appear to pinch your approach to the hole.

The green is tilted, about seven feet from left side to right. The toughest pins are back right. The far bunkers, right and in back, are the designers' way of keeping your ball from disaster; that is, rolling down the very deep slope right of the hole. The sizable apron in front offers a lay-up-and-chip approach.

A member points out, "Don't expect too much respite once you reach the sanctuary of the small greens, because most of the putting surfaces seem to present you with permanent downhill putts." And while the atmosphere and fairways may be wet, the club keeps its greens dry and fast. Historically, number three green was the scene of a dramatic moment in the 1955 U.S. Open playoff between Ben Hogan and the unheralded Jack Fleck. Hogan hit to within two feet while Fleck ended up 20 feet away. Fleck calmly rolled in his birdie and Hogan, uncharacteristically, flubbed his short putt and never righted himself, losing out on a fifth Open title, 69 to 72.

All in all, number three is a formidable short hole that's enough to make even great golfers quake.

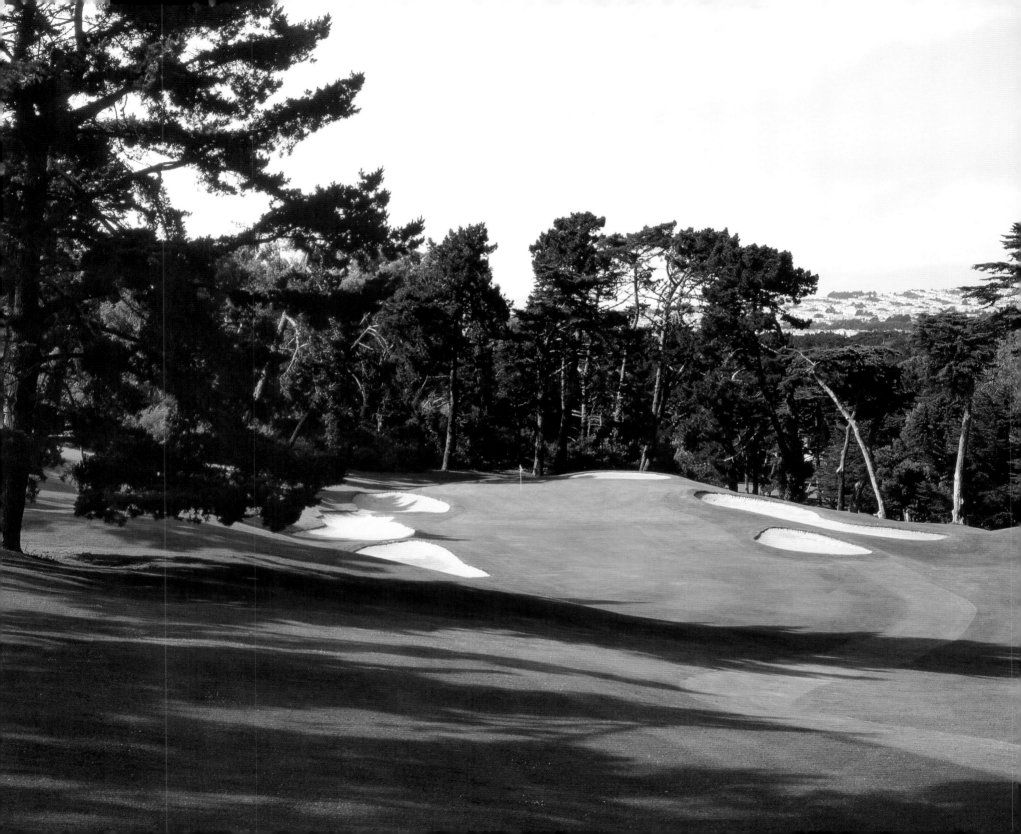

No. 2 Course at Pinehurst Resort

Length: 206–125 yards

Designer: Donald Ross

Opened: 1907

Location: Pinehurst, North Carolina, USA

"It's hard to get mad when you're playing golf at Pinehurst."

— JOHNNY MILLER

Well, that's not entirely true. While the fairway experience is generally pleasurable, play around the greens might cause some heartburn. Tom Doak has said of Pinehurst No. 2, "Those green complexes give it a personality unlike anything I've ever seen."

Design parlance is rife with the term "green complex." In the hands of Donald Ross complex is the key word. Ross spent forty-one years refining the No. 2 Course in order to make sure golfers experienced such subtleties. In his own words, "This mounding makes possible an infinite variety of nasty shots that no other form of hazard can call for . . . competitors whose second shots have wandered a bit will be disturbed by these innocent appearing slopes and by the shot they will have to invent to recover."

All of these defenses are definitely on display at Pinehurst No. 2's par threes. You wait until number six for the first, a longish (200 yards) shot that demonstrates the Ross principle that unless you can play a good long iron you won't hold his greens. At 175 yards number nine is the shortest hole on the course; it features a two-tiered green and a ridge running from front to back. The stretch run includes two one-shot holes.

The fifteenth measures a bit over 200 yards and combines one of Ross's most severely crowned greens with a false front, both aimed to repel your tee ball. Adding to the difficulty are two deep bunkers on the right as well as one front left that brings delicate sand play into the mix. Splashing a recovery to the top level of the green forces risky choices about a correct putting line and speed; pins are invariably placed near the downslopes that, calamitously, guarantee a return putt or even a pitch back up the slope. During U.S. Opens and other tournaments held here, the fifteenth always posts a high scoring average.

Local advice on how to play number fifteen and all of the other greens on Pinehurst No. 2 includes: 1) bring your "A-level" short game, especially a solid bump-and-run shot, and 2) take a caddie and listen to what he or she has to say about the line of your putt. Then invoke the spirit of Payne Stewart, whose masterful display of putting on the Pinehurst No. 2 greens in the final round of the 1999 U.S. Open was his key to victory. For the rest of us, pars on any of the short holes will be trophy enough.

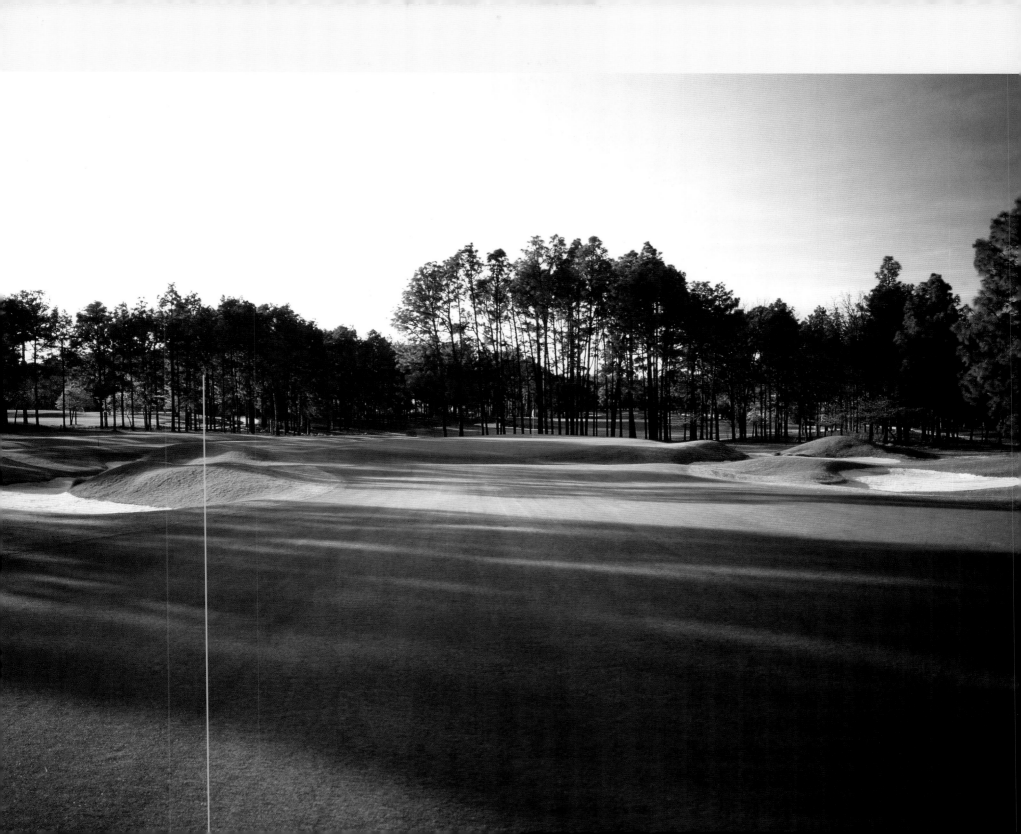

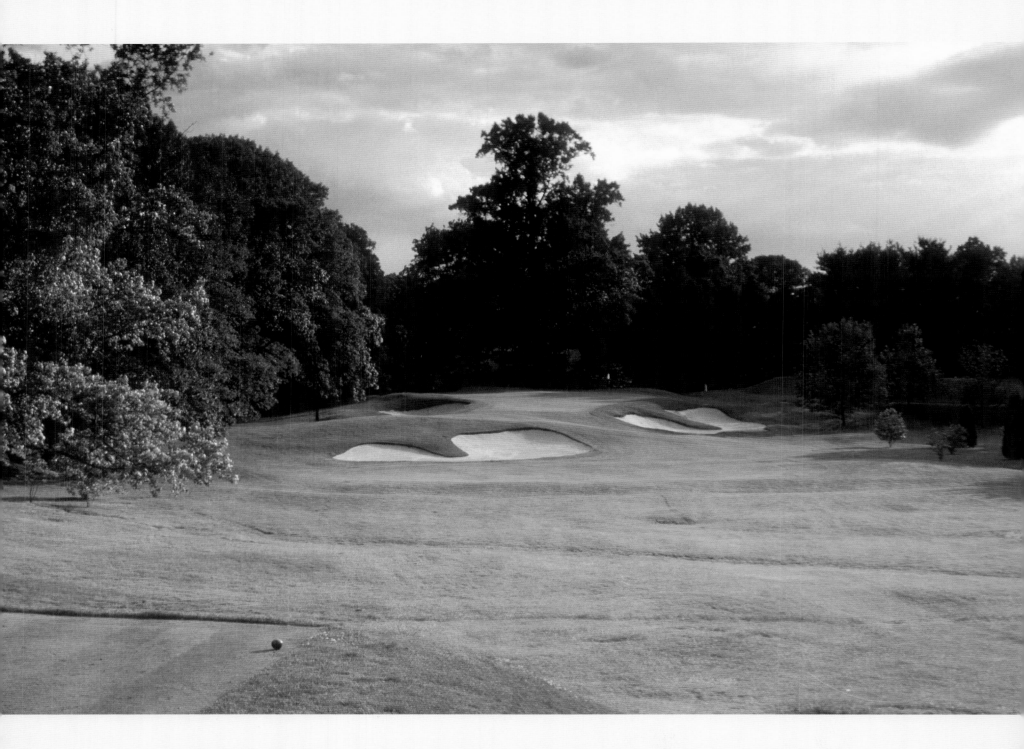

"A three iron into some guy's bedroom." — BEN HOGAN ON GOING LONG AT WINGED FOOT'S TENTH HOLE

West Course at Winged Foot Golf Club

Length: 183–106 yards

Designer: A. W. Tillinghast

Opened: 1923

Location: Mamaroneck, New York, USA

Actually, for today's pros it's more like a seven or six iron, but the hole itself is no easier. When you finish the West Course's front nine and make the turn to the tenth tee, get ready for what may be the most perfect example of A. W. Tillinghast's dictum, "a controlled shot to a closely guarded green is the surest test of a man's game." Creator of some of golf's finest courses and best holes, Tillie himself said this was the best par three he ever made. He dubbed it "Pulpit."

Dave Marr, 1965 PGA champion and one-time assistant pro, declared, "Winged Foot is to golf what Yankee Stadium is to baseball." From its inception the club has been a regular venue for just about every golf tournament of consequence. Its stately English-Scholastic clubhouse is home to one of the lowest-scoring memberships in America. Their specialty is playing the bunker shot. The reason: There are seventy-plus bunkers on Winged Foot and most are trouble.

Tillinghast made bunkers like snowflakes, each utterly distinct. His general norm dictated, "Their slopes should be irregular, and the mound work ruggedly natural." A course critic says of Winged Foot's bunkers, "The greenside (bunkers) are at once punishing and beautifully controlled." Number ten has two, kidney-shaped and flanking the green right and left. They are severely sloped, more than six feet deep, and unless you play bunker shots like the members, the odds are 50-50 they'll cost you strokes. A third, small bunker short of the green is technically out of play but can distort distance recognition.

Lest we forget other features: Waiting for hooks left are trees, that bedroom (in a house owned by six-time Winged Foot club champion Buddy Stuart and not that far from the green), plus out-of-bounds to penalize over-clubbed tee shots. The elevated generously sized green originally sloped from back left to front right, was severely contoured, and offered many tough pin positions. Writer Dick Schaap said it was "more difficult to read than a Joycean novel." In the 1980s designer George Fazio softened these twists and turns, and the club usually keeps the speed at a reasonable 10.5 on the Stimpmeter.

It easy to see why Tillinghast loved this hole — it's straightforward, but rich in hidden touches that continue to confound even the best.

Alwoodley Golf Club

#11

Length: 175–139 yards

Designers: Alister MacKenzie and Harry S. Colt

Opened: 1907

Location: Leeds, West Yorkshire, England

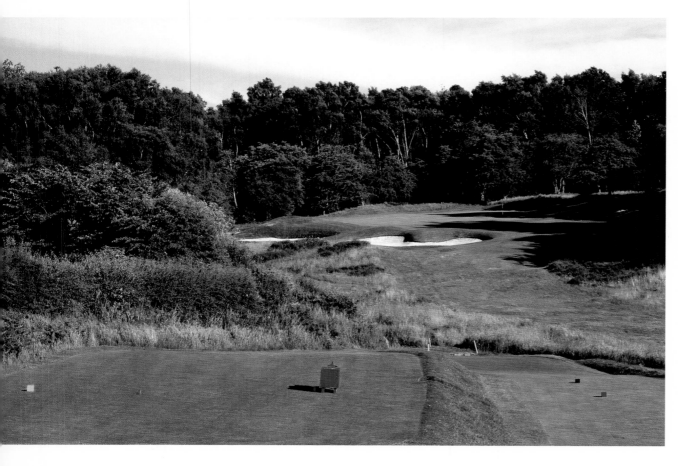

Alvoodley holds a special place with golf historians because it was here that Alister MacKenzie formulated many of the design concepts that made him one of the greatest architects of all time. Set in a copse of attractive trees, the eleventh illustrates what he could do with a one-shot hole. He shaped the putting surface so that it slopes severely from back to front and right to left. Thus, the successful shot should land on the right side, allowing the contours to bring the ball back to the center of a green that is well bunkered on both sides. Miss the green left and you are in serious trouble.

Essex County Club

Length: 175–154 yards

Designer: Donald Ross

Opened: 1908, Completed: 1917

Location: Manchester-by-the-Sea, Massachusetts, USA

#11

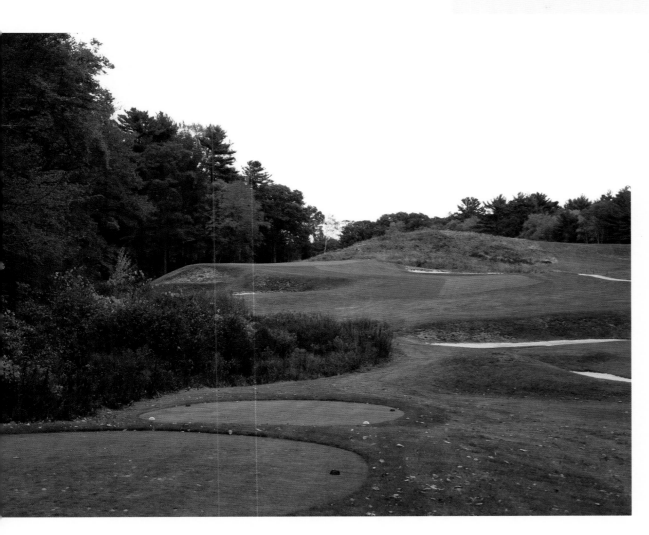

A jewel-box layout, Essex County Club was home to Donald Ross from 1909 to 1913 and he lavished special attention on each of its compact holes. Number eleven has been called "all-world" and for good reason. The uphill tee shot is a reasonable distance to a green elevated about 20 feet and defended by a Redan-like wall on its left side. Shots short left can carom off the graceful mounding or land in any of three shallow bunkers. Right are two very penal bunkers 150 feet long. The green has a mild slope, will accept a correct shot and allow for a reasonable two-putt. At once natural and full of artifice, Essex's number eleven is a testing mid-length one-shotter.

King's Course at The Gleneagles Hotel

Length: 158–113 yards

Designer: James Braid

Opened: 1919

Location: Auchterarder, Perthshire, Scotland

When noted British golf writer Henry Longhurst stated that short holes should be "bristling with bunkers," he must have had #16, called "Wee Bogle," at Gleneagles King's Course in mind. Of the famed British Triumvirate (Vardon, Braid and Ray), Braid was the best architect and like Alister MacKenzie he loved to fashion imposing pot bunkers as a major defense. Here he outdoes himself with nine sandy terrors arranged in a u-shape around a raised green that angles left to right and falls off dramatically in back. True to his role as a proponent of the dogleg hole, Braid offset the green of this little charmer so a golfer might choose to fade the tee shot. Either way, it will bring a keen edge to your swing.

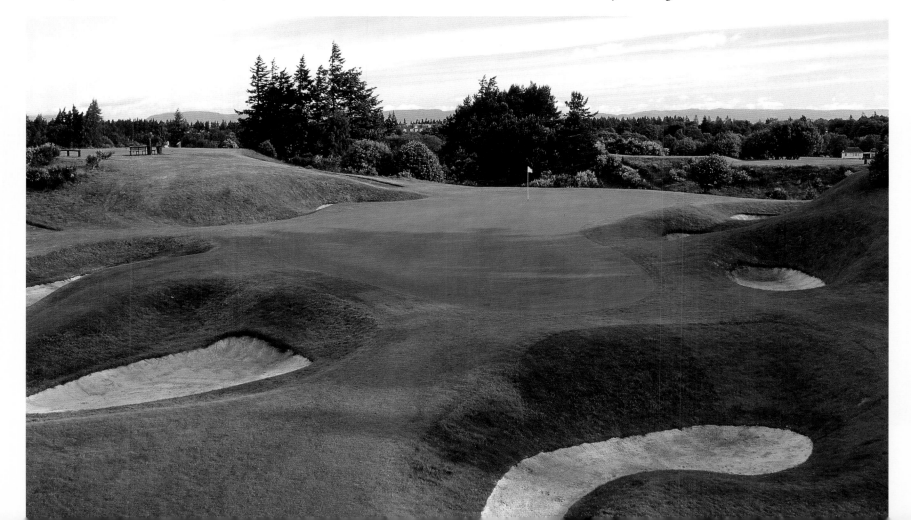

North Course at Los Angeles Country Club

#11

Length: 240–192 yards

Designer: George C. Thomas, Jr.

Opened: 1927

Location: Los Angeles, California, USA

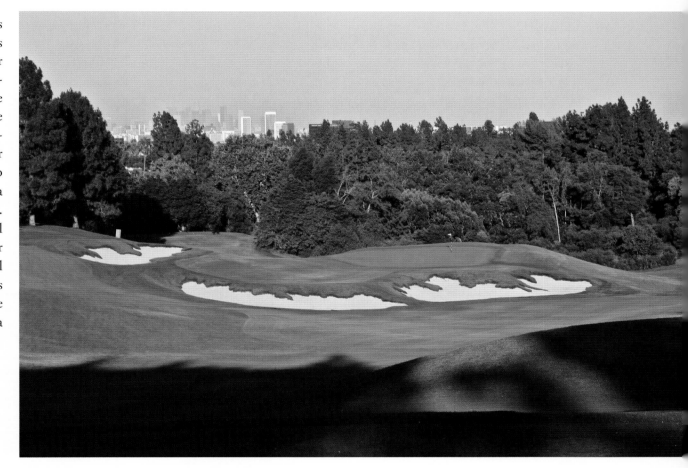

Los Angeles Country Club is one of the world's most exclusive, and a round on its North Course is to be treasured. One hole you are sure to remember is the signature eleventh, which features a reverse-Redan defense that calls for a faded drive into the green. Your tee ritual should include taking in the Los Angeles skyline rising above the trees that curtain the back of the green. When deciding your strategy, it helps to know Thomas wanted eleven to play three different ways — as a very long three, a short four (300 yards) or short three (front tees). Even with the downhill shot, only an adept few will fly the ball 240 yards to the green. You can aim over a bunker that is 40 yards short and let your ball roll on. Alternatively, the percentage play is Thomas's short-four approach. Find a good spot clear of the bunkers, pitch on and get a two-putt 4. That's a good score on a very difficult hole.

South Course at Oakland Hills Country Club

#13

Length: 191–131 yards

Designers: Donald Ross/Robert Trent Jones, Sr.

Opened: 1918/1950

Location: Bloomfield Hills, Michigan, USA

Oakland Hills Country Club's notorious reputation as a punishing tournament course is attributed to Robert Trent Jones, Sr., who revamped the original Donald Ross design for the 1951 U.S. Open, won by Ben Hogan. Hogan called it "this monster," and the epithet definitely fits the thirteenth where the green is ringed with seven bunkers, one of which is a deep pot no bigger than a kitchen table.

Jones did retain the classic Ross green contours, especially the distinctive hollow in the front, which is four feet below the upper surface. All the hole locations on the top plateau, only 25 to 30 feet deep, make club selection a difficult proposition — unless you are Hogan, who birdied it on his way to his self-proclaimed finest round, a Sunday 67 that brought the monster to its knees.

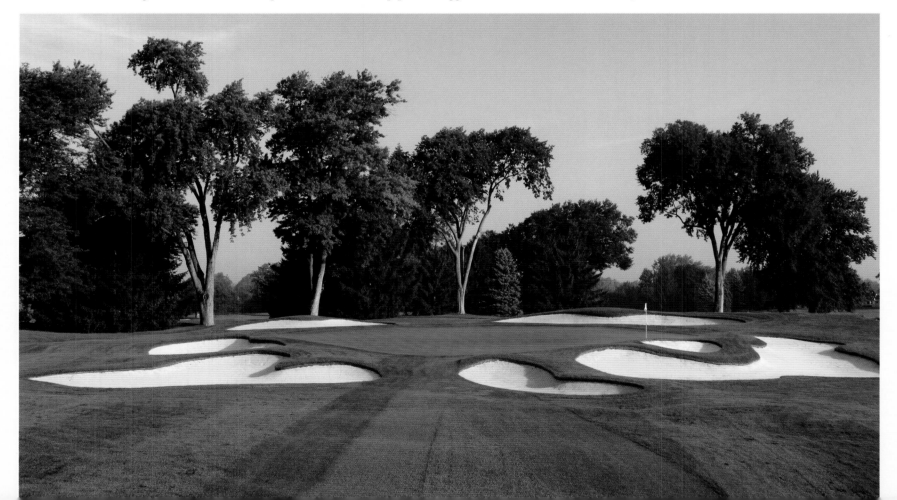

Oakmont Country Club

#8

Length: 288–185 yards

Designers: Henry Fownes and William Fownes

Opened: 1904

Location: Oakmont, Pennsylvania, USA

In the ratings for "toughest course in the world," Oakmont places in the top 10. And that's the way Henry Fownes wanted it. Originally, he installed 300 bunkers, now reduced to about 200. One of these is the major hazard at the eighth. Called "Sahara," it stretches along the left side of the hole for 100 yards, devouring weak and offline shots. Right, there are three smaller bunkers and a medium-size one nestling against the back of the green. The fairway has a mild bend to the left, which suggests short-hitters should lay up and take four. Oakmont's greens are the standard for speed, rolling 13 to 15 on the Stimpmeter; in, fact, it was at the 1935 U.S. Open at Oakmont that Edward Stimpson got the idea for his eponymous device used to measure the speed of greens. And, if you're wondering about the 288-yard tee listed above, it's the length set for the pros at the 2007 U.S. Open. With a large, flattish green, the USGA thought it a fair test. We're sure both Henry and William Fownes would agree.

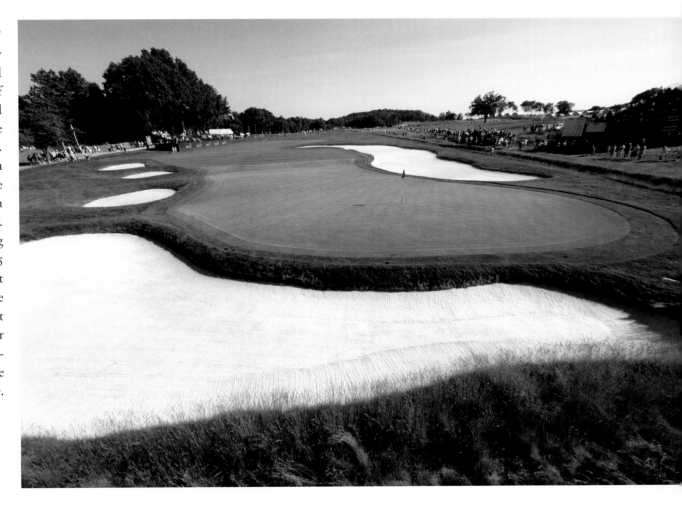

Valderrama Golf Club

Length: 206–146 yards

Designer: Robert Trent Jones, Sr.

Opened: 1974

Location: San Roque, Cádiz, Spain

Called the "Augusta National of Europe," Valderrama is one of the best-conditioned courses in the world. The approaches are mown so finely that players sometimes can't tell when they are on the putting surface. Two winds mingle here — Poniente from the west and Levante from the east. They move constantly and influence every shot. Lining the holes are 2,000 cork oak trees. The fifteenth is the longest of four very fine threes. Jones used the phrase "full painting" in describing the view of the Mediterranean from the elevated tee. You hit over a valley alive with natural vegetation to a slightly angled long and narrow green defended by three bunkers. Irish professional Ronan Rafferty's line about Valderrama definitely applies to fifteen: "You are always looking for pars; birdies are a bonus."

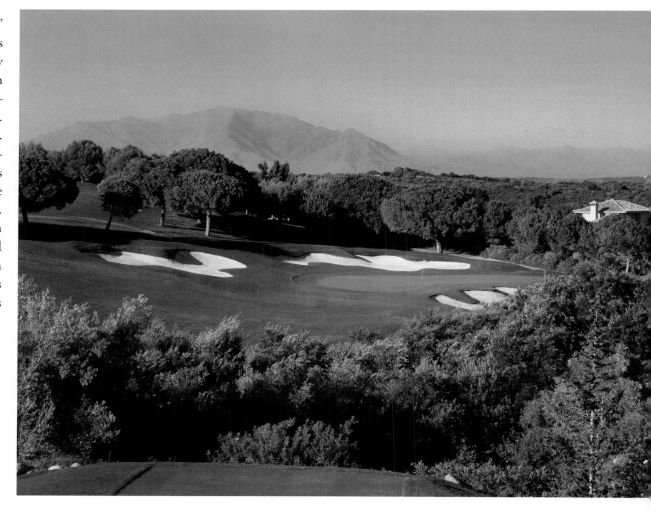

DROP SHOT HOLES

There are elevated tees, and then there are elevated tees. While most holes are on essentially the same plane, some, thanks primarily to the terrain or routing requirements, beg for a dramatic tee shot that sends the ball plunging to a green far below.

Drop shot holes afford some of golf's great vistas, such as the Canadian Rockies or Ni Pali wilderness on the Island of Kauai. They are exhilarating too, requiring a calculation golfers use only occasionally; that is, figuring the ratio of hole length to vertical drop in order to select the right club for reaching the green. One thing's for certain, it's always farther than it appears.

Here are six holes with drops ranging from 30 to 120 feet that demonstrate how spectacular and tricky a top-to-bottom hole can be.

Banff Springs Golf Club

Length: 199–79 yards

Designer: Stanley Thompson

Opened: 1929

Location: Banff, Alberta, Canada

Friendly and interesting as its principal cities are, the glory of Canada is its wilderness, of which the Canadian Rockies are the centerpiece. When the Canadian Pacific Railway finished building a trans-Canadian train route that ranked as one of the most beautiful in the world, they matched the scenery with a string of luxury hotels that resemble European castles and built one golf course in particular that achieved world-class recognition — Banff Springs Golf Club. Banff Springs' spectacular backdrops leave golfers gaping as they wend their way through the mountain routing, playing along and over the Bow and Spray Rivers and, in the case of number four (its signature hole), directly down a valley toward Mount Rundle, on which the hotel is perched.

Rated by *Golf* magazine as one of the four finest par threes in the world, Banff Springs' "Devil's Cauldron" deserves such an accolade. In the original layout done by gifted Toronto architect Stanley Thompson, this was the eighth hole that now plays as today's 199-yard fourth.

Without hyperbole, the views are Banff's first hazard. Allow time to enjoy them, but then focus on the task. At the fourth it consists of playing off a tee elevated about 80 feet higher than the green. It is defended, in order, by swirling winds, the glacial pond that requires a healthy carry, six artful bunkers whose shapes — in an aesthetic Thompson touch — mimic the ragged edges of Mount Rundle, and a concave green that can welcome a ball or whisk it away.

First, reckon the wind and factor it into this long drop shot, since the winds at your target may be different than those on the tee. The translucent glacial pond (created by an avalanche the winter the course was under construction) reveals balls that ended short, and its surface can make you think the green is closer. Thompson's bunkers ring the hole to capture balls off-line and they too foreshorten distance perception.

The green sits on a terrace and slopes front to back, both to receive your shot and to make sure water runs off. Beware front pin placements; land short and you may run back down the steep bank in front; land above the hole and putts may slide off the green and aggressive chips will end up in the water. In general, aim for the center of the green, and no matter what the situation, when you swing, don't do it by half.

"The Canadian Pacific Railway doesn't do things by half." — CPR PRESIDENT, WILLIAM CORNELIUS VAN HORNE

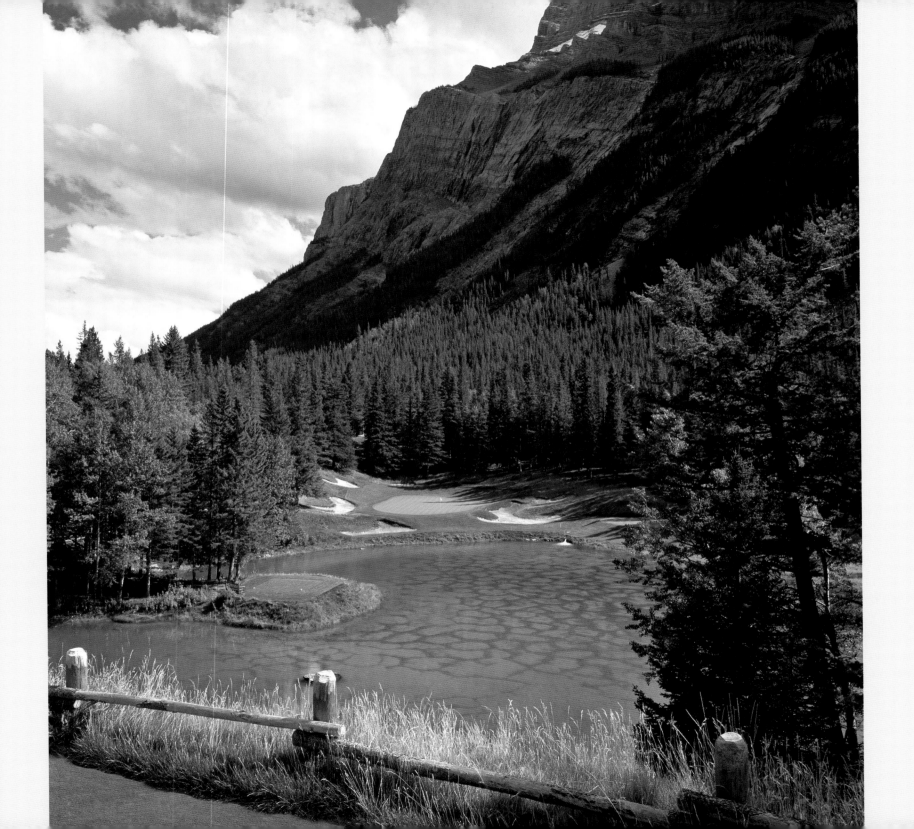

Sugarloaf Golf Club

Length: 216–150 yards

Designer: Robert Trent Jones, Jr.

Opened: 1985

Location: Carrabassett Valley, Maine, USA

"The next series of holes plays down, over and around the river like a chain of diamonds — these are the sparkling holes."

—— SUGARLOAF DESIGNER, ROBERT TRENT JONES, JR.

There are drop shot holes and then are drop-dead gorgeous drop shot holes. Summer or fall, Sugarloaf Golf Club's eleventh belongs in the second category.

You'll be going a bit off track to reach Sugarloaf. It lies in the remote western part of Maine, not far from the Canadian border and Quebec City. This limits the playing season, but during these months the views of Bigelow Mountain in particular are spectacular, in a class with Banff and its dramatic par-three fourth hole. You may feel your golf cart straining as you climb to the tee some 120 feet above the green and its major defense — the Carrabassett

River. Take a moment to scan the Carrabassett Valley and distant views that point to Canada. As a visitor quipped, "It's you and a million trees."

Drop shot holes require command of wind factors and club selection. Success means creating the right trajectory and letting the ball land softly enough to hold the green. At Sugarloaf's eleventh, there are two elevated tees, playing 216 and 190 yards. No doubt you get a clear view of the challenge. Jones has contoured the left side of the green against the twisting Carrabassett and tucked a small bunker there just for good measure. The river

crosses in front of the green to guard the target line. Push the ball right and you are in a stand of birch trees. Between these and the right side of the green is a large 120-foot bunker that flashes up to the fringe. Back left is a safety-net bunker and a small bailout area.

Jones has really built two holes here. Golfers opting to use the lower tees and not cross the river play down a fairway from a distance of 165 and 150 yards. In either case, reaching the green in one shot will be an achievement on a hole that combines finesse with mountain grandeur.

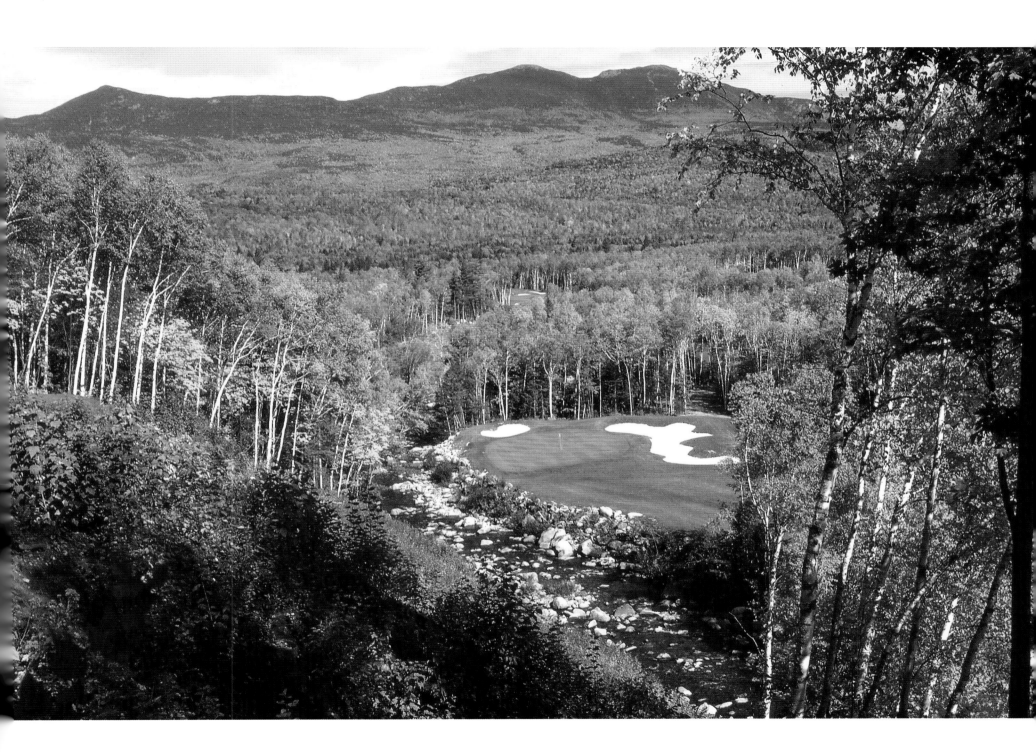

Mauna Kea Resort Golf Course

Length: 247–166 yards

Designers: Robert Trent Jones, Sr./ Rees Jones

Opened: 1963

Location: Kohala Coast, Big Island, Hawaii, USA

Often overlooked because of its more celebrated sister, the heroic #3, Mauna Kea's eleventh is an equally tough challenge. Proof: During a tournament, Jack Nicklaus bogeyed it three times running. From the tips, your tee ball must cover 247 yards while dropping a total of about 90 feet. The equation makes not for some precipitous plummet, but a carefully calibrated arc through tradewinds toward the distant green below. There is a generous apron of grass in front, and you can bounce on between bunkers front left and right. Rees Jones's 2006 renovation made the green a bit more receptive, but he also added new tiers and contours. Some things in life don't get easier.

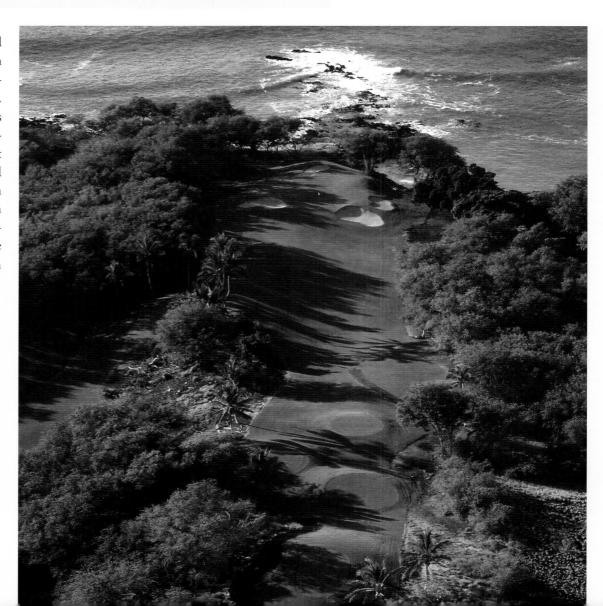

Makai Course at St. Regis Princeville Resort

#3

Length: 181–130 yards

Designer: Robert Trent Jones, Jr.

Opened: 1971

Location: Hanalei, Kauai, Hawaii, USA

Robert Trent Jones, Jr.'s gift to tropical golf, this magnificent, and very precipitous drop shot hole plays against the stunning background of the mountainous and mysterious Ni Pali wilderness on Hawaii's garden isle, Kauai. Any advantage felt from playing off the high tee overlooking the green is quickly tempered by the ever-present tradewinds and the small green fronted by a large pond. Selecting a cooperative club from your bag is most of the battle since the vertical drop to the green is 100 feet. When's the last time you got to practice this tee shot?

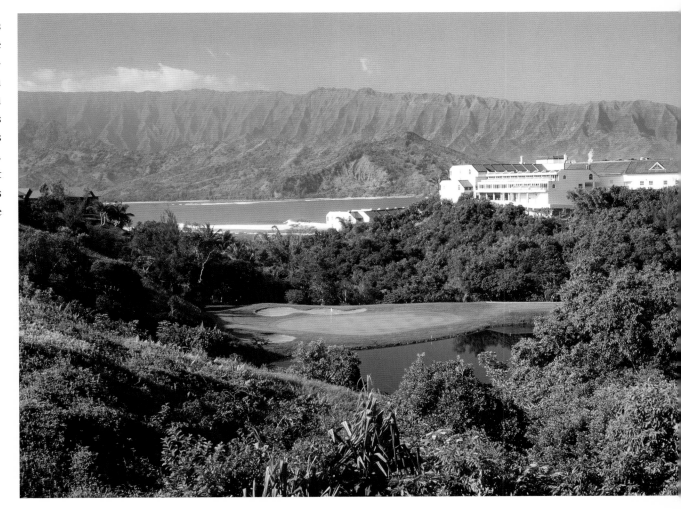

San Francisco Golf Club

Length: 184–166 yards

Designer: A. W. Tillinghast

Opened: 1915

Location: San Francisco, California, USA

#7

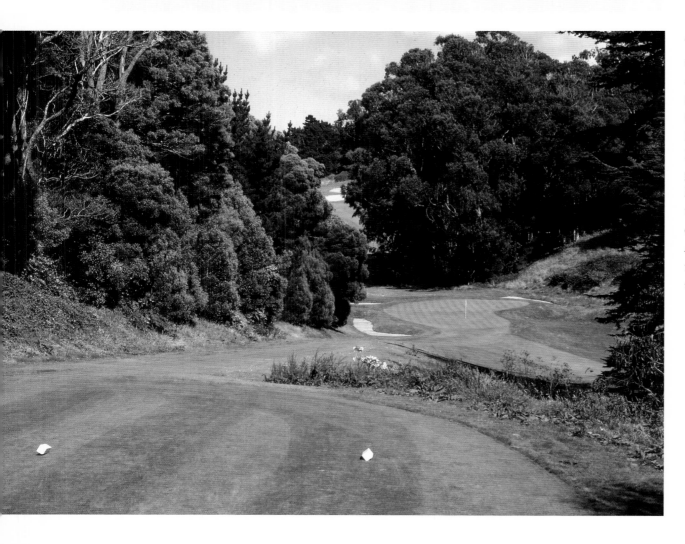

The design quality of the seventh at San Francisco Golf Club has often been overshadowed by its choice as the site for an 1859 duel between U.S. Senator David Broderick and Chief Justice of the California Supreme Court David Terry that ended in the senator's death. Thus, the nickname "The Duel Hole." These days the only dueling is between golfers confronting Tillinghast's gambit; specifically, how to negotiate the sizable 30-foot drop to the two-tiered green whose center is whale-backed and capable of bouncing balls into the bunkers behind. A stand of eucalyptus trees once framed the back of this hole, but they were removed several years ago, thus restoring a view of the eighth fairway.

North Course at Torrey Pines

#6

Length: 206–141 yards

Designers: Billy Bell and W. F. Bell

Opened: 1957

Location: San Diego, California, USA

The sixth at Torrey Pines' North Course vies with the third on the South Course for the most photographed of the par threes and gets the nod as a playing challenge. Don't rush in order to savor the view from a 75-foot tee elevation that overlooks the Pacific Ocean. You'll quickly see that far left and long will send your ball down a wicked slope. Play right and you have two bunkers to avoid. Winds rule here — in your face, and it's easily 200 yards; at your back, the distance shrinks to 150 to 180 yards. The medium-size green slopes sharply from back to front and to the right. A three that is beautiful, thoughtful and fair.

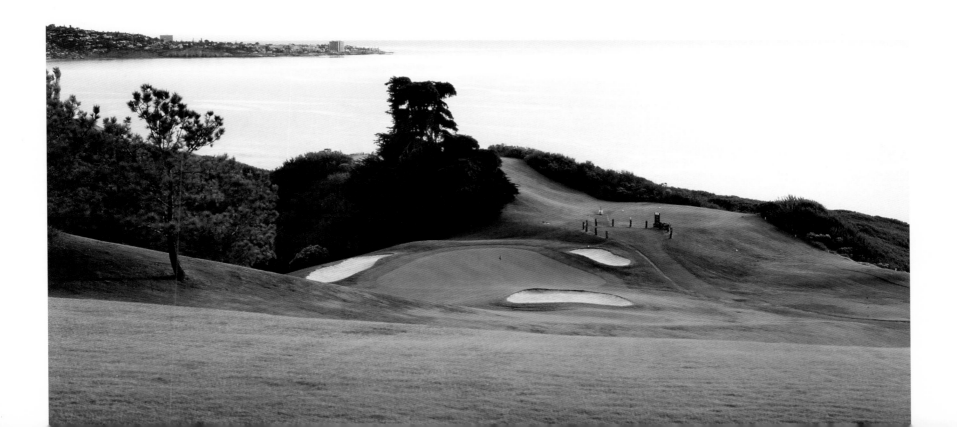

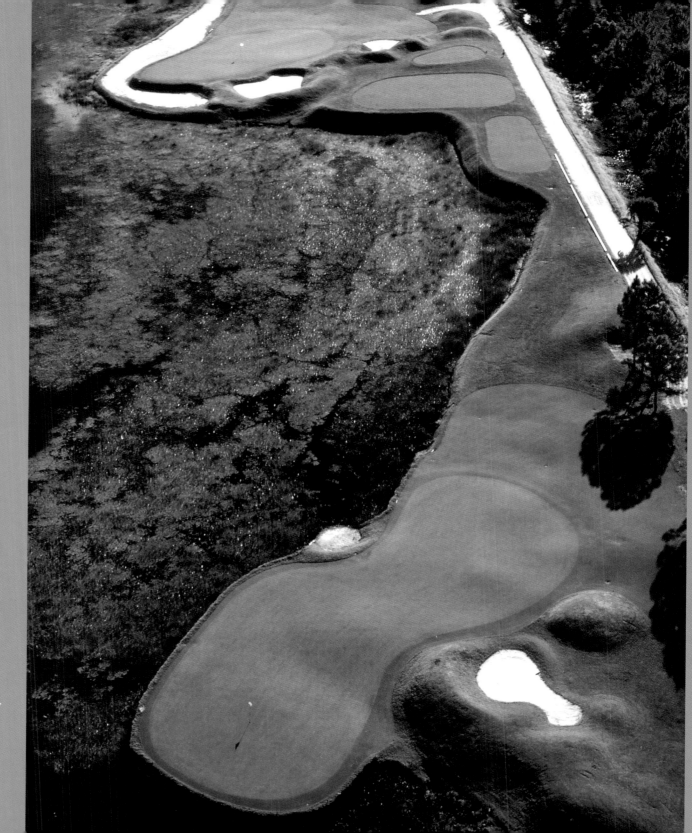

Pete Dye and the Everglades —
a match made in golfing heaven.
On land abutting the famous wetlands,
the eighth at Old Marsh is a master-
piece of form and function.

ISLAND AND PENINSULA HOLES

Golf's penal school of architecture never met an island green it didn't like. Whether ringed by water or sand, island-green holes are pretty scary for most golfers and generally exact an inordinate penalty if the tee ball lands anywhere but on the putting surface. The well known seventeenth at the TPC Sawgrass's Stadium Course sets the standard for undue punishment.

The island green's design cousin is the peninsula green, in which two-thirds to three-quarters of the putting surface is exposed to water or sand. Architects who want to be fair — not all do — build in bailout areas of grass and safety bunkers around their island and peninsula greens. If your recovery skills are good, you may land in one of these and still make par.

Here are eight island- and peninsula-green holes that amply demonstrate what "risk and reward" is all about.

The Kittansett Club

Length: 167–121 yards

Designers: William Flynn and Frederick Hood

Opened: 1922

Location: Marion, Massachusetts, USA

During the 1978 Massachusetts Amateur held at the Kittansett Club, a young contestant, pummeled by forty-miles-per-hour winds blowing from the nearby coastline, asked a long-time member, "Is it always like this?" The reply: "No, usually it's windy." An aerial shot of the course reveals why. The Kittansett Club sits along the flat shoreline of Buzzards Bay across from Cape Cod, thus exposing the course's spit of land to winds of all stripes, including hurricane-force gales.

Kittansett is Native American for "near the sea," though standing on Kittansett's third tee you might feel like you're in the sea. It laps at the rocks a few feet to your right and extends in a sandy arc all the way to the green surrounded by more sand. But it's not the water you need fear. The two major obstacles to par are purely natural —wind and unkempt sand, both in their own way unpredictable.

There is always some kind of wind. In summer it might be left to right and carry your ball to a water landing. If there's a big blow, who knows how it will affect your shot? It's launch-and-hope time. Number three also gives new meaning to the golf term "on the beach." While you try to guide your ball over 150 yards of water through whatever wind to the small green, you must keep it from landing in an expanse of sand that measures about 50,000 square feet, totally encircling an elevated green.

Kittansett's greens are kept at 10 to 11 on the Stimpmeter, so reaching the slick putting surface is only half the task when trying for par or birdie. Big hitters will need only a short iron, but distance is not the point. Precision and some luck are the essence of this windblown one-shotter. If you haven't guessed, Kittansett #3 is an entry in the Puritan Purgatory Hall of Fame. Only the skillful tee ball succeeds. All others are punished in some measure.

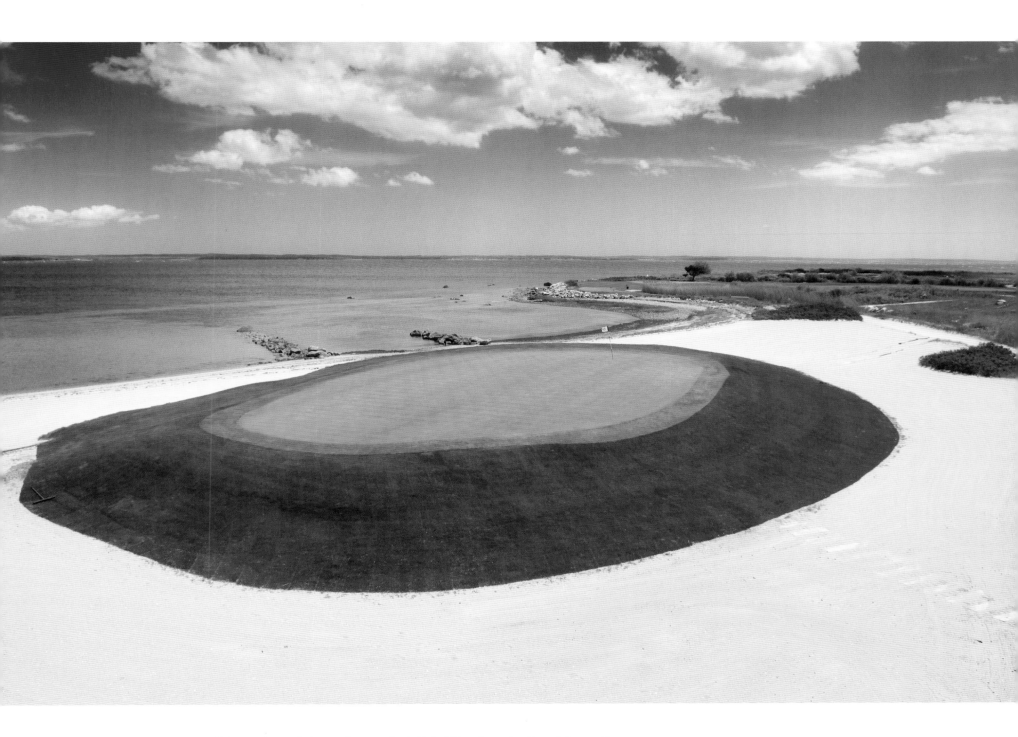

"True, the celebrated one-shot third lived up to its pictures." — GOLFCLUBATLAS.COM

Stadium Course at TPC Sawgrass

Length: 132–80 yards

Designers: Pete and Alice Dye

Opened: 1980

Location: Ponte Vedra Beach, Florida, USA

"The easiest par five on the course." —— PGA CHAMPION, JOHN MAHAFFEY

Call it golf's version of a Roman amphitheater. At the original spectators came for blood — either gladiator or Christian. At Sawgrass's seventeenth during the Players Championship some 20,000 fans gather on huge mounds overlooking the hole to see the world's best players sweat blood on the tee, or worse, fall on their swords when they ruin a chance for victory on the seventy-first hole of the tournament.

While an estimated three million balls have found a watery grave in Lake Balata, the man-made pond that surrounds and guards the green, at least a million words have been written trying to convey why this par three has become one of the best known and most feared in the golf universe. Three might suffice: humiliation, death, television. Humiliation: Watching gleefully as the world's best, or your opponent in a small wager, douse one, two

or three balls, and try to look graceful while doing it. Death: The tee shot either reaches the safety of the green site or you must reload and try again and again and maybe again. Television: Since the course became the venue for the Tournament Players Championship (now the Players Championship) in 1982, a multitude of viewers have seen its salient features — timbered retaining wall, small pot bunker and narrow walkway. From a sky-cam, it resembles a water-bound evil eye fraught with terror.

Pete Dye's first version was a relatively mild-mannered one-shotter with a splash of water on the side. However, prompted by his wife, Alice, who saw its full potential, it became the most terrifying hole on a course so vilified when first opened that Dye had to soften it up.

Playing at 132 yards from a perfect lie to a 3,900-

square-foot green with a short iron, the shot sans water would be easy. But the finality of a wet ball is the essence of the hole. The green has two shelves, and the front tier is lower than the back tier. The small pot bunker is on the right bottom portion of the green. The Sunday pin position is usually just right of the pot, so Tour players aim for center or center-left. From there putts have to negotiate a ridge that can speed a ball past the cup.

Over the years the pros have averaged around 3.3 strokes. There have been two aces since the TPC moved to Sawgrass in 1982. The highest tournament score belongs to Robert Gamez: 11. There are no records kept on regular players' scores. Mahaffey's quip about an easy par five is probably the norm for average golfers. When in doubt, take pro Darren Clarke's advice: "Close your eyes and hit it quick."

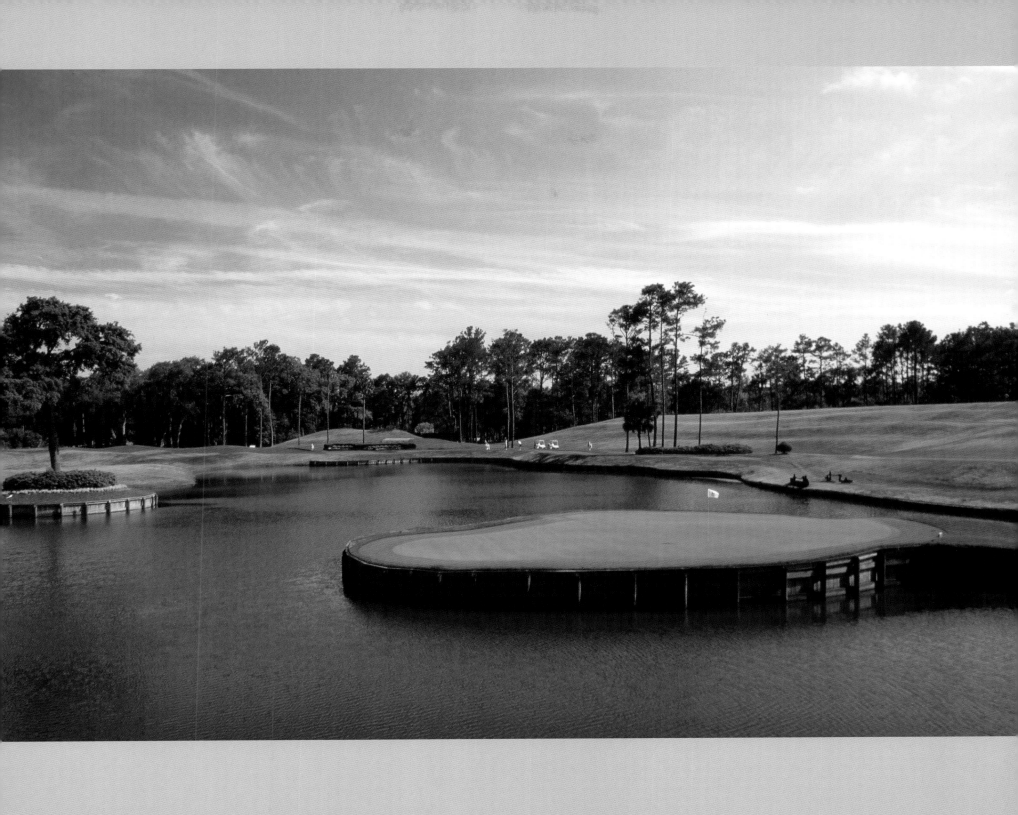

Coeur d'Alene Resort Golf Course

#14

Length: 218–95 yards

Designer: Scott Miller

Opened: 1991

Location: Coeur d'Alene, Idaho, USA

This hole is a wonderful conceit: Taking the evolution of the island green to the outer limits of the concept, Coeur d'Alene's fourteenth is not only an island green, but one afloat and equipped to be very short or long (see yardages above). Usually it sits out in Coeur d'Alene Lake at about 150 yards, affording a manageable distance for most players. But it's still all or nothing, and the drop zone is a mere pace away from the tee markers. If you miss with your first shot, tee it up and try again. Players are transported by the Putter Boat to the 15,000-square-foot green where all putts are said, humorously, to break toward the water.

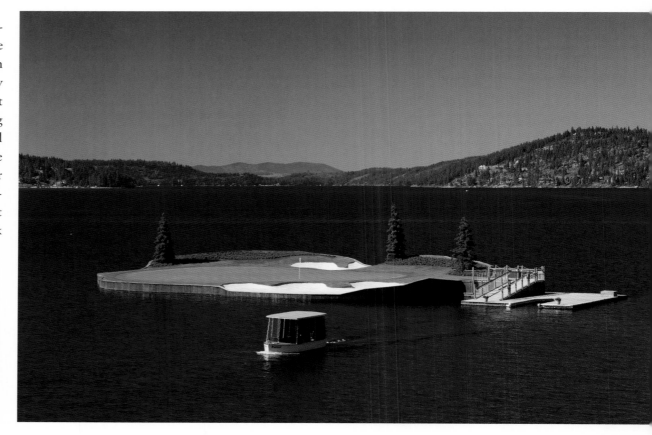

Saint Endréol Golf Club

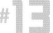

Length: 260–109 yards

Designer: Michel Gayon

Opened: 1992

Location: Var, France

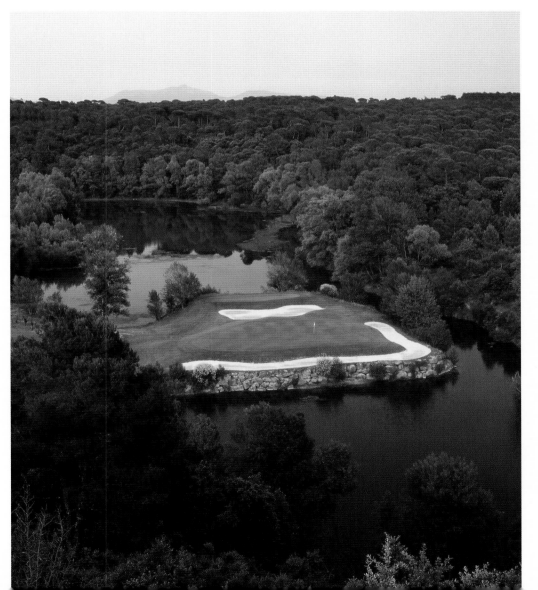

Not far from two of France's best-known locales, Provence and the Côte d'Azur, the Saint Endréol Golf Club is situated in the shadow of the famed Rocher de Roquebrune. The terrain is described as seductive and capricious, and this would surely apply to the course laid out by noted French architect Michel Gayon, who set each hole in isolation among beautiful stands of trees. Nowhere is this better exemplified than at the signature thirteenth, where the green is set on a peninsular arm jutting into the rushing Endre River. The tees are stepped along a high bluff overlooking the target, which lies some 30 feet below. Thus, Gayon melds two design challenges — a drop shot to a green closely protected by water. And from the pro tees he requires a prodigious drive of some 260 yards. "Avec la viande," as the French would say. For regular players, less onerous distances apply. The green is sufficiently large to hold any shot that reaches its surface. A long strip bunker guards the entire front and right sides and summons comparison to C. B. Macdonald's designs. Easily one of the most beautiful and demanding island-style threes in the world.

Gold Course at Golden Horseshoe Golf Club

Length: 169–97 yards

Designer: Robert Trent Jones, Sr.

Opened: 1963

Location: Williamsburg, Virginia, USA

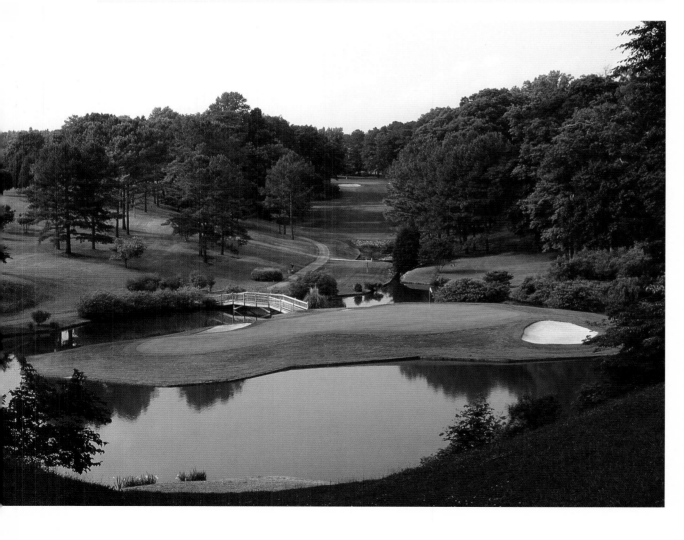

Island greens are not the sole province of Pete Dye, as evidenced by the very fine sixteenth at the Golden Horseshoe, designed by Robert Trent Jones, Sr., who knew a thing or two about water holes. Reaching the putting surface of this hole requires a calm, purposeful swing. But Jones eases the strain a bit with a generous target, a 9,500-square-foot green set on a 30,000-square-foot island. The green is also guarded by large, shallow and potentially saving bunkers. Jones had deep affection for the Golden Horseshoe and once told his associate Roger Rulewich he considered it one of his best.

Kemper Lakes Golf Club

#17

Length: 203–82 yards

Designers: Ken Killian and Dick Nugent

Opened: 1979

Location: Kildeer, Illinois, USA

Kemper Lakes is one of the "Big Shoulders" courses Chicagoans love to tout. It's long (7,200 yards), rolling, tree-lined, dotted with bunker complexes, has large greens and demands big carries, some over water. Number seventeen combines all these features, making it the logical choice as Kemper's signature hole. Just after you've survived number sixteen, the toughest four, you come to the next tee and look out at 180 yards of water stretching toward a two-tiered, heavily contoured, bunkered green wrapped in a wooden retaining wall and measuring 50 yards front to back. Big Shoulders for sure.

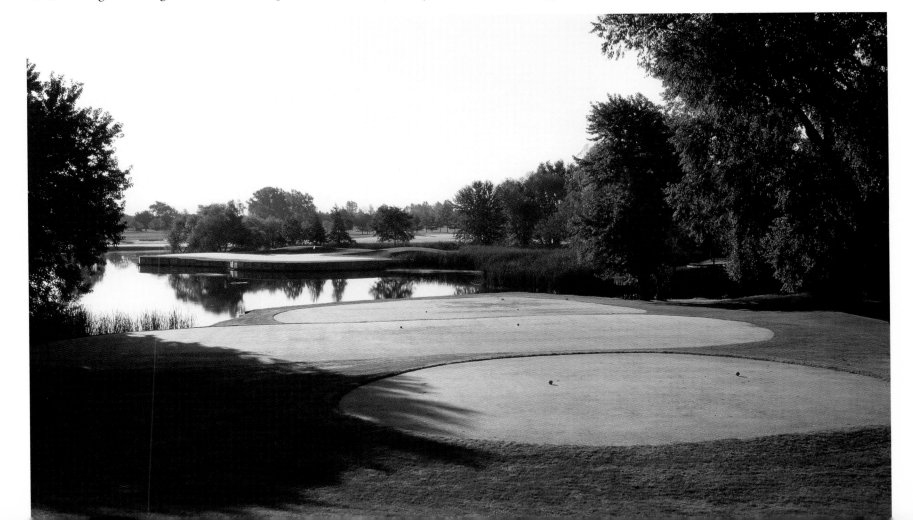

Ocean Course at Ponte Vedra Inn & Club

Length: 144–105 yards

Designers: Herbert Bertram Strong/Bobby Weed

Opened: 1928

Location: Ponte Vedra Beach, Florida, USA

Not far from the Ponte Vedra Inn & Club lies the most famous island hole in the world — TPC Sawgrass #17. But its progenitor is here. In 1928 Englishman Herbert B. Strong was given a former mining site marred with trenches and piles of sand. Out of this Strong built the Ocean Course's ninth, the prototype for island water holes. His version was meant to be fair. An aerial view shows an island, kissed lightly by a cart path and surrounded by water. The green, though, is only a quarter of the island, leaving some room for error. There are seven bunkers. Two of these front right guard shots aimed at the heart of the green. One front left forces a long bunker recovery. The four in back act as safety nets. Front left, there is a generous landing area of some 30 yards. Your odds of staying dry are good here. It's the two-tiered and slick green that imperils your par. Regardless of your score, you get to play a course-design touchstone.

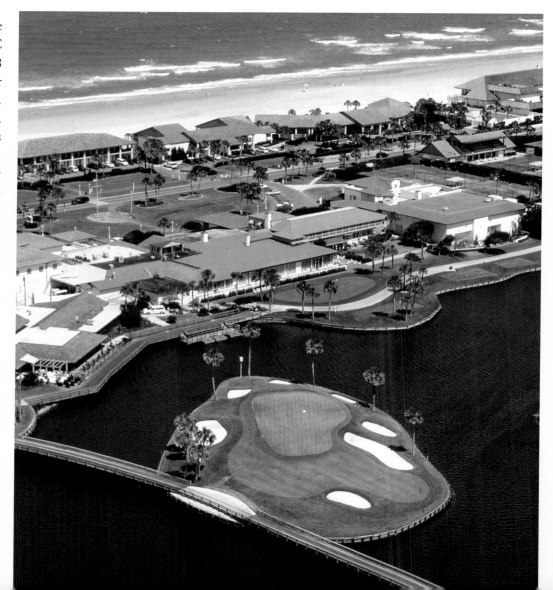

The mental game is enhanced when an island green appears at the close of a day's round, especially when crafted by a master of misdirection. After creating his island-green masterpiece, number seventeen at TPC Sawgrass's Stadium Course, Pete Dye found himself flooded with requests for copies, most of which he declined. He did agree to one in the arid Coachella Valley of Southern California. Such on-or-wet holes terrify all levels of players, since a good round can be erased with one bad swing . . . or two or three. That it comes at the seventeenth hole only adds to the misery. Even though pros call it "Alcatraz," PGA West's version is not a

#17

TPC Stadium Course at PGA West

Length: 168–83 yards

Designer: Pete Dye

Opened: 1986

Location: La Quinta, California, USA

maximum security prison. For one, the tee is elevated, ensuring a full view of the green surface, and while the surrounds are boulder strewn, the mid-iron distance allows a fuller swing, with less finesse than needed at its shorter Florida sibling. The putting surface is straightforward, mostly level and true, and absent the lumps and swales typical of many Dye productions.

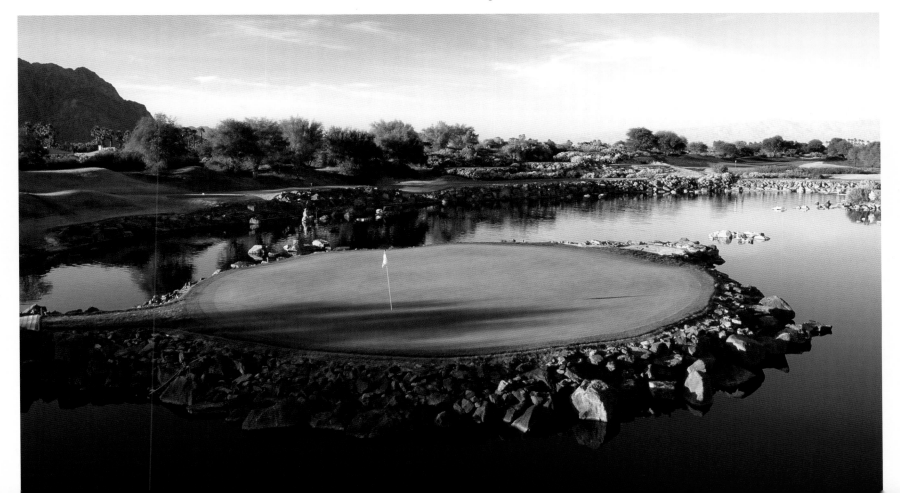

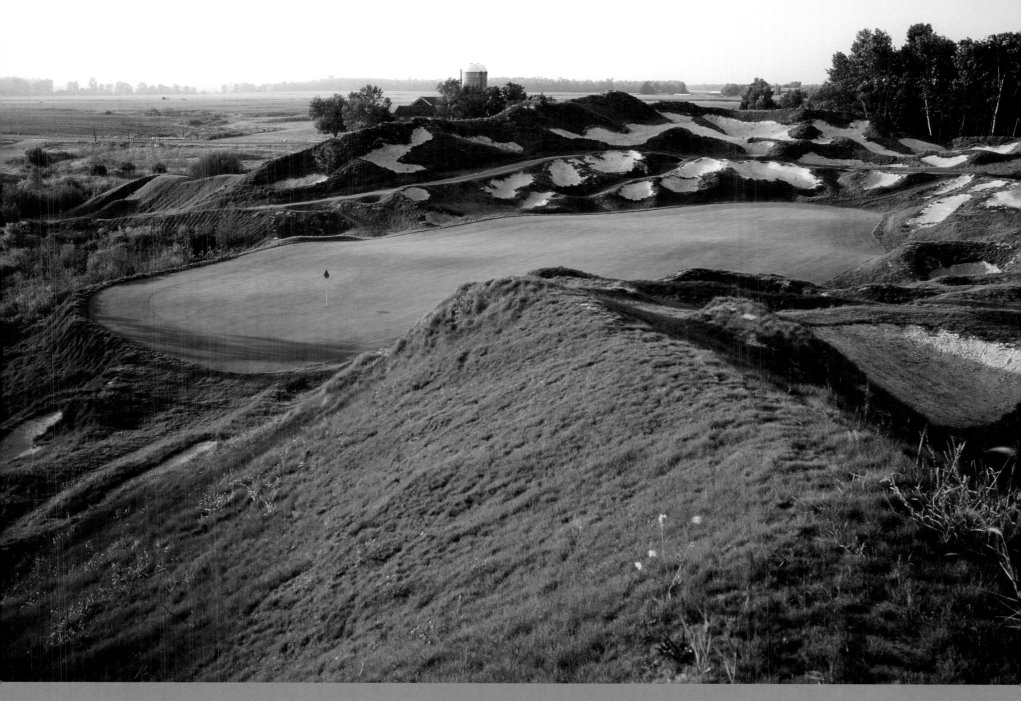

An amphitheater of bunkers surrounds the thirteenth on the Irish
Course at Whistling Straits, near Sheboygan, Wisconsin.

SAND AND DUNE HOLES

Sand is an essential component of golf courses. It is the foundation for seaside linksland and nurtures grasses distinctive to links courses. Here, hollowed by winds and animals, it morphs into bunkers; rising to great heights as a series of dunes it can influence the routing of courses, block the view of a green or be used as the site for elevated tees and greens.

Geographically, there are interior regions like Melbourne's Sandbelt (Royal Melbourne), the Pine Barrens of New Jersey (Pine Valley) and the Sand Hills in Nebraska (Sand Hills GC) that also provide wonderful opportunities for holes where sand dominates. Some of the world's greatest courses are laid down on such a sand canvas, with the designer "painting" contoured swatches of turfgrass — tees, fairways, greens — to make a course routing. On such courses, the sand is often left unraked, giving a more unpredictable quality to recovery shots.

Though not as absolute as water in their punishment, sand hazards can still exact big scores as golfers flail about unsuccessfully trying to get out of them. Here are nine one-shot sand holes that illustrate the best in this category.

Hills Course at Jupiter Hills Club

#9

Length: 190–130 yards

Designer: George Fazio

Opened: 1970

Location: Tequesta, Florida, USA

"Trust the land and the course to discover each other." — GEORGE FAZIO

Comparisons between the Jupiter Hills Club in Tequesta, Florida, and Pine Valley include a direct link in the person of George Fazio. Fazio the competitive golfer is best known for losing to Ben Hogan in a 1950 U.S. Open playoff. Fazio the touring professional was affiliated with Pine Valley and learned its strategic playing lessons. Fazio the designer had the good sense to see that the Jupiter Hills site he was given needed little alteration to yield a superior course.

Astutely, Fazio drew eighteen holes from acres of rolling sand and scrub that nestled just inland from the Atlantic Ocean. While Florida is for the most part flatland, Jupiter Hills enjoys 80 feet of vertical drop dotted with stands of palmetto, oak and mahogany. In short, it looks more like the New Jersey pine barrens or Carolina sandhills. There are a number of wonderful holes but the par-three ninth best illustrates the marriage of nature and design achieved by Fazio.

Listed on the card at 190 yards, it plays slightly uphill and, like Pine Valley, the task is to hit from one safe grass area to another. What appears to be a series of bunkers is really a sandy waste extending 140 yards from the teeing areas until it flashes up to guard the front of the green. Land anywhere in this forbidding valley and you face a vexing recovery. To help a tad, Fazio left a 15-foot ribbon of grass just off the front edge of the green.

The medium-size green slopes gradually from upper left to lower right and will receive a shot from the back tee. Factor in Atlantic Ocean winds, hit the right club, and you have a fair chance at a well-earned 3.

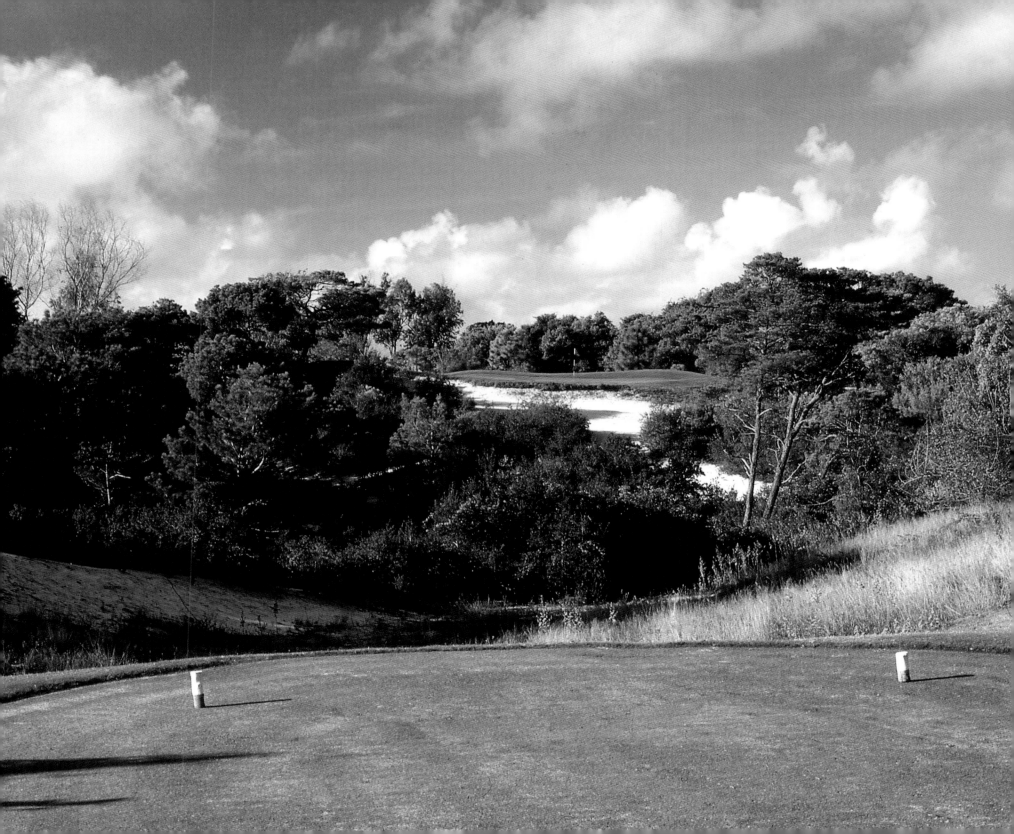

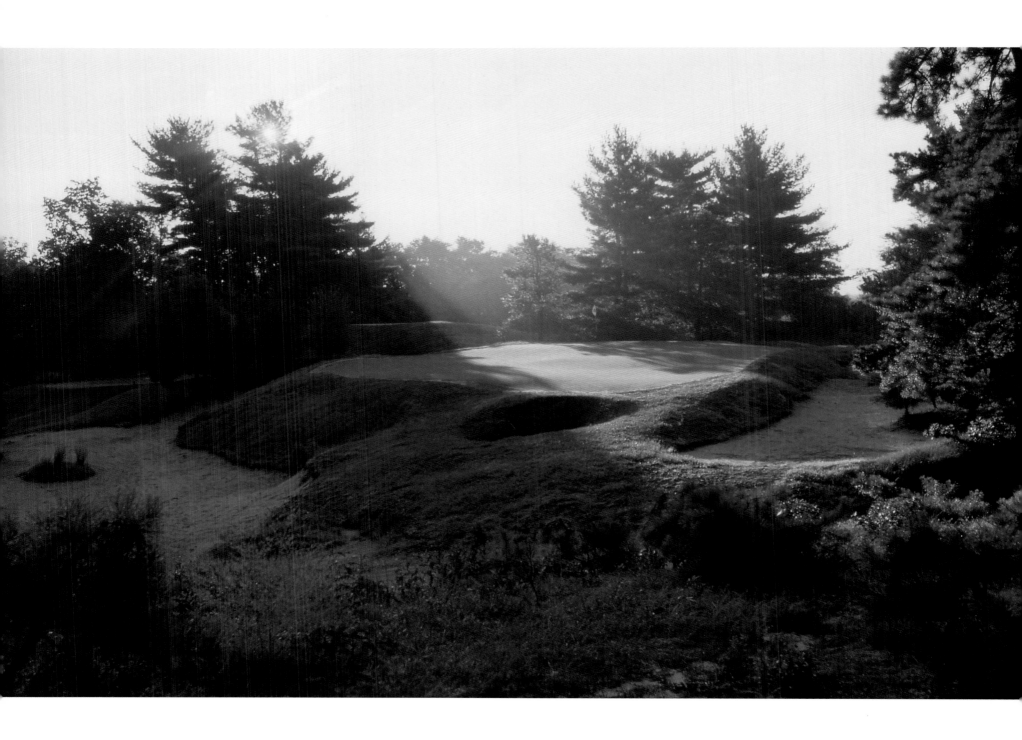

"A 184-acre bunker." — VISITING PRO AFTER A DISASTROUS ROUND AT PINE VALLEY

Pine Valley Golf Club

Length: 145–130 yards

Designers: George Crump/Harry S. Colt

Opened: 1919

Location: Clementon, New Jersey, USA

When writing about Pine Valley, biblical — and scatological — references come easily. There is "Hell's Half Acre," one of the world's biggest sand hazards. And then there is what course historian Geoff Shackelford, in a torrent of adjectives, called, "this nasty, menacing, dirty, unpleasant, foul, mean, horrid, vile, ungracious, loathsome, beastly and hideous" bunker, euphemistically named by members "The Devil's Aperture." After playing the tenth hole, most golfers use its more forthright nickname, "The Devil's Asshole," with invectives added.

Only a limited number of courses start the back nine with a par three. If you've survived Pine Valley's front and come to the tenth thinking you've got a respite, forget it. Bob Hope negotiated a respectable 43 at the turn but scored 11 on ten to spoil his day. Others have done much worse. One gentleman had managed a nifty 38 on the front nine, and then equaled it with 38 strokes. So why is this modestly distanced three such a round-breaker?

Maybe it's the elevated tee that lulls you into thinking you don't have to hit a firm shot. Or it's because the island green is ringed by sand, scrub and trees. When the pin is up front, getting close demands an extremely delicate shot. Miss and you end up in the waste left or the aforementioned pot bunker. As one writer says, "The Devil's Asshole 'gathers' shots, as if there were some hidden magnetic force that pulls balls into it." Recovery from the D.A. can mean drastic choices, like taking an unplayable lie and hitting again from the tee, or playing out backwards to the hillock where you might be able to reach the green in three. Land on the back of the green and hit a too-hot chip or putt, and you can end up you know where.

Early pictures of the tenth show that the now legendary bunker wasn't even in George Crump's original design. It evolved from a two-foot depression into the eight-foot menace we know today. On top of this, the back-to-front slope is nearly three feet.

Herbert Warren Wind called Crump the "Gauguin of golf." His reference stresses how beautifully Pine Valley retains its primitive vitality. While big holes like numbers seven, thirteen and fifteen can destroy your round, the tenth is often the most hellish of them all; maybe because its mesmerizing intimidation makes you think the devil does have you by the throat.

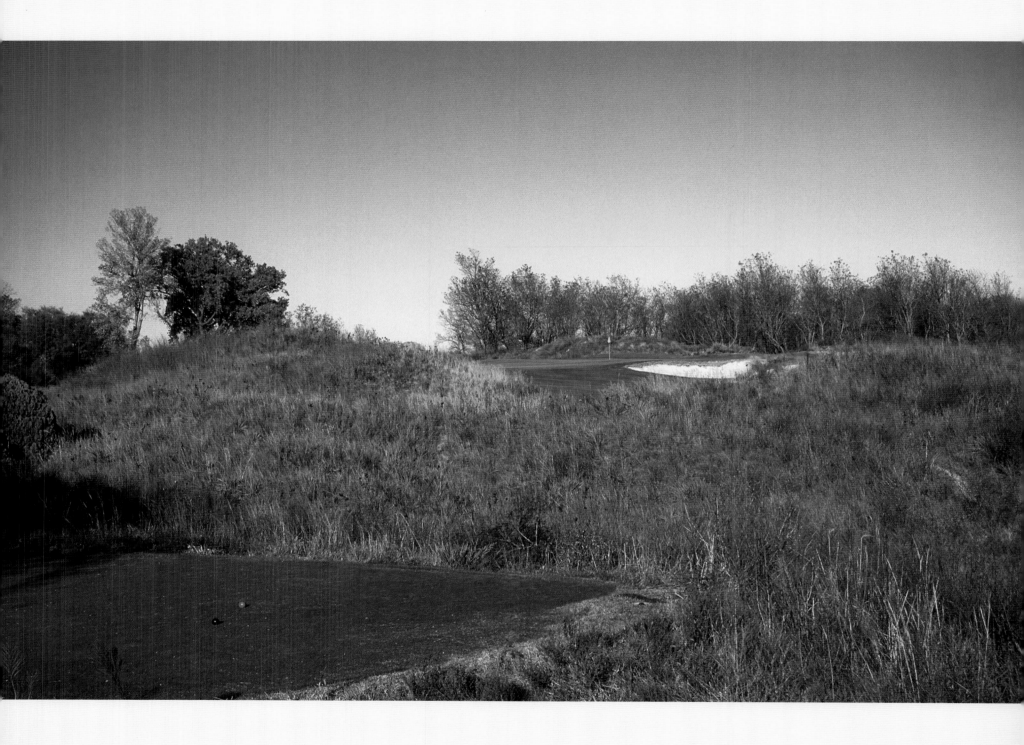

Prairie Dunes Country Club

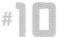

Length: 185–85 yards

Designers: Perry Maxwell/J. Press Maxwell

Opened: 1937/1957

Location: Hutchinson, Kansas, USA

"The golf course should be there, not brought there." — PERRY MAXWELL

After Perry Maxwell walked the Kansas prairie property the Carey family had purchased for a golf course, he concluded, "There are 118 golf holes here and all I have to do is eliminate 100." The actual number he cut out was 109 because when Prairie Dunes Country Club opened in 1937, Maxwell had completed only nine. Twenty years later his son, J. Press Maxwell, seamlessly integrated nine more to complete the eighteen, a tandem Maxwell family masterpiece.

Prairie Dunes has four strong one-shot holes. They share two features — all play uphill and their greens, like every green at Prairie Dunes, share lineage with Augusta National (specifically #12), where Maxwell *père* did renovations and absorbed the subtleties of MacKenzie's undulations and contours.

The one-shots are #2 (Willow), #4 (Hill Top), #10 (Yucca) and #15 (Chute).

Number two and number ten vie for "best three" at Prairie Dunes. We have made the tenth our choice, but first a word about two, named for the willow tree sitting back left of the green. It plays at 161 yards uphill some 15 feet to a green complete with a menacing 12-foot-deep bunker. There is a bit of a false front, and you see only part of the putting surface. The green is set diagonally and has two tiers. Very tricky. You definitely don't want to be long.

Perry Maxwell modestly called number ten, "the best par three in America," and his favorite. Professional Dave Bisbee, who grew up playing Prairie Dunes, has these firsthand observations: "Not as elevated as the second, it too has a deep,

penal bunker right front. The green is medium size but very subtle: it tilts and rolls and falls off in back. Winds always blow at Prairie Dunes and average about 10–15 mph. What makes them difficult is they create a one-half-club to one-club difference, which can be tough to reckon. At ten you have growths of native grasses and yucca plants, or gunch as they call it, from tee to green and in back. Get in this and you're dead."

Unlike Nebraska's Sand Hills Golf Club, which is truly remote, Prairie Dunes is accessible from Wichita, Kansas, and true to their hospitable reputation, members welcome all who have heard about this low-profile course so artfully built by one of America's less-heralded design families.

West Course at Royal Melbourne Golf Club

#5

Length: 176–142 yards

Designers: Alister MacKenzie/Alex Russell

Opened: 1926

Location: Black Rock, Victoria, Australia

"A course to humble the giants or confirm their greatness."

—— AUSTRALIA'S PETER THOMSON, FIVE-TIME BRITISH OPEN CHAMPION

Bustling Sydney is the unofficial capital of Australia, but the more sedate Melbourne can boast it has the premier golf courses in the country, the West and East at Royal Melbourne Golf Club, the country's oldest, dating to 1891. One of the club's most significant years was 1926, when architect Alister MacKenzie designed Royal Melbourne's West Course.

Although not as dramatic as the Monterey Peninsula property where he created the Cypress Point course, the club's newly acquired acreage in the "Sandbelt," as the local area is called, provided a wonderful setting for MacKenzie's talents. Critics cite in particular the absolute naturalness of the routing, which took advantage of the wild, dunes-like landscape, replete with bracken, heather, dwarf reed, she-oaks and tea-trees — much like many of the earliest old world courses.

When it comes to par threes, Royal Melbourne's West and East Courses may have the best collection anywhere. All these one-shotters are, as one Australian golf writer put it, "fascinating." Each has all the elements that make a great hole — beauty, integrity, shot value. At Royal Melbourne the fifth on the West stands first among equals.

If there is a "perfect distance" for a three, it's about 150 to 180 yards, long enough to require at least a mid-iron, but not too long as to preclude average players from actually aiming at the pin. On the card number five plays at 176 yards and definitely allows most golfers a chance at reaching the green.

To force an absolutely straight shot, MacKenzie put three bunkers right and two left. As punishment for shots gone further astray, there are trees right and back. Assuming proper club selection, your shot must land and hold. The medium-size green slopes front to back and has a "beveled" front edge that sends weak shots rolling yards off the putting surface. And the putting is no easier since the speed always runs to fast.

Peter Thomson's description of the entire course perfectly describes number five — you will come away humbled, or on the upside, discover the better golfer in you.

136

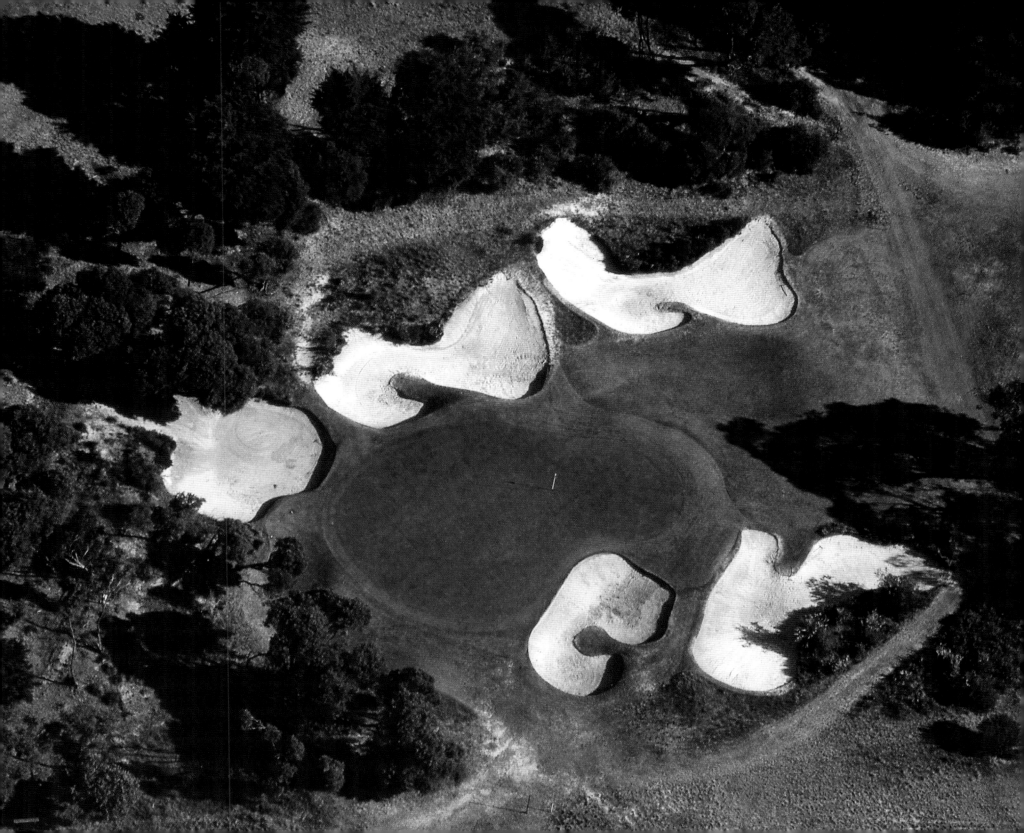

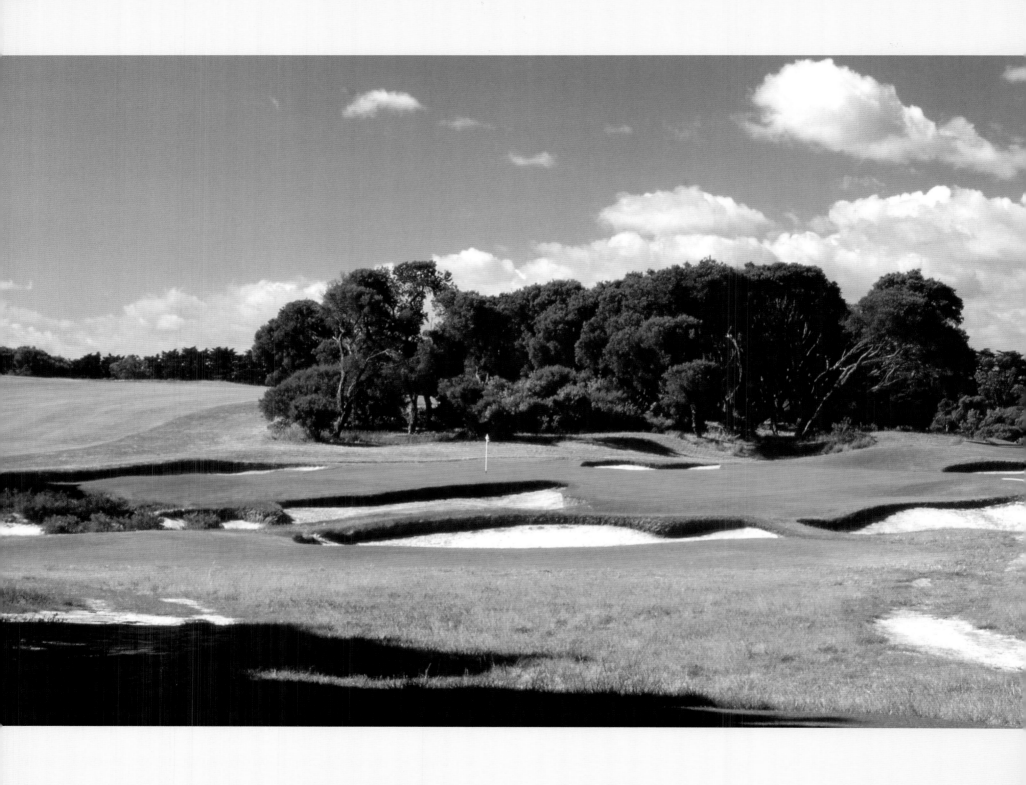

East Course at Royal Melbourne Golf Club

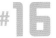

Length: 167–129 yards

Designers: Alex Russell and Alec Morcom

Opened: 1932

Location: Black Rock, Victoria, Australia

"Why aren't we playing that hole? It's better than the one we just played."

— BEN CRENSHAW ON THE SIXTEENTH AT ROYAL MELBOURNE'S EAST COURSE

When major competitions are held at Royal Melbourne, the club uses a composite layout (called the President's Cup Course) consisting of ten holes from the West Course and eight from the East. Unhappily, as Ben Crenshaw noted, nobody plays number sixteen from the East Course. You might call this a case of neglecting a diamond in the sand.

The story of the East Course is overshadowed by the brilliance of Alister MacKenzie's work on the West. After it was built, there was still room on the Black Rock property for another eighteen holes. This time Alex Russell, MacKenzie's assistant, along with superintendent Alec Morcom, got the job. The success of their work is validated by the choice of eight East Course holes on the composite.

The sixteenth is a three worth showcasing. The hole plays level from tee to green at a mid-length 160 yards. But ringing the target are six massive bunkers, one front beauty with a nose sticking well into the putting surface as though a wayward ship off nearby Port Phillip Bay had beached. Another sandy intruder plows into the rear of the green, creating such miniscule landing zones that only a perfectly struck shot, careful of wind and trajectory, will land safely. Like all of Royal Melbourne's greens the sixteenth is slippery, fast and slopes back to front.

As if the green complex conundrums weren't enough, a row of trees lines the right side from tee to green, buffering the hole from nearby Reserve Road. Subtly, the trees nudge the tee shot left and suggest that a high fade is the best approach — surely the kind that Russell, the 1924 Australian Open champion, would have played himself.

Sand Hills Golf Club

Length: 139–115 yards

Designers: Bill Coore and Ben Crenshaw

Opened: 1995

Location: Mullen, Nebraska, USA

#17

One of America's least-known natural wonders, the 20,000–square-mile Sand Hills region of Nebraska is the million-year-old residue of an inland water body, now the largest grass-covered dunesland in the world. Located hours from any major urban center, the area sits on the Great Plains exposed to shifting winds that continuously reshape its contours.

In 1991 developer Dick Youngscap purchased 8,000 acres here and called in Ben Crenshaw and Bill Coore to help him build a golf course that flowed from the dramatic setting. As the story goes, Crenshaw and Coore identified some 130 hole possibilities which they pared down to the final eighteen. Once opened, Sand Hills rose quickly to the top of the world rankings. Among U.S. courses, it is truly *sui generis*.

While the fives and fours are the signature holes, specifically the spectacular 610-yard sixteenth, the seventeenth merits a place alongside these. Of the par threes, numbers three and thirteen both play at 216 yards and number six is 198 yards, each relatively long for the average player. At 139 yards seventeen is reachable by all and exemplifies Crenshaw's personal devotion to short one-shot holes.

It also proves the Coore-Crenshaw commitment to Golden Age design values that stress accuracy and ball control on shots into the green. From the tee, one absolutely must gauge the wind and the small uphill angle correctly to reach the 4,000–square-foot green. Unlike the other seventeen holes, which are accessible from the front, the designers, given the length, force you to fly the ball to the target. After

playing sixteen, where there are no greenside bunkers, seventeen is boxed in with them. They are perfectly sculpted, many purely by nature itself, with high, grassy lips. If you miss the sand and find the native grasses, you may be in worse trouble. Safely on the green, you face a very fast surface.

A stay at Sand Hills reflects its isolation and the primitive beauty of the course. Open only four months a year, from June 1 through September 30, it has simple accommodations for about 50 people; the clubhouse is modest with good food. Fittingly, for a club set in a timeless landscape, there are no clocks.

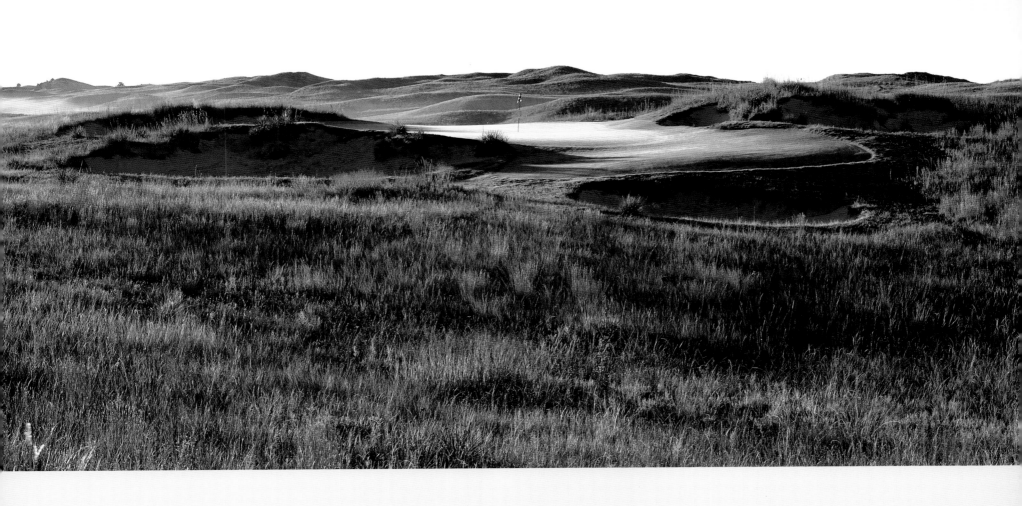

"The light air about me told me that the world ended here; only the ground, sun and sky were left."

— NEBRASKA-BORN AUTHOR WILLA CATHER

The Dunes Club

#2

Length: 200–131 yards

Designers: Dick and Tim Nugent/Mike Keiser

Opened: 1990

Location: New Buffalo, Michigan, USA

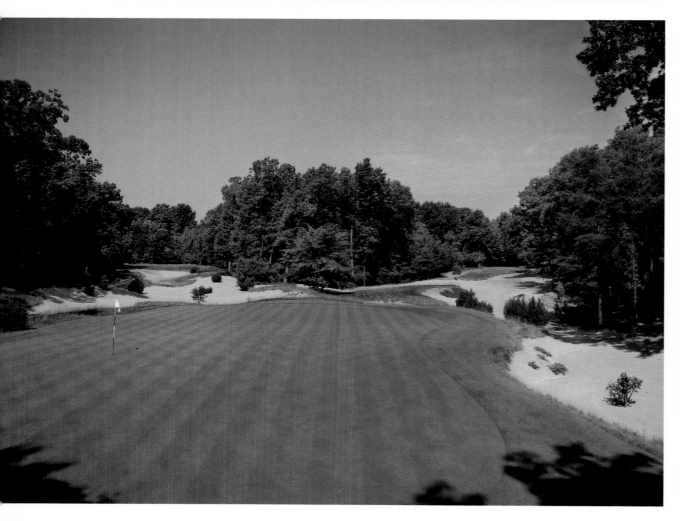

In 2010 the Dunes Club ranked #1 among America's nine-hole layouts. Founder Mike Keiser, (known primarily for his Bandon, Oregon, courses) cut his design teeth here on 90 acres of sandy wastes and thick tree stands on the southeastern shore of Lake Michigan. The second hole is the par three of choice for Keiser, designer Dick Nugent and the club staff. On the card it lists at 165 yards, but since every hole has multiple teeing areas, sometimes as many as eight, pinpointing where you start is impossible. At two, carries run from 160 to 200 yards with the prevailing wind at your back and moving left to right. Your target is a fair-size green with a hogback, speeds of 10 to 11 on the Stimpmeter and only a three-foot safety collar between you and trouble. If you never play Pine Valley, do your best to get one of the ninety members to invite you tee it up at the Dunes Club.

Kingston Heath Golf Club

#15

Length: 155–123 yards

Designers: Dan Souter/Alister MacKenzie

Opened: 1925

Location: Cheltenham, Victoria, Australia

This justly famous hole has long been considered one of Australia's most testing threes, due in no small part to the creative bunkering added by Alister MacKenzie during his visit in 1925–1926. From tee to green, this medium-length uphill one-shotter is all sand bunkers carved in true MacKenzie fashion with tongues of turf darting here and there from their edges. The crowned green is narrow in the front but widens as it climbs to the back edge. Any mis-hit shot will spill well off the surface. A chip and putt might save par, but bogey is more likely.

Seminole Golf Club

Length: 162–130 yards

Designer: Donald Ross

Opened: 1929

Location: Juno Beach, Florida, USA

Arguments are made that Donald Ross's Seminole Golf Club course has been overlooked in favor of his masterpiece, Pinehurst No. 2. While Pinehurst No. 2 sits in the gentle contours of the Carolina sandhills, Seminole provided Ross with different topography. In this case, an oceanside property ribbed with two dune-covered ridges inspired a design unusual for Florida. Number seventeen calls for a medium-length, slightly downhill shot into a prevailing left-to-right wind off the nearby Atlantic. Pros and top amateurs call it one of the hardest in the world to execute successfully. The subtly contoured green slopes a precipitous five feet left to right. It is ringed by eight of Seminole's 187 bunkers. Among the threes, seventeen aptly fits Ben Hogan's assertion that Seminole is about "placement."

CHASM AND ROCK HOLES

Some of golf's most memorable holes owe their distinction to two dramatic geological settings — unusual rock formations and chasms.

Many fine courses have been built on or around rocky sites such as quarries, headlands, lava, mountains and deserts strewn with giant boulders. In whatever form, they all offer potential boons and challenges. On the downside, rocks or boulders can be impediments to routing or the siting of a tee or green and may have to be removed, even blasted. On the other hand, they can be the strategic and aesthetic focal point for a hole. Our "Finest 100" includes three holes where rocky landscapes have been employed with great imagination.

Sometimes it's not the presence of rock, but the absence of it that creates an interesting course. Now and then players step onto a tee, look out at the green and then notice a yawning depression, crater or ravine that spells major trouble, especially when the carry is more than 150 yards. To complement our rock holes, we have selected a quintet of holes as illustrative of what we label "chasm holes," where a successful tee shot must be long and precise or disaster ensues. We begin with Harry S. Colt's famous "rim of a crater" creation at Royal Portrush Golf Club.

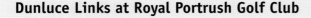

Dunluce Links at Royal Portrush Golf Club

Length: 210–167 Yards

Designers: Old Tom Morris/Harry S. Colt

Opened: 1889, 1933

Location: Portrush, County Antrim, Northern Ireland

#14

"A chain of eighteen magnificent holes, with no compromises, neither does it show any forgiveness for those who may not be up to the test it so honestly lays out." — DAVID BRICE, GOLF INTERNATIONAL, INC., ON THE DUNLUCE LINKS

When golf writers Dave Kindred and Tom Callahan journeyed "Around the World in 18 Holes" (the name of their subsequent book), they chose Royal Portrush's fourteenth as hole #1. The thinking seems to have been if you can survive this fearsome par three then the other seventeen should be easy.

It more than lives up to its name, Calamity, short for Calamity Corner. When Harry S. Colt was commissioned to revamp the original Tom Morris layout of 1889, he must have smiled impishly when he came upon a natural feature more exciting than any bunker — in his words, "the rim of a crater" — and knew instantly he would design a one-shot hole around it.

Colt set the green back left of the crater and sited the tee box in line with the left edge of this yawning chasm, thus bringing it into play both physically and mentally. Experience proves the crater punishes almost as cruelly as a water hazard. At its deepest it measures 25 feet and its tumbling configuration often makes it impossible to build a stance. Landing there, most golfers wisely will want to hit a provisional ball since many tee shots are never found.

Left front of the green are mounds that suggest the option of a difficult run-up shot, but flying it all the way is the better strategy. Generally, the tee shot is downwind, so factor in the knock-down effect. Adding to the difficulty, Kindred said the experience was like "shooting at an island from a cloud."

Two points of interest about fourteen: The green is notable for "Bobby Locke's Hollow," a spot on the left side where the putting genius from South Africa played his ball every round for an easy par during the 1951 British Open. From the tee one can see most of the Valley Course (also by Colt) out to the right; a fine layout worth playing.

Built on a rocky promontory that juts into the Atlantic, Portrush inspires rhapsodic descriptions for its distracting beauty. Some of the local landmarks include the ancient ruins of Dunluce Castle (for which the course is named), the Hills of Donegal, the Isle of Islay in the Hebrides and the Giant's Causeway, a World Heritage site. About five miles away is the Bushmills Distillery, and good or bad fortune at fourteen will be reason enough to head there directly after your round.

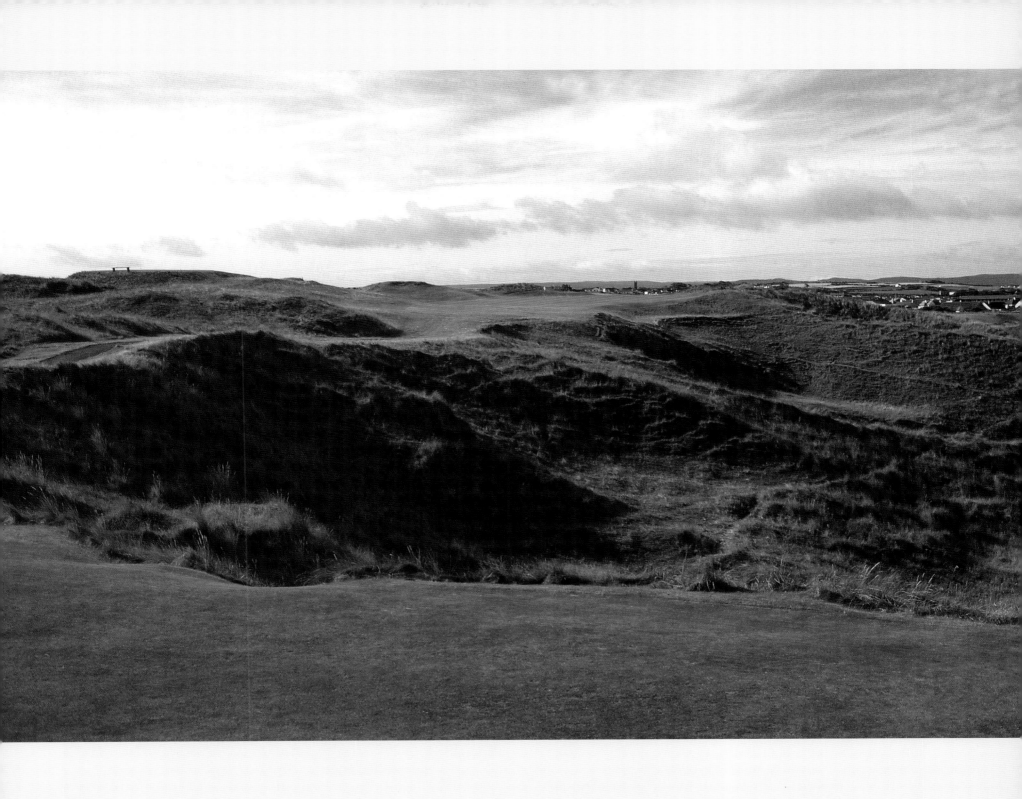

The Challenge at Manele Golf Club

Length: 202–65 yards

Designer: Jack Nicklaus

Opened: 1993

Location: Lanai City, Hawaii, USA

When Jack Nicklaus assessed the landscape that became The Challenge at Manele on the southern coast of Lanai in Hawaii, he surely saw the site for this intimidating hole. It suited the Nicklaus design principle that a carry should be heroic and imposing. Of course, the fact that the twelfth asks a forced carry across a chasm some 200 yards wide and 150 yards deep with not very pacific waves crashing below might have been inspired by his days working with Pete Dye. The green is mercifully wide and deep on the left side, with enough space to hold a less than perfectly struck shot. Nonetheless, the key play is to avoid the cavernous bunker protecting the right front. This course metes out many challenges, but none more formidable than number twelve.

Devil's Paintbrush Golf Club

#13

Length: 226–145 yards

Designers: Michael Hurdzan/Dana Fry

Opened: 1992

Location: Caledon, Ontario, Canada

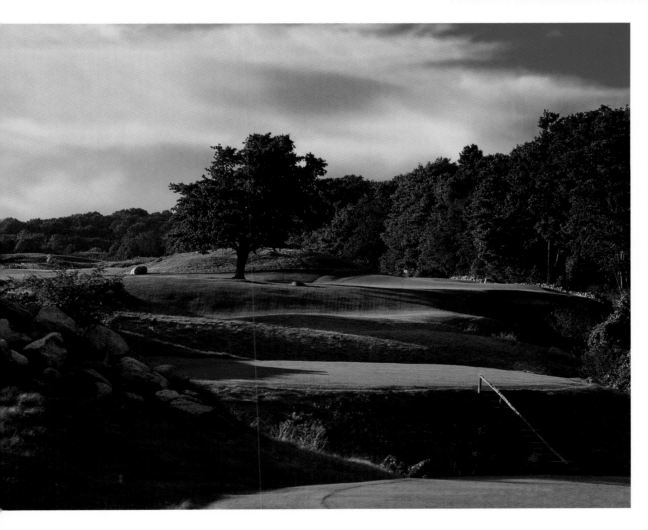

Southern Ontario enjoys rolling, even precipitous terrain that offers great possibilities for course designers. Michael Hurdzan and Dana Fry maximized these natural assets when they built Devil's Paintbrush, a links-style eighteen and companion to their earlier Devil's Pulpit layout. At the thirteenth they found a deep gorge and positioned a large, severe two-tiered green on the other side of it and more than 220 yards from the back tee. The optimum shot plays in the air between a sizable tree left of the green and the pin. With the right side of the hole out of bounds, it all adds up to one of the toughest par threes in Canada.

Pasatiempo Golf Club

Length: 169–88 yards

Designers: Alister MacKenzie/Tom Doak

Opened: 1929

Location: Santa Cruz, California, USA

It takes steely nerve by a designer to conclude a course with a par three. The brainchild of founder Marion Hollins and designer Dr. Alister MacKenzie, the eighteenth at Pasatiempo mirrors their earlier mutual, and bold, agreement to make the sixteenth at Cypress Point a dramatic and testing one-shot hole.

Situated on the edge of one of the broad 35-foot deep barrancas that crisscross the upper nine, this closer plays at 169 yards and requires a full carry to a false-front green. Shots short of the necessary distance end up in one of three punishing places: the canyon, a tangle of thick rough or two massive bunkers that guard the forward portion of the green. A tee shot too long is also problematic, since the green slopes significantly back to front and left to right, causing an indelicate chip or sand shot from a back bunker to scurry toward the aforementioned hazards. While not as daunting as Cypress number sixteen, the tee shot is every bit as challenging and beautiful.

Recently, Tom Doak was asked to restore the course and he did a wonderful job of re-capturing the original vision of MacKenzie and Hollins, including the deep swale directly in front of the green. There are few guarantees a chip from the long

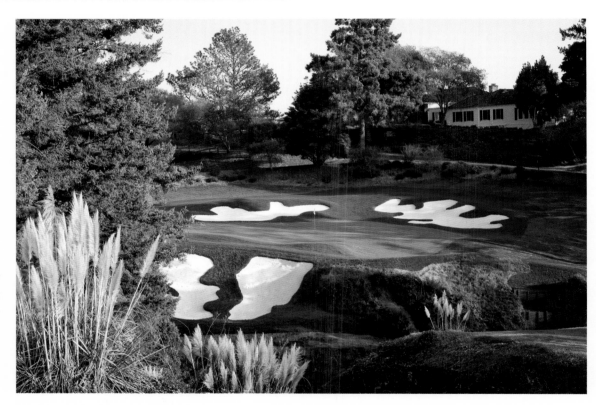

grass there will produce a positive result. All in all, Doak's fine effort would be heartily applauded by the Doctor from the porch of his home on the sixth fairway at this, his favorite course.

Royal Course at Vale do Lobo Golf and Beach Resort

16

Length: 235–145 yards

Designers: Henry Cotton/Rocky Roquemore

Opened: 1968/1997

Location: Almancil, Algarve, Portugal

When one combines an ocean-coast locale with geological formations that carve dramatic indentations in an acrophobic cliff line, drama is sure to follow. Visually, the sixteenth at Vale do Lobo's Royal Course summons comparisons with two other great threes — number fourteen at Brazil's Terravista and number twelve at Manele in Hawaii.

From the tee, distinguishing marks are the ribbed, russet-hued chasms that edge the left side of the hole, two of which must be carried to reach the distant green, and a serpentine string of white out-of-bounds stakes. Yardage from the back lists at 215 meters or about 235 yards, making this a big-stick tee shot for average golfers. On a quiet day, the idea is to avoid the very large bunker protecting the front of the green and land a shot near the chipping area to the right or hit a draw onto the wide putting surface. When Atlantic winds are up, strategies change; even Tour pros have been known to lay up to position a chip and one-putt. For those who can pull it off, the maximum shot is left to right out over the beach below with the winds carrying the ball home.

Vale do Lobo's two courses are the work of three-time British Open champion Sir Henry Cotton, who laid out the nine-hole Yellow and Orange courses in 1968 (followed six years later by the Green). Thus, the sixteenth is sometimes listed

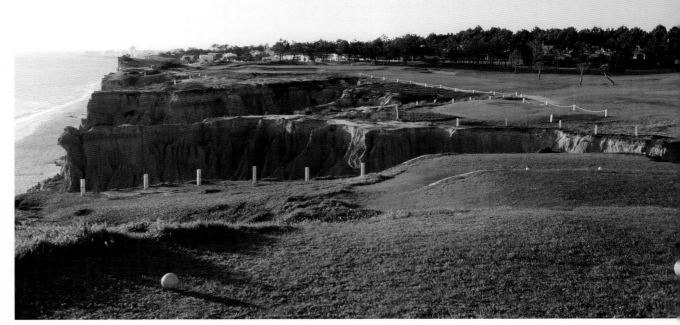

as the seventh on the Yellow Course. In 1997 American designer Rocky Roquemore, working with Cotton's original concepts, completed what is now the Royal Course and added nine more holes to make the Ocean Course. While not the most difficult hole on the Royal Course, because of its aerie-like perch and imposing rock faces number sixteen is always the most remembered.

The Estancia Club

Length: 137–94

Designer: Tom Fazio

Opened: 1995

Location: Scottsdale, Arizona, USA

If you've never played golf in Italy, a round at the Estancia Club will be a good substitute. While the name suggests ranches in Argentina, Tuscany is the inspiration for the clubhouse and homes. The European-looking complex blends naturally into the Sonoran Desert setting at the base of the well-known Phoenix landmark, Pinnacle Peak. When Tom Fazio and his fellow designers made their first visit, they found themselves scrambling over gorgeous rock formations, agog at the possibilities for dramatic tee and green sitings.

One in particular caught Fazio's attention and he said, "That area would make a great par three." Developers: "But, we don't own that parcel." Fazio: "Sure would make a great par three." The dialogue continued until the developers finally relented and bought the property for Estancia's number eleven and Fazio had his par three.

Some holes are "pre-created" before a designer walks the course. What Fazio saw on his maiden visit was an opening in a miniature amphitheater of rocks. In his words: "A sliver of space among the boulders was an obvious natural frame for the par-three eleventh at Estancia."

Using this as his template, he sketched a medium-size green whose shape derived from the natural contour of the boulders. He finished it off with a sweeping slope that runs twenty yards away from the front. The message? Get home or you'll roll back down the slope. Go long and you'll play pinball and who knows where you'll be. For good measure, a nicely sculpted bunker nestles between the front left of the green and another rock wall.

As you survey the hole from the tee, you are looking directly at the summit of Pinnacle Peak. From the back the hole plays at 137 yards. Think full carry. The strength of the hole is its absolute naturalness. It beckons you to fly your ball clear of the rocks onto the emerald green surface. Fazio made sure it's easier seen than done.

"That area right there would make a great par three." — TOM FAZIO

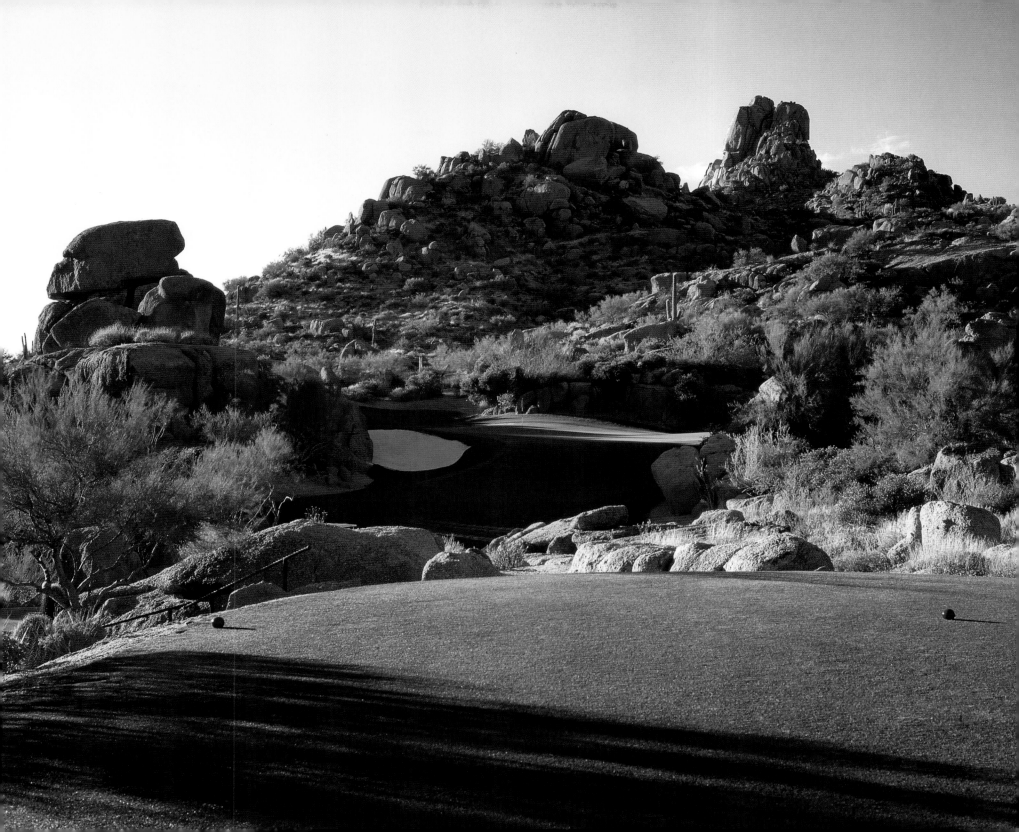

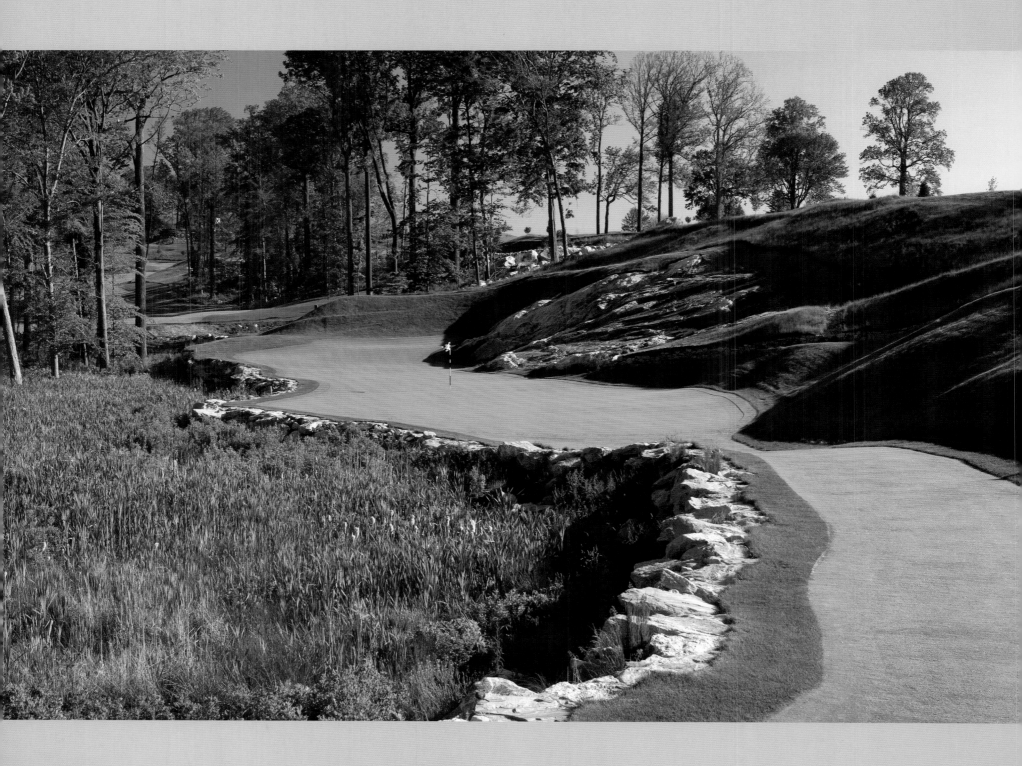

Pound Ridge Golf Club

Length: 174–124 yards

Designers: Pete Dye/Perry Dye

Opened: 2008

Location: Pound Ridge, New York, USA

"The first time I walked onto one of his courses, at Sawgrass, I had the feeling of being in the middle of a giant math problem conjured up by a master of geometry."

— KEN WANG, POUND RIDGE GC OWNER, ON PETE DYE

Pete Dye is often portrayed more as a mad scientist than as an environmentalist, but with Pound Ridge Golf Club, Dye demonstrated he was as much the latter as the former. During the opening day round, Dye stopped at the fourth green to point out a pond where water had been gradated in specific depths, noting, "It's for the tadpoles. The next time you play this hole, there will be so many frogs here you won't be able to hear yourself think." Such solicitude for wetlands teeming with such small creatures — not to mention woods full of deer, foxes, coyotes and wild turkeys — doesn't come cheap.

Ken Wang, an avid golfer, wealthy industrialist and brother of fashion designer Vera Wang, invested eleven years and $40 million in Pound Ridge, and for that he got not only a layout that balanced ecology and geometry, but also a standard-setter for public course operations and inclusion in the best new courses lists for 2008 and 2009. Located in New York's tony upper Westchester County area, Dye's creation, a paean to the Stone Age, plays to 7,100 yards from the tips and features dramatic ups and downs, sophisticated green complexes and 14,000 feet of rock walls — some decorative and others dangerous.

Named "Headstone," the fifteenth at Pound Ridge gives golfers their own lesson in angled deflections. It sets up this way: a large elongated green, 185 feet by as much as 75 feet, that angles at about ten or eleven o'clock; wetlands that partially obscure the putting surface; and those rocks. Specifically, there is the signature craggy granite slab center or right, depending on your tee position. According to observers, while the course was under construction Dye would hit balls off its large face onto the green. Eventually, in inimitable Dye fashion, he began to call it a "swing aid." In front, lies an artfully arranged necklace of mini-boulders defining the green and its approach. Bounce off either the slab or the boulders and who knows what can happen — one-putt for two or double-trouble for six. Professor Dye's school of math.

Mountain Course at Ventana Canyon Golf & Racquet Club

Length: 107–98 yards

Designer: Tom Fazio

Opened: 1984

Location: Tucson, Arizona, USA

#3

When it was completed in 1984, Ventana's third, named "Hole-in-the-Wall," was the most expensive golf hole ever built. (It had a $1 million price tag.)

Short at 107 yards, it is set among the talus of Tucson's Santa Catalina Mountains and has two-story boulders standing fortress-like near the tees

and around the green. A drive can easily ricochet off these formations, and while a finessed wedge is the shot, the small pip of a green once saw four putts from none other than Tom Watson in a Merrill Lynch Shootout. Tom Fazio and his aide-de-camp Andy Banfield crafted this subtle gem, worth every dollar it cost.

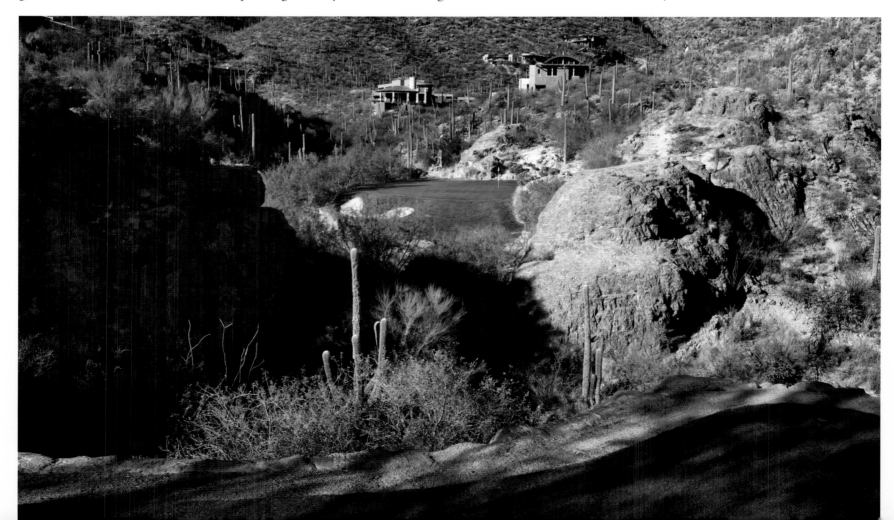

BLIND HOLES

#15	Cruden Bay Golf Club
#5	Old Course at Lahinch Golf Club — "The Dell"
#5	Prestwick Golf Club — "Himalayas"

Call them awkward or museum pieces, but blind-shot holes were very much a part of early golf course architecture. There was nothing contrived about them. Endowed with great sandy dunes and hills the earliest course sites invited, even required, that the designer build holes around or over them, in many cases creating a blind approach or tee shot.

Beginning in the early twentieth century, due in the main to terrain that was flatter and the principle that players should always be able see the target, blind holes began to disappear. Modern designers avoid blind-shot holes since most feel there's enough uncertainty in the game without introducing more. But with the current trend toward retro designs, perhaps the blind shot will once again find some adherents.

We know there are others, but we're sticking with three classics from the late nineteenth century that define the type — all designed, as it turns out, by Old Tom Morris.

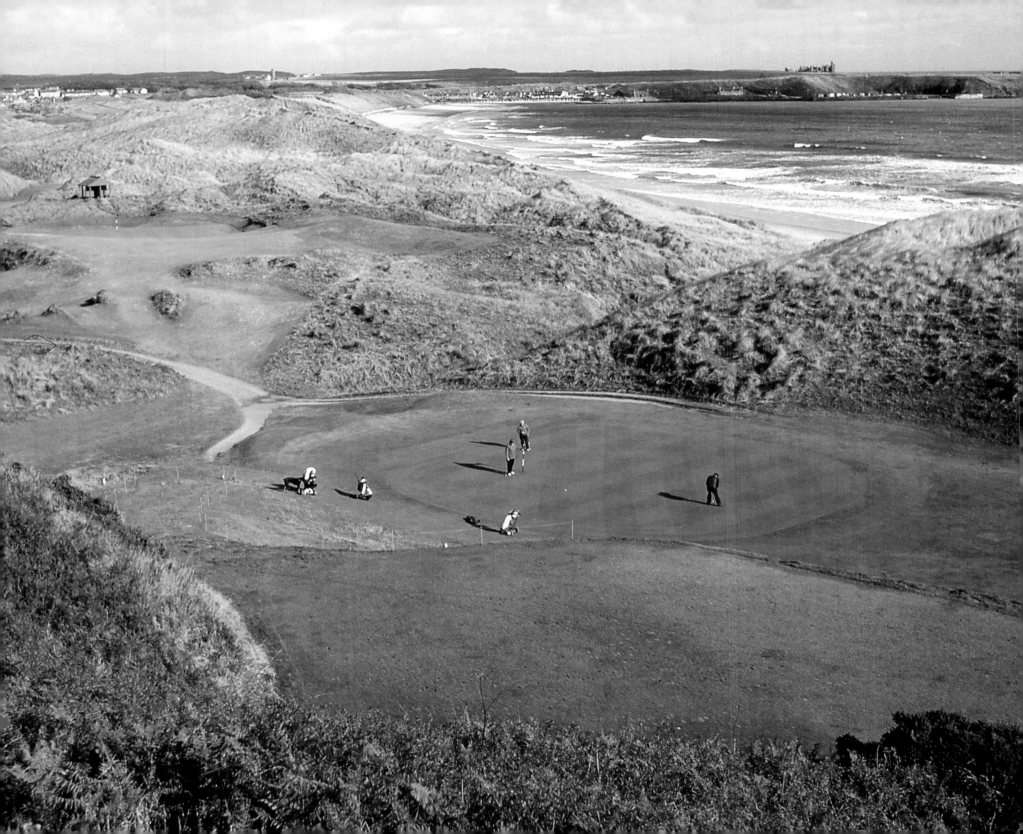

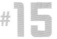

Cruden Bay Golf Club

Length: 239–210

Designers: Old Tom Morris/Tom Simpson and Herbert Fowler

Opened: 1899/1926

Location: Cruden Bay, Aberdeenshire, Scotland

"Oh, go. Cruden Bay was the funnest round of golf I ever played."

— ROYAL DORNOCH MEMBER AFTER CRITICIZING THE COURSE

So there you have the paradox of Cruden Bay. Even those who pan its design irregularities end up enjoying it — possibly even the fifteenth, which some would describe as both subterfuge and clever turn. It's definitely these and also good enough for Cruden Bay's original architect, Old Tom Morris, who also laid down two more blind tee shots at the Dell at Lahinch and the Himalayas at Prestwick, his first major course effort.

Before focusing on the fifteenth, we need to acknowledge accolades given to the fourth at Cruden Bay. Many writers, reviewers and players are thumbs up on this hole, judging it the best of the par threes; respected architect and course critic Tom Doak once said, "It just might be the best short hole in the world." We suspect one reason lies in its position as the first of seven seaside holes and a quartet (4-5-6-7) touted as the heart of the course. In addition, the view of picturesque Port Erroll from the tee is a Scottish postcard moment.

However, we present fifteen, named appropriately "Blin' Dunt," because everyone should experience blind holes. If one wonders why Morris and Simpson concocted such a silly hole, the answer comes back, "They didn't. It was there." Doak points out Old Tom did a superb job of routing because "the holes follow the same path a person would take to walk the property before the course was built." Others point out Morris had to fit in eighteen holes where he could — like the fourteenth with its sunken green sited in a natural hollow (requiring a blind approach). Having finished fourteen, Morris would have been standing about 150 yards from the tallest sand dune on the course.

Beyond it he found a natural hollow that allowed him to fashion a punchbowl green and assure that a player's ball would find the putting surface.

What boggles people is the tee shot. First-time players are advised to pause at the eighth hole for a full view of the putting surface on fifteen. They will see that while the tee shot is blind, there is ample room to hold the green. The distance from the back requires a big hit, slightly uphill, and with the North Sea on your right, factor in a crosswind. Your directional guide is a white marker set halfway up the slope of the dune hill: Trust it and you'll be fine.

The charm of the hole is that one can, with help from the blind-shot deities, almost always make it to the putting surface.

Old Course at Lahinch Golf Club — "The Dell"

Length: 154–118 yards

Designers: Old Tom Morris/Alister MacKenzie/Martin Hawtree

Opened: 1893/1928/2003

Location: Lahinch, County Clare, Ireland

"This is raw golf at its truest, where notions of fairness, aesthetics and beauty have no part in the golfing equation." — GOLF ARCHITECT BRETT MOGG

The Dell at Lahinch may definitely get your goat. Or should we say the goats that seek shelter near the pro shop when a rain squall threatens to blow. If you like your golf predictable and "fair," then don't make the twisting road journey to this links course set near the 300-foot Cliffs of Moher not far from Shannon Airport. Lahinch is definitely an original and to this day inspires either fulsome praise or damnation within the golfing community. If you find fault with the design, then, again, blame Old Tom Morris who laid it out in 1893 and Alister MacKenzie who left it alone when he reworked the course between 1927 and 1928.

You warm up for the Dell by playing Klondyke, a 472-yard par five that features a huge sandhill about 250 yards from the tee, creating the first blind approach you encounter at Lahinch. While on number four, take the chance to scout the Dell, which can be seen on the left. Note, too, that Klondyke and the Dell cross number eighteen, so in the interest of safety the club often keeps a watcher who sits atop Klondyke and directs traffic.

Once on the fifth tee, we enter the realm of uncertainty. Somewhere out there is a green, mostly hidden in a small amphitheater formed by two sandhills. Since you can only see a sliver of the right side, target your tee shot by aiming into the prevailing wind at a white stone marker that is moved each day to align with the pin. The green is flat, almost perpendicular to your shot, and pencil thin, no more than 20 feet front to back. Played in the right spirit, the Dell is great fun.

But whether your experience is fair or foul, there is no doubt playing five is like golfing in another era. You will begin to understand the evaluation of the eminent Herbert Warren Wind, who summed up Klondyke and the Dell this way: "These may be defective holes in this day and age but at Lahinch they are absolutely right: two living museum pieces, two perfect Irish holes."

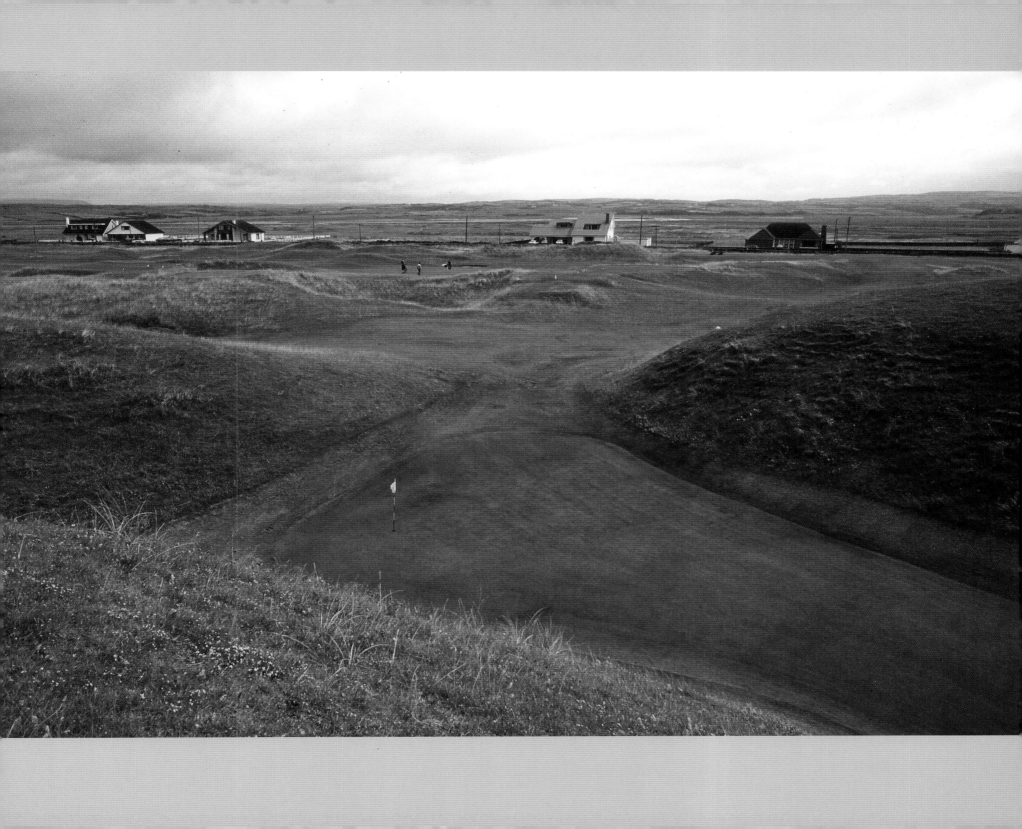

"The course went dodging in and out of sand hills."

— HORACE HUTCHINSON, 1886 AND 1887 BRITISH AMATEUR CHAMPION

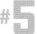

#5

Prestwick Golf Club — "Himalayas"

Length: 236–113 yards

Designers: Old Tom Morris/James Braid

Opened: 1851

Location: Prestwick, Ayrshire, Scotland

Like many of the earliest courses, Prestwick is full of bumps, doglegs and blind approaches, a raggedy concatenation of twelve holes made immortal as the site of the first Open Championship on October 17, 1860. Its current seventeenth is called the Alps. And not to be outdone, the par three fifth is called Himalayas, after the dune that must be carried to reach the green — which you can't see.

In his book *Tommy's Honor*, Kevin Cook relates how Old Tom Morris laid out Prestwick's original dozen, naming each "with a wink and a smile." Hutchinson describes the setting and the challenge of the fifth this way: "The holes were, for the most part, out of sight . . . for they lay in deep dells among those sandhills; you lofted [your shot] . . . and there

was all the fascinating excitement, as you climbed to the top of it, of seeing how near to the hole your ball may have happened to roll."

Others have been less than enthusiastic. The eminent Bernard Darwin said, "The fifth is the 'Himalayas,' a hole of great fame but no transcendent merit. A good cleek shot should see us safely over this hill and onto the green on the other side, which is now guarded by pot bunkers." Dan Jenkins describes playing the fifth this way: "Prestwick has a number of charming atrocities. There is a 201-yard fifth hole . . . which one plays with anything from a five iron to a driver. You flog the shot over a mountainous dune and discover, on the other side, about a hundred feet down, a green. You ring a bell when

you've putted out." Another description goes like this: "A big blind thump of 200 yards over a huge sandhill; very old-fashioned, of course, but not easy, with the green heavily bunkered and none too big."

Standing on the fifth tee one has a sense of expectancy. The carry to the green over the aptly named Pow Burn is approximately 180 yards. If this is your first time playing the hole, you are mercifully spared awareness of six pot bunkers — five of them on the left — hedging the green. The key is to believe — in the guiding stone, the advice your caddie may offer and your club selection.

And don't forget to ring the bell when you finish.

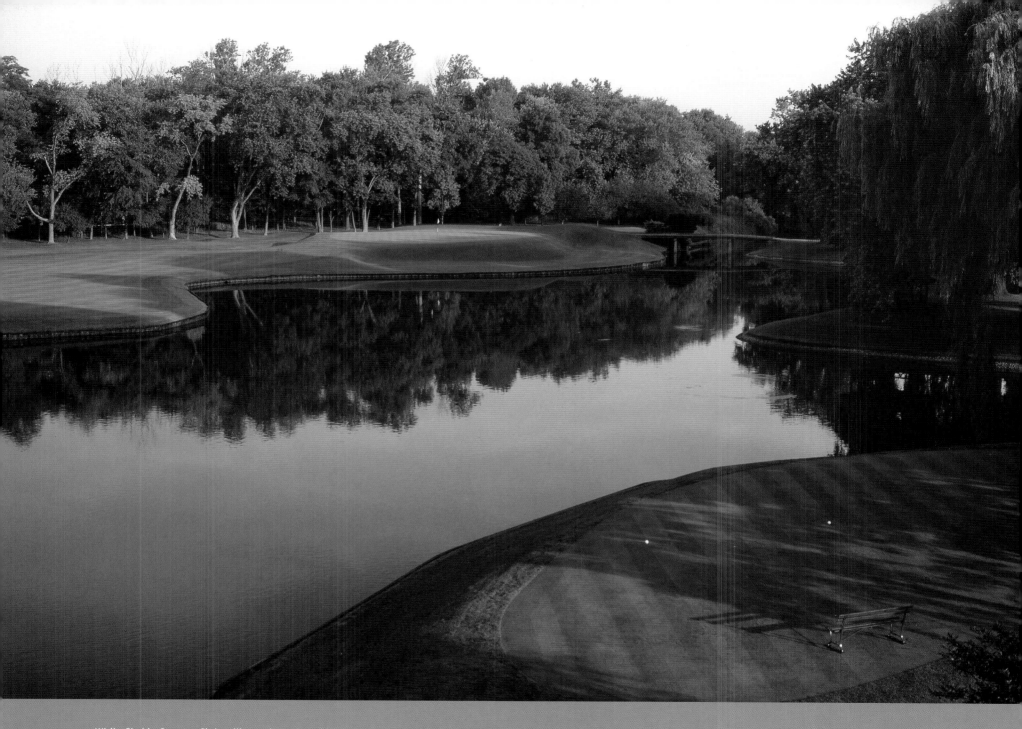

While Skokie Country Club still remains a Donald Ross course, thanks to the fine restoration of Ron Prichard in 1999, the signature par-three twelfth is the effort of local design team William Langford and Theodore Moreau, who created the hole in 1938. From the tips it plays at 228 yards to a tabletop green elevated 8 feet above the tee and protected in front by a steep slope, and left and back by a bunker and thick trees.

POND HOLES

When it comes to water hazards, it's great to have a site sitting tight to an ocean, sea or major inland lake, but most of the time architects are working with rivers, streams and ponds. The latter are woven along and across holes to plague golfers who go long, short or wide. The pond may be the most ubiquitous of water hazards.

Many are natural (Pine Needles #3 and Capilano #11); some are formed when a stream is dammed up (Augusta National #16); others are created when the architect digs one (Baltusrol #4 and Medinah #17).

Pond holes play to the golfer's fear of water, since most position the tee and green right near the pond and require carries of 150 to 200 yards to reach safe ground. The great pond holes complement the distance requirement with sand hazards and well-contoured greens to finish off the test.

From a long list of candidates, here are a fine nine.

Augusta National Golf Club

Length: 170–145 yards

Designers: Alister MacKenzie and Bobby Jones/Robert Trent Jones, Sr.

Opened: 1933

Location: Augusta, Georgia, USA

"I have always said this can be a very easy course or a very tough one. There isn't a hole out there that can't be birdied if you just think." — BOBBY JONES ON AUGUSTA NATIONAL

Playing Augusta's one-shot holes, it's probably best not to think too much, number twelve being the prime example. The next most difficult is sixteen and at the Masters the thinking is mostly about where the pin sits on Sunday.

Augusta aficionados know the original sixteenth was a short shot (approximately 110 yards) across Rae's Creek from alternate tees on either side of the fifteenth green. It stayed that way until 1947 when the club asked Robert Trent Jones, Sr., to make it stronger. Trent Jones's description shows best how the hole became what it is today: "Bob Jones wanted a long par three that required a carry over a pond, so . . . we dammed the creek to create a pond which runs from the front of the tee all the way to the front and left of the green . . . we built a new bean-shaped green, terraced at the back and right and sloping from right to left toward the water . . . the left tee

was extended so the hole would play 190 from the back. Two bunkers were built on the right side of the green, and the next year a bunker was added on the left and the green was extended behind it to provide another pin placement." The bunker back right is the one you definitely want to avoid.

The pin settings illustrate Bobby Jones's quote about the course being both easy and tough. The toughest is back right where Tom Watson once started eight feet above the hole but finished 35 feet away and five-putted. Back left just above the slope is almost as difficult and is the frequent Sunday placement. Right and left front positions offer birdies during the early rounds. Sixteen is all about putting your ball in the right spot. Hit it to the wrong spot and you'll suffer Watson's fate. In 2000 the green was recontoured to soften but not eliminate the almost outlandish breaks that sometimes

saw players stroking U-shaped putts that start out going *away* from the hole.

While sixteen often ruins hopes of claiming a Masters jacket, two brilliant shots here have paved the way to victory. In 1975 Jack Nicklaus sank a 50-footer for birdie and went on to win his fifth Masters. In 2005 Tiger Woods's tee shot ended behind the green, leaving a very delicate situation. A magical chip sent the ball curling toward the hole, where it hesitated on the lip and then disappeared for a two, propelling Woods to a playoff victory. Aside from the dramas enacted here, sixteen is aesthetically the most beautiful hole on the back nine. In late afternoon, long shadows combine with hushed silence, pond, stately trees and a profusion of redbud blossoms to create a cathedral-like setting.

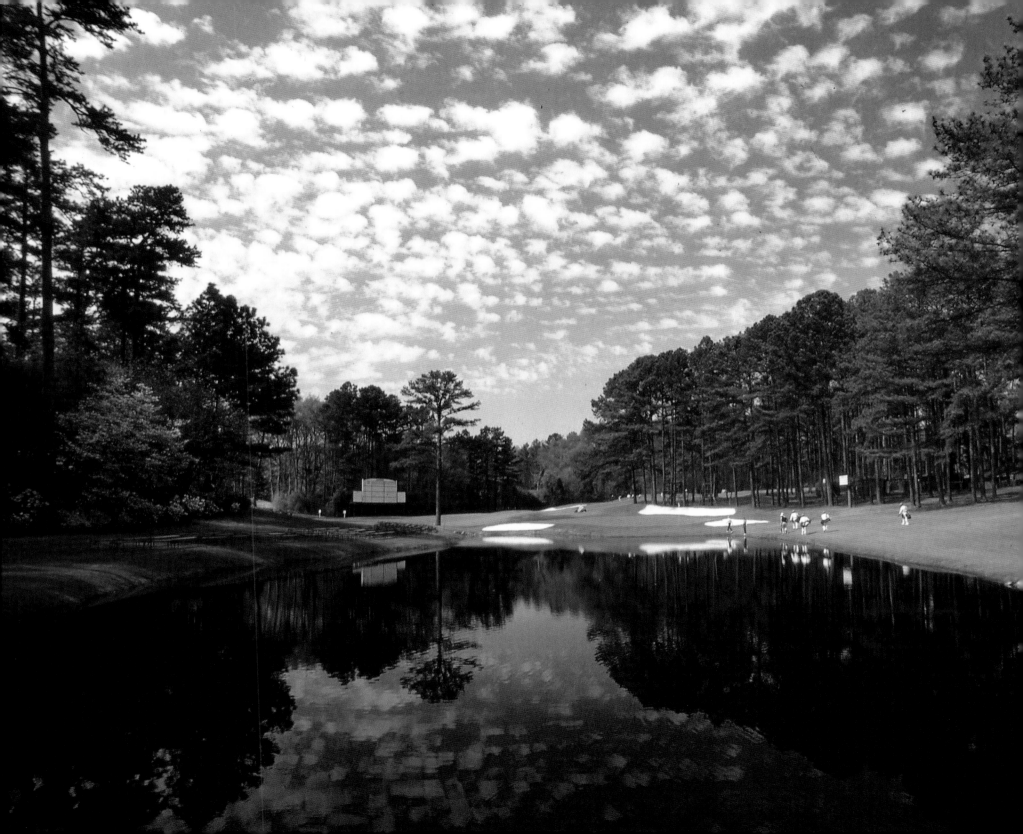

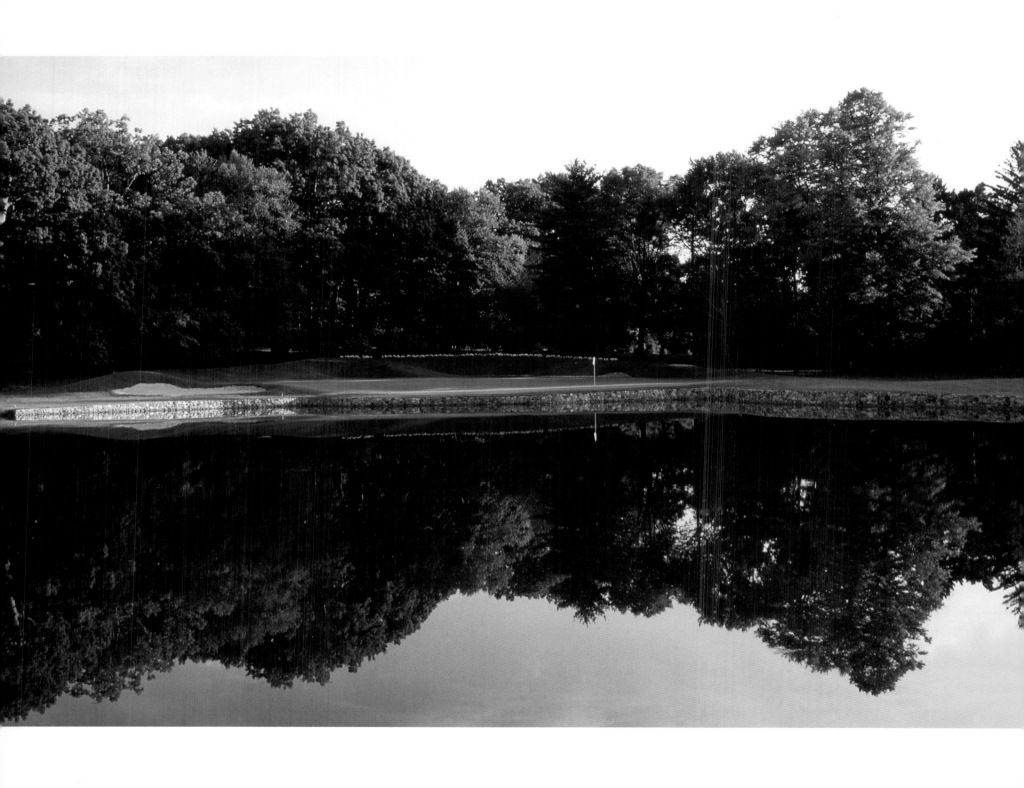

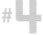

Lower Course at Baltusrol Golf Club

Length: 199–101 Yards

Designers: A. W. Tillinghast/Robert Trent Jones, Sr.

Opened: 1922/1952

Location: Springfield, New Jersey, USA

"As you can see, gentlemen, this hole is fair — eminently fair." — ROBERT TRENT JONES, SR.

The Ripleyesque tale involving architect Robert Trent Jones, Sr., and Baltusrol's Lower Course fourth hole is well known. Having revamped the course for the 1954 U.S. Open, Jones was challenged by members who contended he had made the par three too tough — specifically by moving the tee back 70 yards to require a 190-yard carry over a pond. When the group reached the fourth, Jones teed his ball, swung — and made an ace! He then turned to them with a wry smile and uttered the famous line we've quoted here.

Visually, the hole is quite beautiful with the shimmering pond and stands of evergreens and hickory trees, typical of a Golden Age parkland layout designed by A. W. Tillinghast. Regarding club selection, keep in mind the hole sets up to appear shorter than it is. And whatever the distance (140 yards to something over 200 for the tournament tees), you must carry your tee shot all the way home. The reason: A stone wall wraps around the front edge of the green; thus, you are either safely on or hitting three from the drop zone.

Jack Nicklaus, who won U.S. Opens at Baltusrol in 1967 and 1980, has these observations on playing to the large two-tiered green: "Any shot must be hit high to clear the water by a safe margin, but if the pin is located in the upper-left corner the shot should be hit toward the center of the green and 'worked' up the slope with right to left draw. If the pin is in the lower-right portion, a cut shot with left-to-right trajectory will have to be played into a very tight position."

The last features are the three bunkers in back. They act as a safety net, but the problem is that exploding out of them onto a green that runs toward the water is a dangerous task. A small bunker far left and a stream that feeds the pond from the right catch balls hit way off the mark.

Coming early in the round, the fourth has less strategic value than the very long par three sixteenth, although at the 1961 U.S. Women's Open, Mickey Wright began a dramatic come-from-behind victory surge with a brilliant two at the fourth. But more commonly, this hole's potential to cause big numbers frequently destroys a round or tournament aspirations. If you can hit what for most golfers is a lengthy tee shot and putt better than usual, you won't equal Jones's ace but may gain a rewarding par.

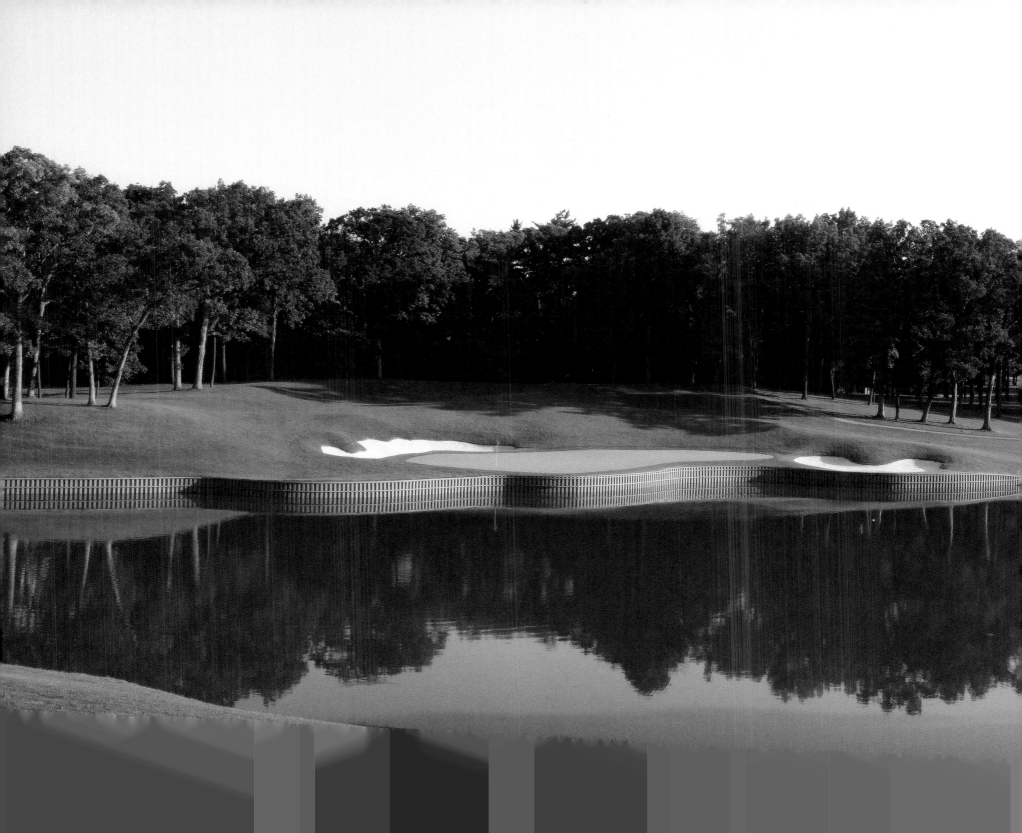

No. 3 Course at Medinah Country Club

Length: 206–133 yards

Designers: Tom Bendelow/Roger Rulewich/Rees Jones

Opened: 1928/1999/2003

Location: Medinah, Illinois, USA

"Make no small plans. They fail

to stir men's souls."

— DANIEL BURNHAM, CHICAGO

ARCHITECT AND CITY PLANNER

When Medinah's founders met in 1922 to draw up plans for a new club on a heavily wooded tract west of Chicago, they were definitely under the spell of Burnham's grand vision. From the get-go they intended three eighteen-hole courses, a mammoth Italianate-Byzantine clubhouse, and recreational facilities that included a man-made lake for boating, a ski run, a gun club and an equestrian center. They hired the best they could find to execute these but in a bit of golf irony chose oft-maligned architect Tom Bendelow to design the courses.

Told to build a "ladies course," Bendelow produced one of his best layouts — the fearsome Medinah No. 3, perennially ranked in America's top 100. The watery center of No. 3 is Lake Kadijah. Three of the four par threes cross it at various lengths ranging from 180 yards (#2) to 206 (#17). Seventeen's strategic positioning and proximity to the water make it our first choice. Sam Snead and Ben Crenshaw would likely agree, since seventeen cost both of them U.S. Open titles.

One might say, "Play Medinah's seventeenth quick, since it could change soon." The original setup had the green close to the lake, emphasizing Bendelow's original goal of balancing a heroic carry with control. At one point, in another attempt to improve the course, the back nine was rerouted, and seventeen became the thirteenth hole. In 1996 Roger Rulewich tried to model seventeen on Pine Valley's famous fifth and set up a hilltop-to-hilltop carry of about 206 yards. This was met with great unhappiness from both players and members. So in preparation for the 2006 PGA Championship, Rees Jones returned the hole to its original form, putting the green back down near the water and giving it a less severe angle.

Today, it's a 200-yard shot through unpredictable winds into a 108-foot-wide target nestled a few feet from the water and guarded by bunkers back left and front right. The sharply rising grassy back slope may be the biggest challenge, since chipping off it can send the ball scooting toward the water. Fair or not, Medinah is a brute course that rarely lets up. Seventeen is just one more example of its testing nature, and it meets all the criteria for a demanding final-stretch par three.

Muirfield Village Golf Club

Length: 184–107 yards

Designers: Jack Nicklaus and Desmond Muirhead

Opened: 1974

Location: Dublin, Ohio, USA

"Wouldn't it be terrific if something similar to this could be done in Columbus?"

— JACK NICKLAUS AT THE 1966 MASTERS TOURNAMENT

As we know now, Nicklaus was speaking of Muirfield Village Golf Club, his homage to Augusta National and Scotland's original Muirfield Golf Club, where he would shortly win the first of his three British Open championships. It took eight years to bring Augusta to Columbus, but the reality easily matched the dream.

Since its opening in 1974, this creation of Nicklaus and Desmond Muirhead (who influenced the routing), has evolved into one of golf's great venues, recognized for its design excellence and as home of the Memorial Tournament, a regular PGA Tour stop. The architectural consensus on Muirfield Village is that the fives rule, but two other holes also remain in the mind — the brilliant 363-yard par four fourteenth and the par-three twelfth with its direct links to Augusta National.

Nicklaus believes a good golf hole should lie open to view and instruct as to what shot(s) will best succeed. The sight line from the tees (there are four) illustrates this principle and implements another Nicklaus preference — that golf is a game much better played downhill. What one sees is a healthy carry of about 170 yards, all across water, to a two-tiered, kidney-shaped small green angled up at forty-five degrees. An aerial view reveals what the first-time player might not see — the pond encompasses 50 percent of the green complex. So too long or far right means you'll be hitting three.

The two bunkers also borrow inspiration from Augusta. For starters, they are beautifully proportioned to the size of the green. As with Augusta's twelfth, the wide right front bunker catches balls just short of the putting surface. Unlike Augusta, there is no severe manicuring of the slope near the pond, so you have some chance of staying up. Serious students of Augusta will appreciate the shape and flashing on the bunker that guards the back left, since it mirrors the bunker back right at Augusta's sixteenth.

Yet despite the twelfth's homage to Augusta, there are significant differences between the twelfth holes at Muirfield Village and Augusta. The wind at Muirfield Village is on average much less vexing. On the other hand, the green is more severe. Hale Irwin described Muirfield Village's greens as "some of the most beautiful and well contoured in the world — and some of the toughest." When you do putt though, there are never any excuses about being true. Part of the Muirfield Village mystique is the conditioning of the course, remarked upon by everyone who plays there. A Memorial Tournament participant once said the greens were "almost too good." When one surveys Muirfield Village's eighteen holes winding sinuously through thick Ohio tree stands and the ever-present Deer Creek, Augusta easily comes to mind, especially on the graceful twelfth.

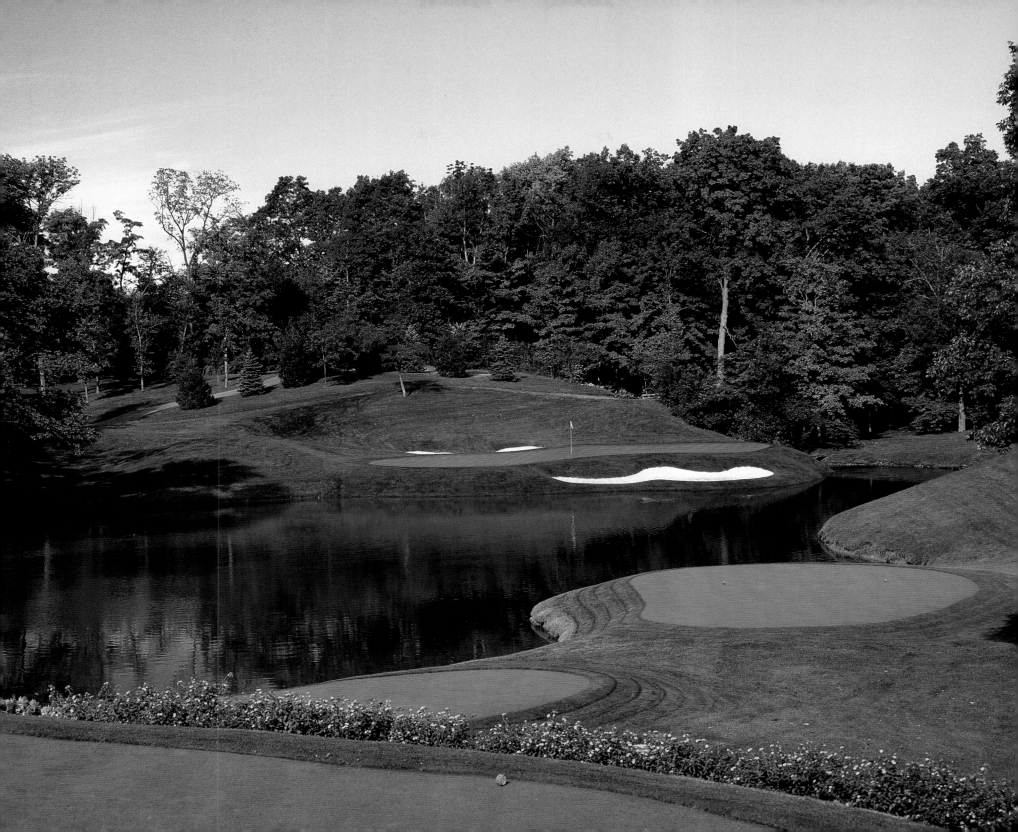

Pine Valley Golf Club

Length: 226–217 yards

Designers: George Crump/Harry S. Colt

Opened: 1919

Location: Clementon, New Jersey, USA

We are left to wonder if J. Wood Platt would have made three or better on Pine Valley's fifth. In the now legendary account, he played the first four holes 3, 2, 1, 3 (two birdies and two eagles for a total of six under par). Whether it was the proximity of the clubhouse bar to the fourth green or anxiety over the intimidating tee shot on five, Platt decided to fortify himself with a drink. And never came out.

The par-three fifth at Pine Valley epitomizes designer George Crump's belief that a good score requires numerous, successful forced carries. Thus, a round on his hand-built creation means hop-scotching from one island of turf to another, attempting to avoid the sandy wastes and thick pine tree stands that are the canvas on which Pine Valley lies.

Five owes some of its challenge to routing requirements. In order to get from the fourth green to a ridge where he wanted the sixth tee, Crump devised this wonderful, slightly uphill one-shot hole over the lake that separates the first four holes from the rest. Getting to the green in regulation requires a carry of more than 190 yards. Caddies routinely hand mid-range players a driver with the warning, "It's farther than it looks." A second look reveals Crump has left an out. Hit the ball 130 to 140 yards and you will be on grass, short of the green but safe from the bunkers short left, the sand all around and the huge fall-off into pines on the right. Being *straight* is especially key here. The large (12,000-square-foot), two-tiered, narrow green will accept a ball flown to it.

One of the most evocative accounts of the perils and perfection the fifth offers comes from the great Henry Longhurst: "Walking along a wooded path to the fifth at Pine Valley, for instance, you come upon a deep ravine, with a lake full of turtles at the bottom. At eye level on the far side, a full drive distant, you perceive a long, narrow green, sloping to the right, with the flag in the far left-hand corner. Miss it on the left and you are in a sand pit. On the right and your ball trickles down among the pine roots and you may be down there for a long, long time. I once did this hole in 2. For several days life had nothing more to offer."

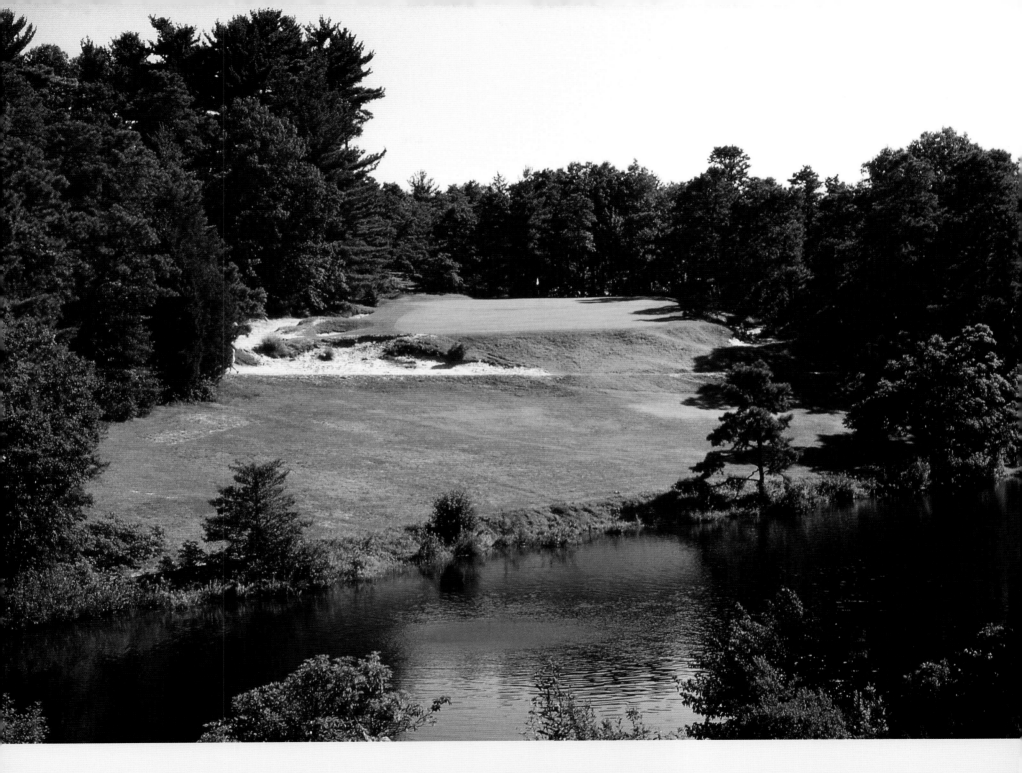

"Only God can make a three." — PINE VALLEY REFRAIN

Capilano Golf & Country Club

Length: 168–116 yards

Designer: Stanley Thompson

Opened: 1938

Location: West Vancouver, British Columbia, Canada

One wonders if in naming this — the favorite par three of all he designed — "Wishing Well," architect Stanley Thompson was trying to tell us something, besides pointing out there is a pond to carry. If well means feeling good because on the tee you are looking into a contemplative setting of tall conifers and a placid blue pond, then it surely is. On the wishing side, you might hope for easier club selection to match the subtly swirling winds and 20-foot drop to the medium-size green, which is in turn artfully pitched to cause landing and putting problems. Typically, Thompson has framed it with four aesthetically shaped bunkers, beautiful but threatening too. If Thompson won't, we wish you well.

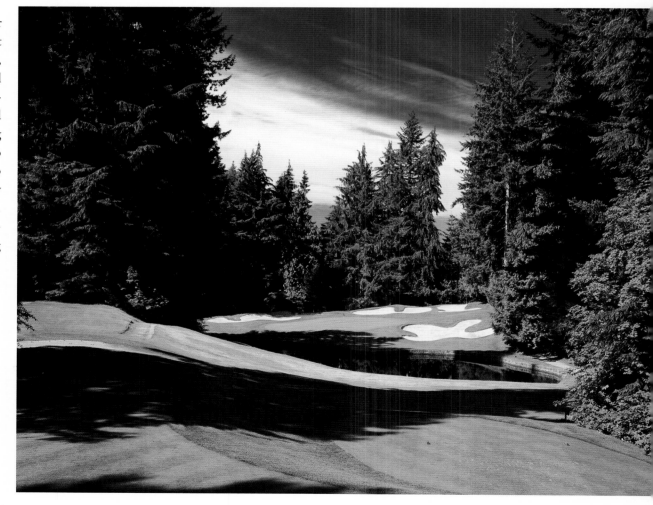

Pine Needles Lodge and Golf Club

#3

Length: 145–110 yards

Designer: Donald Ross

Opened: 1928

Location: Southern Pines, North Carolina, USA

Dornoch, Scotland, was the birthplace of Donald Ross, so he might be faulted for creating a hole with a pond, a feature not seen at Royal Dornoch, or, for that matter, on most other British courses. But the little wetland at Pine Needles' third must have seemed too good not to use in his design. At such a short distance, the hole appears somewhat tame until you realize how beautifully Ross integrated the pond, front bunker and the back-to-front slope of the green to defend it. John Fought's recent restoration added to the conundrum when he reduced the putting surface by a third, thus resurrecting Ross's original, smaller green.

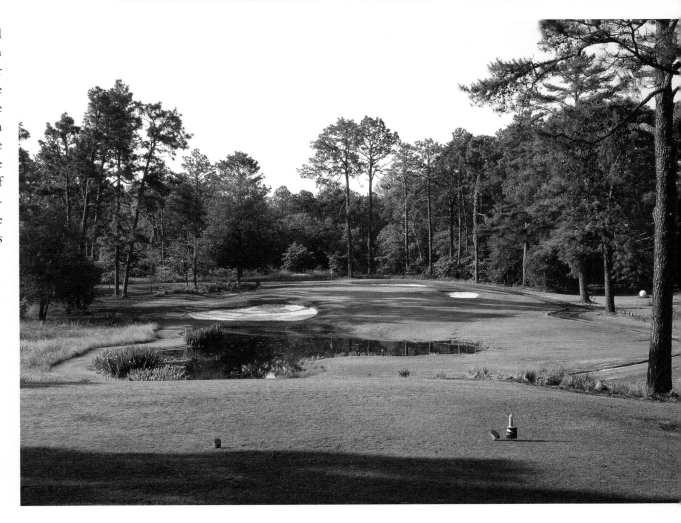

Red Course at Royal Golf Dar Es Salam

Length: 189–121 yards

Designer: Robert Trent Jones, Sr.

Opened: 1971

Location: Souissi, Rabat, Morocco

If there is a master of "aesthetic irrigation," it's Robert Trent Jones, Sr. One of Jones's favorite concepts was the pond hole, evidenced by his work at Augusta National's sixteenth, Baltusrol's fourth and here at Dar Es Salam's ninth. The green comprises one half of a large island replete with stands of tropical fern trees and is framed with two catcher's-mitt bunkers. The tee shot must carry the full watery distance of 189 yards and, if you were hoping, the ball will not bounce off the lily pads onto the green.

Sedona's majestic red rocks surround this impressive Tom Weiskopf design. His par threes at Seven Canyons interpret famous holes much in the way C. B. Macdonald brought old world styles to the National Golf Links. The seventh is evocative of the sixteenth at Augusta but goes one better by framing it in a setting not of pine trees, but magnificent weathered sandstone. The tees are located among cascading waterfalls and the longish shot must carry a sizable pond to a large green protected on all the remaining sides by big, deep bunkers. The green has a whaleback in its center, which, in a neat optical trick, is in fact sloped front to back. Putts gain speed racing to a rear flag and often tumble well off the back. Caveat golfer!

#7

Seven Canyons Golf Club

Length: 198–123 yards

Designer: Tom Weiskopf

Opened: 2002

Location: Sedona, Arizona, USA

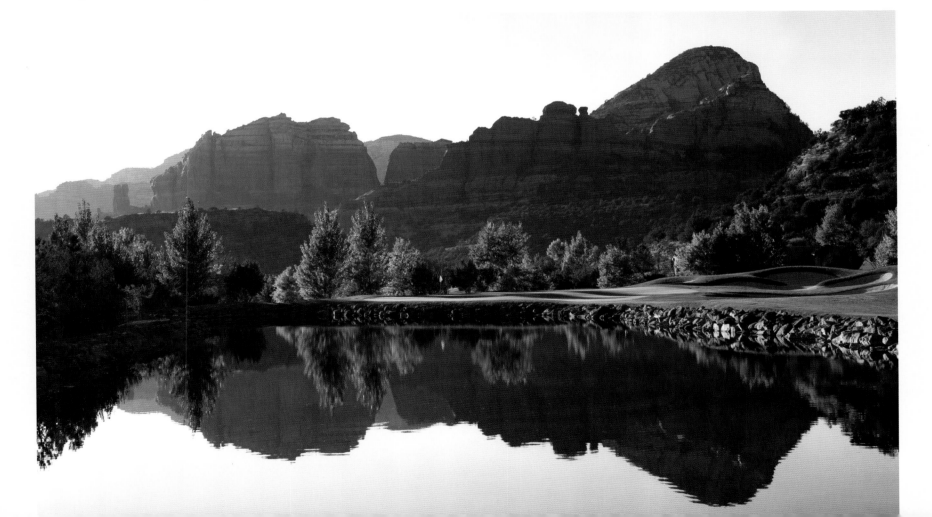

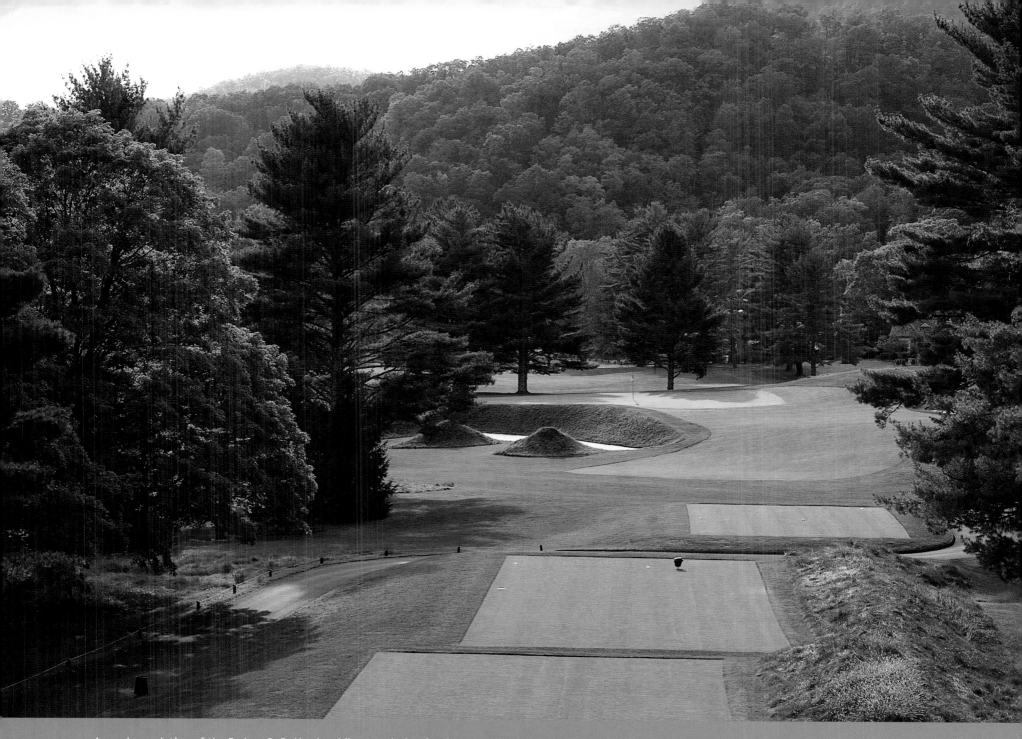

An early emulation of the Redan, C. B. Macdonald's 1914 design for the eighth on the Old White Course at The Greenbrier Resort was recently restored, including the unique conical mounds left of the green.

BIARRITZ AND REDAN HOLES

Two of golf's most interesting design concepts — the Biarritz and the Redan — owe their popularity to the work of Charles Blair Macdonald who incorporated the best ideas from European courses into his American designs.

The Biarritz, named after the first version at a course in Biarritz, France, has had more limited replication, partly due to the unusual shape and size of its green, specifically a giant swale separating the front and back portions of the putting surface. Landing your ball on the correct part of the green to avoid an adventurous putt is the key to par. All Biarritz holes are long — well over 200 yards — which often makes it hard for average players to reach the green with their tee shot.

The Redan, as pointed out in our "Evolution" section, is not peculiar to the par-three hole alone. Its name comes from a fortification used by the Russians during the Crimean War, and its most notable features are a tilted tabletop green defended by a wide and deep bunker, usually set on the left side. This configuration is also used on par fours and fives. There are hundreds of Redan-inspired holes in the world. While the original is in North Berwick, Scotland, many believe the best example is the fourth hole on the National Golf Links of America, a C. B. Macdonald creation.

Following are three examples of the Biarritz form and four of the Redan.

Yale University Golf Course

Length: 213–146 yards

Designers: Seth Raynor and Charles Blair Macdonald

Opened: 1926

Location: New Haven, Connecticut, USA

Golf archaeologists seeking remains of the original Biarritz green will dig in vain. While the 18-hole course Scottish pro Willie Dunn laid out in 1888 in this seaside resort town in southwestern France still survives as a nice muny, his dramatic innovation is long gone. Thankfully, C. B. Macdonald and Seth Raynor's fascinating re-creation at the formidable ninth hole on the Yale University Golf Course allows any golfer to experience Dunn's roller-coaster concept.

When Macdonald was approached by the university to carve a course out of a 700-acre wilderness tract close by the school, he immediately asked Raynor, his partner and protégé, to be the lead designer. Raynor crawled around and under thickets and gnarly growth and produced eighteen holes that are "big and burly . . . with bunkers that are deep and deeper." Think Pine Valley and Oakmont and you get the overall profile. After playing the course, British Open Champion Tommy Armour said number nine was "one of the best holes in existence."

Contouring is of course an understatement with a Biarritz. Standing on Yale's ninth tee some twenty feet above Griest Pond, which runs 100 yards to the far shore, one sees a green that is just about twice as long as it is wide, approximately 90 by 200 feet. At an expansive 12,000 square feet, you can't complain the target isn't big enough. However, careful scrutiny reveals what looks like two greens linked by a depression deep enough to hide anyone less than six feet tall. This trench, gully, swale (take your pick) is the defining characteristic Dunn incorporated into the first Biarritz. Yale's number nine lowers this, one might say, to another level.

Many contend that the pin at nine should always be in back since the design calls for landing the ball and "slinging" it through the gully onto the rear portion of the green. This is the plan. If your first shot carries the 160 to 180 yards over the pond but only reaches the first half, then hope the pin is in front that day. If not, your choices are: 1) Stroke an amazing lag putt close to the hole, or 2) as many choose to do, pitch over the gully and get close for a one-putt. As they say in Biarritz, "*bonne chance.*"

"The feeling one gets playing the hole the first several times is that of standing on a precipice hitting over an abyss to a green that is impossibly far away." — GOLFCLUBATLAS.COM

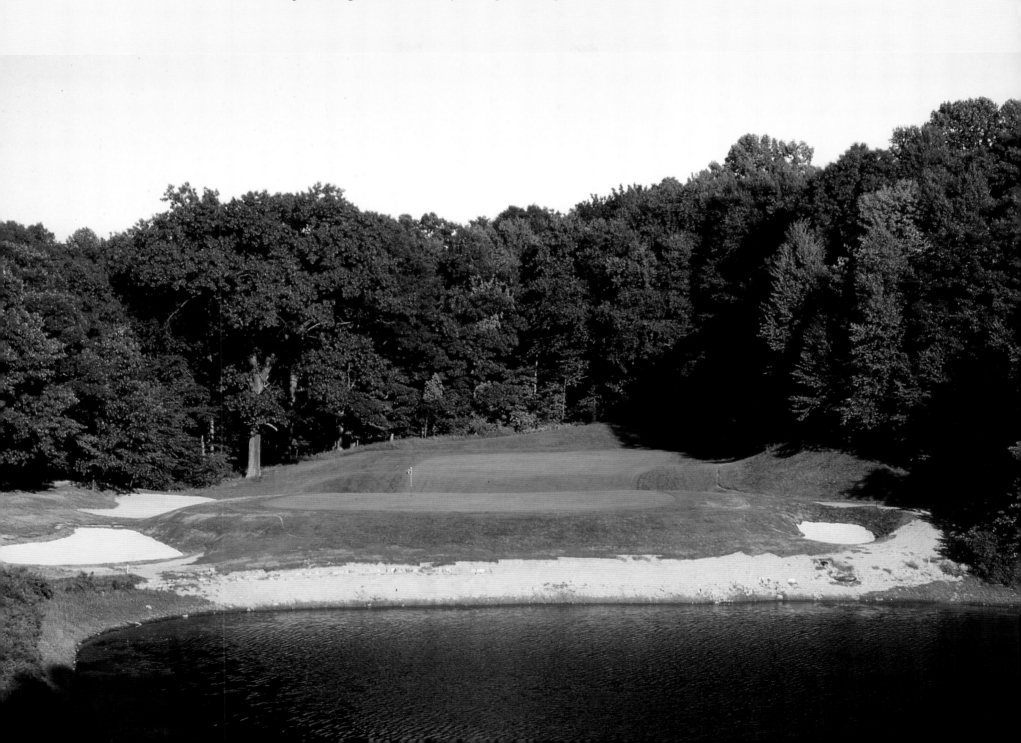

Fishers Island Club

Length: 229–141 yards

Designer: Seth Raynor

Opened: 1926

Location: Fishers Island, New York, USA

Seth Raynor took the Biarritz concept to Fishers Island and of the few replicas in the world, his rendition comes closest to the French original designed by Scottish pro Willie Dunn. Dunn's version had a long carry of 220 yards over a chasm with the Bay of Biscay on the right to the Biarritz-style green with its defining giant swale set in the middle. At Fishers Island's fifth, the view from the tee shows the huge elevated green with symmetrical bunkers in the distance and a curving waterline of sand and rock right. Here, power plus accuracy equals success.

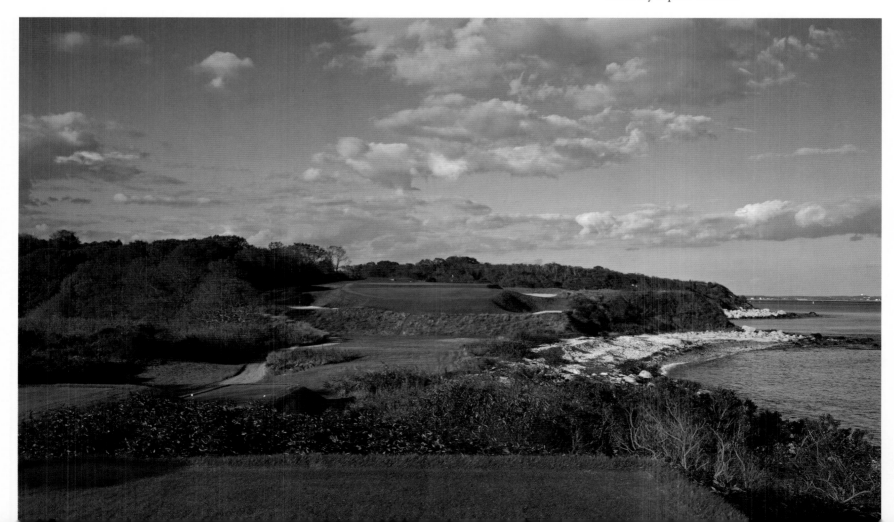

The Mid Ocean Club

Length: 238–188 yards

Designer: Charles Blair Macdonald

Opened: 1921

Location: Tucker's Town, St. George's Parish, Bermuda

#13

This C. B. Macdonald version of the Biarritz has an elevated tee that clearly reveals its hallmark symmetrical configuration — a huge green with a swale in the middle and four neatly placed bunkers, two on each side. As you ready your shot, you need not worry about the front half of the green. In order to guarantee that the hole plays to its full yardage and not too much like Mid Ocean's other par threes, the club maintains only the back portion of the green. So get out a big club and let it fly to the manicured surface, or face a chip off the front and a likely four. Assuming you don't end up in one of the four bunkers, that is.

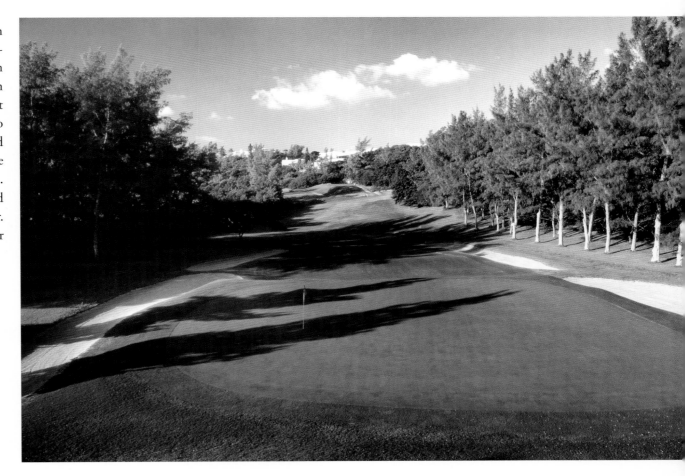

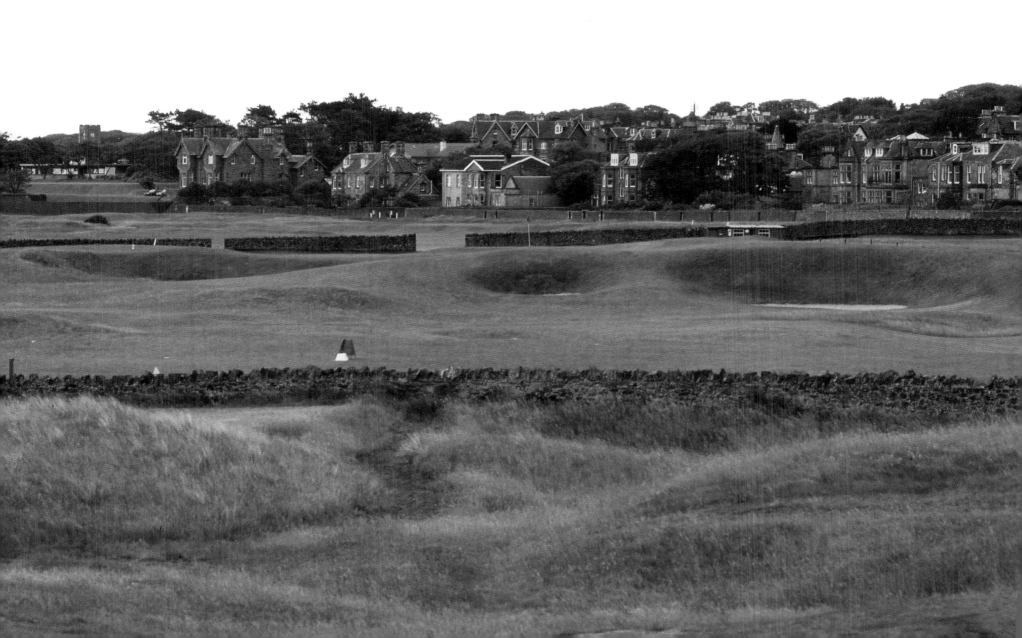

"Here's a hole that makes a man think."

— CHARLES BLAIR MACDONALD'S CADDIE ADVISING HIM ON PLAYING THE REDAN

West Links at North Berwick Golf Club — "The Redan"

Length: 192–173 yards

Designer: David Strath

Opened: 1832–1876

Location: North Berwick, East Lothian, Scotland

If you can name the number of this celebrated and imitated hole, then you are a golf insider. Generally, it has come to be known by its name, the Redan, and you don't have to go to Scotland to confront its challenges because architects have been re-creating it on every continent in the world. In the U.S. alone you can see Redans at the National Golf Links, Somerset Hills, Piping Rock, Merion, Shinnecock Hills, Riviera, Seminole and many others.

As one design historian aptly states, "The Redan is more than a golf hole. It is an idea about golf architecture. While the Redan Bunker is especially notorious, the entire hole is a hazard in itself." To grasp why it can be so intimidating, it helps to understand how the name arose. A redan was a fortification developed by the Russians against the English and French armies during the Crimean War (of Sevastopol and "Charge of the Light Brigade" fame). The Great Redan was, as the French word defined it, a "jagged notch" like a saw tooth and consisted of two huge earth faces that were angled in such a way as to make it almost impossible to breach.

The home of the Redan, North Berwick, is a town, a links and a region of Scotland, part of an East Lothian cluster of courses that include Gullane and Muirfield GC. North Berwick the club was founded in 1832 and, according to its own research, is the thirteenth oldest in the world. Started with only six holes, it grew to eighteen in 1895 when the Redan, which had been the sixth hole, became the fifteenth.

Referencing North Berwick's original, Macdonald instructs on how to build a Redan: "Take a narrow tableland, tilt it a little from right to left, dig a deep bunker on the front side, approach it diagonally, and you have the Redan. At North Berwick, of course, all those things were done in the beginning by nature. The only original thing the green keeper [Davie Strath] did was to place the tee so that the shot had to be played cornerwise, so to speak, instead of directly down the tableland."

The caddie who proffered advice to Macdonald was right — stop and think. And when confronted with the original, what should we be thinking about? North Berwick's membership offers this advice: "The green is blind from the tee and the player has to shape the shot into the prevailing wind, allowing for the ball to finish below the flag stick. The slope of the green runs diagonally from right to left, and anything above the hole is in three-putt country. The bunkers on two sides, deep enough for the player to disappear from view, add to the difficulty of securing par."

Seems reasonable enough, but this discounts what one observer described as "an angle that simply does not agree with the nature of the golf swing and the flight of the ball." British golf writer Bernard Darwin echoed this strategic feature when he wrote, "The tee is set at an angle to give the shot the greatest possible poignancy." This inspired forty-five-degree adjustment by Strath combined with the position of the bunker left, the green falling away in the rear and a ridge that makes the shot partially blind, produce one of golf's most finicky tee shots.

Bottom line, it's about taking risks. If you want to make birdie or par, you have to fly the ball over the bunker and most of the green. The conservative shot will land short of the green and run up and follow the contour of the green toward the hole, assuming it has proper speed and you play the prevailing wind correctly. No matter what you do, Horace Hutchinson's line captures the challenge of the Redan: "It has an aspect of no little terror as one faces it from the tee."

National Golf Links of America

Length: 195–159 yards

Designer: Charles Blair Macdonald

Opened: 1911

Location: Southampton, New York, USA

"Time is not able to bring forth new truths but only an unfolding of timeless truths."

—— LANDSCAPE ARCHITECT PRINCE PÜCKLER, AS QUOTED BY TOM DOAK

Of the numerous Redan holes in the world, the fourth at the National Golf Links of America may be the best. When Keeper of the Green Davie Strath designed the first Redan at North Berwick, he wanted to make a very tough one-shotter, and succeeded. Serendipitously, he produced a model used by course architects ever since.

In order to re-create an original one must know it well, and architect Charles Blair Macdonald (our best guide to the hole) was someone who did his homework in the extreme. Of his research for the National he says, "Through sketches and right principles of the holes that formed courses abroad and had stood the test of time, we learned what was right and what we could use."

What distinguishes the National's version? As he routed the course along the sandy shores of Long Island's Peconic Bay, Macdonald found a natural site

formation, already elevated, tilted and angled. His contributions were the bunkering and a design that emphasized his belief that every hole should inspire multiple shotmaking options. Unlike North Berwick, the National's fourth is fully visible from an elevated tee. Macdonald's own scenarios, described in detail, suggest how to make par depending on the nature of the wind. For example, with the wind, the player flies the ball a good 190 yards and then "the ball landing on the high end of the tabletop will break to the left and be kept going more to the left by the fact that the green is banked like a circular bicycle track; and so a shot played twenty yards or more to the right of the hole may end up within a foot of the flag." Such a prospect inspires the better player to go for it.

Failure is landing in a bunker, a hazard that in Macdonald's opinion is meant not only to hurt your

score, but to punish egotism. There are five deep bunkers circling the green. Landing in any of them will require a healthy explosion to reach the elevated green. The cautious golfer can eschew flying it to the green and, with the aim of avoiding disaster, play a layup shot that may bounce onto the green in hope of feeding into the flag or leave a chance for a chip and a putt.

Summing up the hole, Macdonald said, "At the Redan it takes an exceedingly good shot to stay anywhere on the green; and to get a putt for a two is something to brag about for a week." If there is a bigger challenge than making a par at number four, it is getting to play the course, one of America's most exclusive. One can always hope for entry and a two at the fourth — equally difficult prospects.

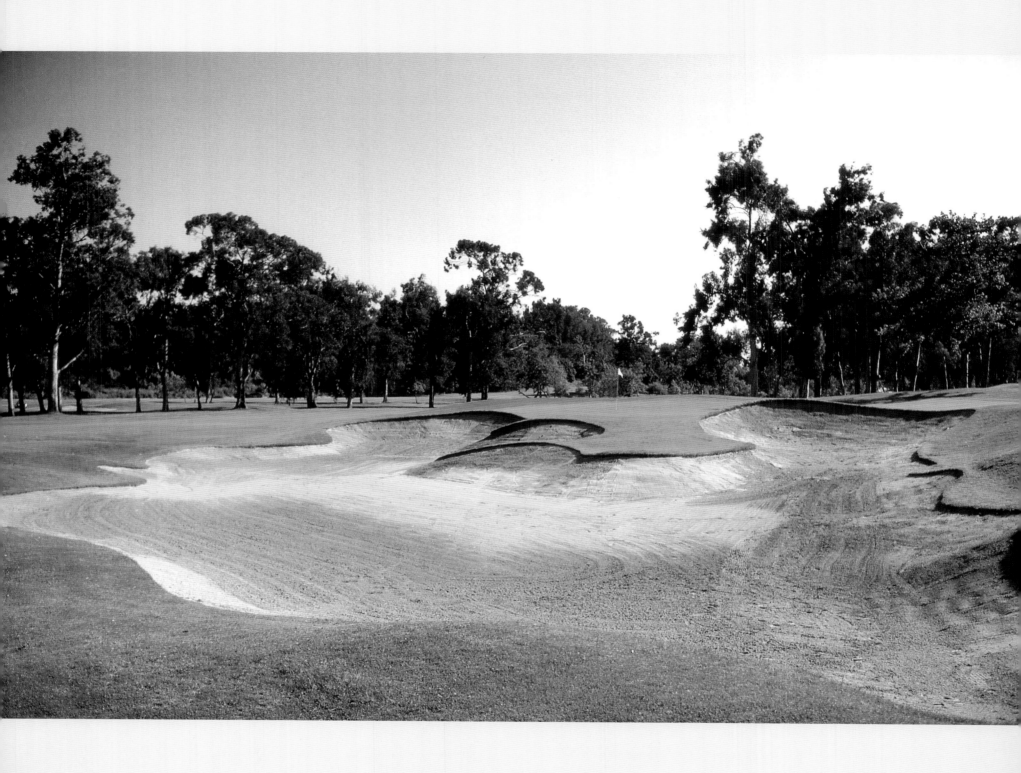

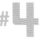

Riviera Country Club

Length: 236–186 yards

Designers: George C. Thomas, Jr./Billy Bell

Opened: 1926/1927

Location: Pacific Palisades, California, USA

"It's the greatest par-three hole in America." — BEN HOGAN, *Los Angeles Times*, 1948

Given that Ben Hogan talked very little on or off a golf course, let alone lavished praise on anything, his commendation of Riviera's fourth has to carry some weight. And while Riviera became "Hogan's Alley" from 1947 to 1948, it is more likely his evaluation of number four was as objectively analytic as his preparations for a major.

So what did he see in what is generally called an "epic par three"? We do well to let the architect himself, George C. Thomas, Jr., provide his analysis: "This hole is a typical Redan, with the natural contours helping the shot. It is a one-shot hole, which, from the back part of the tee, has a distance of 236 yards into the prevailing westerly wind, with a carry of 175 yards to secure the roll of the ground to the green, or a very correct placement to the left of the carrying trap. From the forward part of the tee this carry is distinctly less. The short player has open fairway of over 200 yards in which to place his shot short of the hazard blocking the way to the green. It is practically impossible for the long player to carry this trap into the prevailing wind . . . a one-

shot hole that will require the finest play from the back part of the tee to secure a three."

Comparisons between Riviera's fourth and the Road Hole at St. Andrews are apt. Both offer the accomplished or adventurous golfer a heroic route with a big shot directly at the flag. Simultaneously, they provide a secondary route for the weaker or timid player; at Riviera, it means hitting your tee ball at the fairway right of the bunker in order to catch a contour that will send the ball onto the green.

As is consistent with a Redan, the green angles at about forty-five degrees. It is large enough (about 120 feet across) to hold a long tee shot of 230 yards and slopes dangerously from right to left. What the average player sees more than anything is the menacing bunker rising up to protect the entire front of the green. Design authority Geoff Shackelford calls it "the elder statesman of man-made bunkers."

If you accept Hogan's evaluation, not only one of the five best Redans in the world but an extraordinary par three.

Somerset Hills Golf Club

Length: 175–148 yards

Designer: A. W. Tillinghast

Opened: 1918

Location: Bernardsville, New Jersey, USA

The work of A. W. Tillinghast, who, like C. B. Macdonald, made a thorough study of the original at North Berwick, this version features all the hall-marks that make Redans so memorable — right to left tilt of the diagonally set green, a steep fronting bunker on the left face and bunkers behind on the right. The cumulative effect makes club selection a deal with the devil since going for the pin isn't always the best route to par, and, once on, the player is confronted with rolls and pitches that threaten a two-putt escape. There are numerous Redans in the world but few truer to the name than the second at Somerset Hills.

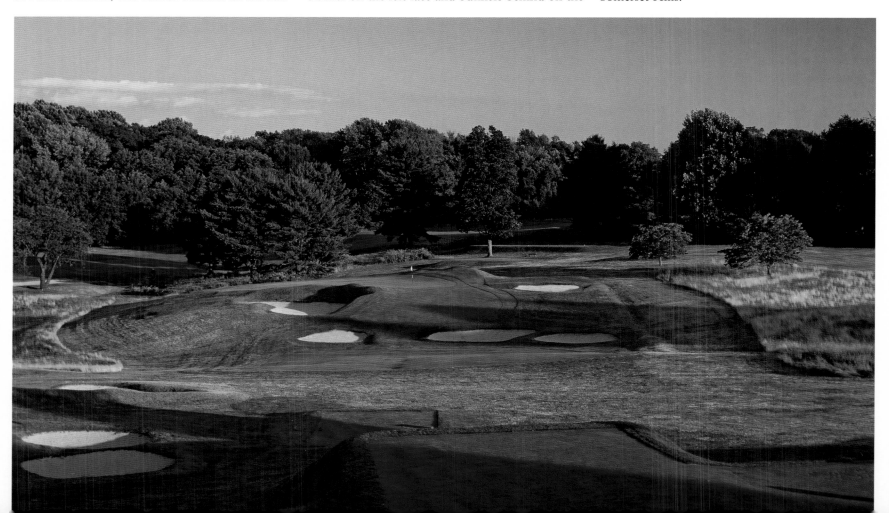

SHORT HOLES

In the introduction to our "Finest 100" we quoted Ben Crenshaw on the short par three. One reason Crenshaw likes the "little holes" is that most golfers can get to the green with a chance to make a birdie 2. While recent trends show architects building at least one giant three (250 to 300 yards) into their layouts, these are aimed primarily at pros and skilled amateurs.

The tee marker for this concluding section stops at 140 yards, a distance that under normal conditions can be reached with anything from a wedge (long hitters) to a mid-iron (higher handicappers). Or, when the wind is up, long irons and even woods. Our list mixes the best-known wee holes with others that are not as famous. Yet each stresses the need for exact club selection and a special touch to avoid the many perils defending these small one-shotters.

Pebble Beach Golf Links

Length: 106–90 yards

Designers: Jack Neville and Douglas Grant/H. Chandler Egan

Opened: 1919

Location: Pebble Beach, California, USA

The wild and spectacular Monterey Peninsula is the setting for some of the greatest golf in the world, eighteen holes of which are found at the Pebble Beach Golf Links. Pebble's memorable sequence of seaside holes run from numbers four to ten. Nestled in the heart of this strenuous test is the jewel recognized as one of the world's greatest short-short holes.

It's a good thing Jack Neville did this course, because Pete Dye admits he might have walked by the small spit of land that contains the seventh. Some call it a promontory; it's really not that big, but it is proportioned perfectly for a 106-yard shot to a 3,000–square-foot green about 50 feet wide and guarded by a phalanx of six bunkers. Of these the most important are the two comma-shaped bunkers in front and the safety bunker that catches balls headed for the Pacific. Praise is also due to H. Chandler Egan who was responsible for the green complexes that took Pebble from good to great.

Most people know the Pebble Beach story. Samuel F. B. Morse purchased 7,000 acres to preserve them and set out to build a world-class golf community. He commissioned Neville and Douglas Grant, two leading amateur golfers in California, to design a course that would sit right on the ocean. In addition to the famous fours and fives, they produced a complement of threes that compares favorably with Pine Valley, Augusta National and Royal Melbourne. While the seventeenth has produced two of the most spectacular shots in golf history, the seventh along with eight and eighteen are the holes golfers remember.

Like one of its cousins, the Postage Stamp at Royal Troon, Pebble Beach number seven is a tiny hole and the shortest par three among the U.S. major championship venues. Like Augusta National twelve, it requires particular discernment and is heavily conditioned by the wind. In this case, not the subtle swirling that goes on at Augusta, but weather that ranges from mild breezes to the lashing rain storms that can buffet the peninsula.

Thus, when you stand on the tee — 25 feet above the green — and see that you are hitting directly toward the ocean, a bit of tension creeps in.

Except for the aforementioned bunkers, there is no backstop if you go long. And, unless you are a confident bunker player, recovering from the other five is no guarantee. On good days, the shot is like the gentle underhanded pitch used in softball; you'll be hitting wedge or nine iron. When the wind blows, many players punch a mid-iron low; some, like pro Art Wall, have even used a putter to stay under the wind, bouncing their ball down the hill toward the narrow neck in front.

A Scot playing it on calm days might name it "Respite," coming as it does after the arduous uphill sixth and before the demanding eighth. Given normal conditions it makes the case for great threes leaning more to accurate control. It is, to quote the *World Atlas of Golf*, "an eloquent plea for delicacy."

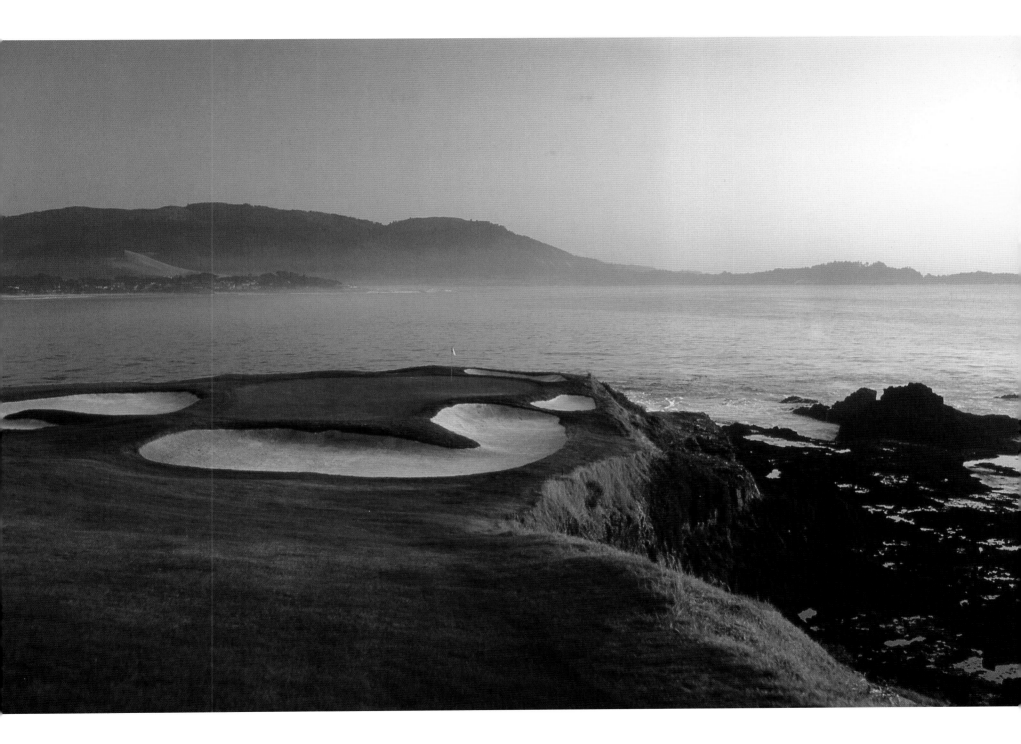

"The drop zone is in Honolulu." — JIMMY DEMARET, THREE-TIME MASTERS CHAMPION

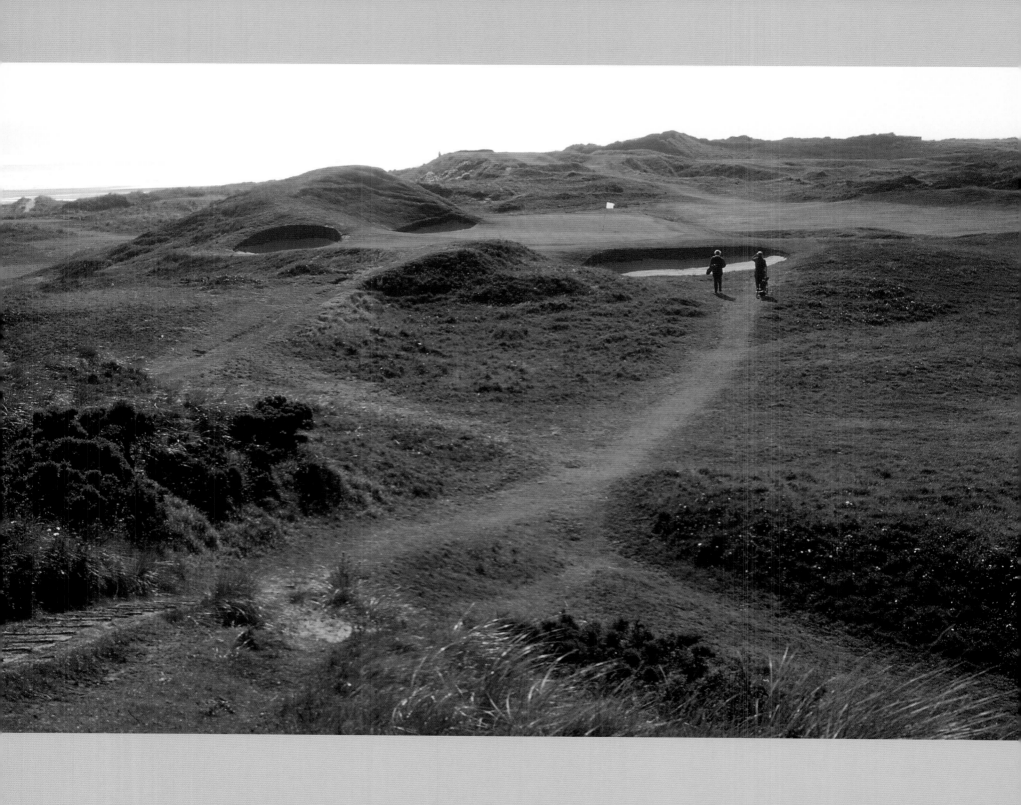

Old Course at Royal Troon Golf Club

#8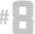

Length: 123–114

Designers: George Strath/Willie Fernie/James Braid

Opened: 1888

Location: Troon, Ayrshire, Scotland

"A pitching surface skimmed down to the size of a postage stamp."

— WILLIE PARK, JR., BRITISH OPEN CHAMPION

There are a handful of "wee threes" that merit the term great. Royal Troon's eighth is one of them. With a green that measures a mere 25 feet wide and wind that knocks the shot every which way, judging the right stroke to stay on the green amplifies its moniker, "The Postage Stamp." At first it was named "Ailsa" because it offers a perfect view of the famed rocky islet the Ailsa Craig. It got its nickname, when Scottish pro Willie Park, Jr., coined the now-famous postage stamp description in *Golf Illustrated*.

It's definitely in Tiger Woods' "Bad Holes" file. On his first trip to Royal Troon for the 1997 British Open, the seventh to be held there, he carded a triple bogey. The all-time disaster occurred when German amateur Herman Tissies flailed from one of the five bunkers to another, finally finishing with a one-putt 15. On the upside, there have been holes in one, the most famous by septuagenarian Gene Sarazen, who scored an ace in the first round of the 1973 British Open, exactly fifty years after his first attempt to qualify for the Open. Sarazen hit a five iron that bounded in front of the green and rolled into the cup. Just to prove he was master of the hole, in the second round he hit his tee shot into a bunker and holed out for a birdie. His total score for two rounds was 3. A news headline the next day read, "Sarazen Licks Postage Stamp!"

While the designers weren't thinking island hole, the Postage Stamp is actually darn close, since the tabletop green falls off sharply into a gulley or a quintet of bunkers near the putting surface. There is no run-up shot. The ball must be played in the air and, like the infamous seventeenth at Sawgrass, you are either on or in trouble. The large sand dune to the left shelters part of the green and hides the movement of the wind. Because of the extreme wind swings, the range of clubs used for such a short distance seems unbelievable. Good golfers, pros included, say they've hit everything from a three iron to a wedge. Of course, we can't forget the woman who, playing into an extra stiff wind, was given a driver by her caddie. Falling short of the hole, she exclaimed, "You under-clubbed me!"

As the official shortest hole in the entire British Open rota, the Postage Stamp forces all comers to judge club and wind correctly. If not, a small hole adds up to a big number.

Cape Kidnappers Golf Course

Length: 119–96 yards

Designer: Tom Doak

Opened: 2004

Location: Hawke's Bay, New Zealand

During the last twenty years Tom Doak has vaulted to the highest echelon of golf course designers and Cape Kidnappers is one reason why. Set high on the bluffs of New Zealand's North Island, it is unlike any other golfing ground in the world — a perfect amalgam of architectural excellence and location. Like its Scottish cousin "The Postage Stamp," "Al's Ace," as the hole is called, may prove to be the hardest short-short par three you'll ever play. The small green sits near a cliff that tumbles 200 feet to the South Pacific. And if this isn't enough to scare you, Doak has fall-away slopes on all sides of the green complex. A two-putt here is cause to celebrate.

Chicago Golf Club

#10

Length: 139–125 yards

Designers: Charles Blair Macdonald/Seth Raynor

Opened: 1895/1923

Location: Wheaton, Illinois, USA

C. B. Macdonald gets credit for America's first eighteen-hole course, at Chicago Golf Club, but it was his protégé Seth Raynor who did the version we now play. In the case of Chicago's tenth, Raynor retained the essence of Macdonald's 1895 concept, an imitation of the sixth at the National Golf Links, the famed "Short." A pond runs 130 yards from the front edge of the tee to land. Judging the distance is important, but accurate placement is critical if you want to avoid the serpentine sand that encircles 90 percent of the green. Safely home, you must navigate two ridges that rib the ample green. Definitely a vintage experience.

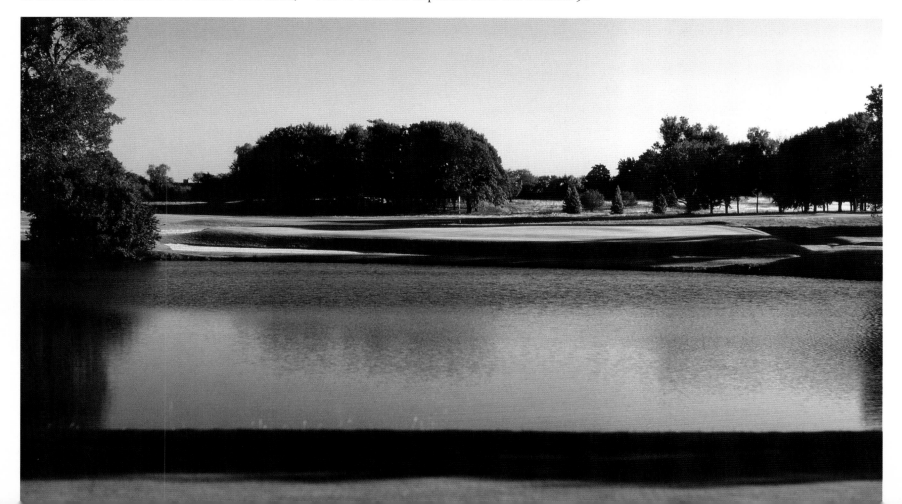

Doonbeg Golf Club

Length: 111–82 yards

Designer: Greg Norman

Opened: 2002

Location: Doonbeg, County Clare, Ireland

#14

After you've played Ballybunion's twelfth and the Dell at Lahinch, make sure you drive over to Doonbeg, book a suite at the five-star Lodge at Doonbeg Golf Club and get a tee time on one of the world's "new" links courses. Actually, the land lay waiting centuries before Greg Norman, with environmentally driven precision, sculpted eighteen holes on the Atlantic. When you think shelf green and no-margin-for-error tee shot, Doonbeg's daunting fourteenth will forever come to mind. It's all grass, winds and distracting waves. One of the best tiny holes on the planet.

East Course at Merion Golf Club

Length: 127–114 yards

Designers: Hugh Wilson/William Flynn

Opened: 1912

Location: Ardmore, Pennsylvania, USA

The par threes at Merion Golf Club run from very short to extra long. The seventeenth is a 246-yard behemoth across the famous quarry. The thirteenth, on the other hand, measures 127 yards and is, supposedly, the "easiest three" on the course. Like all pitch-length tee shots, gauging the right distance is of the essence. If you come up short, you'll be in Wilson's principal hazard, one of Merion's "white faces," a beautifully crafted bunker replete with tufts of grass and blocking the front of the green. Misdirection can get you in one of the other four sand hazards. To the far right lies Cobb Creek and a splashdown. Predictably, the green is small and saucer shaped, directing balls toward the middle. Easy does it on this "easy" hole.

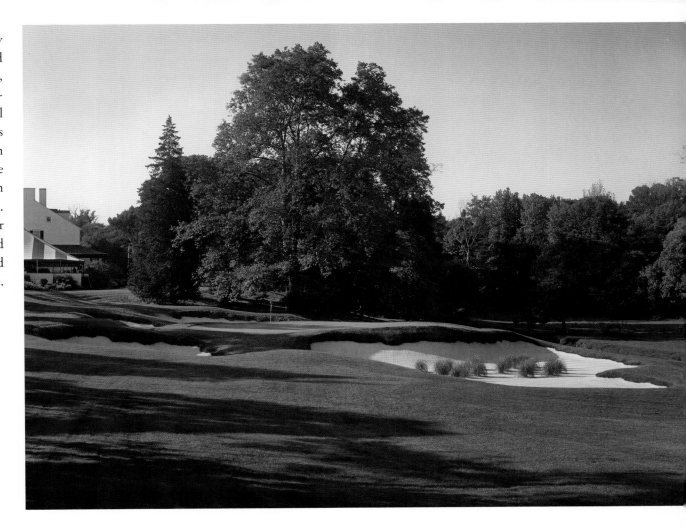

National Golf Links of America

Length: 141–110 yards

Designer: Charles Blair Macdonald

Opened: 1911

Location: Southampton, New York, USA

The National Golf Links is a fascinating compendium of classic replicas balanced with C. B. Macdonald's own inspirations. He believed a course should offer a one-shot hole reachable with a short iron. His "Short" (modeled on the fifth at Royal West Norfolk GC in England) plays slightly downhill from an elevated tee; most players will use a medium iron. The wide, 11,000–square-foot elevated green angles slightly and offers a generous target, but does run away front to back. The main challenge is staying out of seven bunkers that engulf the putting surface. From a time perspective, fast usually means a par and slow equals double or triple bogey.

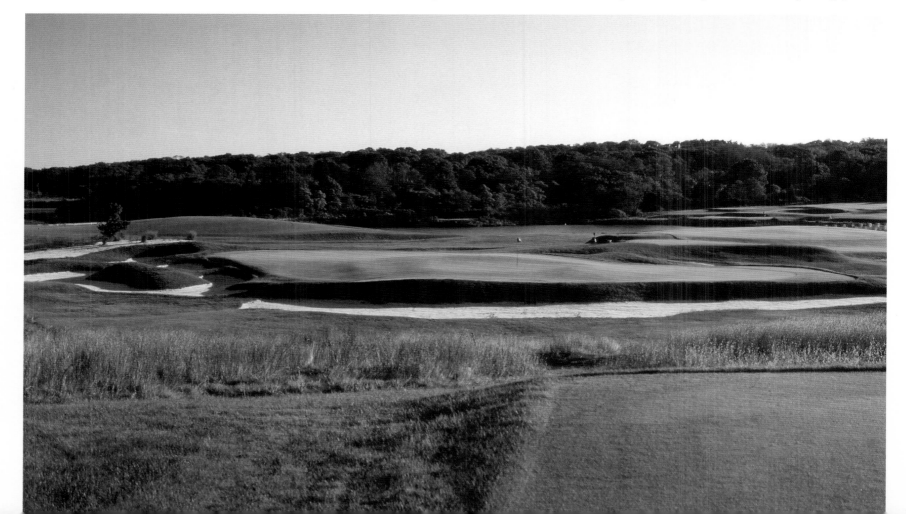

The seventh at Royal Porthcawl is as far as one can get from the rocky shoreline of Rest Bay on the Bristol Channel; it is also the highest among the upland holes. The short hit to the green must be judicious to avoid the sextet of pot bunkers placed at the front and both sides of the green. The back-to-front slope falls a radical three feet and this combines with roller-coaster contours that easily send balls sliding miserably into the nest of bunkers. Front pin place-

#7

Royal Porthcawl Golf Club

Length: 122–113 yards

Designers: Charles Gibson/Harry S. Colt

Opened: 1895

Location: Porthcawl, Mid Glamorgan, Wales

ments usually prove toughest of all. This hole has been described as delightful, but perhaps the delight lies in making par.

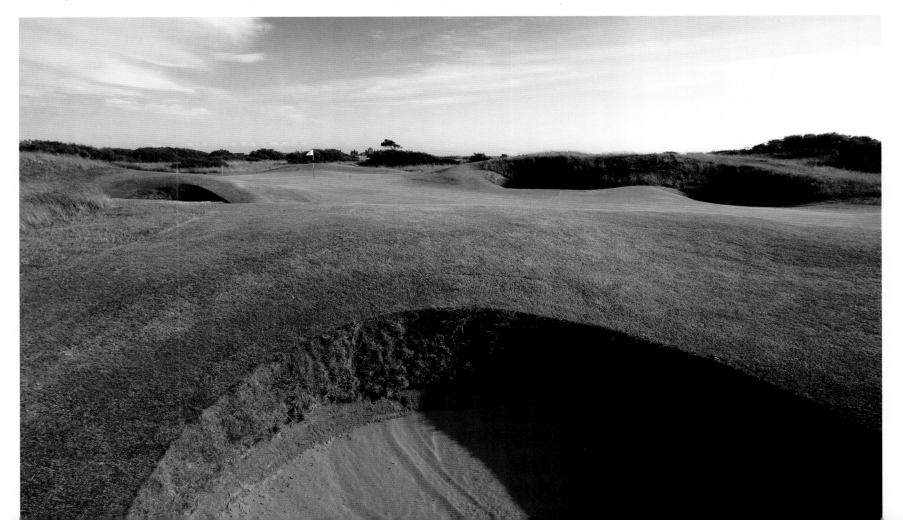

Spyglass Hill Golf Course

Length: 130–84 yards

Designer: Robert Trent Jones, Sr.

Opened: 1966

Location: Pebble Beach, California, USA

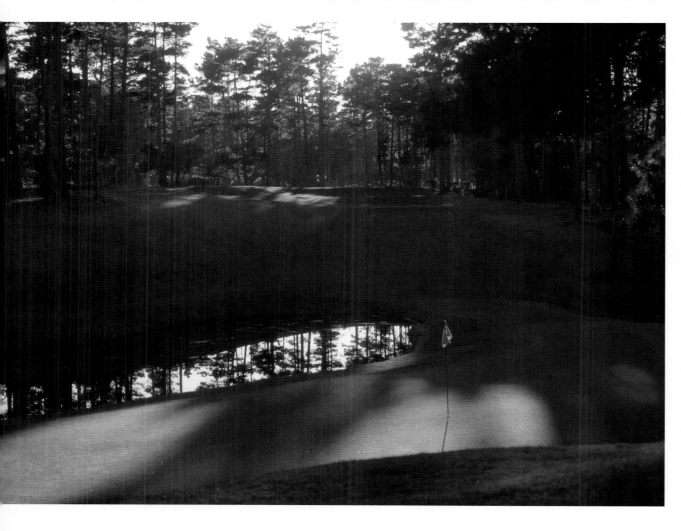

Charming is not a word generally used to describe holes from the hand of Robert Trent Jones, Sr., specialist over the years in "big and testing" courses. In this case, he made a lovely little 130-yard shot downhill to a diagonal green set against a sizable pond. To keep things sporting, Jones couldn't resist sloping the green toward the water much like he did at Augusta National's sixteenth. An amphitheater of Monterey pines rising around the hole creates a wonderful feeling of isolation. This diminutive three is a counterpoint to the argument that Spyglass is all monster, and that Jones didn't know how to make holes asking for subtlety over strength.

Stone Canyon Golf Club

#6

Length: 135–90 yards

Designer: Jay Morrish

Opened: 2000

Location: Oro Valley, Arizona, USA

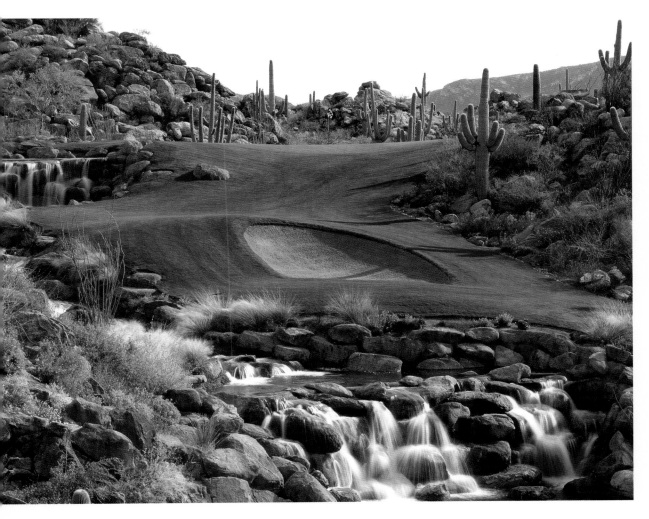

The fiftieth course he designed, Stone Canyon may be Jay Morrish's finest and the sixth hole shows why. Named "Echo Canyon," and playing at a compact 135 yards, it has an impish quality. The hole is remarkable for its distractions — including a smorgasbord of boulders large and small, and a multi-tiered waterfall streaming down the left side — that might excuse a player for some degree of inexactitude if his drive miscues. To compound the difficulty, the shot is uphill to a largely unseeable green whose only saving grace is a large protection bunker set directly behind it. The green's back-to-front slope will easily hold a less-than-perfect tee shot, but finding the correct putting line will test even an accomplished player.

Troon Country Club

Length: 139–115 yards

Designers: Tom Weiskopf and Jay Morrish

Opened: 1986

Location: Scottsdale, Arizona, USA

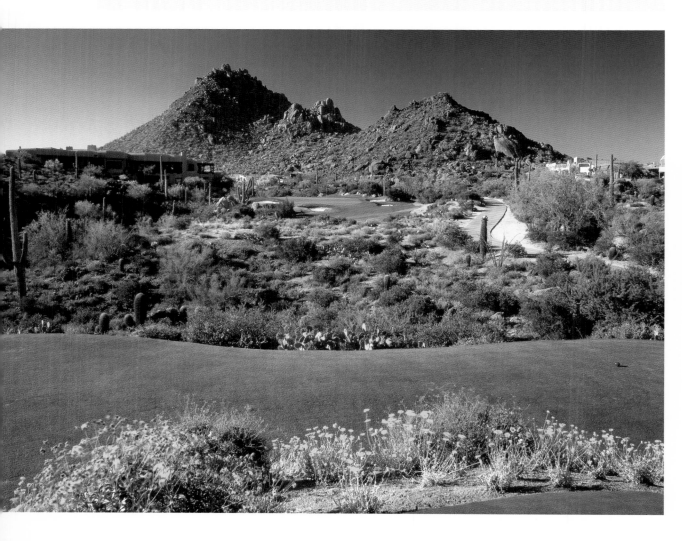

Troon Country Club was the first collaborative effort from the partnership of Tom Weiskopf and Jay Morrish and remains one of their best, still ranked among the top 100 U.S. courses. The fifteenth is a short, demanding hole with a very small, three-tiered green that slopes back to front. A deep ravine runs the length of the left side and a desert garden of chollas, prickly pear, yuccas and saguaros fills the landscape between tees and green. At the green site, an array of seven bunkers waits to capture the wayward shot, especially the four bunkers on the left front that sit well below the level of the green. Putting lines are difficult to determine and breaks of two feet or more are commonplace. Staying below the hole is the preferred position.

Wannamoisett Country Club

Length: 138–116 yards

Designer: Donald Ross

Opened: 1916

Location: Rumford, Rhode Island, USA

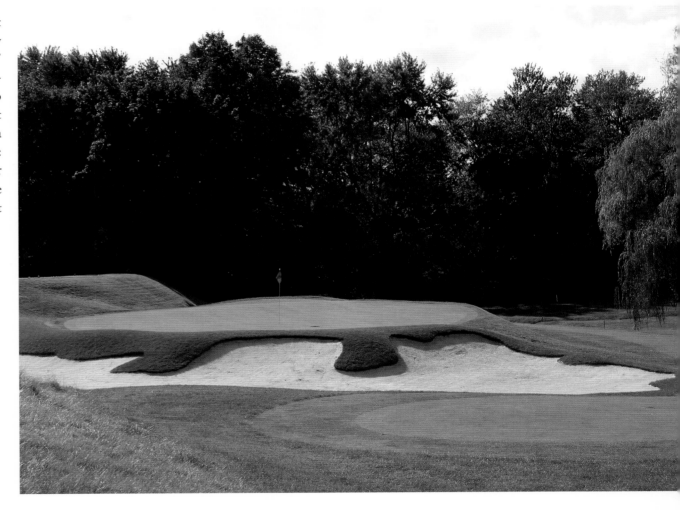

#3

If the Donald Ross Society uses the third green at Wannamoisett for its logo, its members must know something. The third has been called a "pitch shot" and "devilish" and fulfills Ross's dictum that "hazards and bunkers are placed so as to force a man to use judgment." Two scooped bunkers left and front defend 60 percent of the raised green. Right is a slope deflecting shots falling short. The strategy: Decide what kind of recovery shot best suits your game. You will need it. Once on, of course, you face the master of green-surface magic. At Wannamoisett #3, there is really nowhere to hide.

THE ULTIMATE 18-HOLE PAR-THREE COURSE

As we researched more than a thousand par three holes to find our "Finest 100," we began to think about an "Ultimate 18-Hole Par-Three Course."

We envisioned laying it out on a fantasy golf island that accommodated appropriate topography and climate — magnificent coastline for our California, New Zealand and Hawaiian water carries; linksland, dunes, sandhills; stands of parkland trees; a small mountain or volcano for drop shots; ponds, creeks and a beautiful lake with a tantalizing island green. As needed, winds and weather to give each hole unpredictable challenges. Maybe an intrepid developer will someday build such a course.

This Ultimate 18 is comprised of holes as old as the game, such as St. Andrews' eleven, and new as this century, like Sand Hills' seventeen. We have tried to use the work of as many designers as possible, but space is limited. Adding premier holes from other leading architects, we could quickly create a second, third or fourth eighteen that would be almost as good.

Our sequencing makes you shift gears all the way around. Add lengths that run from 106 to 237 yards and a variety of holes, drop down to island green, and golfers will need every club in their bag and best shotmaking skills to score well. In fact, we believe that if we could actually play this course it would be difficult but not impossible to card a 54. Take a moment to analyze each hole (with the help of our profiles and pictures), and you'll understand why it is such a complete test.

And do sit down and sketch out your ultimate par three course. We're sure there are many intriguing and delightful versions yet to be conjured.

THE ULTIMATE 18-HOLE PAR-THREE COURSE

		Hole	Type	Length	Designer(s)
1	St. Andrews (Old Course)	#11	Links	174–150	Unknown/Allan Robertson and Old Tom Morris
2	Mauna Kea Golf Course	#3	Coastal	210–140	Robert Trent Jones, Sr./Rees Jones
3	Royal Troon GC (Old Course)	#8	Short	123–114	George Strath/Willie Fernie/James Braid
4	North Berwick GC (West Links)	#15	Redan	192–173	David Strath
5	Bandon Dunes (Pacific Dunes Course)	#10	Links	206–129	Tom Doak
6	Lahinch GC (Old Course)	#5	Blind	154–118	Old Tom Morris/Alister MacKenzie/Martin Hawtree
7	Banff Springs GC	#4	Drop Down	199–79	Stanley Thompson
8	Pine Valley GC	#10	Sand	145–130	George Crump/Harry S. Colt
9	Yale University Golf Course	#9	Biarritz	213–146	Seth Raynor and C. B. MacDonald
10	Pebble Beach Golf Links	#7	Short	106–90	Jack Neville and Douglas Grant/H. Chandler Egan
11	Muirfield Village GC	#12	Pond	184–107	Jack Nicklaus and Desmond Muirhead
12	Augusta National GC	#12	Inland	155–145	Alister MacKenzie and Bobby Jones
13	Riviera CC	#4	Redan	236–186	George C. Thomas, Jr./Billy Bell
14	Sand Hills GC	#17	Sand	139–115	Bill Coore and Ben Crenshaw
15	Winged Foot GC (West Course)	#10	Inland	183–106	A. W. Tillinghast
16	Royal Portrush GC (Dunluce Links)	#14	Chasm	210–167	Old Tom Morris/Harry S. Colt
17	TPC Sawgrass (Stadium Course)	#17	Island	132–80	Pete and Alice Dye
18	Cypress Point Club	#16	Coastal	231–208	Alister MacKenzie and Robert Hunter

A greenside view of the eleventh hole at Papago Golf Course in Phoenix, Arizona.

"The up-to-date course must contain fine examples of three pars. Such stand out in one's mind with distinctness . . . Oftimes an entire test is made prominent by a noted one-shot hole." — DESIGNER GEORGE C. THOMAS, JR.

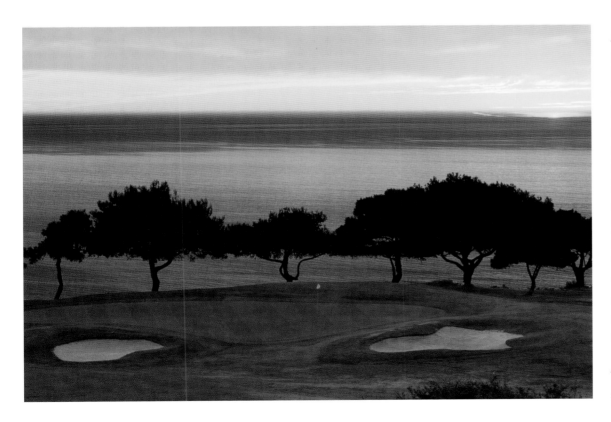

As we worked our way toward a final selection of the finest par threes in the world, we started collecting other lists that told us there were many ways to look at the one-shot hole. For example, it became apparent that those courses perennially ranked among the "Top 100 in the World" almost always have four very good to great par threes. Or, we found many holes that were truly "outside the box," for a variety of reasons. Historically, we read about dramatic championship moments that took place on par threes. As we saw back-tee distances that exceeded 240 yards, we decided to create a "Big Shots" list. On the other end of the spectrum, we catalogued first-rank par-three and short courses. With more time and space we know we could double the ways one can look at the one-shot hole.

The third at Torrey Pines' South Course offers gorgeous setting-sun views of the Pacific Ocean.

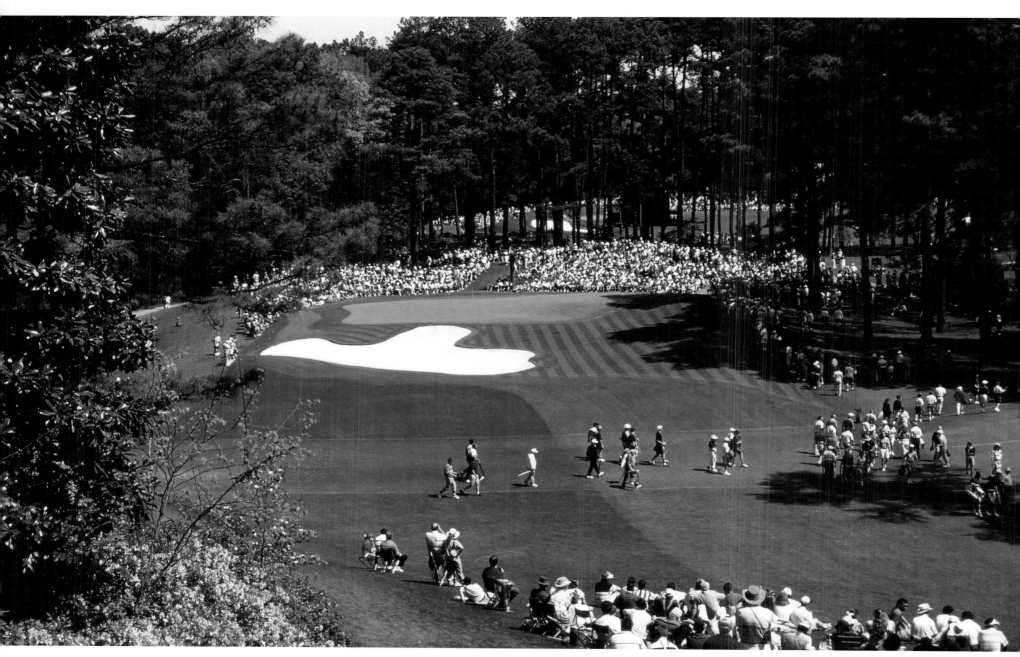

Augusta National's 180-yard sixth hole is protected left by a single
bunker that is nearly as large as the slick and subtly contoured green.

1. BEST SETS

The principle that a course can be judged by the quality of its par three holes still applies, and investigation reveals the majority of top-rated courses have a strong complement of one-shotters. Here are some, listed in alphabetical order, under the heading "Best Sets of Par Threes on a Single Course."

What the golfer sees from the tee at number sixteen on Pete Dye's Teeth of the Dog Course.

Augusta National Golf Club

Flowering Crab Apple, Juniper, Golden Bell, Redbud — Augusta's threes. The last two are known to millions via Masters telecasts and perennially prove to be pivotal points in the tournament. Like Augusta's front nine, numbers four and six are not as familiar but are part of what the pros call "the other Amen Corner." Four is the longest at 240 yards, playing downhill; six (180 yards) defends with its imposing front-left bunker. In each case, your approach must land in the right spot or you will run away from the hole or even off the green.

Casa de Campo (Teeth of the Dog Course)

Of the seven holes located directly on the coastline, three are one-shotters, each forcing tricky carries to well-defended greens. Number five (155 yards) is the signature photo-op hole and has water left, as does the longer (225-yard) seventh. The sixteenth (185 yards) plays along a beach with waves lurking right. Maybe the toughest of this Pete Dye line-up is thirteen (175 yards), where the target is a sand-encircled island green. It's aerial golf all the way.

Cypress Point Club

The first of Cypress Point's par threes, the third hole plays medium length to a green that allows, as Alister MacKenzie wanted, a carefully aimed run-up shot.

A close call for inclusion here since the third and seventh holes are relatively tame inland threes, both playing about 160 yards. Their strength is the tour-de-force MacKenzie bunker complexes. Tipping the balance are the world-renowned fifteen and sixteen, so utterly distinctive one forgets you are playing two short holes in a row.

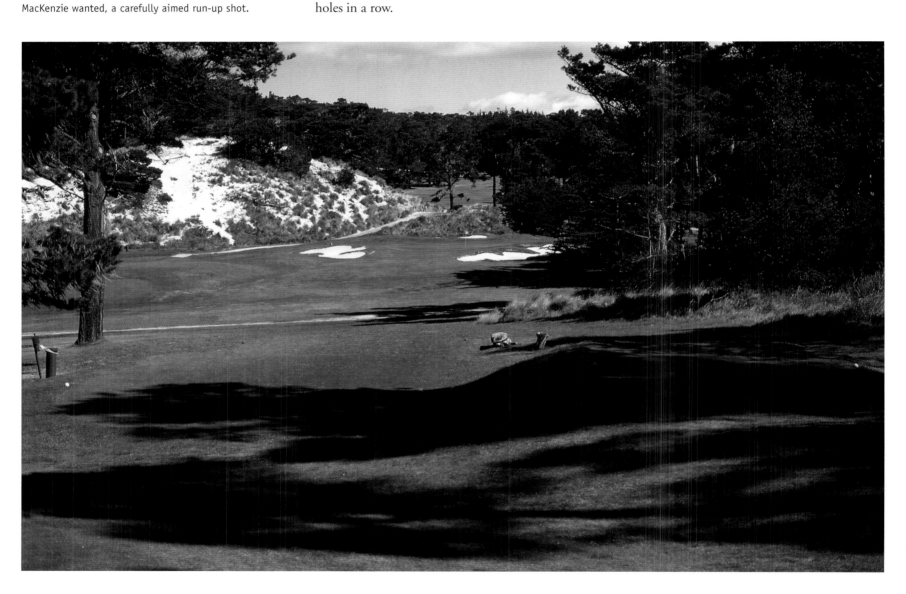

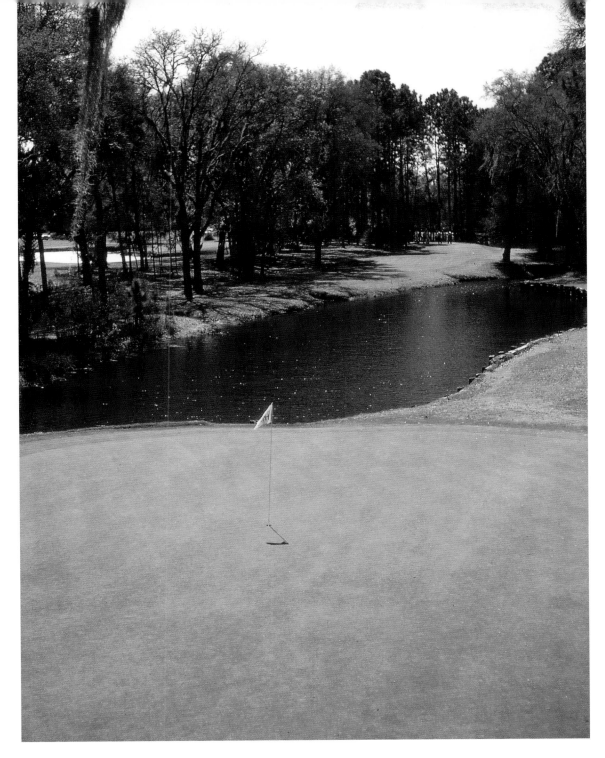

Fishers Island Club

This was Seth Raynor stepping away from his mentor C. B. Macdonald. At number two he built a Redan that plays across a pond. The fifth imitates the Biarritz form, brilliantly executed at 230 yards. Number eleven gets top marks as a version of St. Andrews eleventh (Eden), complete with Hill and Strath bunkers. Raynor closes out with Macdonald's Short, a downhill 146-yard shot over water. Maybe the best quartet of par-three "imitations-with-a-twist" ever made.

Harbour Town Golf Links

A collaboration between Pete Dye and Jack Nicklaus, Harbour Town reawakened golf to strategic shot placement. Today, the four threes all play between 180 and 200 yards, but the similarity ends there. Number four is a full carry with water all the way; seven has water right and the green is almost completely ringed by sand; fourteen takes you directly across water; and the famous seventeenth, where a huge 100-yard bunker hugs the left side of the green, makes for great tournament finishes.

The conundrum at Harbour Town's 192-yard fourteenth is how to manage the shot across the water that subtly dominates the entire hole.

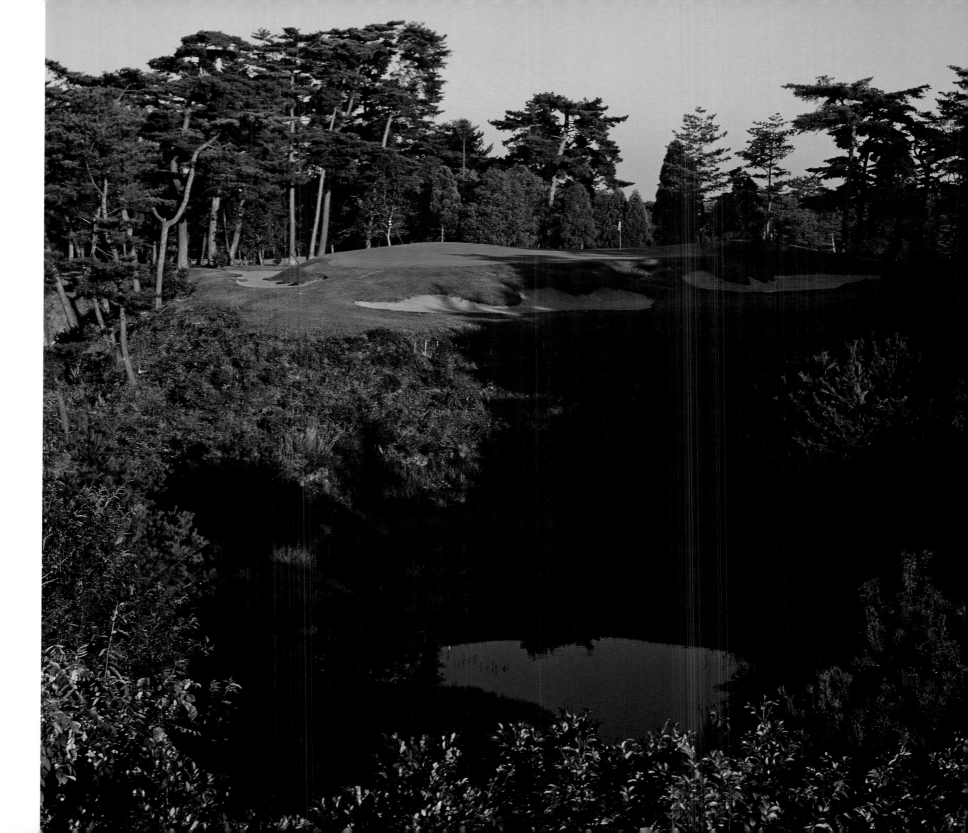

Hirono Golf Club

Laid out in 1932 by Englishman Charles Alison, Hirono consistently ranks among the world's Top 50 courses. In particular, critics cite its four short holes — named, in order, Fiord, Devil's Divot, Loch Lomond and Lake Side. Three of these use water as a defense — the fifth is a finesse shot over an inlet to a green featuring the flashed bunker faces known as "Alisons"; the seventh, ranked one of the best par threes in Japan, is defended by sand and a treacherous gully; number thirteen is sometimes compared to Augusta's twelfth; and at 230 yards, seventeen offers two options: full carry over a lake and a pond lurking on the left side or running a ball up the approach fairway onto the green.

Merion Golf Club (East Course)

One of America's storied layouts has four one-shot holes that integrate beautifully into its total sequence. All are protected by designer Hugh Wilson's "white faces of Merion," the course's hallmark bunkers. Going out, numbers three and nine play at 219 and 206 yards to sloping greens circled with sand. Coming home, Wilson chose to balance the minute 120-yard thirteenth with the brawny 246-yard seventeenth, each defended by five well-placed bunkers.

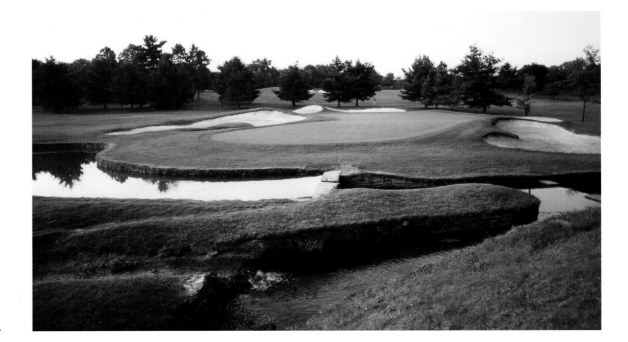

OPPOSITE: Elevated, with roller-coaster contouring and ringed by formidable bunkers, the green at Hirono's fifth makes it one of Japan's finest par threes.

RIGHT: While its overall distance is modest, Merion's par threes can play long and fierce, as at the 219-yard ninth.

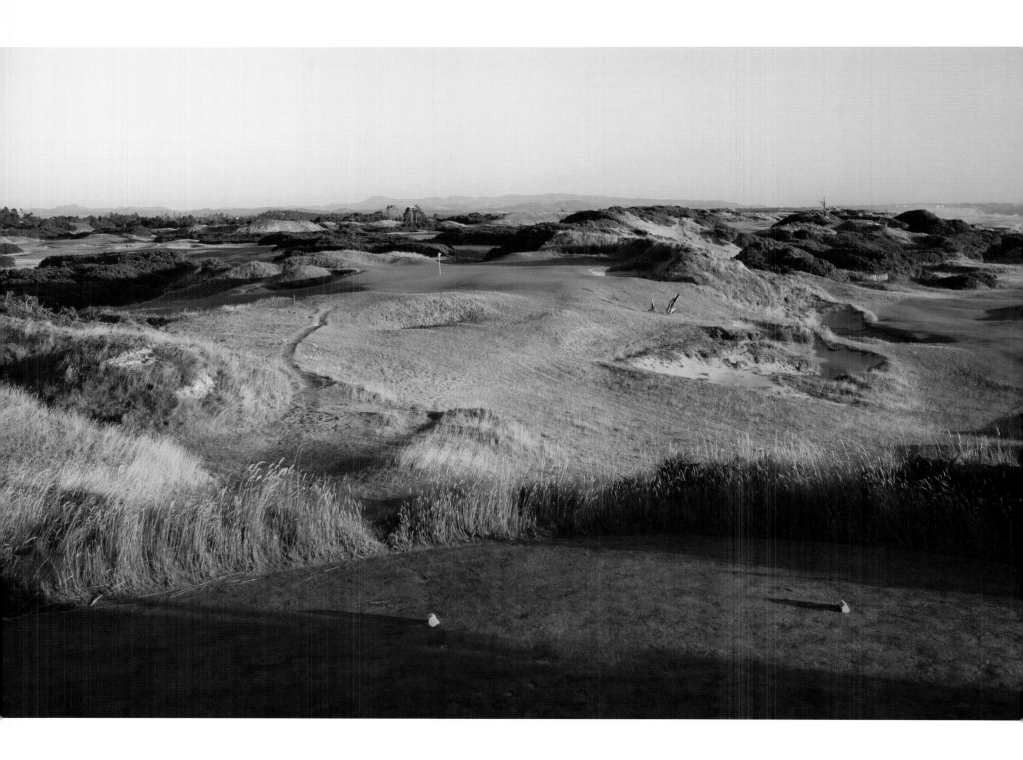

Bandon Dunes Golf Resort (Pacific Dunes Course)

Tom Doak's links layout definitely showcases par threes. It has five — one on the front nine and four on the back. Two are consecutive (ten and eleven), three play at a distance of 200 yards and two fall in the "short" category at 145 and 148 yards. This sequencing came from Doak's belief in following the land and not a formula for various pars. Records show numbers five, ten and eleven, all in the same corner of land, were the first holes built. The routing keeps you guessing about wind direction and velocity. Variety in defenses is illustrated by number ten, with no bunkers, and eleven, which is surrounded by them.

Pebble Beach Golf Links

Pebble Beach's threes are a mix of straightforward and tantalizing. In 1998 Jack Nicklaus completed a brand new fifth, making it a true ocean hole. The seventh remains one of the world's best short-short holes. Number twelve is a 200-yard tee shot into the prevailing wind at a Redan-type green and bunker. Seventeen is the first of two great finishing holes and has been the setting for triumph and heartbreak at U.S. Opens and the annual AT&T Pebble Beach Pro-Am.

Pinehurst Resort (Course No. 2)

Donald Ross waited until the sixth for his first one-shotter, but it's a healthy 220 yards. He followed at the ninth with a classic-length 175-yard play over pine needles. Fifteen is 203 yards, and seventeen, 190. However, it's all about the seamless green complexes (contours, swales, bunkers), which, depending on your strategy, multiply four holes into a dozen different tests of your game.

Pine Valley Golf Club

Definitely a case of three the hard way times four: number three (198 yards and downhill over sand), number five (muscular at 235 yards with an uphill carry across pond and scrub), number ten (the world-famous "Devil's Asshole" — the shortest at 145 yards but delicate, difficult and often disastrous), and number fourteen (220 yards downhill across a lake). Herbert Warren Wind's evaluation: "The four par threes are masterly, and, all in all, it is hard to think of another course that possesses as many absolutely wonderful [short] holes."

Number fourteen at Pacific Dunes illustrates how skillfully a hole and the land can be seamlessly integrated.

Prairie Dunes Country Club

An isolated gem set in Hutchinson, Kansas, and designed by father and son Perry and J. Press Maxwell, Prairie Dunes doesn't have a weak hole. Among the threes, which all play uphill, number two vies with the tenth, Perry Maxwell's personal favorite, as the best. The fourth is a 170-yarder to an artfully bunkered shelf green that can produce four putts. "The Chute," number fifteen, requires a shot among cottonwood trees that cloak the winds around a green nicely bunkered right.

Royal Melbourne Golf Club (West and East Courses)

The Royal Melbourne Club is composed of two courses — the acclaimed West and an East layout. Owing to the consistent creativity in green shape, penal sloping and perfectly situated bunkers drawn from the region near Melbourne, all eight of the threes are superior, giving Royal Melbourne the finest collection found at one club anywhere in the world. The best-known are numbers five on the West course and sixteen on the East.

Rye Golf Club

Rye's five par threes are distinguished by the perplexing humps and bumps that surround its elevated and sloping greens. Number seven is the consensus best one-shotter on the course. Rye is best known as one of Harry S. Colt's very first layouts and as the venue for the annual President's Putter match in which teams representing Oxford and Cambridge play in January.

Swinley Forest Golf Club

Also the work of the great Harry S. Colt, who did Royal Portrush Golf Club, the New Course at Sunningdale Golf Club and the Eden Course at St. Andrews. Critics agree his forte was the one-shot hole. At Swinley Forest, his masterpiece, he listened to the land and it delivered five par threes — a short at 140 yards, a long at 205 yards and three medium-length between 170 and 180 yards. They are beautifully sequenced in Colt's artful arrangement of short holes.

All of Donald Ross's threes at Pinehurst will bring out the best, or worst, in your chipping and putting games; number nine is one example.

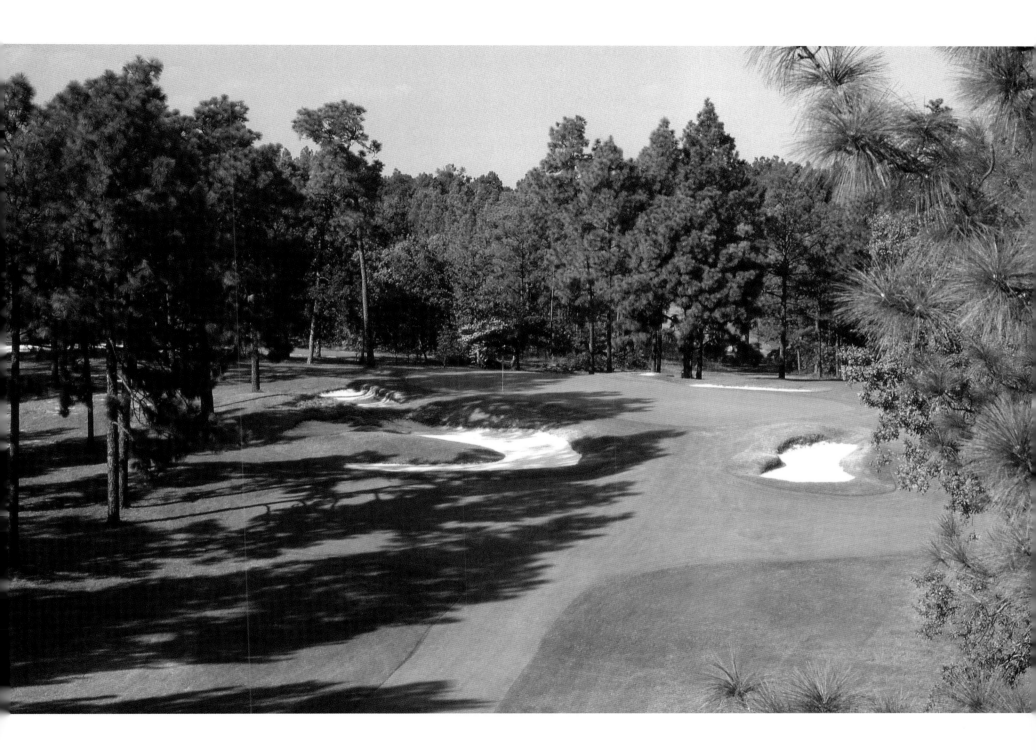

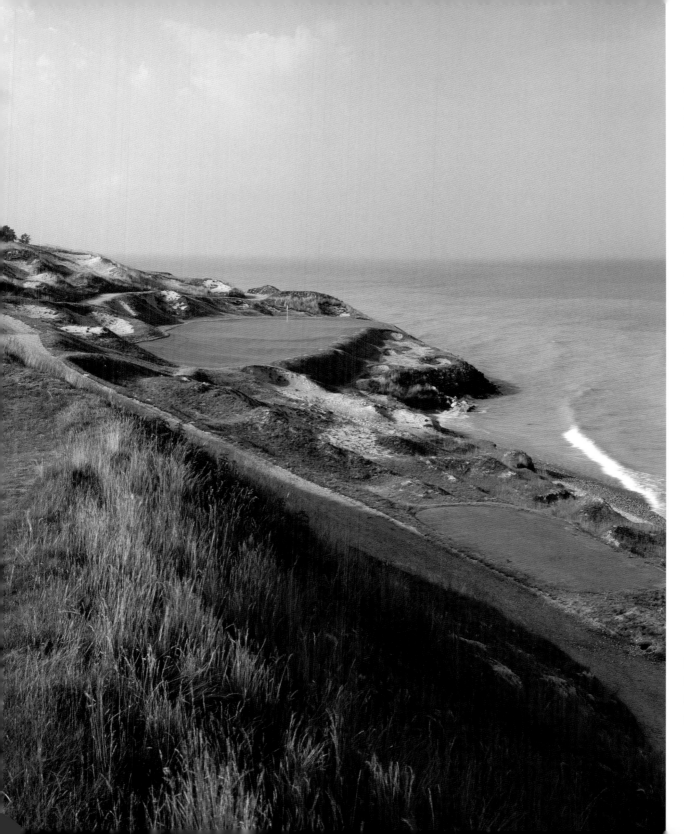

The Straits Course at Whistling Straits

If someone told you a round at the Straits Course meant negotiating four holes, each hard on the shore of tempestuous Lake Michigan, named (in order) "Oh, Man," "Shipwreck," "Pop Up" and "Pinched Nerve," you might be apprehensive. Correctly so. Each one says, "Get it on, or else." The number three and seven tees lie close together, with three going south toward a Redan-like green and seven north to an angled putting surface right on the water. Coming home, you play the short 166-yard twelfth and then the epic seventeenth with its 200-yard carry across sandy wastes. The summary: a gauntlet of threatening threes.

Beautifully sited on Lake Michigan, Whistling Straits' 214-yard seventh, named "Shipwreck," is hemmed in by sand, to say nothing of capricious winds that may play havoc with your tee ball.

2. MICRO GOLF

The twenty-first century trend toward building "little courses" continues for a variety of reasons: making the game faster, using less land (environmental movement), lowering costs (construction, maintenance, playing fees), making it easier for people new to the game and less demanding for seniors, creating a practice area that mimics an existing 18-hole course, and many others. "Micro Golf" courses include par threes (nine holes, eighteen holes, and numbers in between), short courses (a mix of threes and fours) and practice courses featuring threes. Most are public, affordable and eminently playable.

But micro doesn't necessarily mean minimalist, and there are par-three and short courses by premier designers with substantial budgets, prime property and a mandate to execute something special. Here are eight that represent the best of the genre.

Par-3 Course at Augusta National Golf Club

At Augusta National, perfection is the norm, even in short courses. In 1958, Clifford Roberts, impresario of the Masters Tournament, commissioned architect George Cobb to build a par-three course to be used for practice. In 1960 he announced a "Par-3 Contest" to be held on Wednesday of Masters week. Later, the club asked Tom Fazio to build two more par threes, for a total of eleven. Today's event is played on seven Cobb holes and two by Fazio. It has become one of many Masters rituals, akin to a garden party where Masters invitees, along with their children and grandchildren, engage in a warm-up full of aces (the ringer score is nine), some clowning and bonus entertainment for badge holders. Given the quality of the field, it's the ultimate par-three competition.

Conservation Course at Bandon Dunes Resort

After playing eighteen on one of the four great courses at Bandon Dunes, visitors began to wish they could play some more, but not another full round. Well, owner Mike Keiser came up with a solution — the 12-hole Conservation Course to be done by Ben Crenshaw and Bill Coore, who designed Bandon Trails. Keiser found property on the ocean, so these dozen threes are alive with shifting winds and run from a tiny 66 yards to almost 200 yards in length. The course is scheduled for completion in 2012, and Keiser has earmarked all revenue for the State of Oregon Parks and Recreation dunes conservation program.

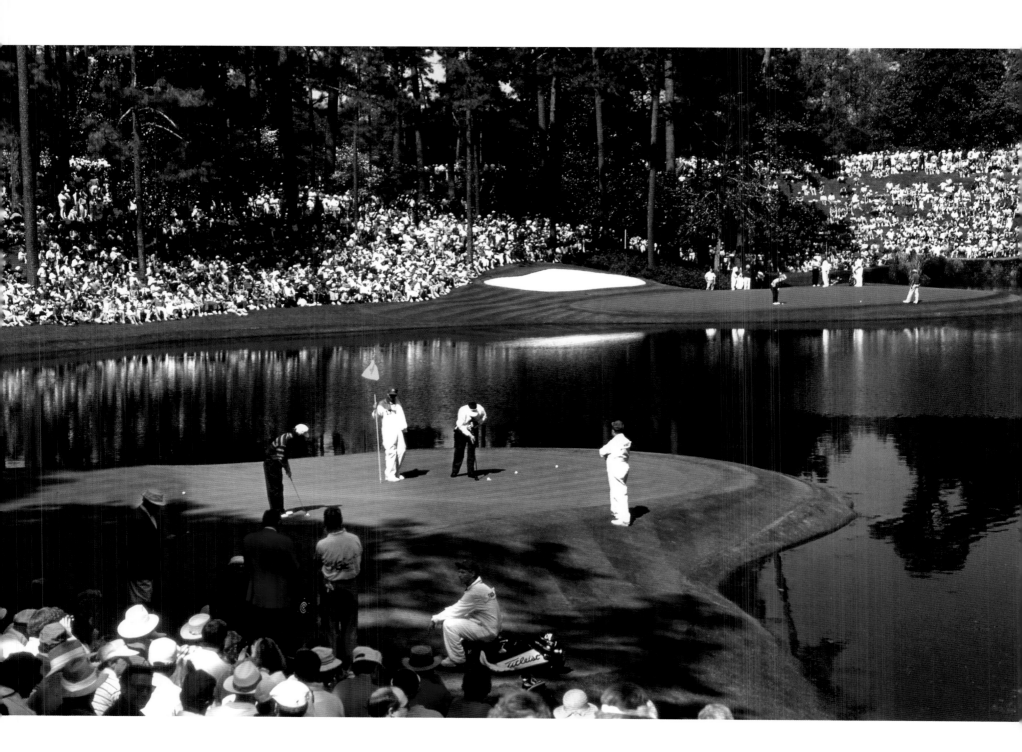

Short Course at The Club at Cordillera

When short-game guru Dave Pelz was invited to set up shop at Cordillera Resort in Colorado and given carte blanche to design a short course to act as a practice area for his seminars, he jumped at the opportunity. The result is a one-of-a-kind 10-hole layout, meticulously plotted to test every aspect of short-game play. Measuring 590 yards from the front and 1,250 from the back, it features uneven tees that simulate a variety of lies. Hazards include large bunkers on number seven, water on the downhill third and a peninsula green on six. All the greens are 5,000 to 6,000 square feet to ensure long-putt opportunities. The whole place has the look, feel and challenges of a full-size course scaled down to modest distances. As a bonus, you get gorgeous views of the surrounding Rocky Mountains.

Par-Three Course at Fairmont Southampton Golf Club

The 18-hole par-54, 2,684-yard course is the only golf available at this luxurious Bermuda resort, but once or twice around will be enough for most players. It's a well-conceived and tricky test, and few equal par. In his prime, Johnny Miller played here and managed a 57. The holes range over dramatic elevation changes and are exposed to daily Atlantic Ocean breezes, sometimes escalating to stout winds. By our reckoning, this is the best 18-hole par-three course in the world.

OPPOSITE: Part garden party, part short game virtuosity, the Masters Tournament "Par 3 Contest" is unique in golfdom.

RIGHT: Sharp vertical drops and testy Atlantic winds make Southampton Golf Club's layout the world's toughest 18-hole par-three course.

Cliffs Course at The Olympic Club

The third of Tom Weiskopf's nine whimsical but demanding threes on the Cliffs Course at San Francisco's Olympic Club.

In 2000 Tom Weiskopf did some renovations at Olympic's famous Ocean Course. While there, he took 35 acres perched above the Pacific and fashioned a delightful par-three layout, full of some of the drama and challenge of Olympic's big courses. Each hole is an original, done, Weiskopf explains, "with a bit of whimsy but respect for the quality of the club and its two world-class 18-hole courses. We balanced the

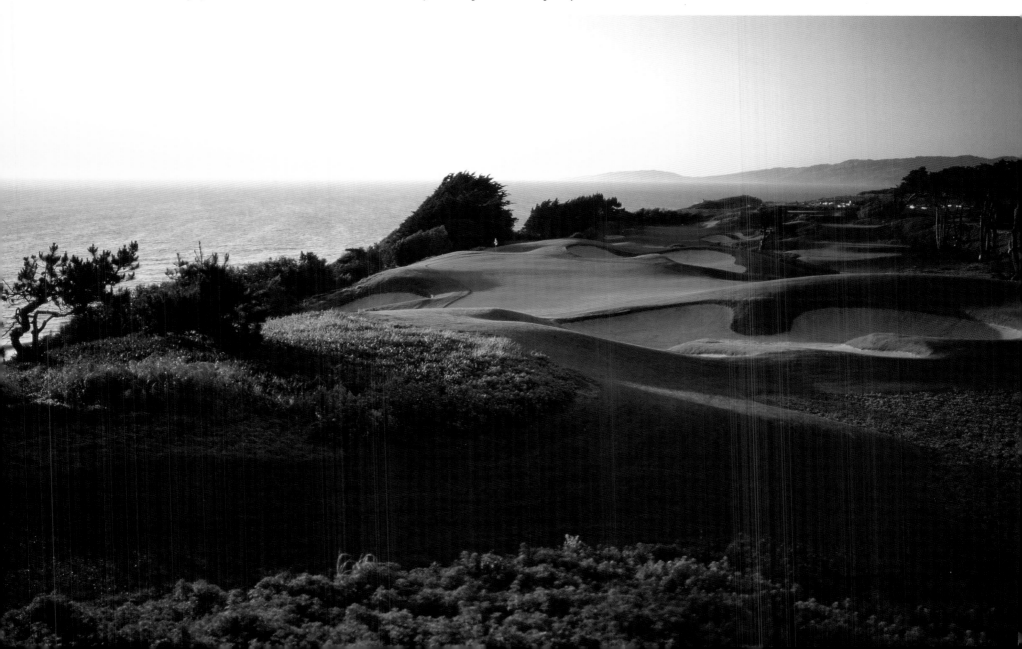

nine with three short, medium and long holes, one or two over 200 yards and built a double green at five and seven." Sitting close to the ocean, the Cliffs often plays through mist and winds that add more complexity to this fine miniature.

Short Course at Pine Valley Golf Club

Asked by club chairman Ernie Ransome to design a short course that would allow members to ready themselves for one of the world's greatest (and toughest) eighteens, Tom Fazio, himself a Pine Valley member, demurred. "How do you repeat a masterpiece?" he asked. Nonetheless, with the agreement that the 10-hole layout would not compete, he and Ransome used adjacent land similar to that used for Pine Valley's original eighteen. They found similar settings for eight holes, and finished the project off with two original concepts. Now members use it for a pre-round warm-up, a chance to sharpen their game or a friendly Nassau. Talk about craftsmanship: Fazio and Ransome rolled up their sleeves and personally hand-shaped the bunkers.

The Horse Course at The Prairie Club

Newest entry among golf clubs in the Sand Hills Region of Nebraska, the Prairie Club lies on dramatic, rolling prairie and the canyon rim of the Snake River. Designer Gil Hanse used these natural features to great advantage when he laid out the 10-hole Horse Course. Of the name, he explains, "Unlike a typical par-three course, The Horse Course will have no tees, only expanded fairways and ten greens. The winner of the previous hole, like the basketball game of 'horse,' gets to choose the stand, lie, shot and green for the next hole." Depending on where players set the tee shots, the course plays from a gentle 485 yards out to 1,125. The real name of the game is short-shot fun.

Threetops Course at Treetops Resort

The work of noted teaching pro Rick Smith, Threetops lives up to its billing as "The #1 Par 3 Course in America." Total yardage for the nine holes is 1,300 yards. Labeled "Devil's Drop," the third plunges 145 yards and at 216 yards is the longest hole. Lengths for the other eight are a comfortable 140 to 169 yards. Smith sets up each hole as a distinct short-game exam. The second hole features two greens for more variety, the bunkering is memorable and the conditioning top notch.

3. OUTSIDE THE BOX

In moments of playful inspiration, designers have left us par threes, individual and multiple, that break new ground or defy categorization. Here is a sampling of these distinctive holes.

#10 Bel-Air Country Club

Nicknamed for the "The Swinging Bridge" that spans the ravine between tee and green, the hole was born when designers Jack Neville and George Thomas agreed, lightheartedly, that if they could carry the ravine using a putter, then the distance was fair. Both made it to the other side.

#7 Brickyard Crossing Golf Course at the Indianapolis Speedway

A lesser-known feature on the grounds of the famed "Indy 500" is an 18-hole course designed by Pete Dye. Four holes are actually inside the brickyard oval; one, the seventh, is a 190-yard par-three with a carry over water to a narrow green.

#5 and #14 Carambola Golf Club

Robert Trent Jones, Sr., built this course on St. Croix for magnate Laurance Rockefeller in 1966 and artfully laid down holes on opposite sides of a pond to create mirroring threes — one at 179 yards and the other a gentle 139.

#s 4-6-8-10-12-14 Canyon Course at Forest Highlands Golf Club

This dramatic mountain course near Flagstaff, Arizona, by Tom Weiskopf and Jay Morrish equals the record for most threes on an 18-hole course. Walking the property, Weiskopf knew immediately he wanted more than four one-shot holes. As he says, "I think it worked because most people never realize that from the fourth to the fourteenth every other hole is a par three."

Remembering the innovative twist George C. Thomas, Jr., added to the sixth at Riviera CC — a bunker in the middle of the green — Jack Nicklaus created his own version at the par-three fourteenth on Desert Mountain's Chiricahua Course.

Another Weiskopf paean to short holes, the fourteenth at Forest Highlands GC completes a string of six alternating threes that starts at the fourth.

#6 Green Zone Golf Club

Sitting astride the Finnish-Swedish border, this club's 132-yard par-three sixth hole has the tee in Finland and the green in Sweden. Hit your tee shot, take your stamped customs form, cross the border and putt out. The Canadian–U.S. border has a similar shot at Portal Golf Club's 125-yard ninth hole, where the tee is in Saskatchewan and the green in North Dakota.

#19 Legends Golf & Safari Resort

The green traces the shape of the African continent on what is the most unusual par three in the world — #19 at the Legends Golf & Safari Resort in South Africa.

At 630 yards, most of it vertical, this is the ultimate drop shot par three, or any par for that matter. Players are transported from tee to green by helicopter and a hole in one pays $1 million. In 2009, British Open champion Padraig Harrington became the first player to make three.

#3-A and #3-B Pacifico Course at Punta Mita Resort & Golf Club

Sometimes one version of a hole is not enough. After you finish Punta Mita's second, you have a choice of playing one of two versions of the third hole. For the less adventurous, play "3-A," a 150-yard shot to a green short of the Pacific. Those wanting a longer and more dangerous carry over water should play "3-B." To complete "3-B," you are ferried across a causeway in a cart that takes you to and from the green.

#6 Riviera Country Club

When designing the tough Riviera Country Club layout, George C. Thomas thought that a green with a bunker in the middle would add spice to the challenge. And indeed it has caused bemusement and heartburn for many players. Our picture shows Jack Nicklaus's version of the bunker-in-a-green concept, the 159-yard fourteenth hole on the Chiricahua Course at Desert Mountain Golf Club in Arizona (see photo on page 228).

#5 Royal Worlington & Newmarket Golf Club

Outside of the otherworldly USGA greens prepared for U.S. Opens, Royal Worlington's fifth is the leader-in-the-clubhouse for the par three with the "green-most-impossible-to putt-on." It slopes in all directions and four- and five-putts are common.

#9 Spring Lake Park Golf Course

Credit for this entry goes to one of golf's greatest students of architecture, Ron Whitten. Whitten, along with PGA Hall of Fame member Gary Wiren, grew up playing this still-going hardscrabble urban nine-holer in Omaha, Nebraska. It finishes with a 100-yard pitch shot over the city's 16th Street.

#7 Stone Harbor Golf Club

The golf world needs a few more Desmond Muirhead–inspired par threes, as in his famous "Clashing Rocks" at Stone Harbor, now without its menacing clawed bunkers.

Desmond Muirhead was one of the most daring architects who ever sketched a course. Some designs were exercises in what he called "symbology." Stone Harbor's original island-hole seventh was named "Clashing Rocks" and evoked the sea odyssey of Greek mythology's Jason and the Argonauts. Muirhead did numerous other unusual shapes, most of which have succumbed to more conservative tastes.

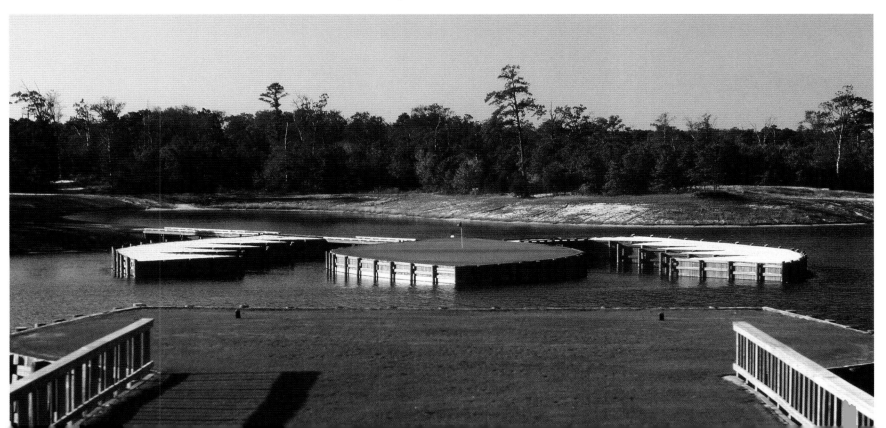

#16 Stadium Course at TPC Scottsdale

Looking more like a NASCAR venue, the sixteenth at this Phoenix stop on the PGA Tour is completely enclosed by stands, bleachers and corporate boxes. The cumulative decibel measurement from 20,000 spectators carries all the way to Tucson at this harbinger of "Stadium Golf on Steroids."

#13 Trump National Golf Club Westchester

Leave it to Donald Trump to spend $7 million on a single hole. At 101 feet, the waterfall in back of the green is the highest on any course in America. Architect Jim Fazio added a smaller waterfall and a pond in front to make this hole both dazzling and difficult.

#19 Mountain Course at Bear Mountain Resort

Yes, the number is correct. Bear Mountain is our stand-in for a handful of courses that offer a 19th hole you can play, most of them par threes. At 165 yards it's just as rugged as the rest of this Canadian layout.

4. BIG SHOTS

In our section on "Short Holes" (see page 193), we cite one-shotters 140 yards or less to illustrate the appeal of finesse. At the other end of the scale, there are threes that put driver in the hands of most golfers and realistically play as a short four. Here are eighteen "Big Shots" in the par-three universe, chosen for length (more than 230 yards) and good design elements. By our reckoning this colossal course stretches to 4,490 yards.

#15 Ballyneal Golf & Hunt Club (237 yards)

On this Tom Doak creation, make sure you carry the ridge in the fairway. If so, your ball may run to the front part of the green. Get to the rear of the green, avoid the plateau right, and your ball will feed left.

#8 Black Mesa Golf Club (238 yards)

Designer Baxter Spann, who set this hole in a gap on a high ridge, says it can become "a wind tunnel at times." Add a 40-foot drop to the large green and you have a black tee brute.

#17 Brae Burn Country Club (255 yards)

At the 1919 U.S. Open, Walter Hagen got stuck in the mud on this hole and made five. It plays from an elevated tee with trees to the right and ringing the back of a green that lies open to balls bouncing on, assuming they are straight and miss bunkers left and right.

#16 Championship Course at Carnoustie Golf Club (245 yards)

Sixteen is named "Barry Burn" for the stream that winds through the course, although it's not in play here. On his way to winning the 1975 British Open, Tom Watson never made better than four. Your target is a good-sized oval green with five bunkers — three left and two right — guarding its front entrance.

When Cypress Point was a venue for the Crosby event, a sought after vantage point was in back of number sixteen tee watching the pros go for the green.

#13 Circling Raven Golf Club (253 yards)

Your first task is to carry downhill (which is some help) over 235 yards of wetlands; your second is to avoid the big bunker right front; and lastly, don't forget the pine needles in the bailout area left.

#4 Colonial Country Club (246 yards)

In preparation for the 1941 U.S. Open, Perry Maxwell put his hand to numbers three, four and five and turned them into Colonial's "Horrible Horseshoe." Bookended by two 460-yard fours, this three is tree-lined and punishes shots hit left of the green.

#16 Cypress Point Club (231 yards)

Besides its many all-world features, the tee shot remains one of the most thrilling heroic carries in the world. With Pacific winds in your face, it can be nearly impossible.

Number six is just one rugged reason the USGA will hold the 2011 Amateur Championship and 2017 U.S. Open at Wisconsin's Erin Hills Golf Club.

#13 Blue Course at Doral Country Club (245 yards)

An appropriate-length short hole for a Tour venue nicknamed the "Blue Monster," Doral's thirteenth features a teardrop-shaped green protected by bunkers left, center and right.

#12 The Dunes Golf & Beach Club (245 yards)

A muscle-stretching warm-up for the famed dogleg par-five thirteenth, this is a straightaway power shot, from a tiny tee tucked into marshland, at a generous green with a bunker in each corner.

#6 Erin Hills Golf Course (242 yards)

Success means working your ball in a prevailing wind that sends shots left and long to a large saddle-shaped green running away to the back where, happily, there are no hazards.

#16 The Pete Dye Course at French Lick (301 yards)

One of Pete Dye's latest efforts, this Indiana layout stretches to an extreme 8,102 yards (tournament tees). Number sixteen is a first installment on what will likely be a twenty-first century trend — the 300-yards-plus par three.

#7 The Pines Course at The International (277 yards)

Consistent with its title as America's longest course (8,325 yards as of 2010), it balances its 715-yard fifth hole with this U.S. Open–length three.

From the tournament tee, the gargantuan 301-yard sixteenth hole at Pete Dye's French Lick course is his answer to equipment technology and the increased skill sets of today's pros.

#4 The Fairmont Jasper Park Lodge Golf Course (240 yards)

Named "Cavell" by architect Stanley Thompson, a designer renowned for his long-ball threes, it features four bunkers, one of them in the middle of the fairway and short of the green. After you complete four, have a go at Thompson's "Cleopatra," the 230-yard ninth.

#11 Mauna Kea Golf Club (247 yards)

This one is reachable for an average player when winds at your back combine with the 100-foot vertical drop. Realistically, think four here.

#17 Merion Golf Club (246 yards)

An anomaly on a relatively short course, the seventeenth (below) plays across the famed Merion quarry to a narrow, sloping green complex with bunkers on three sides and its own "Valley of Sin" in front.

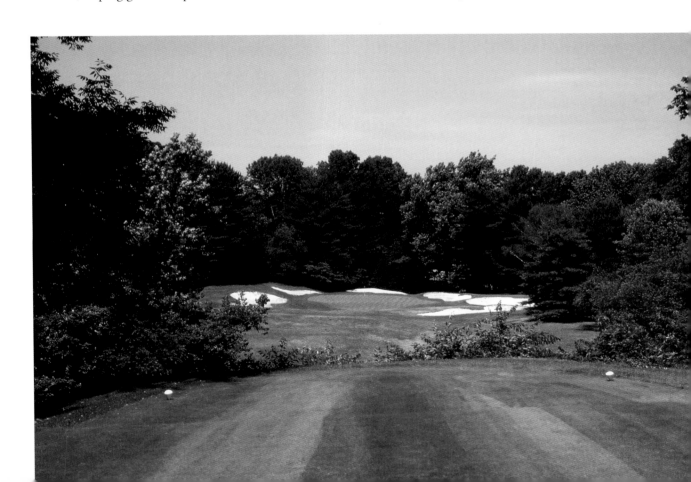

#3 Myopia Hunt Club (253 yards)

Once a par four, it is now a three. The only problem is they forgot to expand the green, which remains a small target.

#8 Oakmont Country Club (288/253 yards)

At the 2007 U.S. Open, the USGA made this 288 yards, and, for at least one round, 300 yards. You will only have to negotiate 253 while avoiding the famous 100-yard Sahara bunker covering much of the left side of the hole and four more rimming the right and back right.

#14 Scioto Country Club (236 yards)

Scioto was Jack Nicklaus's training ground and we wonder what the young immortal used to reach a distant green angled at two-o'clock with two sizable bunkers tight to the putting surface.

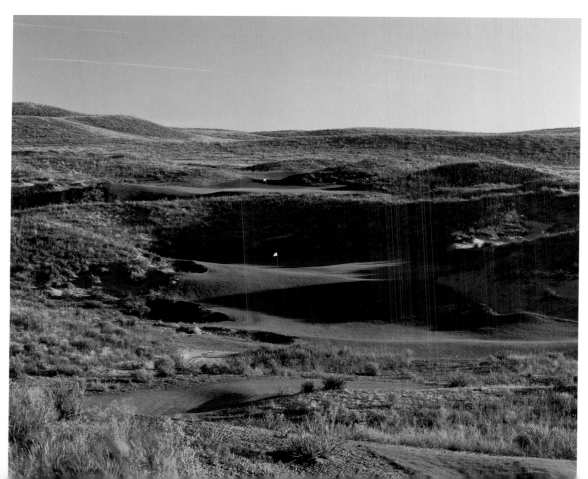

The natural amphitheater surrounding Ballyneal's fifteenth symbolizes architect Tom Doak's commitment to minimalist design principles.

5. BOOKENDS

OPENING AND CLOSING THREES

When routing a course, most designers follow the accepted rule that par threes should begin no earlier than the third hole. They also finish the course with a strong par four or par five. However, there are examples where these rules have been broken; that is, a par three actually starts or finishes a round. Such instances belong in the "there must have been a good reason, but we're not sure why" category. Our research uncovered these examples.

OPENING HOLE

Blue Course at The Berkshire Golf Club (217–207 yards)

It is recommended you play the highly ranked Berkshire Red Course as a warm-up for this difficult opener on the Blue. The long shot to a plateau green is played over a valley of heather. Oh, and the tee sits right in front of the clubhouse, so you always have a gallery watching.

Royal Lytham & St Annes (206–169 yards)

Because Royal Lytham & St Annes (left) is in the British Open rota, the world actually gets to see pros start a major with a one-shot hole. They play from a tee tucked near the pro shop, making it tough to judge the wind. The shot must land on a green with two bunkers short and more ringing it. In the third round of the 1979 Open, David Graham aced this with a five iron.

Old Course at Walton Heath Golf Club (235–195 yards)

Played from the tips, this is a fairly testy one-shotter. The green is about 100 feet deep and angles diagonally at two o'clock. Two bunkers guard the front, with a small neck for run-up shots. Out of bounds on both sides completes the challenge.

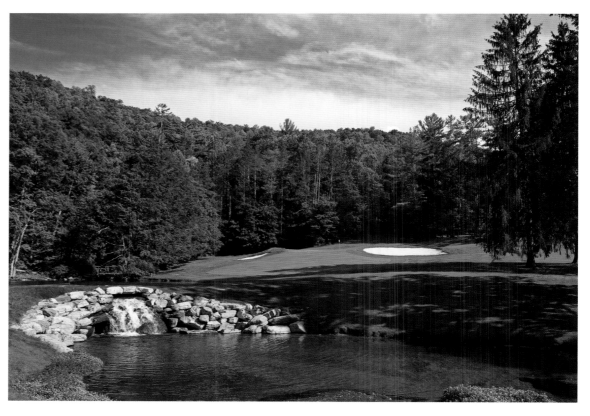

Yarra Yarra Golf Club (220–194 yards)

Scene of Gary Player's first pro win in 1956, Yarra Yarra is a Melbourne Sandbelt layout, as are its better-known neighbors Royal Melbourne and Kingston Heath. This opener is the longest of the par threes and well bunkered; so make this — your first stroke of the day — a good one.

CLOSING HOLE

Cascades Course at The Homestead Golf and Winter Resort (192–145 yards)

On the Cascade Course's eighteenth (see above) the proper target is below the hole because this William Flynn green is the steepest back-to-front slope on the course. There is room to be short, but you must carry the water and stay between front bunkers left and right.

Geronimo Course at Desert Mountain (197–143 yards)

Geronimo's eighteenth has become the signature hole on this Jack Nicklaus course and features a heroic carry across a barranca to a double-tiered green set in a dramatic frame of rocks and saguaros. At the time, this was the only closing three Nicklaus had ever done.

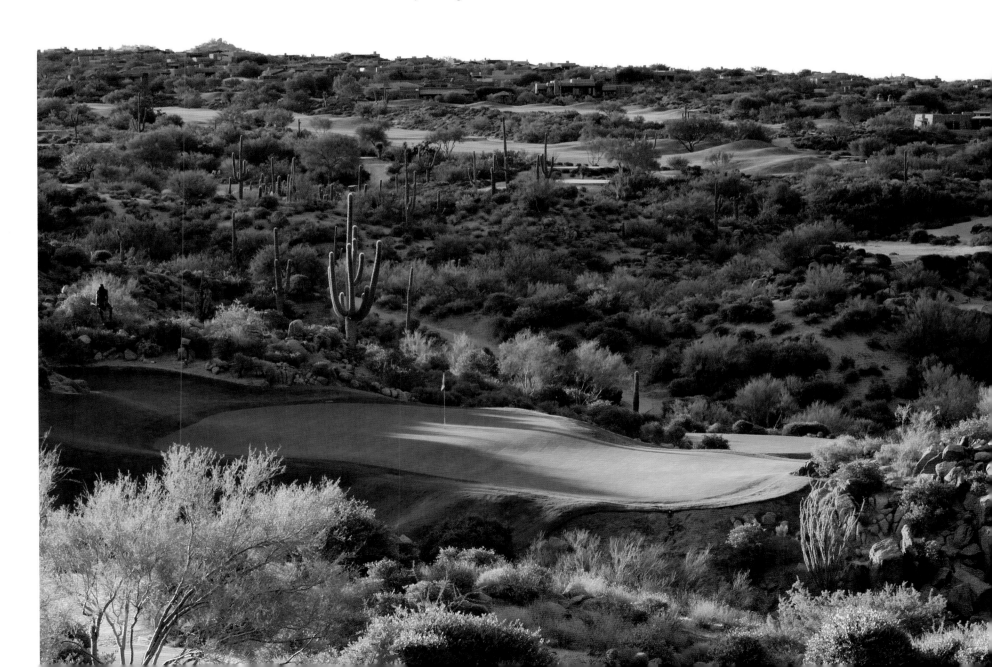

East Lake Golf Club (232–168 yards)

A Donald Ross design restored by Rees Jones, East Lake was Bobby Jones's home course for years. The eighteenth remains a wonderful test with a shot over part of East Lake to a sloping green that confounds even tour pros at the season-ending Tour Championship.

Old White Course at The Greenbrier (162–102 yards)

The Old White was originally designed by C. B. Macdonald and opened for play in 1914. Macdonald named number eighteen "Short," and it echoes the challenge of his original at the National Golf Links. Of mid-iron length at 162 yards, it is all carry to a green girdled by four bunkers.

Mahony's Point Course at Killarney Golf & Fishing Club (196–124 yards)

Situated on a small peninsula jutting into Lough Leane, this dramatic closer demands a full carry along the rugged shoreline to a narrow green protected by four bunkers left and a stand of conifers right.

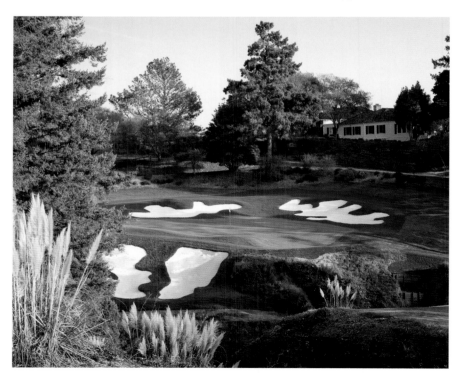

Garden City Golf Club (190–159 yards)

A bit of pressure is added here since your ball must carry a pond to a green located near an outdoor dining area full of spectators. The bunkering was done by one of the game's great amateur players, Garden City member Walter J. Travis.

Pasatiempo Golf Club (169–143 yards)

This one-shot finale (left) is a testament to Alister MacKenzie's willingness to break the rules about par-three holes. Here, your downhill shot crosses over a huge barranca to a green perched near a canyon. The green is open in front, but has sculpted bunkers left, right and back. The local advice? Don't try to be clever; just get on the green.

6. MASTER STROKES

Great holes produce great shotmaking. We ranged through competitive history and found these exceptional shots on par threes that determined the outcome of a major competition.

Master of Gravity

Spectators still shake their heads wondering how Fred Couples's tee shot in the final round of the 1992 Masters Tournament hung on the manicured slope in front of Augusta National's twelfth green. Moving quickly before a breath blew it into Rae's Creek, Couples pitched the ball close, sank the putt for an amazing par and went on to capture the Green Jacket.

The Little Chip That Woods

Sunday of the 2005 Masters: Tiger Woods was one up on Chris DiMarco after fifteen holes. His tee shot at sixteen ended back left, just off the green. Hoping for a one-putt par, Woods feathered a chip that curled 20 feet to the edge of the cup, paused, then fell in for a birdie two. Galvanized, Woods eventually went on to win a playoff and his fourth Masters title.

A Kite in the Wind

On the final day of the 1992 U.S. Open at Pebble Beach, where whipping wet weather made standing up an achievement, Tom Kite hit a five iron into a terrible position left of the seventh green. Hoping to save par, he chipped in for an amazing birdie that convinced him he could win what would be his only major title.

One and Done

In 1972, fighting to win his third U.S. Open on his favorite course, Jack Nicklaus surveyed the pin position and the blowing wind and chose to hit a one iron from 218 yards on Pebble Beach's seventeenth. Adroitly, he hit a high, hooking shot that bounced off the base of the flagstick and dropped inches away, setting up a birdie and clinching the victory.

Elementary, My Dear Watson

A decade later in 1982, Nicklaus was close to becoming the first five-time winner of the U.S. Open. While he waited in the clubhouse, Tom Watson, tied for the lead, came to the seventeenth tee. Needing a birdie to win, he hooked a two iron into the thick rough bordering the green. When his caddie Bruce Edwards said, "Get it close," Watson retorted, "Hell, no, I'm going to make it." He did, skipping across the green in celebration. Another birdie on eighteen capped his marvelous finish.

Licking the Postage Stamp

On the fiftieth anniversary of his British Open win at Royal St. George's, Gene Sarazen found himself standing on Royal Troon's eighth tee facing one of the hardest short holes in the world. One smooth five iron, a bounce and roll, and he had aced the famed Postage Stamp. For good measure, the next day he made birdie for a two-day total of three strokes.

Intimations of Immortality

At the 1994 U.S. Amateur Championship held at the TPC Sawgrass, an eighteen-year-old Tiger Woods surveyed the fearsome seventeenth island green, took a wedge and went right at the pin, set in a dangerous right-side position. The shot stayed on, barely three feet from the edge of the green, leaving a 14-foot birdie putt that Woods sank, giving him the first of three consecutive U.S. Amateur titles.

Turning Point at Turnberry

The historic "Duel in the Sun" between Jack Nicklaus and Tom Watson at the 1977 British Open may be the finest 36-hole mano-a-mano battle in golf history. The turning point was Turnberry's 209-yard fifteenth, where Nicklaus put his tee shot on the green and Watson faced a testy chip to save par. With a two-shot swing in the balance, Watson took a putter and rolled his ball some 60 feet into the cup for a 2, pulling even and eventually winning the Open.

One-of-a-Kind

While there have been eagles to win a PGA Tour event, not until October 24, 2010, had a golfer won a title by making a hole in one. The venue was the Justin Timberlake Shriners Open at the TPC Summerlin course in Las Vegas. The setting was a three-way sudden-death playoff between Martin Laird, Cameron Percy and Jonathan Byrd. They halved three holes and then, with darkness closing, agree to play the 196-yard seventeenth. Six iron in hand, Byrd hit a draw that landed 20 feet short, then rolled gently into the cup. Results: Ace, tournament victory and a two-year exemption on the Tour!

One of the greatest rivalries in golf history saw Tom Watson and Jack Nicklaus battle for Open championships on both sides of the Atlantic.

7. THREES AND ACES

Golf historians report the first recorded hole in one was made by Young Tom Morris on the 145-yard eighth hole during the 1868 British Open at Prestwick Golf Club. Statistics show some aces have been recorded on par fours and even fives, but 99 percent are made on par threes. Ask anyone — golf writers, designers, players — and they all agree the coolest thing about the one-shot hole is — you can complete it in one shot. Chris Rodell, author of *Hole In One!*, points out that average athletes can't expect to compete with pros or perform amazing feats in most sports. In golf though, "they could one day hit a shot that pros couldn't improve on. When you make a hole in one, that is your greatest shot ever."

The tee shot on a reachable short hole is special for a single, everlasting reason. It evokes the hope that maybe, just maybe, this one time, the ball will actually end up in the hole. At this point the plus-3 and 30-handicap player are equal. Because they are the venue for most aces, par threes stake their claim to being the "everyman" among golf holes. On the short holes kids and octogenarians can all enjoy the wonderful feeling that comes when you swing and watch your ball disappear into the cup. The happy results: a "1" on your card, celebrations after the round and a lifetime memory.

Those interested in the almost endless records and statistics on the hole in one can consult *Golf Digest*'s Hole-in-One Clearinghouse, which has been tracking these since the 1950s. There is even a "Hole In One Society" devoted to the ace.

But if you see it as only a number, you miss the point. Making an ace puts you in a special club among golfers. Lee Trevino said, "The hole in one in golf is special because it's the only thing in golf that's perfect." We'll leave the final words on the subject to writer Darren Kilfara: "The hole in one. In a sense, the ace is the heart in the body of golfing mysticism. It is 'one,' it is everything, it is perfection, it is why we play the game."

A dazzling rainbow arches toward the green at "Laird's Ain," the par-three fifth hole at the Machrie Golf Links on the island of Islay in the Hebrides.

GOLF'S 100 FINEST PAR THREES

Gold Holes	Hole	Length	Designer(s)
Augusta National GC	#12	155–145	Alister MacKenzie and Bobby Jones
Augusta National GC	#16	170–145	Alister MacKenzie and Bobby Jones/Robert Trent Jones, Sr.
Ballybunion GC (Old Course)	#12	214–165	James McKenna/Tom Simpson and Molly Gourlay
Baltusrol GC (Lower Course)	#4	199–101	A. W. Tillinghast/Robert Trent Jones, Sr.
Bandon Dunes (Pacific Dunes Course)	#10	206–129	Tom Doak
Banff Springs GC	#4	199–79	Stanley Thompson
Bethpage State Park (Black Course)	#17	207–178	A. W. Tillinghast/Rees Jones
Casa de Campo (Teeth of the Dog Course)	#7	229–90	Pete Dye
Cruden Bay GC	#15	239–210	Old Tom Morris/Tom Simpson and Herbert Fowler
Cypress Point Club	#15	143–119	Alister MacKenzie and Robert Hunter
Cypress Point Club	#16	231–208	Alister MacKenzie and Robert Hunter
Estancia Club	#11	137–94	Tom Fazio
Harbour Town Golf Links	#17	185–130	Pete Dye and Jack Nicklaus
Jupiter Hills Club (Hills Course)	#9	190–130	George Fazio
Kiawah Island	#17	221–122	Pete and Alice Dye
Kittansett Club	#3	167–121	William Flynn and Frederick Hood
Lahinch GC (Old Course)	#5	154–118	Old Tom Morris/Alister MacKenzie/Martin Hawtree
Mauna Kea Resort Golf Course	#3	210–140	Robert Trent Jones, Sr./Rees Jones
Mauna Lani (South Course)	#15	216–92	Homer Flint and R. F. Cain/Robin Nelson and Rodney Wright
Medinah CC (No. 3 Course)	#17	206–133	Tom Bendelow/Roger Rulewich/Rees Jones
Muirfield	#13	191–133	Old Tom Morris/Harry S. Colt and Tom Simpson
Muirfield Village GC	#12	184–107	Jack Nicklaus and Desmond Muirhead
National Golf Links of America	#4	195–159	C. B. Macdonald
New South Wales GC	#6	187–132	Alister MacKenzie/Eric Apperly
North Berwick GC (West Links)	#15	192–173	David Strath

GOLF'S 100 FINEST PAR THREES

Gold Holes	Hole	Length	Designer(s)
Olympic Club (Lake Course)	#3	223–187	Wilfrid Reid/Willie Watson/Sam Whiting
Pebble Beach Golf Links	#7	106–90	Jack Neville and Douglas Grant/H. Chandler Egan
Pebble Beach Golf Links	#17	208–148	Jack Neville and Douglas Grant/H. Chandler Egan
Pine Valley GC	#10	145–130	George Crump/Harry S. Colt
Pine Valley GC	#5	226–217	George Crump/Harry S. Colt
Pinehurst (No. 2 Course)	#15	206–125	Donald Ross
Pound Ridge GC	#15	174–124	Pete Dye/Perry Dye
Prairie Dunes CC	#10	185–85	Perry Maxwell/J. Press Maxwell
Prestwick GC	#5	236–113	Old Tom Morris/James Braid
Riviera CC	#4	236–186	George C. Thomas, Jr./Billy Bell
Royal Birkdale GC	#12	183–145	George Low/Fred Hawtree and J. H. Taylor/Martin Hawtree
Royal County Down GC (Championship Links)	#4	212–159	Old Tom Morris/George Combe/Harry S. Colt
Royal Dornoch GC (Championship Course)	#6	161–135	Old Tom Morris/J. H. Taylor and John Sutherland
Royal Melbourne GC (East Course)	#16	167–129	Alex Russell and Alec Morcom
Royal Melbourne GC (West Course)	#5	176–142	Alister MacKenzie/Alex Russell
Royal Portrush GC (Dunluce Links)	#14	210–167	Old Tom Morris/Harry S. Colt
Royal Troon GC (Old Course)	#8	123–114	George Strath/Willie Fernie/James Braid
Sand Hills GC	#17	139–115	Bill Coore and Ben Crenshaw
St. Andrews (Old Course)	#11	174–150	Unknown/Allan Robertson and Old Tom Morris
Sugarloaf GC	#11	216–150	Robert Trent Jones, Jr.
TPC Sawgrass (Stadium Course)	#17	132–80	Pete and Alice Dye
Turnberry (Ailsa Course)	#15	206–162	Willie Fernie/Philip Mackenzie Ross
Whistling Straits (Straits Course)	#3	183–106	Pete Dye
Winged Foot GC (West Course)	#10	183–106	A. W. Tillinghast
Yale University Golf Course	#9	213–146	Seth Raynor and C. B. Macdonald

GOLF'S 100 FINEST PAR THREES

Silver Holes	Hole	Length	Designer(s)
Alwoodley GC	#11	175–139	Alister MacKenzie and Harry S. Colt
Bandon Dunes (Bandon Dunes Course)	#15	163–102	David McLay Kidd
Barnbougle Dunes GC	#7	112–85	Tom Doak and Mike Clayton
Cabo del Sol (Ocean Course)	#17	178–102	Jack Nicklaus
Cape Kidnappers Golf Course	#13	119–96	Tom Doak
Capilano GC	#11	168–116	Stanley Thompson
Challenge at Manele GC	#12	202–65	Jack Nicklaus
Chicago GC	#10	139–125	C. B. Macdonald/Seth Raynor
Coeur d'Alene Resort	#14	218–95	Scott Miller
Devil's Paintbrush GC	#13	226–145	Michael Hurdzan/Dana Fry
Doonbeg GC	#14	111–82	Greg Norman
Dunes Club	#2	200–131	Dick and Tim Nugent/Mike Keiser
Essex County Club	#11	175–154	Donald Ross
Fishers Island Club	#5	229–141	Seth Raynor
Gleneagles (King's Course)	#16	158–113	James Braid
Golden Horseshoe GC (Gold Course)	#16	169–97	Robert Trent Jones, Sr.
Kemper Lakes GC	#17	203–82	Ken Killian and Dick Nugent
Kingsbarns Golf Links	#15	212–110	Kyle Phillips and Mark Parsinen
Kingston Heath GC	#15	155–123	Dan Souter/Alister MacKenzie
Los Angeles CC (North Course)	#11	240–192	George C. Thomas, Jr.
Mauna Kea Resort Golf Course	#11	247–166	Robert Trent Jones, Sr./Rees Jones
Merion GC (East Course)	#13	127–114	Hugh Wilson/William Flynn
Mid Ocean Club	#13	238–188	C. B. Macdonald
National Golf Links of America	#6	141–110	C. B. Macdonald
Oakland Hills CC (South Course)	#13	191–131	Donald Ross/Robert Trent Jones, Sr.

GOLF'S 100 FINEST PAR THREES

Silver Holes	Hole	Length	Designer(s)
Oakmont CC	#8	288–185	Henry Fownes and William Fownes
Pasatiempo GC	#18	169–88	Alister MacKenzie/Tom Doak
PGA West (TPC Stadium Course)	#17	168–83	Pete Dye
Pine Needles GC	#3	145–110	Donald Ross
Ponte Vedra Inn & Club (Ocean Course)	#9	144–105	Herbert Bertram Strong/Bobby Weed
Port Royal Golf Course	#16	235–105	Robert Trent Jones, Sr.
Portmarnock GC (Championship Links)	#15	189–176	W. C. Pickeman/Mungo Park
Royal Golf Dar Es Salam (Red Course)	#9	189–121	Robert Trent Jones, Sr.
Royal Porthcawl GC	#7	122–113	Charles Gibson/Harry S. Colt
Saint Endréol GC	#13	260–109	Michel Gayon
San Francisco GC	#7	184–166	A. W. Tillinghast
Seminole GC	#17	162–130	Donald Ross
Seven Canyons GC	#7	198–123	Tom Weiskopf
Somerset Hills GC	#2	175–148	A. W. Tillinghast
Spyglass Hill Golf Course	#15	130–84	Robert Trent Jones, Sr.
Stone Canyon GC	#6	135–90	Jay Morrish
St. Regis Princeville (Makai Course)	#3	181–130	Robert Trent Jones, Jr.
Terravista Golf Course	#14	216–107	Dan Blankenship
Torrey Pines (North Course)	#6	206–141	Billy Bell and W. F. Bell
Troon CC	#15	139–115	Tom Weiskopf and Jay Morrish
Valderrama GC	#15	206–146	Robert Trent Jones, Sr.
Vale do Lobo (Royal Course)	#16	235–145	Henry Cotton/Rocky Roquemore
Ventana Canyon GC (Mountain Course)	#3	107–98	Tom Fazio
Wannamoisett CC	#3	138–116	Donald Ross
Waterville Golf Links	#17	194–120	Eddie Hackett/Tom Fazio

Photo Credits

All photos © Tony Roberts (tonyrobertsphotography.com), with the exception of those contributions noted below:

Koji Aoki (www.afloimages.com): 216
Rob Babcock/Pasatiempo (robbabcock.com): 150, 242
Walt Bukva (bukvaimaging.com): 142
Barnbougle Dunes GC: 59
Cape Kidnappers Golf Course: 198
Capilano GC: 176
Casa de Campo: 65
Coeur d'Alene Resort: 122
Coore & Crenshaw (coorecrenshaw.com): 21, 35
Devil's Paintbrush GC: 149
Tom Doak (renaissancegolf.com): 18, 21, 22, 162, 202
Doonbeg: 200
Joann Dost (joanndost.com): 144
Pat Drickey (stonehousegolf.com): 141
Dick Durrance (drinkerdurrance.com): 238
Jeff Fallon/Portmarnock Golf Club (portmarnockgolfclub.ie): 60
Fishers Island: 184
French Lick Resort: 236
Steven Gibbons/USGA (usga.org): 105
Julian P. Graham (loonhill.com): 9
The Greenbrier: 180
Eric Hepworth (hepworthgolfphotography.com): 42, 100
The Homestead Resort: 240
Mike Hopkins: 19

Paul Hundley (thepaulhundleygallery.com): 235
John Johnson (golfphotos.us): 134
Russell Kirk (golflinksphotography.com): 106, 201
Jim Krajicek (krajicekgolfphoto.com): 154
Legends Golf & Safari Resort: 230
Jim Mandeville/Nicklaus Golf (nicklaus.com): 173
Ken May (rollinggreens.com): 11
Brian Morgan (brianmorgan.com): 85, 98, 151
National Golf Links of America: 189
Oakmont CC: 29
PGA Tour Archive/Getty (gettyimages.com): 10
Ponte Vedra Club: 126
Steve Pope/Royal Porthcawl (fotowales.com): 203
Port Royal Golf Course: 86
Montana Pritchard/PGA of America (montanaphoto.com): 104
Royal West Norfolk GC: 19
Bob Schank: 170
Evan Schiller (golfshots.com): 92, 109
Geoff Shackelford (geoffshackelford.com): 103
Brian Smith (briansmithboston.com): 119
Somerset Hills GC: 192
Terravista GC: 87
TPC Scottsdale: 232
Trump National GC, Westchester: 233
Wannamoisett CC: 207
Tom Waters/EssexCC (essexcc.org): 101

Allen, Peter. *Famous Fairways: A Look at the World of Championship Courses*. London: Stanley Paul, 1968.

Andrisani, John. *Golf Heaven: Insiders Remember Their First Trip to Augusta National Golf Club*. New York: Thunder's Mouth Press, 2007.

Bahto, George. *The Evangelist of Golf: The Story of Charles Blair Macdonald*. Chelsea, MI: Clock Tower Press, 2002.

Barclay, James A. *The Toronto Terror: The Life and Works of Stanley Thompson, Golf Course Architect*. Chelsea, MI: Sleeping Bear Press, 2000.

Barkow, Al. *The History of the PGA Tour*. New York: Doubleday, 1989.

Barrett, David. *Golf Courses of the U.S. Open*. New York: Harry N. Abrams, 2007.

Braid, James. *Advanced Golf: Or, Hints and Instruction for Progressive Players*. London: Methuen, 1908.

Callahan, Tom and Dave Kindred. *Around the World in 18 Holes*. New York: Doubleday, 1994.

Campbell, Malcolm. *The New Encyclopedia of Golf*. London: Dorling Kindersley, 2001.

Christian, Frank. *Augusta National and The Masters: A Photographer's Scrapbook*. Chelsea, MI: Sleeping Bear Press, 1996.

Colt, H. S. and C. H. Alison. *Some Essays on Golf Course Architecture*. Worcestershire, England: Grant Books, 1993.

Cook, Kevin. *Tommy's Honor*. New York: Gotham Books, 2007.

Cornish, Geoffrey S. *Eighteen Stakes on a Sunday Afternoon: A Chronicle of Golf Course Architecture in North America*. London: Grant Books, 2002.

Cornish, Geoffrey and Ronald E. Whitten. *The Architects of Golf: A Survey of Golf Course Design from its Beginnings to the Present, with an Encyclopedic Listing of Golf Course Architects and Their Courses*. New York: HarperCollins, 1993.

———. *The Golf Course*. New York: Rutledge Press, 1988.

Daley, Paul. *Favourite Holes by Design: The Architect's Choice*. Victoria, Australia: Full Swing Golf Publishing, 2004.

———. *Golf Architecture: A Worldwide Perspective*. Victoria, Australia: Full Swing Golf Publishing, 2009.

———. *Links Golf: The Inside Story*. Sydney, Australia: Hardie Grant Books, 2000.

Darwin, Bernard. *Golf Between Two Wars*. London: Chatto & Windus, 1944.

———. *Historic Golf Courses of the British Isles*. London: Duckworth, 1910.

Darwin, Bernard and Harry Rountree. *The Golf Courses of the British Isles*. London: Storey Communications, 1997 (facsimile).

Davis, William H. *The World's Best Golf: A Spectacular Guided Tour of the Greatest Golf Courses in the World*. New York: Golf Digest, 1991.

Diaz, Jaime and Linda Hartough. *Hallowed Ground: Golf's Greatest Places*. Seymour, CT: Greenwich Workshop Press, 1999.

Doak, Tom. *The Anatomy of a Golf Course: The Art of Golf Architecture*. Short Hills, NJ: Burford Books, 1992.

———. *The Confidential Guide to Golf Courses*. Chelsea, MI: Sleeping Bear Press, 1996.

Doak, Tom, James S. Scott and Raymund M. Haddock. *The Life and Work of Dr. Alister MacKenzie*. Michigan: Sleeping Bear Press, 2001.

Dye, Pete with Mark Shaw. *Bury Me in a Pot Bunker: Golf Through the Eyes of the Game's Most Challenging Course Designer*. New York: Addison-Wesley, 1995.

Edmund, Nick and Matthew Harris. *Classic Golf Courses of Great Britain and Ireland: A Hole-by-Hole Comparison*. Boston: Little, Brown, 1997.

Fay, Michael J. *Golf, As It Was Meant to be Played: A Celebration of Donald Ross's Vision of the Game*. New York: Universe, 2000.

Fazio, Tom with Cal Brown. *Golf Course Designs*. New York: Harry N. Abrams, 2000.

Finegan, James. *All Courses Great and Small: A Golfer's Pilgrimage to England and Wales*. New York: Simon & Schuster, 2003.

———. *Blasted Heaths and Blessed Greens: A Golfer's Pilgrimage to the Courses of Scotland*. New York: Simon & Schuster, 1996.

———. *Where Golf Is Great: The Finest Courses of Scotland and Ireland*. New York: Artisan, 2006.

Frost, Mark. *The Match: The Day the Game of Golf Changed Forever*. New York: Hyperion, 2007.

Golf.com

GolfClubAtlas.com

Golf Course Superintendents Association. *Golf Course Architecture*. Chelsea, MI: Sleeping Bear Press, 1996.

GolfLink.com

Graves, Robert Muir and Geoffrey S. Cornish. *Classic Golf Hole Design: Using the Greatest Holes as Inspiration for Modern Courses*. Hoboken, NJ: John Wiley & Sons, 2002.

Gummer, Scott. *The Seventh at St. Andrews: How Scotsman David McLay Kidd and His Ragtag Band Built the First New Course on Golf's Holy Soil in Nearly a Century*. New York: Gotham, 2007.

Hannigan, Frank. "Golf's Forgotten Genius." *Golf Journal*, May 1974.

Hawtree, Fred. *Aspects of Golf Course Architecture 1: 1889–1924*. Worcestershire, England: Grant Books, 1998.

———. *Colt & Co.: Golf Course Architects*. Woodstock, Oxford: Cambruc Archive, 1991.

———. *The Golf Course: Planning, Design, Construction and Maintenance*. London: E & F. N. Spon, 1983.

Hobbs, Michael. *The World's Great Golf Courses*. London: Apple Press, 1988.

Huffman, Bill and Tom Weiskopf. *Arizona's Greatest Golf Courses*. Flagstaff: Northland, 2000.

Hunter, Robert. *The Links*. New York: Charles Scribner's Sons, 1926.

Hurzdan, Michael. *Golf Course Architecture: Evolutions in Design, Construction and Restoration Technology*. Hoboken, NJ: John Wiley & Sons, 2006.

Jacobs, Timothy. *Great Golf Courses of the World*. London: Gallery Book, 1990.

Jenkins, Dan. *Fairways and Greens: The Best Golf Writing of Dan Jenkins*. New York: Doubleday, 1994.

———. *The Dogged Victims of Inexorable Fate: A Love-Hate Celebration of Golfers and Their Game*. New York: Little, Brown: 1970.

Jones, Robert Trent, Jr. *Golf by Design: How to Lower Your Score by Reading the Features of a Course*. Boston: Little, Brown, 1993.

Jones, Robert Trent, Jr. with Larry Dennis and Tony Roberts. *Golf's Magnificent Challenge*. New York: McGraw-Hill, 1988.

Kilfara, Darren. *A Golfer's Education*. Chapel Hill, NC: Algonquin Books, 2001.

Kirk, John and Timothy Jacobs. *The Golf Courses of Robert Trent Jones, Jr.* New York: W. H. Smith Books, 1988.

Klein, Bradley. *Discovering Donald Ross: The Architect and His Golf Courses*. Michigan: Sleeping Bear Press, 2001.

Klein, Bradley. *Rough Meditations*. Chelsea, MI: Sleeping Bear Press, 1997.

Konik, Michael. *Nice Shot, Mr. Nicklaus: Stories About the Game of Golf*. Las Vegas: Huntington Press, 2000.

Kroeger, Robert. *The Golf Courses of Old Tom Morris: A Look at Early Golf Architecture*. Cincinnati: Heritage Communications, 1991.

LeBrock, Barry. *The Front Nine: Golf's All-Time Greatest Shots*. Chicago: Triumph Books, 2008.

Liguori, Ann. *A Passion for Golf: Celebrity Musings About the Game*. Dallas: Taylor Publishing, 1997.

Lipsey, Rick. *Golfing on the Roof of the World: In Pursuit of Gross National Happiness*. New York: Bloomsbury, 2007.

Lumb, Nick and Michael Hobbs and John Pinner. *The Complete Book of Golf*. London: Mallard Press, 1988.

Lyle, Sandy. *Sandy Lyle Takes You Round the Championship Courses of Scotland*. Kingswood, Surrey: World's Work, 1982.

Machat, Udo and Cal Brown. *The Golf Courses of the Monterey Peninsula*. San Francisco: Sports Images, 1989.

MacKenzie, Alister. *Golf Architecture*. London: Ailsa, 1997 (facsimile).

———. *The Spirit of St. Andrews*. Michigan: Sleeping Bear Press, 1995 (facsimile).

Martin, Chris. *The Golfer's Companion*. London: Robson Books, 2005.

Masters Tournament Media Guide. 2008, 2009, and 2010.

McDonnell, Michael. *The Complete Book of Golf*. London: Kingswood Press, 1985.

McKay, Jim. *My Wide World*. New York: Macmillan, 1973.

The Memorial: The Official Magazine of the Memorial Tournament. 2008.

Millard, Chris. *Golf's 100 Toughest Holes*. New York: Harry N. Abrams, 2005.

Miller, Michael and Geoff Shackelford. *The Art of Golf Design*. Chelsea, MI: Sleeping Bear Press, 2001.

Murphy, Michael. *The Kingdom of Shivas Irons*. New York: Broadway Books, 1997.

Nash, Bruce, Allan Zullo and George White. *The Golf Nut's Book of Amazing Feats & Records*. Chicago: Contemporary Books, 1994.

National Golf Foundation. *Golf Course Design*. 2nd ed. Jupiter, FL: National Golf Foundation, 1998.

Nicklaus, Jack with Chris Millard. *Nicklaus by Design: Golf Course Strategy and Architecture*. New York: Harry N. Abrams, 2002.

Official PGA Tour Guide. 2008, 2009, 2010.

Peper, George and the Editors of *Golf Magazine*. *Golf in America: The First One Hundred Years*. New York: Harry N. Abrams, 1987.

Peper, George. *The 500 World's Greatest Golf Holes*. New York: Artisan, 2000.

PGATour.com

"Playing the Top 100 Courses in the World." Top100Golf.blogspot.com.

Plimpton, George. *The Bogey Man: A Month on the PGA Tour*. Gulford, CT: Lyons Press, 1993.

Plumridge, Chris. *The Essential Henry Longhurst: The Best of His Writing in Golf Illustrated*. London: Collins, 1988.

Price, Charles. *Golfer-At-Large: New Slants on an Ancient Game*. New York: Atheneum, 1983.

Ramsey, Tom. *Great Australian Golf Holes*. Richmond, Victoria: Hamlyn, 1989.

Richardson, Forrest L. *Routing the Golf Course: The Art & Science That Forms the Golf Journey*. Hoboken, NJ: John Wiley & Sons, 2002.

Richardson, Forrest L. and Mark K. Fine. *Bunkers, Pits, & Other Hazards: A Guide to the Design, Maintenance and Preservation of Golf's Essential Elements*. Hoboken, NJ: John Wiley & Sons, 2006.

Ross, Donald J. *Golf Has Never Failed Me: The Lost Commentaries of Legendary Golf Architect Donald J. Ross*. Chelsea, MI: Sleeping Bear Press, 1996.

Rowlinson, Mark. *Golfing on the World's Most Exceptional Courses*. New York: Abbeville, 2005.

———. *World Atlas of Golf*. London: Hamlyn, 2008.

Rubenstein, Lorne. *Links: An Insider's Tour Through the World of Golf.* Toronto: Random House, 1990.

Rubenstein, Lorne and Jeff Neuman. *A Disorderly Compendium of Golf.* New York: Workman Publishing, 2006.

Shackelford, Geoff. *The Captain: George C. Thomas Jr. and his Golf Architecture.* Santa Monica: Captain Fantastic, 1996.

———. *The Golden Age of Golf Design.* Chelsea, MI: Sleeping Bear Press, 1999.

———. *Grounds for Golf: The History and Fundamentals of Golf Design.* New York: Thomas Dunne Books, 2003.

———. *Masters of the Links.* Chelsea, MI: Sleeping Bear Press, 1997.

"The Shape of the Game." *Golf Digest.* November 2008.

Taylor, J. H. *Taylor on Golf: Impressions, Comments and Hints.* New York: D. Appleton, 1902.

Thomas, George C. *Golf Architecture in America: Its Strategy and Construction.* Los Angeles: Times-Mirror Press, 1927.

Tillinghast, A. W. *The Course Beautiful: A Collection of Original Articles and Photographs on Golf Course Design.* Edited by Richard Wolfe and Robert Trebus. Rockville, MD: TreeWolf Productions, 1995 (facsimile).

———. *Reminiscences of the Links: A Treasury of Creative Essays and Vintage Photographs on Scottish and Early American Golf.* Rockville, MD: Treewolf Productions, 1998 (facsimile).

Top100Courses.com

Waggoner, Glen. *Divots, Shanks, Gimmes, Mulligans, and Chili Dips: A Life in 18 Holes.* New York: Villard Books, 1993.

Wallach, Jeff. *Beyond the Fairway: Zen Lessons, Insights, and Inner Attitudes of Golf.* New York: Bantam Books, 1995.

Ward-Thomas, Pat. *The Lay of the Land: A Collection of the Golf Writings of Pat Ward-Thomas.* New York: Ailsa, 1990.

Wethered, H. N. and T. Simpson. *The Architectural Side of Golf.* Worcestershire: Grant Books, 1995.

———. *Design for Golf.* Norwich: Sportsman's Book Club, 1952.

Wexler, Daniel. *The Missing Links: America's Greatest Lost Golf Courses and Holes.* Hoboken, NJ: John Wiley & Sons, 2000.

Wind, Herbert Warren. *Following Through: Herbert Warren Wind on Golf.* New York: Ticknor & Fields, 1985.

———. *The Story of American Golf.* New York: Alfred A. Knopf, 1948.

Wikipedia.org

Wilson, Mark with Ken Bowden. *The Best of Henry Longhurst.* New York: Collins, 1979.

Zuckerman, Joel. *Pete Dye Golf Courses: Fifty Years of Visionary Design.* New York: Harry N. Abrams, 2008.

Index